# Communist Posters

Published by Reaktion Books Ltd
Unit 32, Waterside
44–48 Wharf Rd
London N1 7UX, UK
www.reaktionbooks.co.uk

First published 2017

Designed by Sophie Kullmann
Printed and bound in Slovenia by Gorenjski tisk storitve
A catalogue record for this book is available from the British Library

ISBN 978 1 78023 724 4

frontispiece:
**Dimitrii Moor**
*Death to World Imperialism*, 1919

# Communist Posters

**Edited by Mary Ginsberg**

REAKTION BOOKS

№ 22

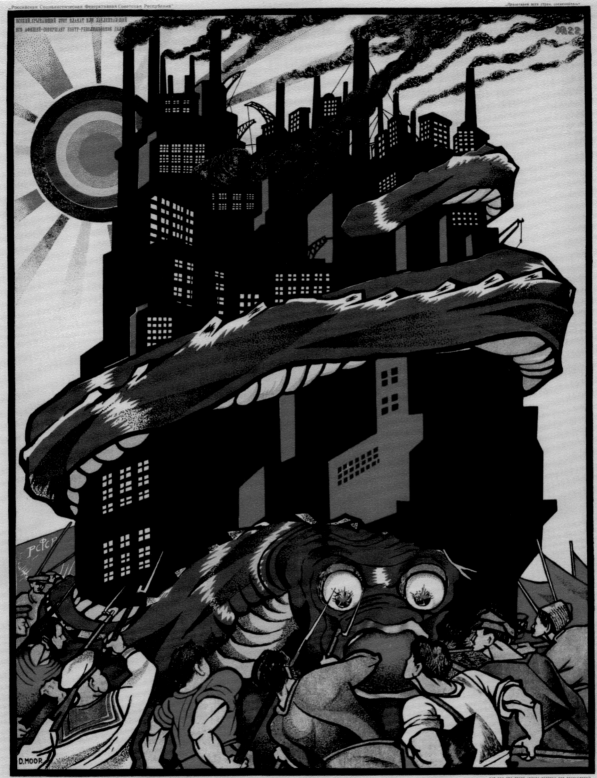

# СМЕРТЬ МИРОВОМУ ИМПЕРИАЛИЗМУ

# Contents

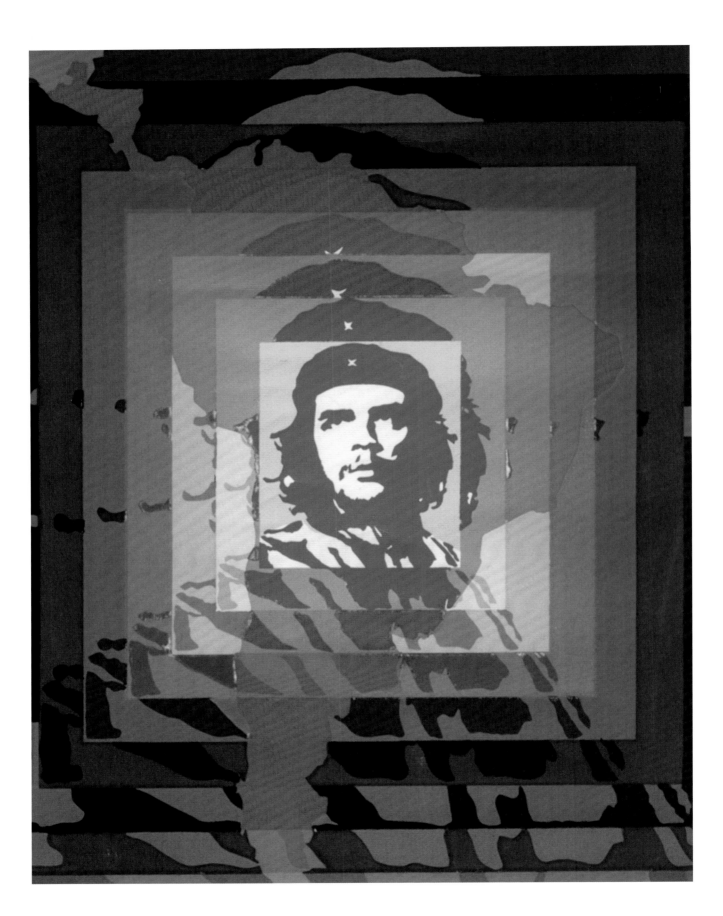

# Introduction

**Mary Ginsberg**

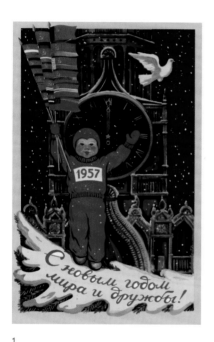

1
**Vera Livanova**
*Peace and Friendship
in the New Year*, 1956

The mobilization of art for revolutionary aims is a defining feature of communism.[1] As early as 1894, Friedrich Engels argued that posters were 'the main means of influencing the proletariat', making 'every street into a large newspaper'.[2] Posters have served as vehicles of persuasion, instruction, damnation and social discourse in every communist nation. They are beacons of revolutionary art – an ideal format for propaganda. They are fast and relatively cheap to produce and easy to transport, distribute and display in public places. Their striking imagery and bold slogans are purposefully clear and comprehensible to mass audiences. People may take more notice of them than of daily transactional items such as stamps or money, which also carry political messages and circulate the authority of the state. On the other hand, posters can also be highly effective weapons of protest, both before and after the establishment of revolutionary regimes.

By their nature, posters are ephemeral markers of time, place, invocation or triumph. Many, however, have far-reaching, long-lasting impact. Consider Picasso's dove, originally designed for the poster promoting the Soviet-backed World Peace Congress in 1949.[3] The dove had long featured in Jewish, Christian and pagan imagery, but from this time became a political symbol of peace in the propaganda of (ideologically atheist) communist states (illus. 1). The dove frequently appeared in communist posters with bellicose imagery, thereby mixing the metaphor (chap. 4, illus. 151).[4] It also served to express dissent within the Soviet bloc (chap. 3, illus. 148). The dove was gradually adopted worldwide and remains a universal symbol for peace (chap. 6, illus. 266).

Even more widely disseminated and re-messaged are the posters derived from Alberto Korda's photograph of lifelong Marxist Ernesto 'Che' Guevara (1928–1967), *Day of the Heroic Guerrilla, October 8* (illus. 2). The image functions in countless versions as political inspiration, commercial advertisement and dorm-room decoration. The symbolism of rebellion persists in political and popular culture, even if contemporary standard-bearers have no idea what Che actually did in Cuba and the rest of Latin America. Che posters appeared in Tunisia's Jasmine Revolution in 2010 (the star on his

opposite:

2
**Elena Serrano**
*Day of the Heroic Guerrilla,
October 8*, 1968

cap replaced by the crescent and star motif of the Tunisian flag), and were carried in Athens by anti-austerity/anti-Europe protesters in 2015.

Posters from China's Cultural Revolution (1966–76) are probably the most widely recognized images of the People's Republic, both within and without. There is a strong collector's market, both for genuine Mao posters of the era and for cheap (re)productions (illus. 4).[5] This phenomenon is commercially motivated, not politically – and remarkable, since most people wish those ten years had never happened. On the other hand, Liberation-era Maoist imagery (1940s) has been revived officially under Xi Jinping, celebrating Chinese national victories (chap. 4, illus. 180).

These are just three examples of how communist poster imagery evolved and has persisted, even when the ideology that inspired it has mostly lost its relevance. The medium, too, has been overshadowed by television, the Internet and digital art. But in the long twentieth century, posters were powerful means of propaganda in the revolutionary movements and govern-ance of communist states. In homes, schools and workplaces, posters played a part in people's lives (illus. 3, 5; chap. 4, illus. 182). Many were imbued with both artistic integrity and personal conviction; others were derivative, formulaic and flabby in message or style.[6]

A broad range of political and visual cultures is revealed in these pictorial documents. While most books about posters cover one country

3
Posters on wall of a home in
Guizhou, China, 2008

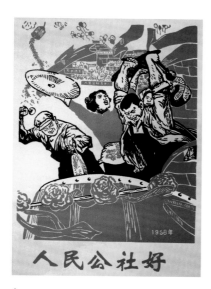

**Anonymous**
*The Communes are Good*, 1958

5
Posters in Mongolia,
1930s–1950s

or set of events, this one is the first survey across the history and diversity of communist poster art. While we cannot cover every communist regime, we hope to shed comparative light on the ideological and aesthetic elements of this essential propaganda format. Some of the following chapters analyse the posters of single collections, historically and thematically (Mongolia, North Korea). Others trace revolutionary posters through various policies, campaigns and leadership changes (USSR, China, Vietnam). The essay on Eastern Europe illustrates official propaganda and protest in nearly equal measure: in some of those countries open dissent was tolerated, if only for very limited periods. The final chapter examines the posters of Cuba, which stand apart in style and priority of subject-matter.

In the twentieth century, socialist regimes were established in Europe, Asia, Latin America and Africa – nominally, at least, under the banner of Marxism-Leninism. Socialism was a stage on the way to communism, the utopian goal.[7] At various times, these states worked together in a bloc, towards a shared ideological vision. At other times, national political interests, economic or social requirements prevailed. Ultimately, the utopian vision failed. Formerly communist states live today under a variety of economic and political systems. Four countries are still officially governed by communist parties, but the prevailing motivating political force is nationalism: 'primordial loyalties' have re-emerged.[8] The economic systems of all but Cuba have moved towards state capitalism, or market socialism.

Marxist-Leninist revolutionary regimes are – or were – committed to the realization of a classless, stateless society inhabited by free individuals working for a common good. This seems to involve a fundamental transformation of human nature, since, prior to the revolution, productive endeavour resulted from narrow, materialistic concerns. Ideally, then, the policies and practices of political socialization create a new system of values, attitudes and behaviour, preparing a 'new man' for the transition to communism.

The history of communist regimes shows, however, that ultimate goals are frequently subordinated to the demands of political and economic reality. This results from a conflict rooted in the revolution itself. No indigenous communist revolution succeeded under the conditions predicted by Karl

Marx. On the contrary, all occurred in conditions of 'underdevelopment'.[9]
The new regimes therefore faced several tasks: achieving a high level of
economic development (implicit in the attainment of communism), and
fostering the classless society. At the same time, they had to ensure their
power against possible foreign aggression and secure the cooperation of the
unconverted masses. In nearly every case, the achievement of these diverse
goals entailed the full mobilization of economic, political and social resources.

The term 'totalitarian' was long used to characterize one-party states
constructing all-embracing systems for development and control.[10] Many
have argued that while 'totalitarianism' subsumes divergent ideologies, these
regimes produce the same 'brand' of art, relying on similar strategies to
create 'identical official aesthetic conceptions'.[11] The cases lumped together
are generally the Soviet Union, Nazi Germany, fascist Italy and the People's
Republic of China (PRC).[12] We take a different view here, examining artworks
only of communist societies. It is true that heroic realism and the monumen-
tal are hallmarks of these four, and of other one-party states; and leader
worship and enemy demonizing are favourite themes of all. However, the
motivations, policies and aesthetics differ in each case: Hitler and Mao, for
example, proffered very different utopias. Representations of modernity and
model social structures are just two examples of their contrasting visions.

Since art is determined by the conditions of its production, we must note
a few factors that distinguish these countries from each other – apart from
their obviously different artistic traditions. One scholar of communist politi-
cal development emphasizes three points of comparison, which may be also
applied to the production and reception of propaganda art.[13] These are:

1.  Circumstances of communists' coming to power: indigenous revolu-
    tions, won after decades of war or colonialism (Russia, China, Cuba)
    clearly had more popular support than regimes installed with or by an
    outside power (Mongolia, Eastern Europe). Some countries endured
    long proxy wars as divided nations (North Korea, Vietnam). Indigenous
    revolutions generally had the cooperation or even enthusiastic support
    of the artists and educators who promoted them, and the populations
    were more accepting of sacrifice and struggle for future goals.

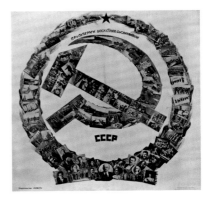

6
**Anonymous**
*The USSR: Workers of All
Countries, Unite!*, 1926

7
State emblem and flag of the
Turkmen Soviet SSR, 1926

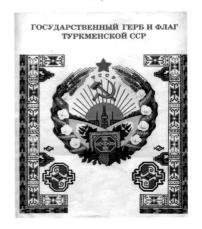

opposite:

8
**Vera Livanova**
*Get Ready for the All-Union
Agricultural Exhibition – the
National Showcase of the Victories
of Socialist Agriculture!*, 1950

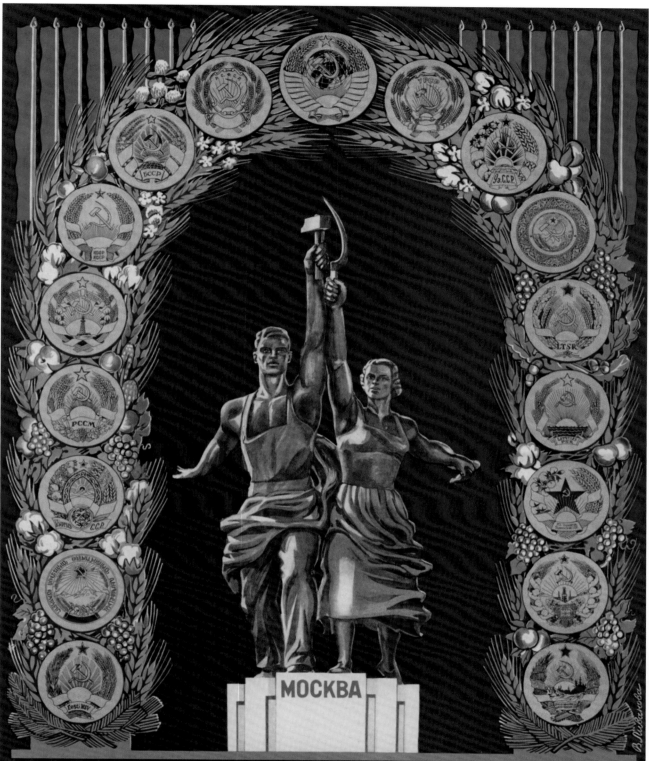

МОСКВА

# ГОТОВЬТЕСЬ К ВСЕСОЮЗНОЙ СЕЛЬСКОХОЗЯЙСТВЕННОЙ ВЫСТАВКЕ-

ВСЕНАРОДНОМУ СМОТРУ ПОБЕД СОЦИАЛИСТИЧЕСКОГО ЗЕМЛЕДЕЛИЯ!

1945-1995

위대한 수령 김일성동지만세!

위대한 령도자 김정일동지만세!

영광스러운 조선로동당창건 50돐만세!

9
**Nguyen Cong Do**
*Diligently Produce and Prepare for Combat*, 1973

2.  Level of development: the less developed the economy and the less educated the population, the more dependent was the government on visual propaganda, rather than text. The less familiar people were with concepts like 'classless society' and the 'New Man', the more necessary it was to saturate the country with new models and imagery.

3.  Existing political culture: Marxism-Leninism was an international ideology, and of course communist propaganda crossed borders, with common elements of style, message and symbolic motif. Socialist Realism, for example, was adopted more or less willingly by poster designers in nearly every communist state. However, each regime made use of traditional imagery, popular rituals and national heritage. Each invoked and adapted the past – or broke with it – as necessary.[14] Each invented its own traditions.[15]

opposite:

10
**Anonymous**
*Hurray for the 50th Anniversary of the Establishment of the Glorious [North] Korean Workers' Party!*, 1995–6

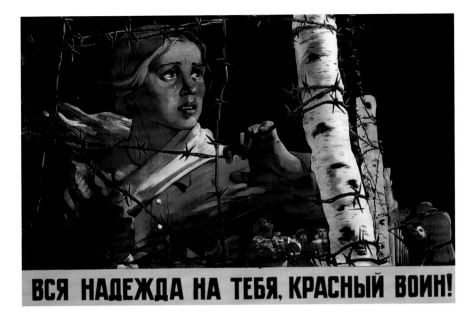

ВСЯ НАДЕЖДА НА ТЕБЯ, КРАСНЫЙ ВОИН!

11
**Viktor Ivanov and Olga Burova**
*Our Only Hope Is You, Red Soldier*, 1943

## Communism in Posters: Sources, Imagery and Subject-matter

The Bolshevik Revolution was a touchstone for all the others. Soviet power influenced the cultural policies of all communist regimes, but the relationships were nuanced across time and place.[16] The visual culture of international communism carried many universal themes, symbols and rituals; national authorities adapted these forms for better accessibility and reception and, thereby, enhanced legitimacy.

The most common communist symbols were the hammer and sickle and the five-pointed star. These feature on national flags, emblems, money and other objects of authority, and appear on posters in a variety of contexts. A photomontage poster from 1926 highlights the significance of the hammer and sickle, which came to stand for the Communist Party (illus. 6).[17] Adopted during the Bolshevik Revolution (1917), it represented worker-peasant unity against exploitation. The photomontage is in the shape of the national emblem, which also includes a wreath of grain, a red star, rays of sun and the internationalist slogan, 'Proletarians of all countries, unite!' The many photographs present scenes of industrial, agricultural, military and political life, as well as portraits of the Bolshevik leadership.[18]

All Soviet republics and several satellite states adopted this imagery for their emblems, though each featured national economic and cultural motifs (chap. 2, illus. 80). A Turkmenistan Republic poster is part of a complete

opposite:

12
**Gustav Klutsis**
*Let's Fulfil the Plan of Great Projects*, 1930

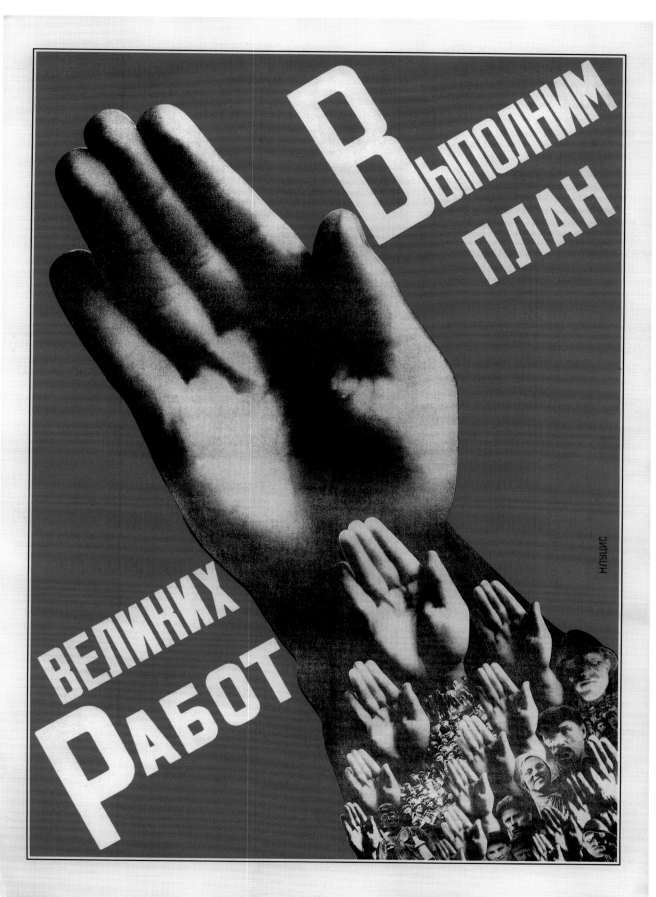

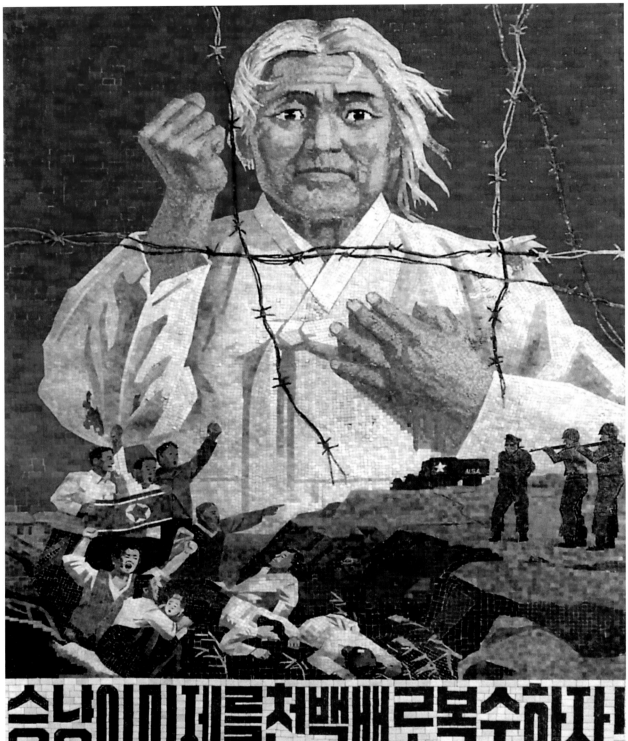

13

**Anonymous**
*Avenge the American Jackals
100 Times*, undated

14
**Viktor Deni**
*The Spider and the Flies*
(detail), 1919

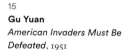

15
**Gu Yuan**
*American Invaders Must Be
Defeated*, 1951

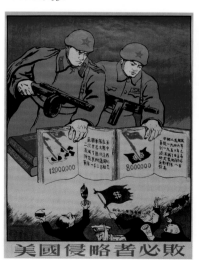

series of USSR flags and state emblems (illus. 7). The design includes symbols of local agriculture (cotton, grapes), industry (oil) and a rug, an important cultural product. The border patterns are traditional carpet guls.

The hammer and sickle took on a gendered meaning in the USSR, immortalized by Vera Mukhina's *Worker and Kolkhoz Woman*, the monumental statue designed for the Soviet pavilion at the 1937 International Exhibition: he raised high a hammer, and she the sickle. The statue was moved to Moscow, symbolizing the All-union Exhibition of Economic Achievements, VDNKH (illus. 8).[19] In Vietnamese iconography, a common male-female pairing was a soldier and an agricultural worker. She may be holding or planting grain, but instead of a sickle, she also carries a gun, representing constant military preparedness (illus. 9).

In the Democratic People's Republic of Korea (DPRK), exceptionally, the hammer, hoe and calligraphy brush form the symbol of the Korean Workers' Party in illus. 10. The brush signifies the white collar class, or intelligentsia, indicating their equal status with factory and agricultural workers. Communist and other mobilization regimes need writers, scientists and bureaucrats for modernization programmes, but generally distrust them for their independent views. Some argue that this sign of inclusiveness belies the North Korean regime's strong anti-intellectualism.[20]

The five-pointed star was the other ubiquitous symbol in communist iconography, but the motif had its origins much earlier, in European heraldry, and has military connotations worldwide. In Russia, it came into general use during or shortly after the Civil War, worn by soldiers of the Red Army. It has various political interpretations: the five fingers of the worker's hand; the five continents; the five groups who will lead the revolution to socialism/ communism (workers, peasants, soldiers, youth and intelligentsia). The flag and national emblem of China have red backgrounds, signifying the spirit of the revolution, with five gold stars representing the unity of the people. In Vietnam, the gold-filled star had revolutionary meaning before the advent of communism and appears in a 1945 poster replete with symbols of the French Revolution (chap. 6, illus. 267). Marianne, symbol of liberty, also provided inspiration for early Soviet poster designers and for progressive Chinese illustrators of the 1930s.[21]

Many other motifs crossed borders in poster design, but often carried different meanings. The mask of deception in Civil War Russia hid the greedy capitalist, while in Second World War China the face behind the mask was the Japanese military aggressor. The serpent was an effective sign against enemies of the Bolshevik Revolution and in the 1930s represented Stalin's real and imagined villains, but later appeared in Cold War calls for vigilance and appeals to 'ban the bomb' (chap. 3, illus. 127).

Compositional and other stylistic devices were shared. Many adaptations of Soviet and Chinese posters are easy to trace. The Mongolian artist Sharav's anti-nobility poster (chap. 2, illus. 82) could only have come from Viktor Deni's 1921 design condemning the church (illus. 14). The repeating hands of the Latvian graphic artist Gustav Klutsis in the 1930s (illus. 12) and post-war Hungary's Fischer (chap. 3, illus. 125) foster solidarity for national construction.[22] Viktor Ivanov and Olga Burova's Second World War Soviet poster *Our Only Hope Is You, Red Soldier* (illus. 11) clearly inspired the DPRK's quintessential call to avenge the 1950 Sinchon Massacre (illus. 13).[23] China's design with larger-than-life soldiers (illus. 15) features in an early Vietnamese call to resist the U.S. (chap. 6, illus. 236).

It is revealing to compare treatments of common political themes and broad social subject areas. Personality cults, loyalty to Party and revolutionary struggle are among the subjects illustrated in the following chapters. The authors also discuss portrayals of women, children, national minorities and other political actors. Yet another representative topic comprises celebrations and rituals: anniversary of the revolution; founding of the communist party and armed forces; birthdays of national leaders and revolutionary heroes; elections, anniversaries of military victories and other unifying ceremonies.

In the early years of the regimes, anniversary posters often reminded citizens of life's hardships before the joyful revolution. The imagery is powerful and easily accessible in Alexander Apsit's renowned poster celebrating the first *Year of the Proletarian Dictatorship* (illus. 18). Worker and peasant stand at a doorway to the sun-filled, modern future society. Happy crowds wave red flags. On the ground are broken accoutrements of the imperial regime: crown, shield and chains.

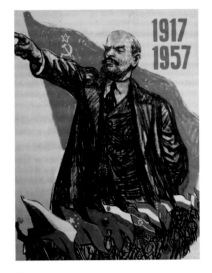

16
**Antonin Pelc**
*1917–1957*, 1957

17
**P.L.A. Pictorial**
*Proletarians of the World,
Unite!*, 1971

全世界无产者，联合起来！

opposite:

18
**Alexander Apsit**
*Year of the Proletariat
Dictatorship, October 1917–
October 1918*, 1918

Российская Социалистическая Федеративная Советская Республика.

ПРОЛЕТАРІИ ВСЕХ СТРАН СОЕДИНЯЙТЕСЬ!

ГОД ПРОЛЄТАРСКОЙ ДИКТАТУРЫ.
ОКТЯБРЬ 1917 - ОКТЯБРЬ 1918

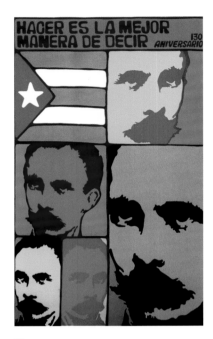

19
**Juan Antonio Gomez**
*To Act Is the Best Way to Make a Point*, 1983

The Bolshevik Revolution was marked by most communist parties every 7 November until the USSR collapsed (chap. 7, illus. 282).[24] A fortieth anniversary poster was in a common style, during a time of strong solidarity within the communist bloc (illus. 16). It is readily distinguishable as Czechoslovakian only by the lead flag in the procession. Other collective celebrations included International Women's Day (8 March), International Labour Day (1 May) and Children's Day (1 June).[25]

Much of the iconography illuminating these occasions was shared and predictable, following evolving policy lines. In the USSR, International Women's Day posters from the early five-year plans showed robust farm and factory women hard at work (chap. 1, illus. 67). After the mid-1930s, when Stalin declared that life had become more 'joyful', there were often flowers and families in these images instead. On 1 May, proletarians of the world united, armed or raising clenched fists. This type of militant, multi-racial iconography served in most communist countries, working equally well with anti-imperialist Cold War slogans or exhortations to defend the revolution. In illus. 17, the protagonists forge ahead to the strains of 'The Internationale'.

Posters celebrating indigenous heroes and festivals are, understandably, designed in national style with popular motifs and references. A poster by Juan Antonio Gomez commemorates the 130th anniversary of José Martí's birth (1853–1895). The flat, boldly coloured design, typical of Cuban silk-screen prints, presents multiple images of the national literary and political hero, still revered as the 'Apostle of Independence' (illus. 19). In Vietnam, posters produced after Hồ Chí Minh's death in 1969 portray the leader in outline or silhouette, while other figures are in colour, showing that he is still there in spirit.[26]

Some symbolism may be meaningful to a local audience, but not to outsiders. A poster honouring Jan Palach (1948–1969), who immolated himself protesting the 1968 Soviet Occupation, would be understood in the Czech Republic and much of Eastern Europe, but not where people don't know his story (illus. 20). Similarly, the clear reference to *The Romance of the Three Kingdoms* would be missed by most non-Chinese viewers of the Great Leap Forward poster in illus. 22.[27]

20
**Yuri Barabash**
*Jan Palach 11.09.1948– 19.01.1969*, 2014

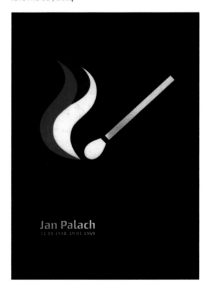

21
**Anonymous**
*Follow the Deeds of Two
National Heroines*, undated

22
**Yu Youfeng**
*Zhuge Comes Out of the
Thatched Cottage*, 1960

Folk art was frequently used to depict national heroes in communist posters. Traditional stories and imagery were more accessible to illiterate populations, and their subject-matter could be adapted to nationalist/communist themes. Trotsky appeared as St George battling counter-revolutionaries on a white horse; Mao Zedong replaced the ubiquitous Kitchen God. The heroic Trung sisters (*c.* AD 12–*c.* 43), ancient freedom fighters, wage the battle for independence in twentieth-century Vietnamese posters (illus. 21), while the legendary Chollima – the horse who covered 1000-*li* (about 650 km) a day – is regularly invoked in the posters and other propaganda media of North Korea (chap. 5, illus. 228).

Traditional markers were especially necessary in less politically developed countries, where communist ideology was totally new. The Mongolian flag combined the Soyombo (national symbol) with a five-pointed red star (chap. 2, illus. 109). Posters promoting new forms of political participation and social development relied on familiar scenes and signs for decades.[28] Elections were important occasions, ritualizing 'democracy' and emphasizing the unity of citizens from all generations, occupations and national minorities. Eager voters feature in the posters of all the countries discussed here (chap. 2, illus. 110; chap. 6, illus. 264).

Political rituals and processions, meetings and mass organizations, monuments, film and print media – all with ubiquitous symbolic systems – reinforced ideal images of the new society. This is how it should be; how it will be (even if we're not there yet). Everyone looks forward, marching to the future, striving to achieve, happy to sacrifice. A North Korean poster, overfull with iconography, commands: *Bring Honour to Our Glorious Country Forever!* (illus. 23). Revolutionary citizens gaze ahead with gratitude and wonderment; a Party member raises high the wisdom of Kim Il Sung (1912 –1994); the intellectual waves the DPRK flag; the girl holds a bouquet, which includes magnolias (the national flower) and blooms of Kimilsungia and Kimjongilia; Young Pioneers and enthusiastic gymnasts participate in a mass event. The national logo, the Chollima Horse Monument (representing super-fast development) and sacred Mt Paektu (or Baekdu) all feature.[29] This may be an iconographically extreme example, but every chapter in this book portrays national visions of life under communism.

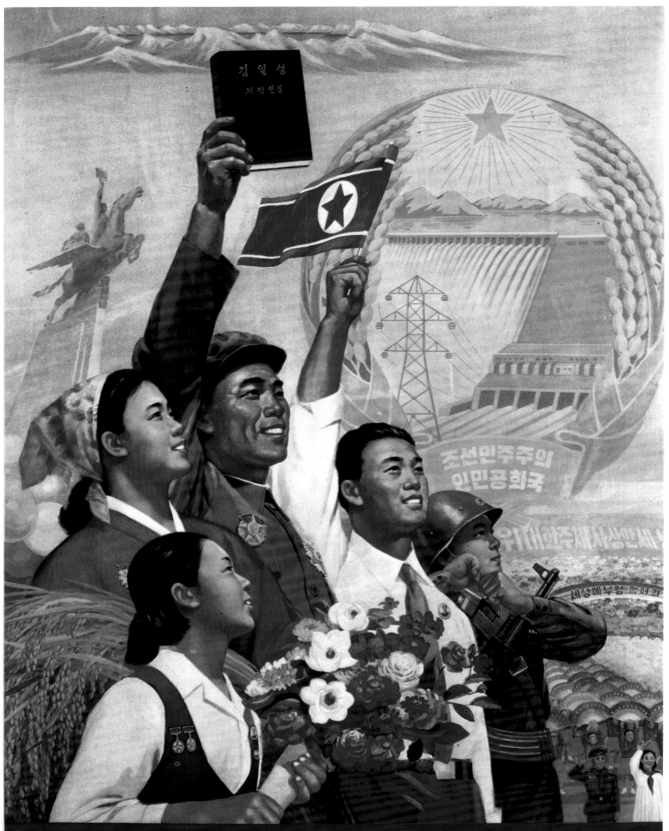

영광스러운 우리 조국을 길이 빛내자 !

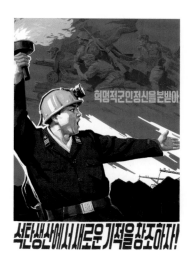

24
**Mansudae Studio**
*In the Spirit of Revolutionary
Soldiers, Let Us Realize New
Miracles in Coal Production!*,
undated

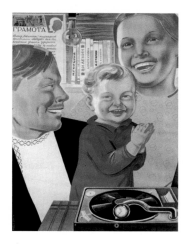

above, bottom:

25
**Konstantin Zotov**
*Every Collective Farm Peasant
or Individual Now Has the
Opportunity to Live Like a
Human Being*, 1934

The New (wo)Man is an enthusiastic political and economic actor –
a tireless worker-hero in agriculture or industry. It was everyone's duty to
raise production, to (over)fulfil the five-year plans, to be frugal and vigilant
(chap. 1, illus. 49; chap. 7, illus. 291, 292). Bold and dramatic images lead
the charge to modernization. Steel production signifies rapid industrial
development (chap. 4, illus. 164). Trains, aeroplanes and rockets mark the
race to technological mastery and the future (chap. 1, illus. 48, 70). Tractors
– especially driven by women – herald agricultural mechanization.[30] In the
early years, most communist economies were agrarian, so a great many
posters encouraged all-out collective effort for animal husbandry and crop
production (chap. 2, illus. 116–118; chap. 6, illus. 269). Agricultural
surpluses provided the capital for industrial development, so concomitant
themes were cooperation between economic sectors and the unity of town
and country (chap. 1, illus. 63).

The utopian principle of distribution under communism was summar-
ized as, 'From each according to his ability; to each according to his
need.'[31] However, this lofty goal fast gave way to economic reality. Lenin's
version was 'He who does not work shall not eat.'[32] The ideal of egalitarian-
ism did not survive in most communist states, as Party, technical and
military elites developed, resulting in great gaps between the more and less
privileged groups in society. Mao Zedong insisted that only 'permanent
revolution' would prevent bureaucratization, hierarchy and a return to the
evils of capitalism. In post-Mao China, however, Deng Xiaoping's dictum
has prevailed: 'It is glorious to be rich' (chap. 4, illus. 177). Perhaps only
Cuba still professes the egalitarian ideal. A baseball player chose pride of
country over American incentives, famously declaring, 'I would rather play
for ten million people than ten million dollars.'[33] Although the notion of
the classless society withered, rather than the state, hard work and vigi-
lance are still promoted for national production and defence. North Korea,
in particular, still produces a great many posters on these themes (illus.
24).

Life in the new society was distinctly public, though it is much less so
today in all these countries.[34] Political, economic and social activities were
carried out in groups and in public spaces, and were depicted as such in

opposite:

23
**Kim Young Sim**
*Bring Honour to Our Glorious
Country Forever!*, late 1980s

every medium. It is remarkable how few posters represent private pursuits or domestic interiors.

Walter Benjamin (1892–1940) wrote of the abolition of private life under communism.[35] In the early Soviet years, some utopian planners envisaged communal child-rearing and the disappearance of the family.[36] Shared living facilities were common themes on posters (chap. 1, illus. 46). The reinstatement of the family and conservative sexual mores in the 1930s coincided with the encouragement of leisure activities and the greater availability of consumer goods. A 1934 Soviet poster shows a rural family enjoying the modern conveniences of electricity and a gramophone (illus. 25). It was criticized at the time for crowding the figures, making the living space appear small.[37] The Second World War required sacrifice and public-spiritedness from all, and personal life again disappeared from view. In the 1950s, as post-war reconstruction progressed, scenes of domestic comfort returned, but they constitute a very small part of propaganda output.

After the establishment of the PRC, posters illustrated the success of land reform by showing family life at home. However, with collectivization (mid-1950s) and especially the establishment of the communes (1958), private domestic scenes disappear. People are shown outside their homes, engaged in various shared activities. A 1972 poster makes this point emphatically (illus. 26). In *Red Loudspeakers Are Sounding Through Every Home*, 'Loudspeakers are attached to the village's PA system, so this family can enjoy the political songs, slogans and lectures broadcasted all day.'[38] What they can't do is turn them off. The people are all outside the house, not in it. The only things you see inside are Chairman Mao's portrait framed by slogans and some red books – *Mao's Quotations or Collected Works*.

The remaining essays in this book include few posters of home life. A North Korean poster shows a woman in her kitchen, but the subject is frugality, and the scene is sparse indeed. It is entitled *In Families, Let's Save Even a Single Drop of Water*.[39] Two Mongolian interior scenes promote cleanliness (chap. 2, illus. 119, 120), but they relate to modernization and communal well-being.

Health and other social issues feature in the posters of every country. Practising sports and maintaining physical fitness were important not just

26
**Huang Entao**
*Red Loudspeakers Are Sounding Through Every Home*,
1972

opposite:

27
**Sergei Vlasov**
*Spartakiad, August 1928, Moscow*, 1928

SPARTAKIADA

СПАРТАКІЯДА

СПАРТАКІАДА

ЛЕНИН

АВГУСТ
1928
МОСКВА

СПАРТАКИАДА

for individual well-being, but for national pride. International sporting events offer a venue for all nations to exhibit their athletic prowess and competitiveness. There is an important political dimension to these occasions, and this was especially true during the Cold War. The USSR participated in the Olympics for the first time in 1952, but held Spartakiads from 1923. Some of these were international, while others were 'All-Union' affairs. For other countries, too, hosting the Olympics or Spartakiads offered an enormous opportunity to showcase national economic, social and cultural achievements (chap. 3, illus. 124).[40] The poster production of these events has always been varied and high-volume, proclaiming international friendship, peace and welcome. For 2008, the Beijing Organizing Committee presented the rather cutesy Five Friendlies as mascots. Their names joined together spelled out 'Beijing welcomes you'.[41] Each represented a continent, a sport, one of the Olympic ring colours and an aspect of China's unique traditional culture. Sixteen official posters were issued, plus a series promoting Olympic security.

28
**Anonymous**
*XXII Olympic Games, Moscow 1980*, 1980

Two sports posters illustrate the Soviet transformation from dynamism to stagnation – of both socialism and its visual expression. A design for the 1928 Spartakiad is full of vibrant, internationalist revolutionary imagery: a powerful athletic hero in the foreground, with images of industry, agriculture, Lenin's mausoleum and a parade of youth marching to the future (illus. 27). Compare this with a static creation produced for the 1980 Moscow Olympics – historically informative, carefully composed and absolutely lifeless (illus. 28). By this time, both poster artists and their intended viewers were merely going through the motions.

Still on the subject of health, and just as important, posters implied that bad habits harm not only the body, but the economy and social order. In the USSR and Eastern Europe, drinking alcohol was the subject of constant propaganda campaigns throughout the decades of communist rule (chap. 1, illus. 54). Vietnam ran poster competitions publicizing social issues and published some remarkably strong graphics (illus. 29). Drug addiction and sexually transmitted diseases, both long denied in communist paradise, finally became issues for public discussion. A cleverly designed AIDS poster from the last days of the USSR warns against casual

29
**Cong (?)**
*Don't Let Cigarettes Destroy Our Future*, 2004

opposite, top:

30
**Anonymous**
*Children Go to Kindergarten, So That Mothers Can Go to School. The People Fight Against Illiteracy*, 1980

opposite, bottom:

31
**Alexander Rodchenko**
*Battleship 'Potemkin' 1905*, 1925

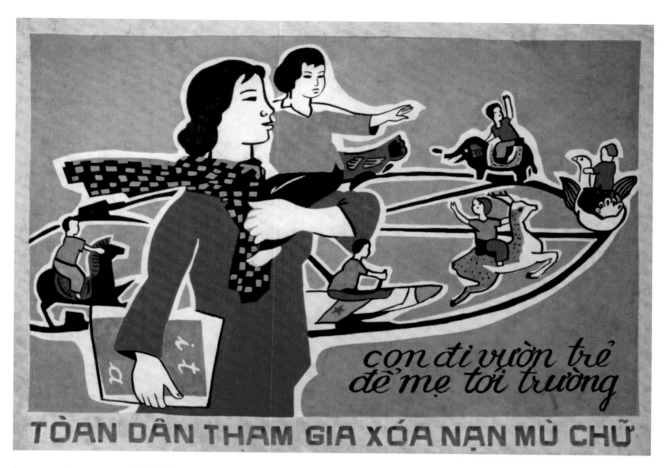

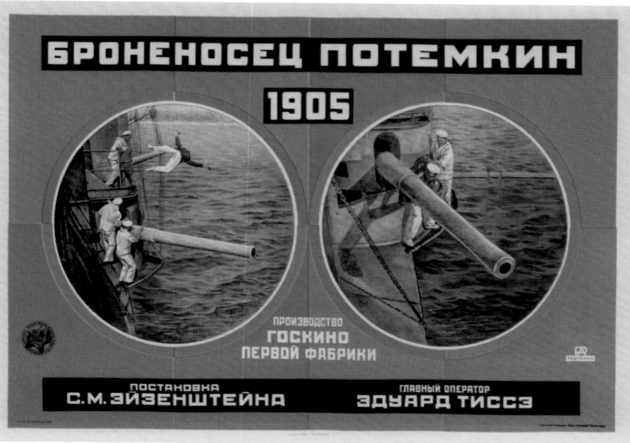

relationships, with two figures lying together on a park-bench-cum-hospital-gurney (illus. 32).

Essential to the propaganda programmes of all communist countries were posters relating to education and culture. Except for parts of Eastern Europe, literacy rates were low where communist regimes came to power. In all those countries, posters insisted on the importance of education and, especially, literacy (chap. 7, illus. 295, 296). Libraries and workers' reading rooms were established, and books and newspapers were sent to the countryside, where literacy rates were particularly low (chap. 1, illus. 63; chap. 2, illus. 90). Students helped their parents learn to read, and parents were encouraged to attend part-time schools (illus. 30). Hồ Chí Minh put it succinctly: 'You must study in order to know . . . and you must know in order to carry out a revolution.'[42] For social, political and economic develop-ment, the masses had to read and write.

China flip-flopped on the issue of education during Mao's episodes of permanent revolution. Literacy was much encouraged in the early PRC years, and specialists were acknowledged to be necessary. However, during the Great Leap Forward and even more so in the Cultural Revolution, Mao insisted that 'red' was better than 'expert'. In 1964, he made the oft-quoted remark that 'To read too many books is harmful.'[43] At the same time, however, publishing houses were still issuing 'Study hard' posters.[44] Following those tumultuous years, China adopted the Four Moderniza-tions, since when studying has been essential (chap. 4, illus. 192).

There has been an enormous output of posters for cultural festivals, performances and especially films. Lenin and then Mao both stressed the importance of film as the most effective revolutionary form of art for 'modernisation, nation building and transformation of the individual'.[45] Soviet film posters of the 1920s were among the most exciting graphics produced, although this ended with the clampdown on Constructivism and the advent of Socialist Realism in the early 1930s. Sometimes numerous posters were designed for a single film – innovative and startling in concep-tion and perspective. Eisenstein's *Battleship Potemkin* (1925) is the classic example, considered by many to be the most influential propaganda film of all time (illus. 31). Eastern European poster designers also created bold,

32
**G. Nemkova and G. Kamenski**
*Chance Contacts: AIDS*, 1990

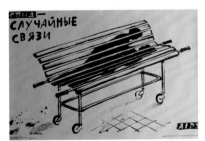

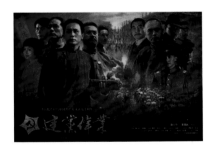

33
**Anonymous**
*The Founding of a Party*, 2011

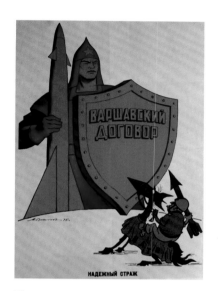

34
**Anonymous**
*A Reliable Guard*, 1975

sometimes quirky graphic works, a number of which are illustrated in Chapter Three (illus. 132, 133). While many were propaganda posters, some were apolitical – created just for entertainment or for local releases of acceptable foreign films.

Films in Maoist China emphasized the new life under socialism – collectivization, modernization of agriculture and industry – while reminding people of the hardships of war and imperialism. Historical dramas and patriotic extravaganzas on these themes are still produced in quantity. The 2009 *Founding of the Republic* was followed in 2011 by *The Founding of a Party*, celebrating the ninetieth anniversary of the CPC (illus. 33).[46]

Film posters were, of course, advertisements. Consumer product ads may be considered as a completely separate category, but also carried political intent. Advertising provided a platform to contrast communism with the greed and economic injustice of capitalism (chap. 3, illus. 134). It serves socialism to buy state-produced goods, and displays of consumer goods show how life has improved. Unity among social groups and other messages could be embedded in commercial advertisements (chap. 1, illus. 61).

Last but not least is the evolution and depiction of the communist movement and its organizations, the Comintern and Warsaw Pact (illus. 34).[47] The worldwide revolution envisioned by the Bolsheviks never happened. Communist governments were installed in the other Soviet republics, Mongolia, Eastern Europe and North Korea. The Comintern was useful in differing degrees to communist revolutionary movements, as it suited Soviet interests.[48]

The Cold War divided the world into seemingly unified blocs, and for some years the communist nations accepted the leadership of the USSR. Many posters declared the unity of the movement and of bilateral, or leader-to-leader relations (chap. 2, illus. 104; chap. 4, illus. 158). All communist countries declared solidarity with revolutionary and anti-imperialist movements in less developed countries (illus. 36). Hundreds of communist posters supported Hồ Chí Minh and the Vietnamese struggle against American imperialism (chap. 4, illus. 171). Cuba's graphic designers were particularly prolific in this activity, through the organizations OSPAAAL and Editora Política (chap. 7, illus. 313).[49] While supporting specific nationalist-

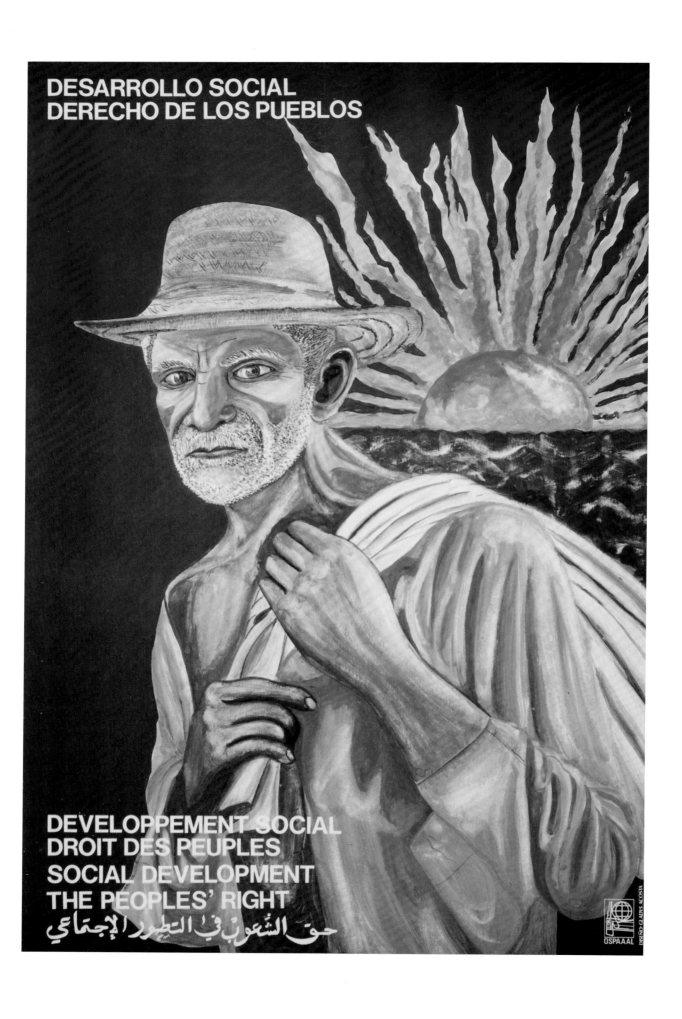

DESARROLLO SOCIAL
DERECHO DE LOS PUEBLOS

DEVELOPPEMENT SOCIAL
DROIT DES PEUPLES
SOCIAL DEVELOPMENT
THE PEOPLES' RIGHT
حق الشُّعوب في التطور الإجتماعي

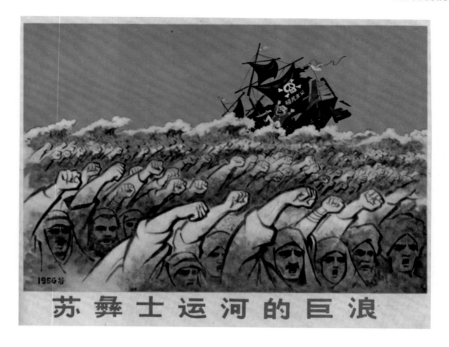

苏彝士运河的巨浪

communist movements, and opposing American/imperialist/colonial regimes, OSPAAAL also made a general stand for human rights and social development (illus. 35).

Yugoslavia was the first to pull away, years before Khrushchev's bloc-buster 'Secret Speech' of 1956. The 1956 uprising in Hungary was quashed, but revealed cracks in the system (chap. 3, illus. 148). The Sino-Soviet split was public and irrevocable by 1960, after which both claimed leadership of the communist movement, as alliances shifted. Romania played one against the other; Albania allied itself firmly with China; Cuba stood with the USSR (chap. 7, illus. 281, 320).

It all fell apart at the end of the 1980s. Starting with Poland, the Eastern European countries seceded one after another (chap. 3, illus. 145, 149). In 1991 the USSR disintegrated. There is no longer a communist movement, though ruling communist parties and workers' parties refer to their countries' policies and programmes as socialist. China, Vietnam and Laos operate increasingly as mixed/market economies, with nationalism the driving political force. North Korea remains highly mobilized and has jettisoned communism for *Juche* (self-reliance). Only Cuba seems still to be inspired by (Marxian) communist revolutionary goals, but the American flag is flying above a newly reopened embassy, and Castro's death may put an end to a once-powerful international secular faith.

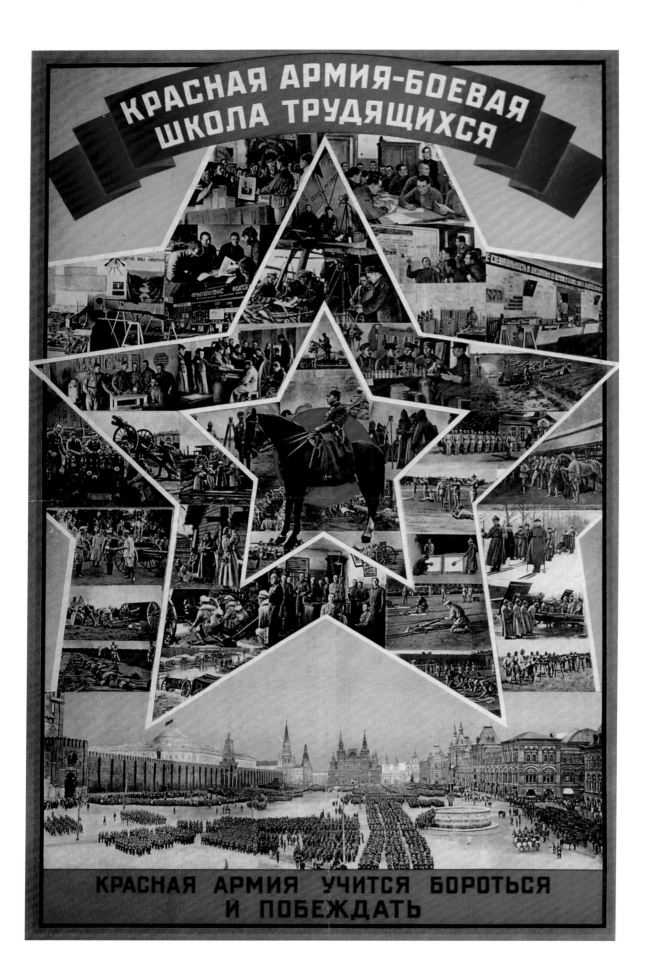

# 1

# Russia/Union of Soviet Socialist Republics, 1917–91

**Mary Ginsberg**

The posters of the early Soviet era are enormously diverse, ideologically inventive and aesthetically imaginative – surely among the best graphics ever produced. Mikhail Cheremnykh (1892–1962), one of the great innovators of Soviet revolutionary art, called one formative type of poster 'flowers of the revolution', but these flowers had traditional Russian roots, as well as nineteenth-century sources.[1]

The popular illustrated broadside, known as the *lubok*, came to Russia from Germany in the sixteenth century, but was Russified in style and subject by the seventeenth century. *Lubki* were produced in great quantity, first as woodblocks, then as copper engravings. Characterized by deliberately crude strokes and native realism, their composition combined narrative illustration and text. Their subject-matter was originally religious, but later included folk tales and legendary heroes, political caricature, town life, festivals and fashions.[2] In times of war, they carried nationalist messages, often hanging in homes near the spiritual images in the 'red corner' or 'icon corner'.[3]

In 1914, a group of avant-garde artists, notably Kazimir Malevich (1879–1935) and Vladimir Maiakovskii (1893–1930), produced propaganda prints and postcards for a short-lived publishing house, Segodniashnii Lubok (Contemporary Lubok). In illus. 38, Malevich ridicules a fat Kaiser Wilhelm II

near the Vistula River in Poland, marking an early success for the Russian forces in the First World War.[4] Maiakovskii wrote the crude text, referring to Prussian flatulence. In these *lubki*, the central figure, whether hero or enemy, is often shown as gigantic, a device that was continued for many decades in Bolshevik posters. Segodniashnii Lubok closed after a few months, but other publishers produced mass editions of patriotic prints throughout the war. These have been criticized as stereotypical, chauvinistic and 'simply bad illustrations', but their wide circulation had a great impact on popular attitudes.[5] Their direct visual language links traditional *lubki* to post-revolutionary posters. Many of the Segodniashnii Lubok artists went on to serve the Soviet cause.

Another important source of the Bolshevik poster was religious art, particularly icons. While Marxism is ideologically opposed to religion, artists relied on familiar imagery with meanings that were accessible to the largely illiterate population. Red – the colour of revolution and communism – was also the colour of fire, holy war, salvation, hope and faith in Russian icons.[6] The poster in illus. 39 shows Lenin as patron saint of the future society. It mixes the ancient iconic motif of a saint in a red circle with futuristic structural visions of town and village, and quotes Lenin's declaration that

37
**Anonymous**
*The Red Army Is the Fighting School of the Workers*,
late 1920s

33

'communism equals Soviet power plus electrification'.

A third influence was the Russian satirical journals of the later nineteenth and early twentieth centuries, which had derived from Western European sources and spread in response to social and political issues. Many of the most prolific and hard-hitting Civil War poster artists had worked on these journals at the end of the Tsarist period, including Viktor Deni (1893–1946) and Dmitrii Moor (1883–1946). Also important were commercial posters, whose production techniques, styles and imagery spread through many countries with the advent of the Machine Age. Dmitrii Moor once identified the work of Jules Chéret (1836–1932) as the basis of all modern posters.[7]

Designers of revolutionary posters adapted the traditional forms and themes in the service of the new social, political and economic order. ROSTA windows (Cheremnykh's 'flowers'), for example, were a quickly produced form inspired by the *lubok*.[8] Other types of visual propaganda followed from new techniques of mechanical reproduction, such as photomontage.

This essay traces the production of Soviet posters from the October Revolution to the end of the communist period. Techniques, objectives and the visual language of propaganda changed with economic and political circumstances, as in any nation's graphic history. Like most accounts of the subject, this one emphasizes the early years, when the aesthetic variety and political urgency of visual propaganda were at their peak. Some histories stop after the first two five-year plans in

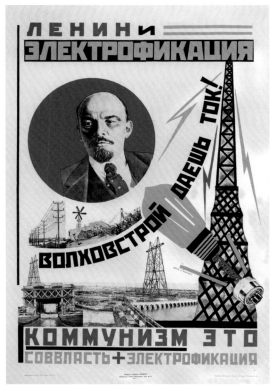

top:

38
**Kazimir Malevich**
*Look, Oh Look*, 1914

1937; others at the death of Stalin.[9] Later posters merit a selective viewing, however. While it is true that most posters after the 1950s were formulaic and largely ignored by their intended audiences, they influenced designs in other communist countries, for better or worse. Finally, there were some interesting developments near the end of the era, when social and political truths managed to break through.

## Revolution and Civil War (1917–21)

The storming of the Winter Palace on 25 October 1917 was not a mass revolution, more an insurrection, staged by about 15,000 people.[10] It overthrew the Provisional Government that had been in place since the forced abdication of Tsar Nicholas II in February that year. The Bolsheviks claimed power, but the political and military victories were not secured. An array of domestic and international forces (Whites) lined up against the Bolsheviks (Reds) in a civil war that lasted for four years. The Red Army contended with numerous independence movements and interventions by Russia's First World War allies, who openly supported the Whites. Conflicts in the Soviet Far East were not finally resolved until 1922.

Lenin's power came from workers, including the many newly arrived seekers of labour from the villages, and from the ever-growing ranks of radical and deserting soldiers, drawn by the Bolsheviks' fierce opposition to the world war. The workers were the vanguard of the revolution, and the Bolshevik Party, with its discipline and central-ized organization, would lead the proletariat to the future society. Other political parties, however, still enjoyed strong popular support, particularly in the countryside.

The revolution was to bring about a new, communist world order. The goals were social and political reorganization, and economic modernization through technological advance and industrialization. However, the post-First World War economy was near collapse, as agricultural and industrial production had declined drastically, and Russia was deeply in debt. 'War Communism' – policies and institutions established during the Civil War – mixed utopian goals with pragmatism.[11]

For Lenin, cultural revolution was as important as political transformation. Education, propaganda and mobilization were essential to create a new people's consciousness – a new Soviet identity. Propaganda would be directed by the Party to generate popular support, but also to control information flows. Although Lenin and his cohorts had recognized the need for political activist agitators as early as 1903, they had no formally prepared propaganda programme when they suddenly came to power in 1917.[12] Peter Kenez calls the Bolsheviks 'the great unconscious innovators of twentieth century politics'.[13]

The Commissariat of Enlightenment (Narkompros) was quickly established to oversee education, culture and censorship, with Anatolii Lunacharskii (1875–1933) at its head. The low rate of literacy meant that mass communication had to be visual, rather than printed words, and in 1918 the first formal propaganda programmes were launched.[14]

bottom:

39
**Yiulii Ezakiekevich Shass and Vasilii Alekseevich Kobelev**
*Lenin and Electrification*, 1925

Lenin decreed the removal of Tsarist statues and other monuments, to be replaced with commemorations of revolutionary heroes. Innovative types of propaganda were mobilized, including agitprop (agitation propaganda) trains.[15] These were covered with revolutionary imagery, carrying public speakers and printed materials on various routes throughout the country. Some trains were equipped with a printing press and film projector. Other visual means of propaganda included street processions, theatrical productions, huge billboards, wall newspapers and posters.

## Civil War Posters

The posters of the Civil War years were military and heroic. Their themes included the glorious victory of the workers' revolution and the evils of the old society; supporting the Red Army to defeat domestic and foreign enemies; the forthcoming triumph of worldwide communism; nationalization of the economy; increased production in factories and on farms; brotherhood with minority nationalities; health; family law; literacy; and atheism. The examples here aim to demonstrate the variety of style, iconography, motif and message. According to an authoritative source, 3,126 different posters were produced in the years 1918–21. More than a thousand had military themes, or 32 per cent of the total.[16] The three most important producers were the Military Publishing House (Litizdat), the State Publishing House (Gosizdat) and the Russian Telegraph Agency (ROSTA). However, posters

were produced by an astonishing 453 institutions in 76 different places.[17] Camilla Gray noted that poster designers were working independently, semi-independently and officially – and so there is much organizational and institutional confusion in the history of these early years. The revolutionary artists were redefining and constantly debating their role in the new society they served.[18]

The first poster produced by the Soviet regime was, in fact, a reissue of an early First World War poster by Leonid Pasternak (Boris's father), entitled *Help the War Victims* (illus. 55). The reissue in 1918 was called *The Price of Blood*, but the drawing was identical. The publisher made clear to Pasternak that all his work now belonged to the state and could be used without any payment, or even his permission.[19]

More uplifting and, by contrast, urging *Everyone to the Defence*, was Dmitrii Moor's 1919 poster designed as a star atop the walls of a fortress (illus. 40). This complex poster draws together many of the slogans and visual tropes of Civil War propaganda. After 1917, the red star symbolized the five fingers of the worker's hand and, more generally, communism. In the centre, a trinity of worker, peasant and communist plan strategy, armed with electricity and a telephone. Between the points of the star, and likewise bathed in light, are five groups fighting for the revolution (clockwise from the top): the communist points out the enemy and leads into battle; the peasant delivers bread; the youth learns soldiering; the woman takes over for the fighter at the front; and the worker forges weapons. In the darkness (top corners), Hunger and Slavery threaten.

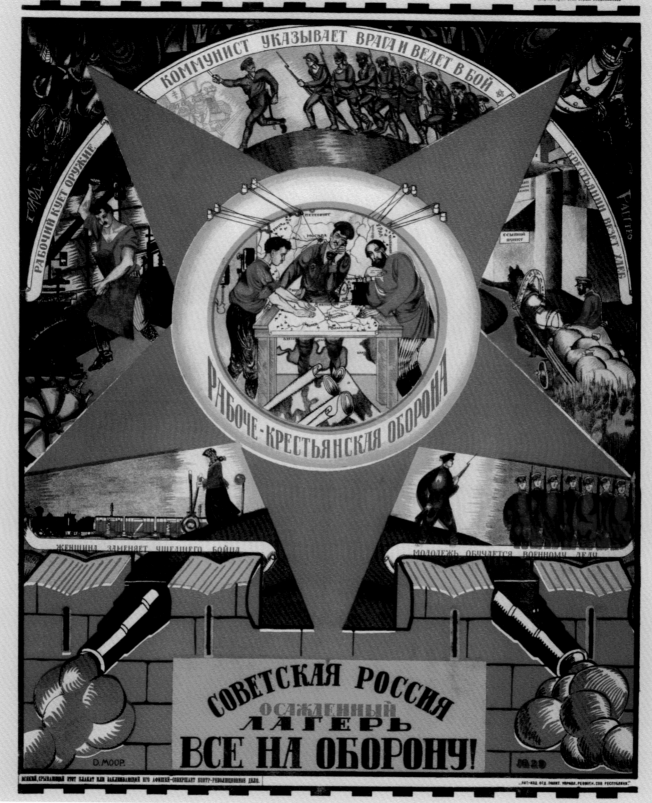

40

**Dmitrii Moor**
*Soviet Russia Is an Armed
Camp. Everyone to the
Defence!*, 1919

Artists mixed new symbolism, allegory and traditional motifs in their work. All contributed to the iconographic repertoire of the revolution and Civil War. Alexander Apsit (1880–1944), who had illustrated popular journals before the revolution, was criticized as derivative and vulgar by his contemporaries, but is recognized today as a founding master of the Soviet graphic.[20] He produced over seventy posters before leaving Russia in 1919. Many of Apsit's posters dealt with historical events and heroes; others with contemporary victories and celebrations (see Introduction, illus. 18). His allegorical demons are hideous and bloodthirsty, his victims blank-eyed and emaciated (illus. 57). He turned to tradition in *The Red Rifle* (illus. 56), a deliberately folksy illustration of a poem by Demian Bednyĭ (1883–1945), who wrote new words to an old, melancholic song, 'The Cudgel'. Bednyĭ proclaims that the old song was 'born out of difficult life and despair', but 'now the people have grown smarter, and are going after the former lords – and not with a cudgel, but with a rifle!'[21] The poster is in the style of a *lubok*, mixing narrative illustration and text. It celebrates the rupture of revolution – the before and after – a device used by many of the poster artists.

As early as 1918, posters were issued in several languages and with motifs to suit the local nationality. An image of a priest, a tsar and a capitalist was published in Russian, Lithuanian, Polish, Tartar and several other languages.[22] This trio of class enemies was one of many tropes of the Civil War years, appearing in varied styles. The 'first significant political poster featuring Lenin' – a 1920

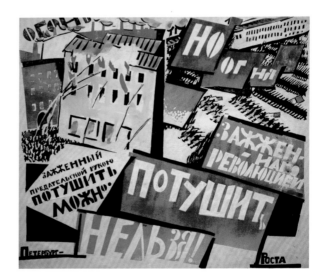

top:

41

**Nikolai M. Kochergin**

*Long Live the Brotherhood of All the Peoples of the Caucasus!*, 1921

bottom:

42

**Anonymous**

*The Fires of the Revolution Cannot be Extinguished*, 1921

cartoon by Deni and Cheremnykh – shows him sweeping away these enemies on the way to global revolution.[23] Another Apsit poster, *The Tsar, the Priest and the Rich Man on the Shoulders of the Working People*, was adapted for a Ukrainian audience with the addition of a Catholic priest and a rabbi. The image clearly alludes to Ilya Repin's realist masterpiece from 1873, *Barge Haulers on the Volga*.[24]

Capitalists, foreign imperialists and counter-revolutionaries were depicted with great imagination and satirical thrust. Apsit, Deni and Moor created particularly vile enemies. Apsit's 1918 poster *The International* shows a hideous crowned beast atop a 'Capital' pedestal (illus. 57). The world's workers will defeat this horror. Verses of 'The Internationale' provide the poster's text. One of Apsit's clearest allegories, this image is exceptional for its monster's female gender.[25] A popular and effective poster by Deni showed capitalism as a porcine figure, revelling in his pile of gold (illus. 58). A fat cat in a top hat became a standard image for foreign and Russian capitalists. In this image he is framed by a spider's web, which represents neglect, decay and ruin.[26]

There was also standard iconography for heroes, especially workers and the Red Army soldier. From the start, the worker had certain illustrative attributes, notably an apron, boots and the hammer he carries (see Introduction, illus. 18). In early posters, he is often pictured as a blacksmith, but this changed with industrialization. Victoria Bonnell notes two aspects of the worker as represented in the Civil War years – dignified contemplation and action. In the 1920s, action prevails.[27] The worker is depicted as a red knight defeating the dark force; as the giant breaking the chains of slavery. He marches with the peasant and soldier, celebrating Red October.

In illus. 41, the worker is the central figure, larger than life among the crowd's banner-wielding revolutionaries. The poster, however, is about unity of the nationalities, in this case, bringing the Caucasus into the Soviet fold: *Long Live the Brotherhood of All the Peoples of the Caucasus!*[28] Very similar imagery appeared on other posters and on different media, as on a plate produced the same year at the reorganized Imperial Porcelain Factory in Petrograd.[29] In this futuristic scene, the worker-hero is stamping on Capital. In both cases and in a great many others, the sun serves as background. Traditionally in Russia, the sun stood for enlightenment, but now it signifies hope, progress and the future.[30]

## ROSTA Windows

In 1919, Mikhail Cheremnykh, Vladimir Maiakovskii and Ivan Maliutin (1889–1933) established a new propaganda format – the ROSTA window. ROSTA was the Russian Telegraph Agency, and the artists created poster bulletins as fast as the news came in.[31] They were large stencilled sheets hung at stations, at the battlefront, on the street and in empty shop windows. Shortages of paper and printing equipment made them a highly effective format for distribution and display. Cutting the stencils and colouring them in was much faster

than lithographic printing, although every copy was produced by hand, so edition numbers were limited. The number of copies was generally only about 150–300, while printed posters were issued in the tens of thousands, depending on their political significance and visual qualities.

Most of the posters were multi-framed (illus. 43), with individual panels pasted on to a backing in the proper sequence. Highlighting a particular event, decree, battle or social issue, they mixed illustration and text, a format accessible to all from the *lubok*. A standard lexicon of images was developed. A flag, for example, meant victory; a handshake, solidarity, and a trio of capitalist, tsar and priest signified capitalist enemies.[32] ROSTA 649, *Salute the 8th Soviet Congress* (which took place in 1920), exhorts all who support the Soviet system to show discipline and take responsibility: dig for coal (panel 2), help repair the railways (4), build the communal inventories (6) so they are warm (7) and bathed in light (8). He who doesn't support the Soviet system prefers the capitalist enemies (12).

Although the ROSTA windows were all unsigned, the designers of many have been identified by style. Maiakovskii wrote the short, sharp captions for most of the Moscow posters. Following their great success, ROSTA studios were established in more than thirty centres, the most important being Petrograd (formerly St Petersburg). Generally, the Petrograd ROSTA posters were produced as linocuts, which allowed editions of up to about 2,000;[33] others were produced by stencil and chromolithography. Many of these were single-panel graphics, as in a futuristic poster of the fires of revo-

lution (illus. 42). Vladimir Kozlinskii (1891–1967) and Vladimir Lebedev (1891–1967) led this ROSTA location.

Other important centres included Smolensk, Odessa and Vitebsk. In Odessa, paper shortages led to production on plywood, the panels being repainted for new bulletins.[34] Vitebsk was the most 'innovative and controversial' ROSTA location.[35] Vitebsk hosted an art school and museum founded by Marc Chagall (1887–1985) and Malevich, and artists from all contemporary movements were represented. Malevich and Lazar (El) Lissitzky (1890–1941) were producing Suprematist works at this time.[36] Best known today, perhaps, is Lissitzky's *Beat the Whites with the Red Wedge* (illus. 59), which was likely inspired by Nikolai Kolli's street sculpture from 1918.[37] Both works depict a Red wedge (the victorious Bolshevik Army) breaking through the White forces of counter-revolution. Unlike ROSTA windows using folk styles and standardized motifs, this poster would have been incomprehensible to many. Like other graphics, though, its message was 'us or them'; hero or villain; Bolshevik or counter-revolutionary enemy.

About 1,600 ROSTA posters or series were created during the Civil War years.[38] They were popular at all levels of society: inspiring, often wickedly humorous and topically up to the minute. Maiakovskii summed up the achievement and impact of the ROSTA enterprise:

*That was a fantastic thing. It meant a nation of 150 million being served by hand by a small group of painters. It meant news sent by telegram immediately translated*

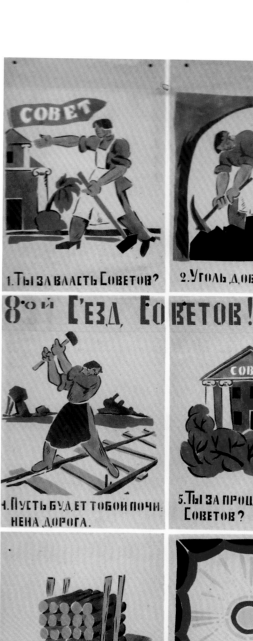

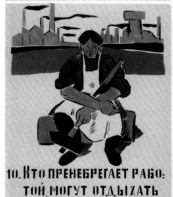

АЗДРАВСТВУЕТ

8-ой С'ЕЗД, СОВЕТОВ!

1. ТЫ ЗА ВЛАСТЬ СОВЕТОВ?

2. УГОЛЬ ДОБЫВАЙ.

3. ПОМОГАЙ ШАХТЕРУ.

4. ПУСТЬ БУДЕТ ТОБОЙ ПОЧИНЕНА ДОРОГА.

5. ТЫ ЗА ПРОЦВЕТАНИЕ СОВЕТОВ?

6. СМОТРИ, ЧТОБ ХЛЕБ У КОММУНЫ БЫЛ

7. БЫЛО ТЕПЛО,

8. БЫЛО МОРЕ СВЕТА,

9. КТО ПРОТИВ ДИСЦИПЛИНЫ,

10. КТО ПРЕНЕБРЕГАЕТ РАБОТОЙ, МОГУТ ОТДЫХАТЬ ВЛАСТЬ

11. ТОТ НЕ ЗА СОВЕТСКУЮ.

12. А ВОТ ЗА ЭТУ ВЛАСТЬ!

РОСТА. N: 649.

43
**Anshei Markovich Nurenberg**
*Salute the 8th Soviet Congress*,
1920

hand-coloured stencil

*into posters, decrees into couplets . . . It meant Red Army men looking at posters before a battle and going to fight not with a prayer but with a slogan on their lips.*[39]

The importance of propaganda posters to the war effort was clear from 'the autonomy, technical assistance and privileged access to supplies granted to it by the government'.[40] Shortages of paper and printing equipment worsened each year. Published book titles declined by more than 50 per cent in the first year after the revolution, but poster production peaked in 1920.[41] The quantity of posters produced by hand, rather than printing, increased from 1.8 per cent in 1918 to a desperate 62.9 per cent in 1921.[42]

### New Economic Policy (NEP), 1921–8

The Civil War years are often called the time of 'Heroic Communism' and 'War Communism'. The severe features of Bolshevik rule in those years were discipline, sacrifice, strict economic controls, growth of bureaucratic centralism, censorship and terror. Even for Lenin, the revolution went too far, too fast.

By 1921, the Civil War had been won, but the economy was a shambles. The grain shortage was critical, and industrial production had dropped catastrophically. Transport, communications and administration were chaotic. The Bolshevik government faced protests on every front. Massive resistance to forced grain requisitions continued in the countryside. Workers in the cities staged strikes because there was no food. Millions of newly

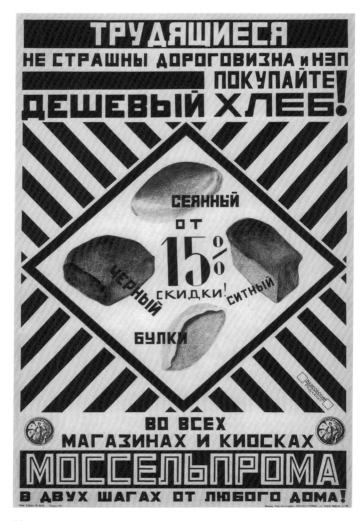

44
**Alexander Rodchenko and
Vladimir Maiakovskii**
*Buy Cheap Bread*, 1923

demobilized soldiers were unemployed, armed and hungry. The Kronstadt sailors revolted – an especially significant breach of loyalty, given their critical support in the October Revolution.

The New Economic Policy (NEP) was launched in the spring of 1921. It was a partial retreat from utopian measures of nationalization and collectivization. Many hard-line communists denounced the NEP, but Lenin pushed for economic reconstruction, accepting that the new system might last a decade or more. First and most important was an end to forced requisition of grain, replaced by a 20 per cent tax in kind. The state kept control of banking, railways, steel and the like, but light industry was reborn in private hands. Small traders were allowed to operate, and the economy began to recover very quickly.

Before these measures were effective, however, the Volga and Ural River regions suffered a terrible famine, which lasted until 1922. The famine resulted from a combination of natural drought, state requisition policies and broken-down transport networks. The death toll from starvation and epidemics in 1921–2 exceeded the combined casualties from the First World War and the Civil War.[43] Dmitrii Moor's startling poster *Help* may be the most telling image of the famine (illus. 60).

Many of the iconic posters of the NEP years were commercial advertisements, and so ideologically problematic. While these posters differed from capitalist ads in message and rationale, they promoted consumption, which was potentially corrupting. The pragmatic Lenin won out on this issue against opposition from Marxist purists,

arguing that the Communist Party newspaper *Pravda* couldn't publish if it had no funding, and the only available funding was from advertisements.[44] Numerous quasi-state advertising agencies were established in the 1920s, but state propaganda units played no part in NEP graphics.[45] There was much debate on how advertising could promote both the economy and Soviet revolutionary goals. The plan that emerged emphasized three main objectives: 'Competition with Nepmen (private traders), building relations between social classes, and consumption as a path to modernization.'[46] Posters aimed at meeting these goals illustrate the diverse styles employed to combine design, politics and commerce during the NEP years. Some look very much like the advertisements which flourished before the revolution; others bring new imagery, typography and technology to poster production.

*Buy Cheap Bread* was one of many collaborative ads by Alexander Rodchenko (1891–1956) and Maiakovskii in their service to revolutionary transformation (illus. 44). Rodchenko designed the images, while Maiakovskii wrote the rhyming texts. 'No need to fear the Nepman and high prices,' the poster declares. 'All types of fresh bread are available, with discounts of 15 per cent at all Mosselprom outlets, just two steps from every home.'[47] Mosselprom sold a huge range of food, beverages, cigarettes and other consumables. Rodchenko and Maiakovskii promoted the organization and specific products with modern, geometric designs. Their poster of the avant-garde Mosselprom building was recognized everywhere,

43

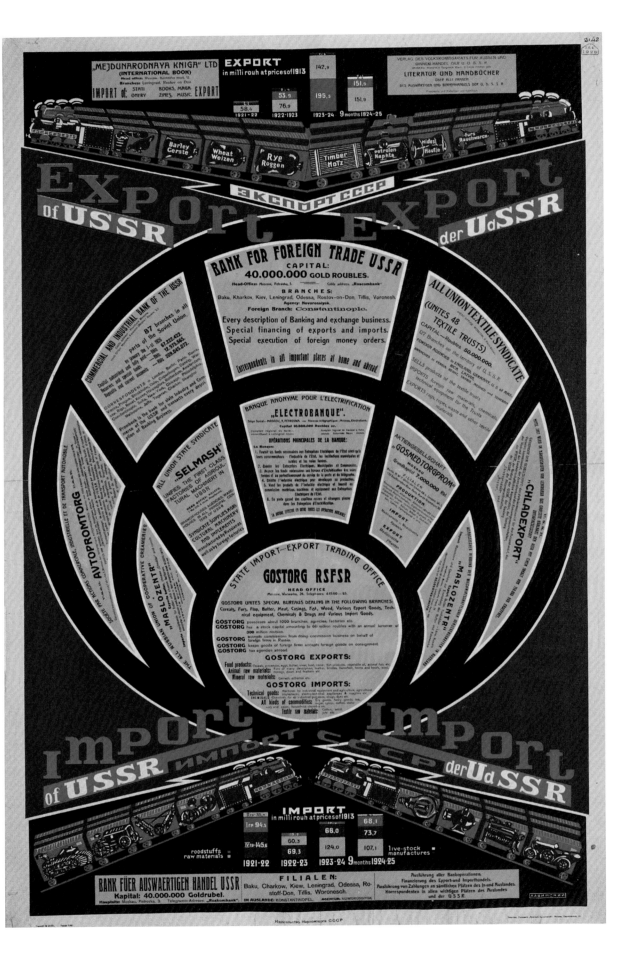

and they created the ubiquitous slogan, 'Nowhere but in Mosselprom'. These commercial posters promoted consumption as a means of serving the state. Maiakovskii declared that,

*The Bourgeoisie knows the power of advertising. Advertising is industrial, commercial agitation . . . Face to face with the NEP, in order to popularize the state and proletarian organizations, offices and products, we have to put into action all the weapons which the enemy uses, including advertising.*[48]

The Donskaya State Tobacco Factory (formerly Asmolov & Co.) had been producing cigarettes since 1857 (illus. 61). Tobacco was nationalized under War Communism and generated essential revenue. The poster shows the sharp turn away from class struggle under NEP and promotes the cohesion of all classes. Of course, the soldier and worker are on the left; the possibly reliable intellectual is in the middle, and the Nepman and his overdressed wife are on the right. Apart from the wife, who is looking back, all the classes are moving forward together. Donskaya produced many different cigarettes, but the product here is called 'our brand'. The image ties in well with a trade name that could emphasize cooperative production or collective ownership, or both; ads for their other brands, such as Karmen and KP, exhibit no such social unity.

Anton Lavinskii's (1893–1968) complex poster of 1926 demonstrates the Constructivist insistence on art as functional (illus. 45). It identifies and promotes the products and agencies of Soviet foreign trade. The network of banks and organizations is displayed in the yellow panels of the globe. Both imports and exports were essential for economic reconstruction, and were growing fast, as shown in the colourful graphs. As industrialization was still at an early stage, agricultural equipment and other machinery were imported, pictured on the bottom trains. These were paid for through exports of grain, timber, oil and furs, named on the top railway trucks. The geometric shapes, dynamic diagonals and multilingual typography of this striking image signal movement and economic progress.

The importance of trade and extent of NEP pragmatism are evident in a poster advertising the products of an American concession. Illus. 62 is very much in the style of American travel posters of the 1920s. Armand Hammer (1898–1990), whose father had left Odessa in the 1870s, brought pharmaceuticals and wheat to Russia in the early 1920s, then was granted a concession to manufacture and sell stationery supplies and typewriter parts, which Russia did not yet produce. Hammer also helped the Soviets sell much Romanov treasure abroad – most notably Fabergé eggs – to raise the hard currency needed for rapid industrialization.[49] Some art from museums and religious relics had been sold during the Civil War, but Lenin and Lunacharskii favoured preserving the national heritage.[50] In the late 1920s, when Stalin was in charge, he ordered aggressive exports of art and antiques to fund the increasingly desperate balance of payments shortage.[51]

*Union of Town with Country* serves both revolutionary and commercial goals (illus. 63). Its

45
**Anton Lavinskii**
*Export of USSR,*
*Import of USSR,*
1926

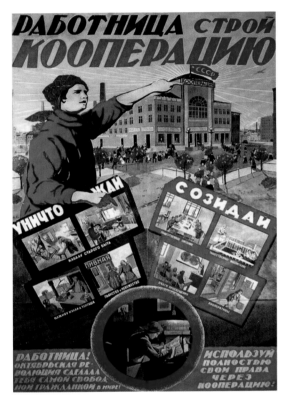

46
**Anonymous**
*Working Woman, Build the
Cooperative Movement,*
c. 1926–7

political subject, the loudly trumpeted *smychka* (urban-rural cooperation), was a Bolshevik goal, not a realized fact. The instruction at the very top, 'Hang this in a conspicuous place,' highlights the importance of the theme. The bottom of the poster promotes Books to the Countryside, organized in 1925 to distribute books in rural areas; achieving universal literacy remained an essential goal.[52] The top half is a composite of product and service advertisements, generating revenue for the cause.

Conditions in the countryside had improved dramatically by the mid-1920s. Cooperative agriculture proved a success, whereby land was farmed communally, but tools and animals were maintained privately. By 1927, half the peasant farms had voluntarily joined cooperative organizations.[53] In town and country, Lenin had been a great supporter of the cooperative movement as a gradual way to build socialism. Posters highlighted the benefits of the cooperatives, especially for women, as in *Working Woman, Build the Cooperative Movement* (illus. 46).[54] Liberated women would be happier with equal rights and a new lifestyle. It compares the old times – always at the mercy of *kulak* (rich peasant) traders, living with alcoholism, endless household drudgery – and the new ways of cooperative eating, education and childcare. Sexual equality was an oft-proclaimed, unrealized goal of the revolution.

Although economic life was less regulated under NEP, social and private life were more organized and scrutinized. Walter Benjamin wrote from Moscow in 1927: 'Bolshevism has abolished private life. The bureaucracy, political activity, the press are so powerful that no time remains for interests that

do not converge with them. Nor any space.'[55] Clubs and reading rooms were organized for workers. Schools emphasized practical work, collective socialization and control.[56] Children were political actors, encouraged in school and in extracurricular forums to carry out the policies and tasks of the revolution. They marched in parades, handed out leaflets, organized exhibition corners and the like. The official children's organization, the Pioneers, was founded in 1922, for children aged ten to fourteen. Pioneers were 'the quintessential empowered children, called upon to harangue their parents into mending their ways, and also to agitate among adults generally'.[57] 'I'm an atheist,' declares the boy on an advertising poster for *The Atheist* magazine in 1925 (illus. 64). Here is a child activist, eager to grow into the role of adult agitator.

The boy's Lenin badge is a manifestation of the cult that erupted following the leader's death in 1924, officially sanctioned by the Party and directed by a specially established Immortalization Commission. The embalming and public display of the body was one important step in the 'construction of the eternal Lenin'.[58] Lenin corners were established in schools, factories and clubs, borrowing the religious form and function of the domestic 'red corners' that housed icons. Bonnell observes that 'Considering Lenin's position in the Bolshevik pantheon, it is striking how few political posters of his image appeared before 1924 and how reserved was the depiction of his relationship with ordinary people.'[59] But after his death, a huge quantity of paintings, posters, statues, badges and other likenesses appeared. The poster in illus. 47

shows Lenin in various roles – as revolutionary, as leader-statesman and in repose. A group of black marchers, presumably mourners, are lit by the sun, for although he is dead, 'He Lives in our Hearts!' As Maiakovskii so quotably put it, 'Lenin lived; Lenin lives; Lenin will live!' Lenin's survivors, especially Stalin, and all future Soviet leaders, invoked Lenin and Leninism at every turn to justify their policies. Needless to say, these often differed from Lenin's real objectives.

## The First Five-year Plan, 1928–32

The first five-year plan put an end to the NEP's mixed economy, class tolerance and the notion of gradual socialist transformation. The economy was renationalized, more urgently, forcefully and effectively than under War Communism. The Soviet Union was at war – with domestic and foreign enemies – and Stalin was determined that, this time, revolutionary Russia would win. In a speech to industrial managers, he declared that the old Russia had been beaten many times because of her backwardness – military, cultural, political, industrial and agricultural. 'We are fifty or a hundred years behind the advanced countries. We must make good this distance in ten years. Either we do it or we shall go under.'[60] This was a battle, and the bywords for development were military: workers' brigades, industrial mobilization, class struggle, cultural front.

To achieve rapid industrialization, production focused heavily on metal: *Fulfilling the Programmes*

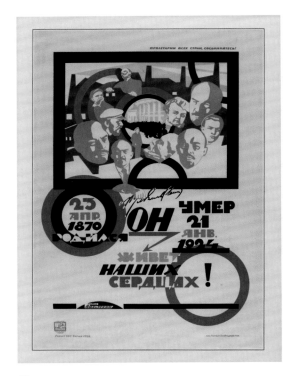

47
**Pavel Liubarskii**
*Born April 23rd 1870/ Died
January 21st 1924/ He Lives
in Our Hearts!*, 1924

*for Cast-Iron, Steel and Rolled Steel – A Job for All the Country's Workers* (illus. 65). The leading worker here is muscular, steady, fiercely loyal and determined. He is the new proletarian hero. Bourgeois experts are no longer needed or even tolerated, as they were during the NEP. The posters of the first five-year plan use photomontage to show workers en masse, as parts of the system. They march forward together, indistinguishable as individuals. In keeping with the military-industrial tone of propaganda, the Red Army was celebrated as the 'Fighting school of the workers'. Illus. 37 is a fabulous photomontage of military activities in the shape of a multilayered five-point star, framed above a grand procession in Moscow's Red Square.

Women had a new image. Lenin said that every cook should also be an accountant, but Stalin wanted every woman to be a shock-worker and organizer. Physically strong and politically dedicated, Soviet women were now machinists and tractor drivers. In *March 8 is the Militant Celebration of Working Women of All Countries*, their economic contributions are enumerated in various categories (illus. 67).

Measurement is a fundamental feature of five-year plan posters. Charts, graphs, percentage increases and fulfilment multiples appear in every context. Production of timber, coal, sugar, machine tools and every other commodity were graphically quantified, promising to achieve the plan in four years or even three. Quantity and time were equally urgent.

Not all sectors kept up with the headlong pace of industrialization, particularly transport

and energy. 'The development of transport is one of the key tasks of fulfilling the Five-Year Plan,' declares the poster in illus. 48, which details increases in freight transported, capital funds and investment. However, here it is acknowledged that challenges remained in the steppes, signified by the camel. The conditions of the past had to be overcome, and the system modernized throughout the Soviet Union. Trains were often shown rocketing the USSR to the future – from socialism to communism – a trope adopted by revolutionary artists elsewhere.

Illus. 48 and 66 were designed by Gustav Klutsis (1895–1938), one of the pioneers of photomontage. His and other artists' posters feature a larger-than-life Stalin among massed workers or peasants, and many include quotations from the *Vozhd* (leader). In illus. 66, Stalin looks to the future and demands that, 'By the end of the Five-Year Plan, the collectivization of the USSR must be basically complete.' The forced collectivization beginning in 1928 consolidated households, animals and land into *kolkhozes* and *sovkhozes*.[61] The leadership believed that the procurement achieved by large-scale agriculture would fund the ambitious plans for industrialization and technological modernization. The peasants resisted this in many ways – peacefully, through meetings; then by hoarding or burning grain, killing their draught animals and simply leaving the land. Many thousands were imprisoned for sabotage, and an all-out war was launched against *kulaks*. Class struggle was reinstituted ideologically, politically, economically and culturally, in marked

contrast to the NEP. The revived association of capitalists, Tsarism and the church – the Civil War troika of evils – led to violent repression of religion and imagined remnants of the old society.

Millions died from starvation and disease in the resulting famine of the early 1930s.[62] The famine was denied, and collectivization advanced, in all propaganda media. *The Day of Harvest and Collectivization* celebrates life on the *kolkhoz* 'Atheist' (illus. 69). Tractors and communal facilities make for huge, easy harvests, unlike the backbreaking hungry old days. The folksy, colourful style was common in posters about the collectivization.

Propaganda of the late 1920s and early 1930s also stressed social and cultural themes. Literacy and workers' reading rooms were frequent subjects. Smoking and alcoholism were targets of major campaigns: not only bad for the individual's health, they were terrible for society and the economy. Smoking wasted time and money; alcohol led to hooliganism and poor-quality work. Production cost and quality were everything, as illustrated in a poster of the Socialist Propaganda Campaign (illus. 49): *Every Worker Must Pay Utmost Attention to the Cost of Goods at his Factory. Some Work Poorly, Others Better, and Some Work Well. Keep Up with the Best and Achieve Overall Growth.* The poster, with Constructivist elements, was, unusually, designed by two women, Lydia Naumova (1902–1986) and the LEF artist Elena Semenova (1898–1986).[63]

Constructivism was at its most influential in the late 1920s, particularly in the work of Rodchenko and Klutsis, and in film posters – a totally separate design category unmentioned thus far.

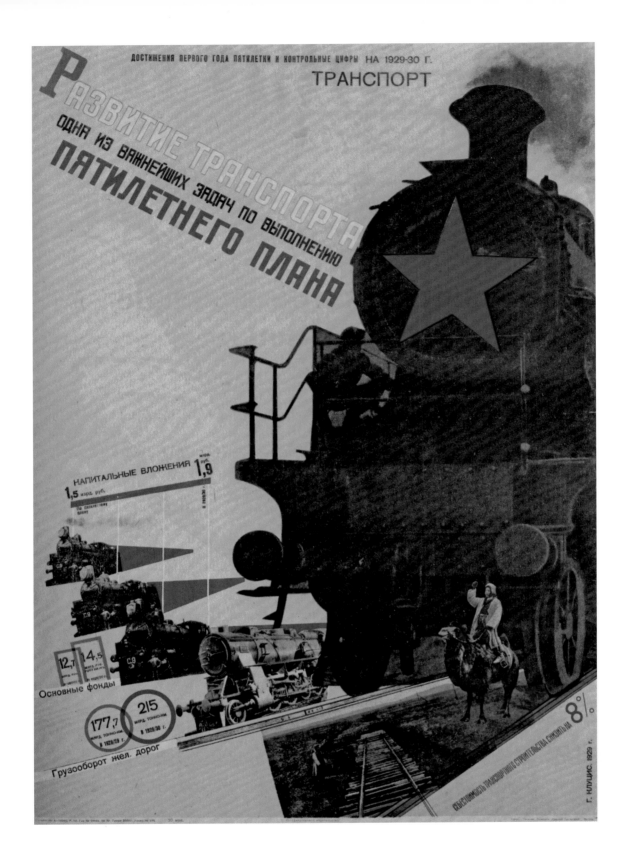

48

**Gustav Klutsis**
*The Development of Transport*
*Is One of the Key Tasks of*
*Fulfilling the Five-year Plan*,
1929

opposite:

49

**Lydia Naumova and**
**Elena Semenova**
*Every Worker Must Pay Utmost*
*Attention to the Cost of Goods*
*at His Factory*, 1929

Most important here are the Stenberg Brothers, Vladimir (1899–1982) and Georgii (1900–1933). Montage, movement and plays with perspective are all evident in the remarkable poster for *Man with a Movie Camera*, a documentary of 1929 about Soviet urban life and the interaction of man and machine (illus. 68). Such experimental creativity would not be allowed for much longer.

### The 1930s

The posters of the 1930s showed two views of the world: the rosy, active optimism of Socialist Realism and the sinister graphics of the dark side.

Beginning in 1931, cultural activities were consolidated under central organizations. All poster production was to be organized by Izogiz, the State Publishing House for Art.

Official unions of writers and artists were established in 1932, eliminating previously independent associations. This spelled the end of avant-garde revolutionary movements and the creative debates of the 1920s. 'Socialist Realism' appeared as a term in the press in 1932 and became official policy in 1934. The prescribed style, combining realism and revolutionary romanticism, was optimistic, heroic and accessible to the masses. It showed the communist ideal in the process of becoming – a visionary conflation of present and future.

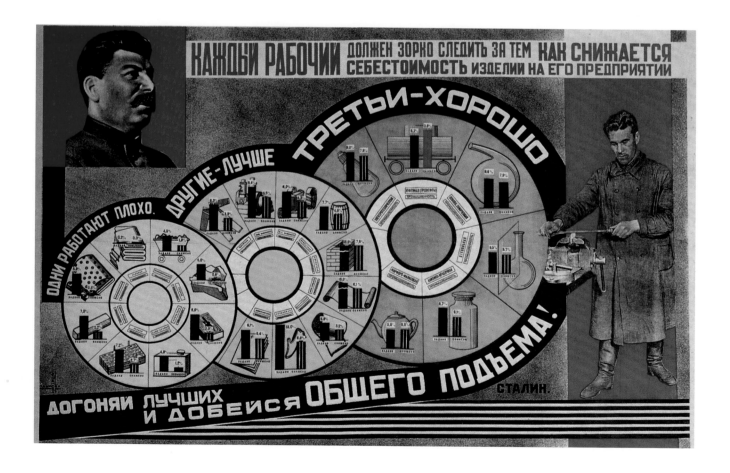

Posters exalted Soviet achievements generally, and huge individual projects, such as the Moscow metro and Dnieper hydroelectric power station. Crowds thronged the grand squares in public rituals, with Stalin the focus of their pride and commitment. Illus. 70 celebrates Soviet aviation, but is called *Long Live Our Happy Socialist Motherland. Long Live Our Beloved Great STALIN!* 'Vladimir Lenin' is the name on the first aeroplane, but the eye focuses on the second, red plane, with 'Josef Stalin' under the wings. The planes on the right form the letters for 'Stalin'; Stalin, in fact, was visible everywhere. By the mid-1930s, when Lenin and Stalin appear in the same poster, Lenin is now in shadow or otherwise placed in the lesser position.

The second five-year plan (1933–7) moved away from doctrinaire proletarian equality and brought back hierarchy. The new Party elite comprised experts and bureaucrats, and the system was based on material incentives for all. Constant sacrifice was relegated to the past, and consumption was no longer bourgeois. 'Life has become better, comrades; life has become more cheerful,' announced Stalin in 1935. Varieties of food and drink, clothing, cosmetics and perfumes were available; restaurants, theatre and jazz were in vogue. These things constituted 'culturedness' (*kulturnost*). Only a limited number of people could afford such things, but the advertisements sold hope for all: 'Things mattered enormously in the Soviet Union in the 1930s for the simple reason that they were so hard to get.'[64] Posters belied the dreariness of most people's material situation. *The Duty of Every Worker* shows a clean, spacious housing complex (illus. 71); in fact,

urban housing in the 1930s was dark, crowded and communal, with individual space declining steadily throughout the decade.[65]

The poster's slogan is promoting social responsibility for the environment, but the image of the mother and her baby illustrates another important theme of the time. The family had regained its status as the basic unit. Conservative social values were in force: the early revolutionary attitudes to divorce, abortion and free love were now condemned. Classical literature and folk arts were promoted, while avant-garde writers, composers and artists were attacked.

Enemies were everywhere, real or imagined. A campaign in 1933 assailed counter-revolutionary remnants and economic saboteurs. *Triple Your Vigilance, Comrades!* shows Cheremnykh's continuing use of the window poster format into the 1930s (illus. 50). The call for vigilance – against spies, blabbermouths, hooligans – is one of the most common themes in Soviet propaganda of all periods.

The Great Terror of 1937–8 purged millions of Party members, military personnel and ordinary citizens.[66] Stalin went after former allies and revolutionary heroes, eliminating anyone he thought represented a potential challenge to his leadership. The red arm of true revolution strangles 'spies, deviationists and fascists' in illus. 51, and the poster promises that we will eradicate them. Bukharin (rightist) and Trotsky (leftist) are linked here with Hitler. Anti-fascist imagery, often bestial, was common from the early 1930s, as Stalin used the threat of foreign attack to justify his headlong economic campaigns.

50
**Mikhail Cheremnykh**
*Triple Your Vigilance, Comrades!*, 1933

**ИСКОРЕНИМ
ШПИОНОВ и ДИВЕРСАНТОВ,**
ТРОЦКИСТСКО-БУХАРИНСКИХ АГЕНТОВ ФАШИЗМА!

## The Second World War and Late Stalinism

Because the USSR had signed a non-aggression pact with Germany in 1939, Stalin was unprepared for Hitler's attack when it came. The Soviet armed forces and population made extraordinary sacrifices in the Great Patriotic War, as it is still called. Their struggle was for Mother Russia, not for the Soviet system. Propaganda of the Second World War referred to past wars and heroes. The brave fighting men of the Kukryniksy's poster are inspired by the red-silhouetted figures of Alexander Nevsky, Alexander Suvorov and Vasily Chapaev (illus. 72).[67] The Kukryniksy was the collective name for three artists who worked together on posters, large paintings, book illustrations and theatre sets, but who are best known for their wartime cartoons.[68]

Earlier graphic forms also returned. Cartoon posters using the illustrated text design of *lubki* were commonly produced.[69] A popular theme was the victory over Napoleon in 1812. Illus. 73 shows Napoleon's retreat from the Russian winter, and Hitler's army fleeing the Soviet Air Force. The caption reads: *Napoleon Was Cold in Russia, but Hitler Will Be Hot!* Multi-panelled window posters, so popular during the Civil War years, reappeared almost immediately. Mikhail Cheremnykh, the guiding light behind the ROSTA enterprise, organized the project at TASS, as it was now known.[70] The first TASS poster was on the street five days after Hitler declared war on the USSR. Some 1,240 designs were produced during the war years, circulated by the TASS teams in Moscow, Leningrad and Tashkent.[71]

Stalin appeared far less often in Second World War propaganda. This was a war of, for and by the heroic people who wholeheartedly supported their forces. El Lissitzky's outstanding composition combines patriotic elements with photomontage (illus. 74). *All for the Front! All for Victory!* immediately recalls his better known poster for the Russian exhibition in Zurich in 1929, with the fused heads of the boy and girl. The 1941 rendition is less startling, less experimental but, arguably, more effective propaganda.

When the Great Patriotic War was over, the USSR turned to reconstruction on the home front and aggressive expansion abroad, forcibly establishing communist satellites in Central and Eastern Europe. The visual propaganda employed to support these activities has been described as 'High Stalinism'. These were years of great material deprivation, but posters 'projected the radiant Communist future as present reality'.[72]

*The People's Dreams Have Come True* is a fine example of post-war trends in style and message (illus. 75). In a comfortable ship's cabin, a grandfather figure proudly gestures towards the clean, modern scene of Soviet ships and factories. *Pravda*, the Communist Party newspaper, is on the table, and the young Pioneer is reading a book by Nikolai Nekrasov (1821–1878), the passionate writer on and critic of urban social conditions. On the wall behind them is the famous Repin painting *Barge Haulers on the Volga*, confirming how terrible things used to be. The contrast between 'then and now' was a time-tested theme; today's characters and colours are rosy and serene.

51
**Sergei Igumnov**
*We'll Uproot Spies and Deviationists of the Trotsky-Bukharin Agents of Fascism*,
1937

The theme of Soviet achievement was emphasized by contrast to the capitalist states as the Cold War began. The United States was a particular target, with posters using the familiar 'us and them' format from *lubki*. *The Same Years, Different Weather* compares late 1940s industrial production figures (illus. 52). The Soviet worker basks in the sun, while a suffering capitalist holds 'war plans' under dark clouds. The yellow lightning feature reads 'Crisis'. It is true that in the post-war years, until about 1958, the Soviet economy grew faster than the American, offering a convincing development model to many, in countries on both sides of the Cold War divide. 'Peace to the world' was a concomitant Soviet theme, despite interventions in Europe and Asia. Andrei Zhdanov, who directed cultural policy, divided the world into the U.S.-led 'imperialist' camp and the Soviet-led 'democratic' one.

Stalin imagery had been much reduced during the war, but reached new heights in the years following the victory. Often depicted in medal-covered uniform, Stalin was the great hero/leader/strategist of Soviet triumph. He sometimes stands giant-sized above workers or farmers, as in the 1930s. In illus. 53, the admiring crowds are multi-ethnic, and a background map testifies to imperial leadership. Often, though, in his final years, he is portrayed alone, hard at work, with a slogan glorifying his achievements as he guides the nation ever closer to communism. This Stalin is older and dignified, bringer of prosperity in the peace. He is also shown with children, workers or soldiers, all of whom try their best to earn his praise.

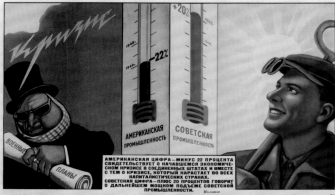

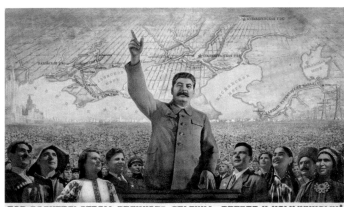

top:

52
**V. I. Govorkov**
*The Same Years, Different Weather*, 1949–50

bottom:

53
**M. M. Soloviev, B. C. Berezovsky, I. M. Shajin,**
*Under the Leadership of the Great Stalin, Forward to Communism!*, 1951

## The Cold War, Khrushchev and Brezhnev

When Stalin died in 1953, the USSR lost its charismatic, unifying symbol.[73] A collective leadership was established which was soon controlled by Nikita Khrushchev (1894–1971). His 'Secret Speech' of 1956 rocked the whole Soviet bloc, as Stalin's crimes were revealed. The cult of the personality disappeared, as propaganda focused on the Party and the Central Committee, and the achievements of the Soviet system. Graphs and charts appeared again, as in the 1930s, trumpeting successes of the revived system of five-year plans. The centralized model was adopted by the whole Soviet bloc, China and Cuba, and appealed to many unaligned developing nations.

A major achievement was in the space race. The USSR launched the first dog, man and woman into outer space (in 1957, 1961 and 1963, respectively). Yuri Gagarin (1934–1968) orbited the Earth and became a worldwide celebrity (illus. 76). Soviet aviation and pilots had been celebrated since the 1920s; now spaceflight was a spectacular triumph for socialism.

Not all was well with the system, however. Campaigns against drinking and smoking, slacking and hooliganism continued throughout the postwar period. Viktor Govorkov (1906–1974) was a master of these designs, in Socialist Realist and cartoon-style posters. In illus. 54, drinking results in flawed, rejected production (*brak*). The slogan was one of Maiakovskii's witty rhymes, first used in a 1929 poster: 'Let's drive out drinkers from the midst of workers.'

Khrushchev was removed in a palace coup in 1964. The Party governed as a collective leadership under the visibly revived banner of Lenin. Leonid Brezhnev (1906–1982), first among ageing equals, declared that the USSR had achieved 'mature socialism'. In fact, the system was stagnating. Political and economic posters combine numerous elements to fuel inspiration, as in illus. 77. This poster of 1984, *The Course of the Party and the People is Creation*, includes revolutionary-red workers and technocrats, workers with a Lenin flag, five-year plan statistics and profound words from the Central Committee. The slogan belies the fact that the objective of the Party at that point was self-preservation.

While much of the late-Soviet propaganda is perfunctory and lifeless, there was some innovative graphic work, largely inspired by Polish design.[74] Under Mikhail Gorbachev's 'glasnost' (openness) and 'perestroika' (reconstruction), some posters dealt truthfully with long-standing social and political issues for the first time. In 1988, Alexander Medvedev's (b. 1963) stylish work criticized bullying in the Soviet Army as a disgrace (illus. 78). The open discussion of this issue was an important achievement of glasnost.[75] At long last, some posters openly reviled Stalin: the show trials, countless murders, starvation, collectivization, arrests and day-to-day fear and brutality. There were calls for post-mortem trials and honest reckonings of his legacy. Alexander Vaganov (b. 1951) used a silhouette to depict Stalin's profile and a bloody scythe in his condemnation of *Collectivization, 1929* (illus. 79). One clever poster showed a rifle with a tongue

for a trigger, damning the treatment of those denounced by others.[76] Others used religious imagery, which would not have been sanctioned before. The openness marked a genuine possibility for systemic reform, but by then, it was too little and too late.

When it finally happened, the Soviet empire collapsed more quickly than anyone would have imagined. The Eastern European countries declared their independence one by one from 1989.

In 1990–91, the Soviet Union disintegrated as the non-Russian republics seceded in a nationalist stampede.[77] More than a decade followed of poorly managed political and economic liberalization, as Russia's global power declined. Since 2000, Vladimir Putin (b. 1952) has led the country in an increasingly nationalistic, less pluralistic way. Military expansionism and one-man rule have not made him unpopular. The West is once again the enemy, and the glories of empire beckon.

**Viktor Govorkov**
*Let's Drive Out Drinkers from*
*the Midst of Workers*, 1966

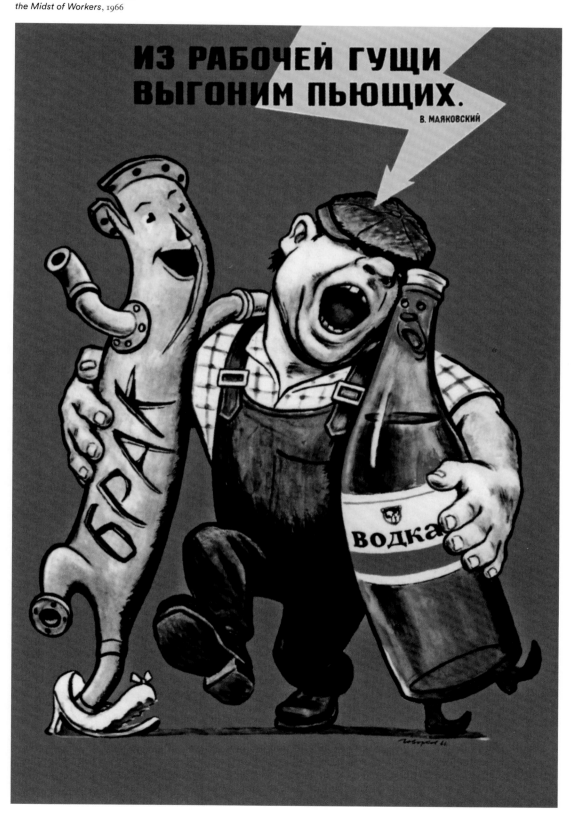

На Помощь Жертвамъ войны

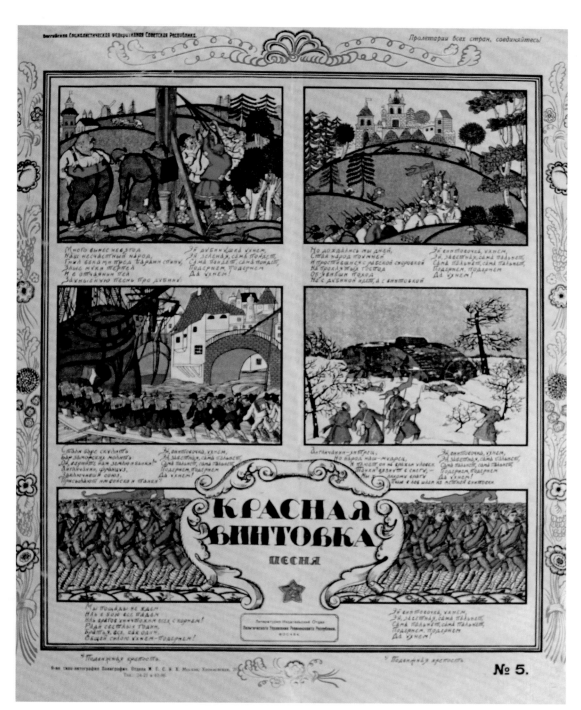

56
**Alexander Apsit**
*The Red Rifle*, 1919

chromolithograph

opposite:

55
**Leonid B. Pasternak**
*Help the War Victims*, 1914

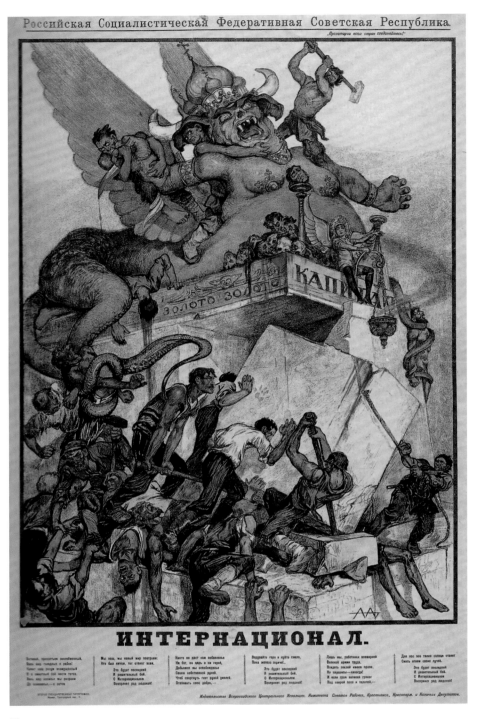

57

**Alexander Apsit**
*The International*, 1918

opposite:

58

**Viktor Deni**
*Capital*, 1919

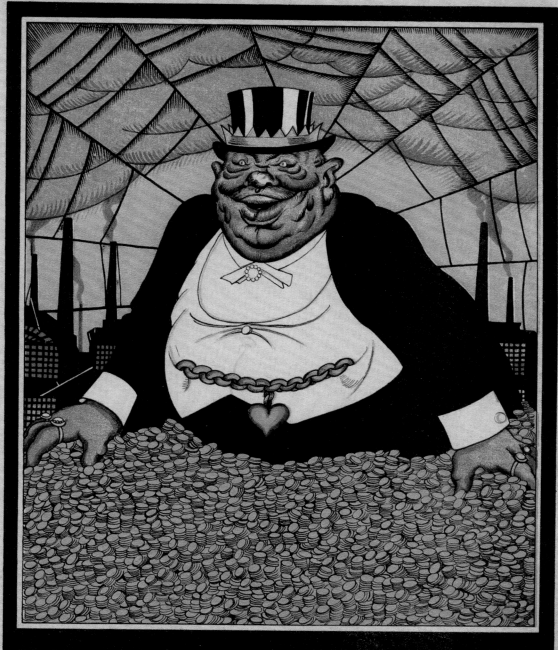

17-я Государств. типо-лит. (бывш. Кушнерева). Москва.

# КАПИТАЛ.

Да не будут тебе бози инии разве мене.

Любуясь дивною картиной,
Рабы, склонитесь предо мной!
Своей стальною паутиной
Опутал я весь шар земной.
Я—воплощенье КАПИТАЛА.
Я—повелитель мировой.
Волшебный блеск и звон металла—
Мой взгляд и голос властный мой.

Тускнеют царские короны,
Когда надену я свою.
Одной рукой ломая троны,
Другой—я троны создаю.
Моя рука чертит законы
И отменяет их она.
Мне все „отечества"—загоны,
Где скот—людские племена.

Хочу—пасу стада в долинах,
Хочу—на бойню их гоню.
Мой взмах—и области в руинах,
И храмы преданы огню.
Средь всех твердынь—моя твердыня
Стоит незыблемой скалой.
Храм биржевой—моя святыня,
Конторский стол—мой аналой.

Мое евангелье—балансы,
Богослуженье—„игра",
Дары священные—финансы,

Жрецы—мои бухгалтера.
Я в этом храме—жрец верховный,
Первосвященник ваш и вождь.
Свершая подвиг мой духовный,
Я золотой сбираю дождь.

Мои сокровища несметны.
Их не отдам я без борьбы.
Да будут вечно ж безответны
Мной усмиренные рабы!
Да будут святы им ступени,
Где жду я жертвы их трудов!
Да склонят все они колени,
Целуя прах моих следов!

№ 47.

Демьян Бедный.

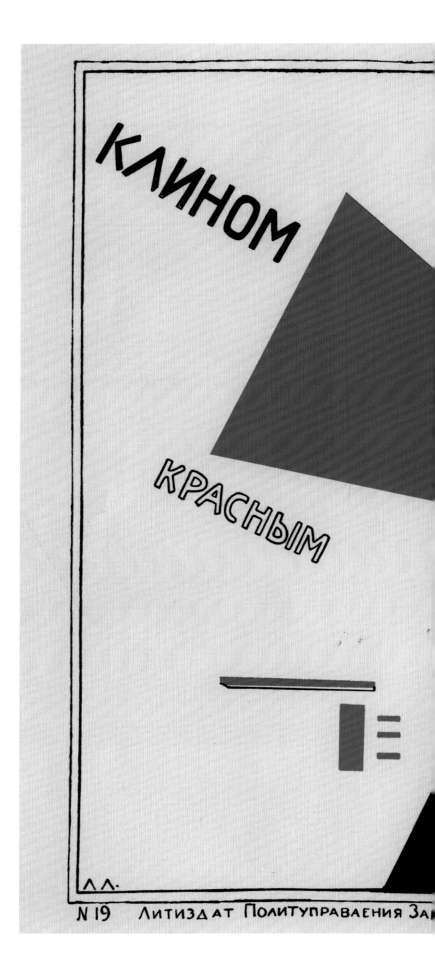

**El Lissitzky**
*Beat the Whites with
the Red Wedge*, 1920

БЕЙ

БЕЛЫХ

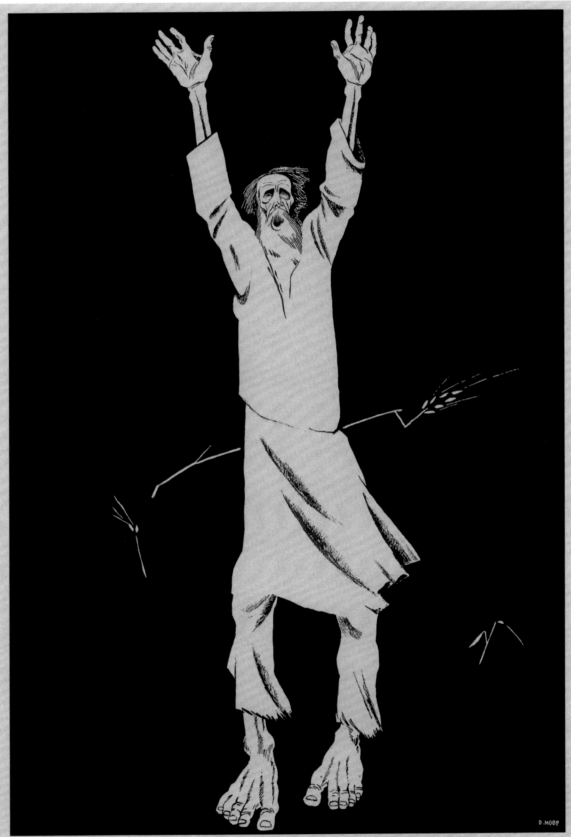

ПОМОГИ

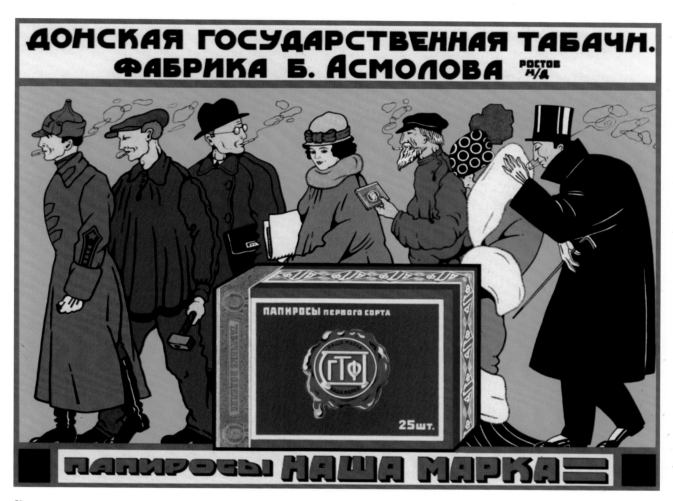

61
**Anonymous**
*Donskaya State Cigarette
Factory*, 1925

opposite:

60
**Dmitrii Moor**
*Help*, 1921

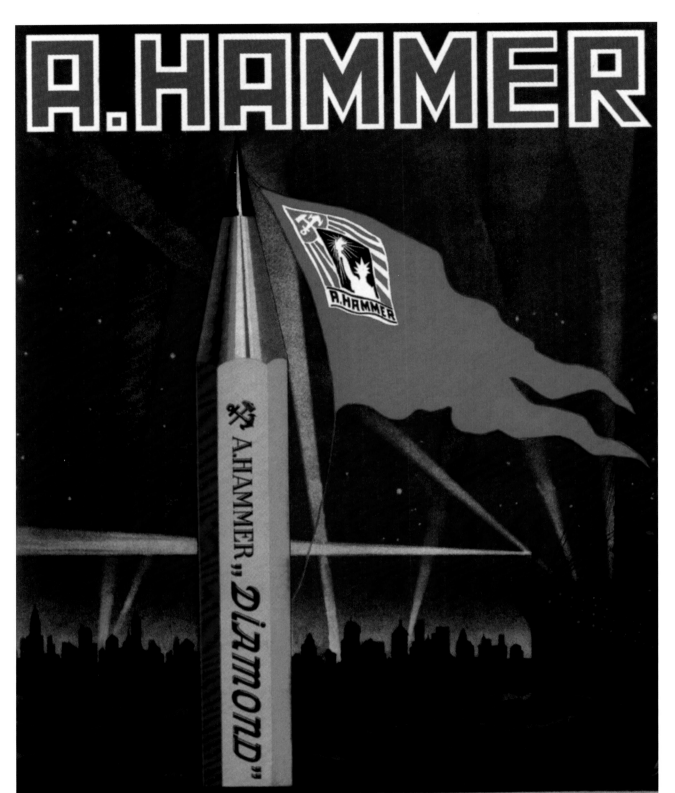

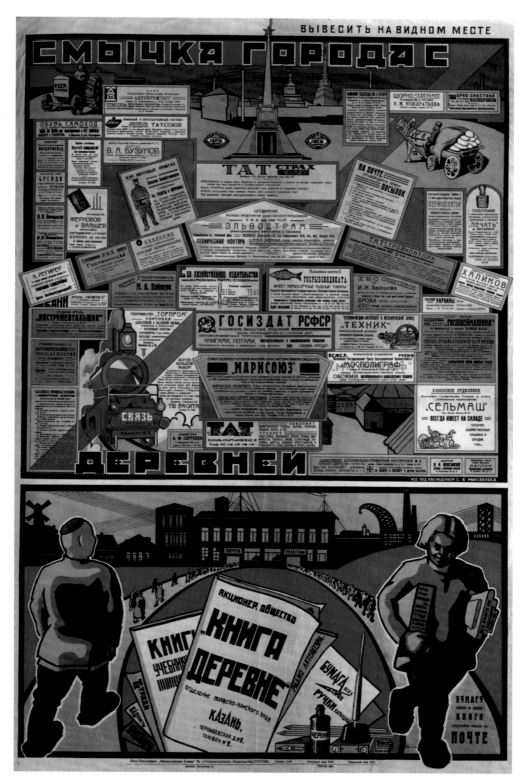

63
**G. Komarov**
*Union of Town with Country,*
1925

opposite:

62
**Anonymous**
*A. Hammer, American
Industrial Concession. Pencils.
Pens. Moscow-New York*, 1927

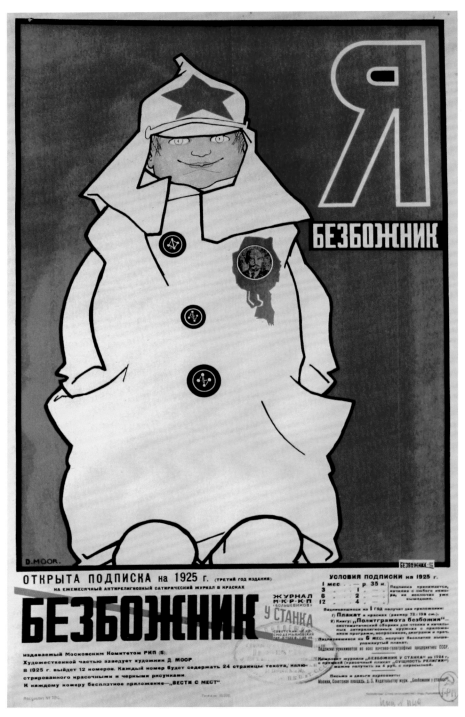

64
**Dmitrii Moor**
*I Am an Atheist,*
1924

opposite:

65
**Natalia Pinus**
*Fulfilling the Programmes for
Cast-Iron, Steel and Rolled
Steel – A Job for All the
Country's Workers*, 1932

ВЫПОЛНЕНИЕ ПРОГРАММЫ
ПО ЧУГУНУ, СТАЛИ И ПРОКАТУ —

ДЕЛО
ТРУДЯЩИХСЯ
ВСЕЙ СТРАНЫ

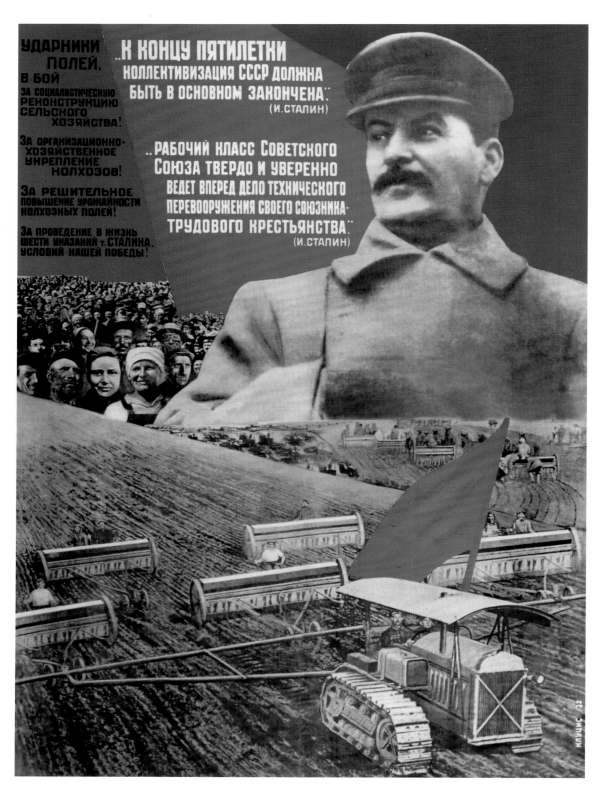

66
**Gustav Klutsis**
*Shock-workers of the Fields
in the Battle for the Socialist
Reconstruction of Agriculture*,
1932

opposite:

67
**A. Mytnikov-Kobylin**
*8 March Is the Militant
Celebration for All the World's
Working Women*, 1932

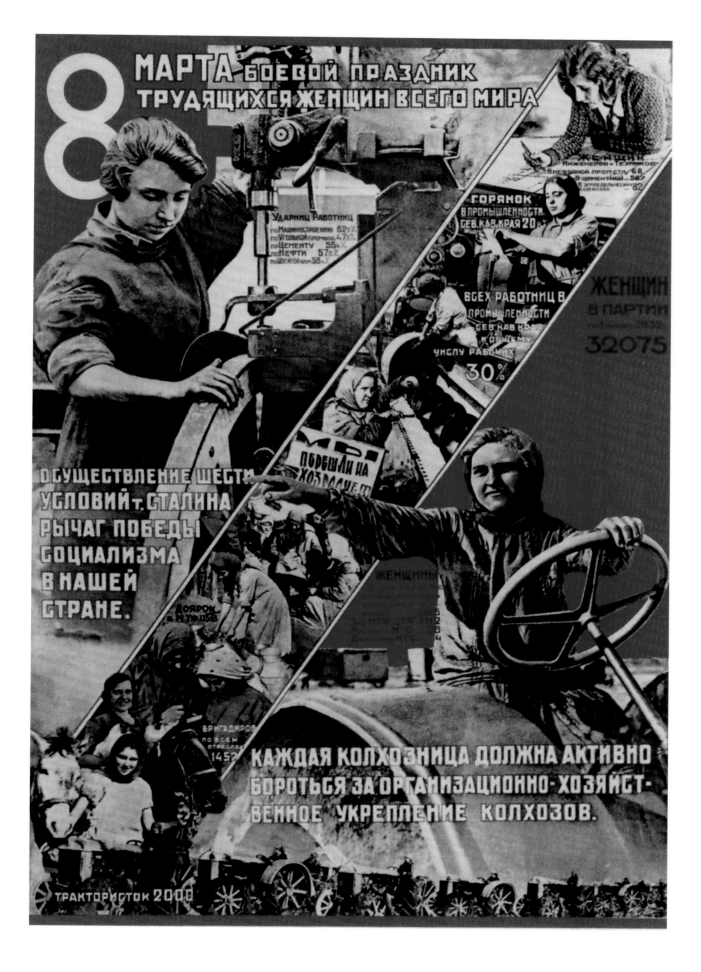

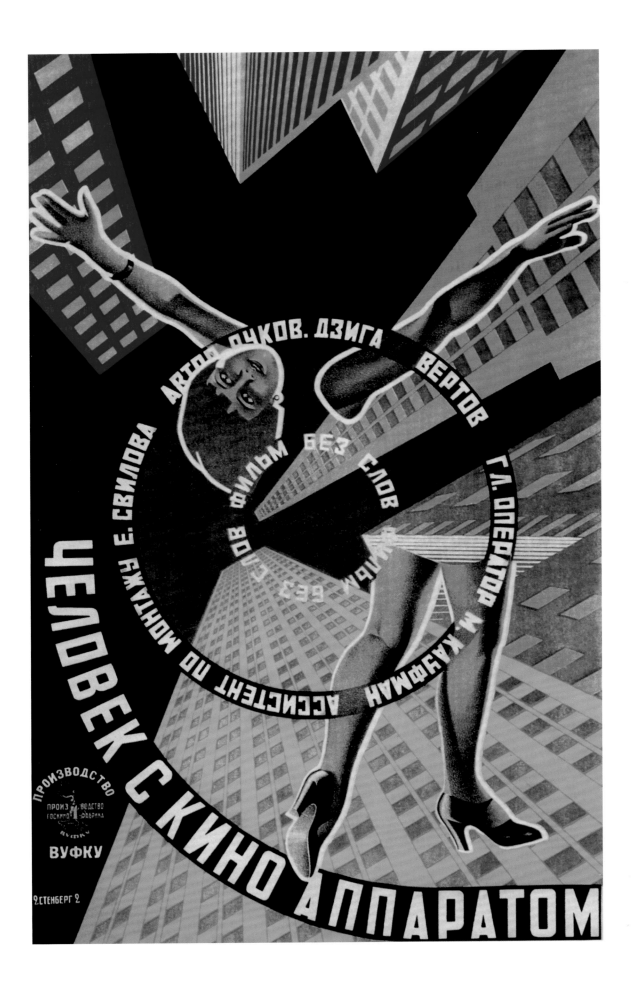

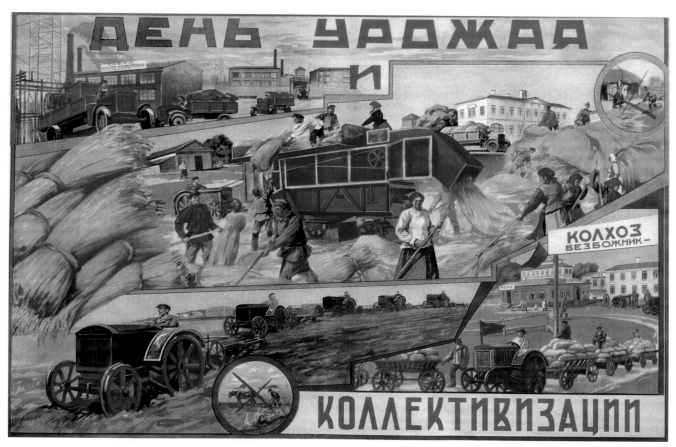

69
**Anonymous**
*The Day of Harvest and
Collectivization*, 1930

opposite:

68
**Vladimir and Georgii Stenberg**
*Man with a Movie Camera*,
1929

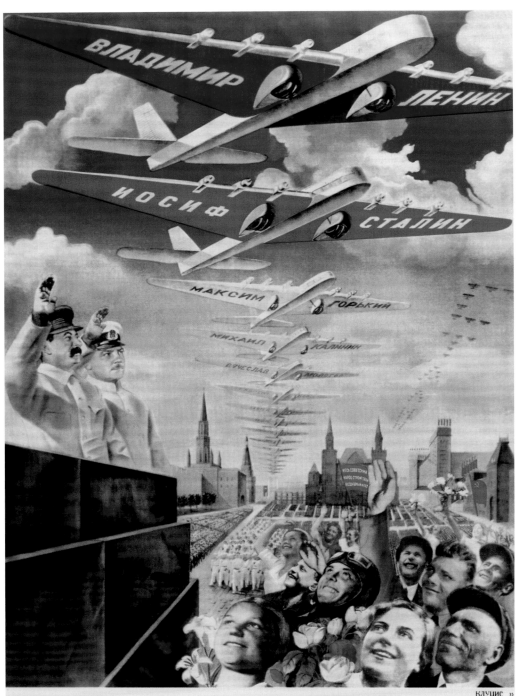

ДА ЗДРАВСТВУЕТ НАША СЧАСТЛИВАЯ СОЦИАЛИСТИЧЕСКАЯ РОДИНА.
ДА ЗДРАВСТВУЕТ НАШ ЛЮБИМЫЙ ВЕЛИКИЙ СТАЛИН!

70

**Gustav Klutsis**
*Long Live Our Happy Socialist
Motherland. Long Live Our
Beloved Great STALIN!*, 1935

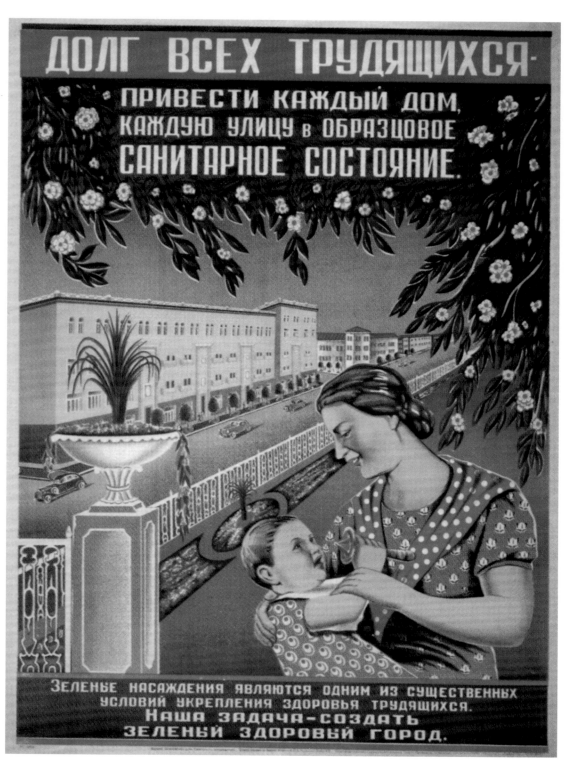

71

**I. Boym**
*The Duty of Every Worker*, 1930s

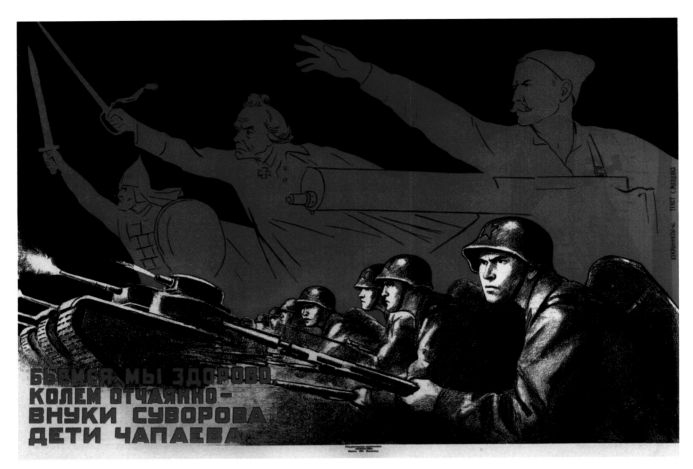

72
**Kukryniksy (Kuprilianov, Krylov, Sokolov)**
*We're Good at Beating, We Thrust Our Bayonets Boldly; We're the Grandsons of Suvorov, the Sons of Chapaev,*
1941

opposite:

73
**Landres**
*Napoleon Was Cold in Russia, But Hitler Will Be Hot!*, 1941

НАПОЛЕОНУ БЫЛО ХОЛОДНО
В РОССИИ,
А ГИТЛЕРУ БУДЕТ ЖАРКО!

75
**Aleksei Lavrov**
*The People's Dreams Have
Come True*, 1950

opposite:

74
**El Lissitzky**
*All for the Front! All for Victory!*,
1942

76
**V. Suris**
*12.iv.61. Cosmonauts' Day*, 1961

**Anonymous**
*The Course of the Party and the
People Is Creation*, 1984

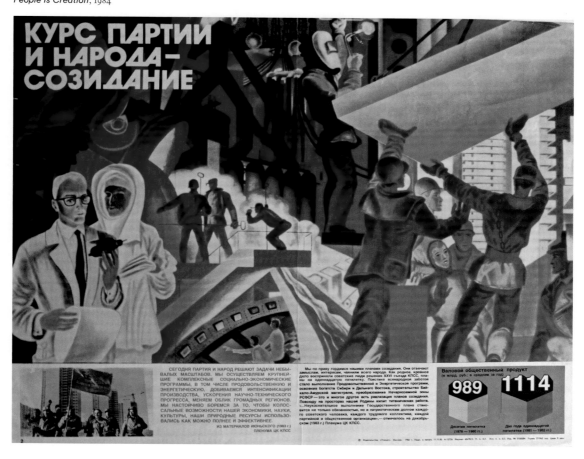

78

**Alexander Medvedev**
*Bullying Is a Disgrace to the Army*, 1988

opposite:

79

**Alexander Vaganov**
*Collectivization, 1929*, 1989

# МАНАЙ ЭНХРИЙ ХАЙРТ ЭХ ОРОН — БНМАУ МАНДТУГАЙ!

Б.Н.М.А. Улсын Сойлын Яам
Зураач Д. Сандагдорж, Д. Нацагдорж, Л. Батсүх
Улсын сайвын редактор Д. Дарамдэмид
Техник редактор Д. Юмжав

А—41563.   Улсын Хэвлэлийн Комбинат
1970 оны 11  дугээр сард 4000  ширхэг хэвлэв.
Үнэ 30  мөн.   Зах № 1138
Улаанбаатар, Сүхбаатарын гудамж, 2

# 2 Mongolian People's Republic, 1924–92

**Morris Rossabi**

After the collapse of the Mongolian Empire in the fourteenth and fifteenth centuries, most Mongolians had returned to their native land. The disunity that had characterized their societies before Chinggis Khan (*c.* 1162–1227) and his descendants organized them into a powerful confederation plagued them for the next five hundred years and would make them vulnerable to their enemies.[1] Struggles among eastern, southern and western Mongolians, along with divisions within each group, weakened them and pushed them off the world-historical stage they had occupied during their conquests. The rest of the world would scarcely be aware of Mongolia for the next five centuries. Starting in the 1570s, one of Chinggis's descendants attempted to end hostilities by promoting the ultimately successful project of converting the population to Tibetan Buddhism, but religious unity did not translate into political unity.

An increasingly powerful China, under the Qing dynasty (1644–1911), capitalized on the Mongolians' weakness. By 1634, it occupied South (or Inner) Mongolia; by 1691, it compelled the eastern Mongolians to accept Qing rule, and by 1756, its armies had crushed the western Mongolians. The Qing, with the collusion of some Mongolian aristocrats and monks, governed Mongolia for a century and a half, and, according to Mongolian accounts, exploited and pauperized the population. Many Mongolians would not forgive the aristocrats and monks for collaborating with the Qing.

The Qing dynasty's collapse in 1911 did not end the Mongolians' travails. Unity still proved elusive, and the period from 1911 to 1921 was chaotic, with Mongolian patriots, White Russians (fleeing from the Bolshevik Revolution of 1917), Chinese warlords and the Bogdo Gegen (1869–1924), the leader of the Buddhist establishment, vying for power. A bizarre and murderous Russian named Baron Ungern-Sternberg (1885–1921) briefly occupied the capital city of Urga (now Ulaanbaatar) and initiated a reign of terror. Finally, Mongolian nationalists, with the vital support of Russian communists, took power in 1921, and Mongolia became the second communist state in world history. Under Soviet tutelage, Mongolian leaders, including Sükhbaatar (1921–3), Choibalsan (often referred to as Mongolia's Stalin; 1930s–1952) and Tsedenbal (1952–84) alternated between moderation from 1921 to 1928, 1932 to 1936, and 1939 to 1945, and the destruction of monasteries and killing of monks between 1928 and 1932 and 1936 and 1939, the latter imitating the Moscow purges of the same period. The Soviets did assist the Mongolians to develop a modern medical structure, an educational system and pensions and social welfare regulations. However, Mongolian leaders

80
**Anonymous**
*Our Mongolian Future*,
early 1980s

and the USSR were determined to destroy their class enemies, the nobility, Buddhist monks and 'avaricious' merchants, the last of whom included many ethnic Chinese. By the late 1920s, the state had expelled nearly all the Chinese, and the purges of the late 1930s virtually eliminated the nobility and monks. The state sought to turn the herders into wage-earning and so-called semi-proletarians organized into collectives. In the post-Second World War period, it initiated industrialization and urbanization policies.

The communists' main objective was to develop New Socialist Men who collaborated with and perceived the Soviets as their 'elder brothers'. Education, the media, public pronouncements and literature and the arts were all enlisted in this effort. Posters also proved to be effective tools for inculcating the values of this new socialist society.[2]

Like their communist predecessors and advisers from Russia, Mongolian communist leaders supported and commissioned the production of posters as a valuable part of their propaganda efforts.[3] To be sure, posters had a lengthy history before their use for political purposes; by the middle of the nineteenth century, advances in technology had permitted the printing of ten thousand sheets an hour.[4] Thus European and American and subsequently Japanese artists began to create posters for commercial advertising, theatrical productions, expositions and government services. The early twentieth century witnessed one of the first elaborate uses of posters when combatants in the First World War ordered them to encourage their own nationals and to portray the enemy as rapacious criminals.

## Communist Regimes and Posters

Russia and, later, Mongolia were among the pioneers in the development and employment of posters to support a regime's political goals, to inculcate its values and to promote its economy. When the Bolsheviks came to power in Russia in 1917, they faced considerable opposition. Four years elapsed before they defeated their enemies in the Civil War. At the same time, they needed to define themselves and to explain their objectives to a populace that knew very little about them. In order to be successful, they needed to gain support from at least a substantial segment of the population.

Posters proved to be optimal in the Bolsheviks' attempt to influence and perhaps win over ordinary Russians, as well as the country's other ethnic groups. Radio and television naturally had not developed. Printed materials offered a means of transmitting the Bolsheviks' ideology and policies. Yet many printing plants had been closed as a result of the turbulence of the revolution, and the country suffered from a severe shortage of paper.[5] Posters, however, did not require elaborate printing plants, or as much paper as books, and could be produced cheaply and convey striking images.[6] The Bolsheviks could draw upon the Russian artistic tradition for their posters, including the icons which helped to disseminate Orthodox ideas. *Lubki* or popular prints, which had developed in the seventeenth century and, on occasion, had satirical intent or political connotations, together with icons, inspired many of the early poster artists.

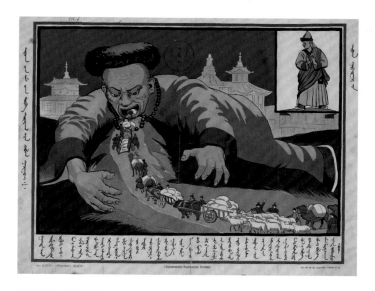

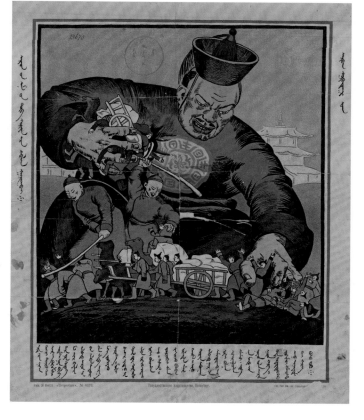

Advertising broadsides and satirical journals also influenced them.[7]

The Mongolian communists came to power in 1921 and faced the same difficulties, as well as others, in disseminating their objectives. They had been cut off from Europe and thus did not initially know about posters. It was only through the USSR and Buryat and other Mongolians who studied there that they became exposed to poster art.[8] In particular, Ts. Sampilov (1893–1953), for whom the national museum in the Buryat Republic is named, was a significant intermediary in providing information about posters, as was the distinguished Mongolian scholar and writer Byambyn Rinchen (1905–1977), who collected posters that he brought back to Mongolia.[9]

They, too, contended with problems in printing and paper supply.[10] In addition, the territory under their control was huge, and the population was widely scattered over this vast domain. In 1922, Mongolia had a population of about 650,000 in a land three times the size of France, making it the world's least densely populated country.[11] The new communist government could not readily reach countryside inhabitants who constituted the vast majority of the population. The lack of railways and the rudimentary and limited road system hampered transmission of books, newspapers and other printed materials, while posters were light and could be transported by the caravans and the postal relay system that linked countryside locations.[12] In addition, the postal relays kept the ever more populous capital city, originally known as Urga and then renamed Ulaanbaatar ('Red Hero') by the

top:

81
**Sharav**
*Buddhist Monk Swallowing Mongolia's Wealth*, 1924

bottom:

82
**Sharav**
*Avariciousness of Mongolian Nobility*, mid-1920s.

communist government, in touch with the pastoral peoples. Yet the relatively poor infrastructure exacerbated the difficulties the Mongolians traditionally encountered with unity, and had indeed been a major factor in the collapse of the Mongolian Empire of the thirteenth and fourteenth centuries.

## Literacy and Posters

The low rate of literacy, paradoxically, contributed to the posters' appeal. On the eve of their communist revolutions, Russia, North Vietnam and China had high rates of illiteracy, as did Mongolia.[13] However, Mongolian communist leaders, as well as some scholars, have probably underestimated the availability of educational opportunities for young Mongolians in the pre-communist period.[14] The Buddhist lamaseries, which enrolled a large number of men, had acted as schools, emphasizing basic literacy for ordinary monks and sophisticated studies for the leaders in the monastic community. Some officials also started so-called tent schools to help youngsters in their employ to master reading and writing. For example, J. Sambuu (1895–1972), who eventually became Chairman of the Presidium of the Khural (or parliament), developed these skills, in part, in such an environment.[15] After the fall of the Qing, authorities during the pre-communist period until 1921 planned to organize scribe schools and secular schools, yet they did not succeed in their efforts.[16] Neither type of school admitted girls. Thus, as the scholar Charles Bawden summarized, 'There was for at least two decades after 1921 a

83
**Sharav**
*Officials Undermining Mongolia
vs Officials Working for
Mongolia*, late 1920s

84
**Sharav**
*Elites Evading Taxes vs Proper
Tax Collection*, late 1920s

crippling illiteracy among the ordinary people.'[17] Even later in the communist period, anecdotal evidence suggests that as late as the 1950s some rural areas in Mongolia did not have elementary schools, and if they did, they had only a limited number of classes.[18] For example, some children living near Kharkhorin, the ancient capital of the Mongolian Empire and site of the country's first Buddhist monastery, had no nearby school. Only with the onset of the *negdels* (herder collectives) in the mid-1950s did many rural regions finally have neighbouring schools in *gers* (or tents), specially constructed buildings or dormitories.

Yet again posters proved to be optimal in light of the limited educational opportunities until the mid-1950s. If necessary, they could be produced in an astonishingly short time. Two specialists on modern Chinese art estimate that a poster could be fashioned in ten hours from the initial drawing to the finished printed version.[19] A Mongolian poster would presumably take the same length of time. The production process was inexpensive, so that the posters could be sold at low prices. Their messages were simple and direct, the symbols they portrayed were easily recognizable and the specific slogans they employed could be repeated and well understood.[20] They had to be visually arresting because they were meant to appeal to both illiterates and the better educated. Many exaggerated the features of figures they represented in order to convey their message to the widest swathe of the population. Moreover, some of these agitprop posters were not of the highest quality because they were executed rapidly and were not well printed.[21]

The message had to be readily comprehended because the vast majority of the Mongolian population was totally unfamiliar with Marxist ideology and the communist leaders' objectives. The Qing dynasty had, as much as possible, prevented Mongolia from interaction with the outside world, and the European philosophy of Marxism had not reached Mongolia. The herders in the countryside had never heard of socialism, communism or other nineteenth-century European ideologies.

## New Socialist Man and Art

Herders would have been startled to realize that the communist leaders planned to construct an extraordinarily different society, which entailed the creation of a New Mongolian Man with different ideals, values and ideas. These leaders intended to change the behaviour of herders, indeed of the entire population, in an attempt to build socialism and then communism. In this new system, social class, rather than religion, ethnicity or gender, would form the basis for unity. The 'heroic position and the collective identity of the working class' were paramount, and the communist leaders thus aimed to turn the herders into semi-proletarians and, eventually, proletarians whose interests and values resembled those of industrial workers.[22]

The communist elite planned to enlist the services of artists to promote these goals and to inspire the people to create a new society. Soviet and Chinese ideologues had maintained that art must serve the people and that the self-expression

91

of the artist, through his works, was not as crit-
ical.[23] Mao Zedong (1893–1976) had devoted
considerable time and effort to delivering speeches
on art and literature to the assembled communist
cadres at their base in Yan'an in 1942.[24] Asserting
that the arts always represented the interests of
a particular social class and could not be labelled
'art for art's sake', he demanded that artists reflect
the objectives of the proletariat, as interpreted by
the Communist Party.[25] Mao's talks at Yan'an are
well known, but Mongolia had adopted the same
ideology earlier. Mao and other communist leaders
had classified artists as intellectuals who could
be infected with bourgeois ideas and values and
thus would be regarded with some suspicion. Mao
prescribed physical labour in the countryside or
factories to rid them of bourgeois or feudal notions
in order to adopt the perspectives of the workers,
peasants or herders.[26] The posters they produced
had to portray both heroic and villainous figures
and not the traditional landscapes, flowers, birds or
animals.[27] They also needed to support the govern-
ment's messages.

The various communist states attempted to
recruit the leading artists of their day to produce
the posters, though some professed that amateurs,
often identified as peasants or workers, were the
main artists of particular posters or paintings.[28]
Vladimir Maiakovskii (1893–1930), the renowned
Russian poet, was a pioneer in Soviet poster art
and transmitted his posters through ROSTA, the
Russian Telegraph Agency, which had offices
throughout the Soviet Union. He was an enthu-
siastic proponent of posters as weapons of mass
persuasion and was willing to use any techniques,
even so-called capitalist tools, to support commu-
nism.[29] He explained that

*We neglected advertising, treating scornfully this*
*'bourgeois thing'. In the NEP conditions, we must use, for*
*popularizing state and proletarian organizations, offices,*
*and products, all the weapons employed by enemies,*
*including advertising.[30]*

Pre-communist Mongolia did not have the art
trends associated with modernism in Russia and
the Soviet Union, such as Constructivism and
Suprematism (whose most renowned figure was
Kazimir Malevich, 1879–1935), and learned about
modern design from the Russians rather than from
their own artistic tradition.

## B. Sharav and the Origins of Mongolian Posters

Baldugiin 'Marzan' Sharav (1869–1939), sometimes
referred to as 'Mongolia's Brueghel' and perhaps
the most renowned Mongolian painter of the early
twentieth century, proved invaluable to the new
Mongolian communist government. Born to a
herder family in the modern province of Gov-Altai,
which was adjacent to the Chinese border, he
visited Inner Mongolia as a young adult and saw
numerous Buddhist images.[31] Thus he began his
career as a painter of Buddhist pictures. Before
the communist era, the Buddhist authorities had
selected Sharav to paint the portraits of the Bogdo

85
**B. Sharav**
*Chinese Monsters*, late 1920s

19680

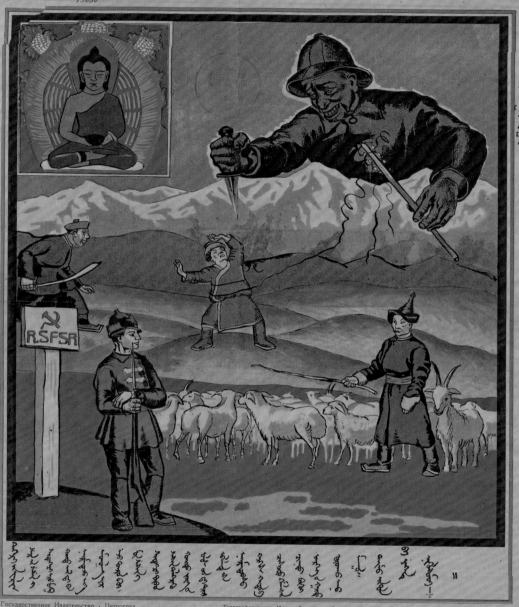

Государственное Издательство · Петроград         Типография имени Ивана Федорова, Звенигородская 11. Петрооблит 6030. Тираж 2000. Гиз. № 6287

Gegen, the most important figure in Mongolian Buddhism, and his wife, Dondogdulam (1876–1923).[32] These almost photographic images, in which the Bogdo Gegen is treated as a real person and not a saint, were completed around 1912 and provided Sharav with additional commissions. He had been exposed to photography in the late nineteenth and early twentieth centuries, and these portraits, as well as one of the Green Tara or Avalokitesvara, show its influence on him – that is, painting realistic depictions of people.[33]

He earned great public recognition with his painting *One Day in the Life of Mongolia*, a large kaleidoscopic and secular work that sought to encompass as much as possible of Mongolian society.[34] It requires numerous views of the painting, which was produced in the traditional Mongolian style, or *zurag*, to observe the milking of animals,

the fleecing for felt, the castration of young animals, the lassoing of horses, the branding of cattle, the mowing of hay, the sexual intercourse and the performance of rituals.[35] About three hundred people are working, playing and resting in this remarkable work, which reveals Sharav's anthropological imagination. During the period between 1912 and 1915, Sharav also executed *One Day, Koumiss Festival* (another secular work), *Green Palace, White Palace* and *Lhasa*.[36]

Despite Sharav's eccentricities, his fame and his willingness to produce posters provided greater legitimacy to the newly formed communist government that took power in 1921. Apparently brought up as an only child, he moved as an adult to the capital city of Urga, certainly not a booming metropolis at that time but more populated than his native region. Here he earned his keep by painting

86
**B. Sharav**
*Japanese Imperialists and Their Allies*, early 1930s

Buddhist works for the lamaseries. He was self-taught and his talent was quickly recognized, but contemporaries found him odd. He frequently did not wash, would on occasion disappear, and would not accept commissions from 'people he did not like'.[37] Adorning himself in Tibetan outfits, he would visit the Tibetan lamas, gamble and lose his money, and then return to his original lamasery to paint Buddhist images in order to survive. The fashioning of Buddhist objects provided him with income until he took up the communist cause. Nonetheless, even after the success of the communist movement, he continued to seek supplementary income beyond the posters he produced for the state. Thus, in the early 1920s, he painted a portrait of Lenin (1870–1924) and in 1930 of Sükhbaatar (1893–1923), the first leader of the communist revolution. Even more unusual, in 1937 he illustrated a Mongolian translation of Daniel Defoe's *Robinson Crusoe*.[38]

Sharav produced some of the earliest Mongolian posters, which focused on defending against and identifying the exploiters of the previous social system and portraying the new government in a positive light. Playing cards, which portrayed the lifestyle of Mongolians, served as examples for him. They often depicted social injustices and exaggerated, to an almost grotesque extent, the features of the powerful and despised. Another influence derived from dice with depictions of animals, often symbolizing the oppressed and the oppressor. However, later posters reflected different themes and objectives. A historian of posters in the Soviet Union has written that,

*As . . . ideological perceptions and understandings changed, so major cultural elements also changed. The regime's message was not static but was a dynamic and developing stream . . . when policy changed, the symbols and their meanings may also have had to change.*[39]

Similarly, the Mongolian communist government changed its objectives as it moved from one stage to another. The posters that the Communist Party, known as the Mongolian People's Revolutionary Party (MPRP), the government and local organizations commissioned were required to reflect the new policies. Mao Zedong had argued that artists had to meet the people's needs, as defined by the Communist Party, but the interests of the population frequently shifted in each successive period. Mongolian poster artists faced the same instructions from the state and government.

Because the MPRP and the new government, which were on shaky grounds in the early 1920s, still faced opposition, they demanded that artists educate the population about its enemies.[40] The Buddhist monasteries, the country's wealthiest institutions, were natural targets. In addition, a significant portion of the population was hostile to the lamas, and Sharav and his fellow artists capitalized on such resentment to portray the clergy as avaricious, ignorant and taking advantage of the population's credulousness. The late Joseph Fletcher noted that 'There was little that ordinary Mongols could do to protect themselves against the growing exactions that banner princes, *monasteries*, and Han [Chinese] creditors imposed upon them.'[41] The late Larry Moses offered this devastating

appraisal: 'The Church, its dogma, and its officers were responsible, in part, for the illiteracy, poor health, and poverty of the population . . . Every Mongol recognizes the venality of the lamas and the parasitic nature of the organized church.'[42]

Abiding by the instructions of the new government, Sharav, who now worked at the capital's first printing plant, produced two posters showing the monks' destructive influences. In the first (illus. 81), a huge and greedy Buddhist monk dwarfs every other figure and is shown literally swallowing up the country's resources through demands for tribute.[43] Tiny depictions of men leading carts pulled by oxen and sheep, as well as camels loaded with goods, head straight for the monk's mouth. In the second poster (illus. 100), the monk's mouth has been locked shut and a caravan with goods and animals moves away from him.[44] The inscription on the second poster reveals that the Mongolian government and the Mongolian People's Party (eventually the MPRP) had reduced the tribute accorded to the monasteries by a third, a policy Sharav approved and for which he praised the communist government. Paradoxically, despite the communist attacks on Buddhism, its images and art, which conveyed its religious message, may have served as a model for the use of images to transmit the communist message.

In any event, the images on the poster can be readily understood. The central figure wears the yellow robes and prayer beads that identify him as a monk, and the buildings in the background are clearly monasteries or temples. The caricature of a monk shows him as a grotesque and evil individual.

The ordinary Mongolian easily comprehended the meaning of the poster. Yet Sharav, whose mastery of the traditional Uyghur script used for the Mongolian written language was limited, apparently commissioned a calligrapher to describe the scenes in detail.[45] These inscriptions seem to attest to Sharav's desire to appeal to both the small group of the educated and to the illiterate part of the population. The literate naturally could recite the inscriptions out loud to those unable to read and thus bolster the themes presented through Sharav's visual images. To be sure, his ideas are sometimes crudely presented, but the posters' colourfulness and charm often outweigh the somewhat simplistic themes. There is some evidence that his sketches were sent to Petrograd (until 1914, St Petersburg, and after 1924, Leningrad), where Russian professional artists may have reworked a few before printing them, but his role should not be minimized.[46]

Sharav also had inscriptions placed on posters caricaturing other enemies, including noblemen and officials. In illus. 82, he depicts an aristocrat in almost the same posture as his portraits of monks in illus. 81 and 100. The greedy and all-powerful nobleman is as huge and grotesque as the monks and, similarly, dominates the scene. He is shown commandeering the property of the people in his territory and orders his henchman to beat those who cannot provide the tribute he demands. Ordinary people have their heads bowed and appear to have accepted their dreadful fates. One part of illus. 83 shows an obese judge crushing tiny representations of human beings in his hands, colluding with

below, top:

87
**Anonymous**
*Mongolians Joining Mongolian
People's Party*, mid-1920s

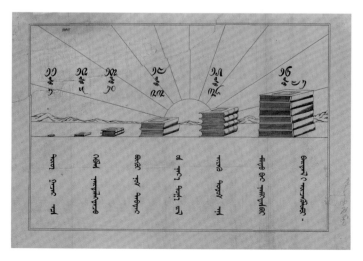

aristocrats to rob ordinary humans of their hard-earned cash, and having his servants beat and torture a pathetic lower-class man. The other section offers a striking contrast by depicting three senior and honest-looking officials who adjudicate a case without using torture or accepting bribes. A similar construction may be found in illus. 84, which again is composed of two frames. In one half of the poster, the ruler's men carry sizeable bags on their horses, representing the taxes they had evaded in the old system while the poor had onerous burdens placed upon them. In the other frame, tax officials, having learned that all Mongolians, including the wealthy, would pay taxes based on their incomes and revenues, head home proudly to inform their people about the new government's more positive policies. The government would be more equitable and would relieve the ordinary people from unjustly having to pay all the taxes.[47]

Sharav and other poster artists then turned to foreign interventionists and aggressors.[48] The 1911 collapse of the Qing dynasty, which had controlled Mongolia since 1691, generated political instability, which foreigners took advantage of. Conflicts among Mongolians precluded unity and allowed foreigners to seek influence or control. Again working in two frames in illus. 101, Sharav first portrays a Chinese man and Baron Ungern-Sternberg, a White Russian (or anti-Bolshevik), as dogs joining and, on occasion, fighting with Mongolian monks and nobles as they jump on the prone body of the Mongolian people. The resolute soldiers of the Mongolian People's Party, with the assistance of the Soviet Union, appear in the second frame and

left, middle:

88
**Anonymous**
*Mongolians Joining Mongolian
People's Party*, mid-1920s

left, bottom:

89
**Anonymous**
*The MPRP Promotes Literacy*,
late 1920s

force the Chinese, Ungern-Sternberg and the Mongolian monks and nobles abjectly to flee in terror.[49]

In illus. 85, Sharav again lambastes China, which seemed to be Mongolia's most dangerous enemy. His portrait of a Chinese man is similar to his depictions of Mongolian monks and nobles. The Chinese in the poster is huge, totally out of scale and ominous. Holding weapons in his hands, he threatens the unprotected Tibetan peoples. The hammer and sickle at bottom left and the Buddhist image at top left signal the correct path for Tibetans – that is, collaboration with the Mongolians, fellow Buddhists and the Soviet Union, the centre of the proletarian revolution, which would prevent the Chinese from annexing Tibet.

At that time, Mongolia actually faced greater threats from Japan, and Sharav turned his attention to the growing militarism of his overseas neighbour. Yet again, illus. 86 is divided into two frames, and yet again in the first frame, a sizeable Japanese soldier leads fierce dogs representing White Russians and reactionary Chinese to crush Koreans and ordinary Chinese. Sharav's use of dogs reverberated with and made an impression on the nomadic pastoralists because 'The dogs of Mongolia are notorious, and every traveler has dramatic stories about the ferocious Mongolian dogs kept around the camps for protection and assistance in handling the animals.'[50] In the first frame, the Japanese soldier attacks Russians and Mongolians, but in the second frame the combined forces of the Russians, the Mongolians, the Chinese and the Koreans kill his dogs and shoot him down in the ocean separating Japan and the Asian mainland.

90

**Anonymous**
*Rider Carries Reading Materials to the People*, late 1920s

## Posters and Counter-revolutionaries

Resisting the threats posed by belligerent foreigners, the MPRP is idealized in the posters. Its supposedly splendid reputation attracted former believers in the feudal system to join in its efforts to foster the interests of the Mongolian population. Yet the MPRP had to be on its guard; posters often portrayed monks and nobles, especially the latter, who joined the revolutionary groups but sought to spread false rumours about them and to subvert the MPRP. The poster artists appeared to be confident that these renegades would be discovered and killed. The government may have commissioned such themes in order to justify the first of the Mongolian purges. The state executed D. Bodoo (1895–1922), the first prime minister of the new regime, and several of his associates, in 1922 and Danzan 'Khorloo' (1873–1924), the Secretary of the Central Committee of the Mongolian People's Party, in 1924, portraying them as traitors who worked for but ultimately sought to overthrow the Mongolian People's Party.[51] In both cases, the evidence against them was ambiguous and flimsy. The posters sought to bolster the MPRP claims, but many innocent men lost their lives in such purges.

However, many of the posters presented a happy ending. A few posters consisted of two frames, one of which would show civil servants smoking, drinking and relaxing instead of working.[52] The second frame provided the contrast of a conscientious official reading reports and writing up judgments. Even more optimistic was the depiction of the increasing number of people who had joined the Mongolian People's Party (illus. 87, 88). One noteworthy feature is that no women are included in the depiction of new Party members. The emphasis in the posters of scenes of conflict and war, or of officials, may explain the omission of women, but that females do not appear as members of a Party that professes to foster gender equality is strange and may reflect their actual limited positions in the Party.

## Posters and Education

Despite these omissions, the posters emphasized many of the traditional concerns of modernization and of communist governments, including dissemination of newspapers, magazines and books as a vital means of influencing the literate group in the population. In illus. 89, the artist shows the spectacular increase of printed material fostered by the MPRP. The growth in the number of books and printing houses is illustrated in diagrams. The posters also attest to the considerable efforts to deliver the government's printed materials. For example, a man on horseback speeds along to deliver books, magazines and propaganda materials to the countryside (illus. 90).[53] Yet by the late 1930s, there were five newspapers in Ulaanbaatar, as well as movies and especially theatre, all of which were meant to contribute to literacy.[54]

The emphasis on books, magazines and newspapers accompanied campaigns for literacy, one of the most significant MPRP objectives. A higher rate of literacy would facilitate its propaganda efforts

1890

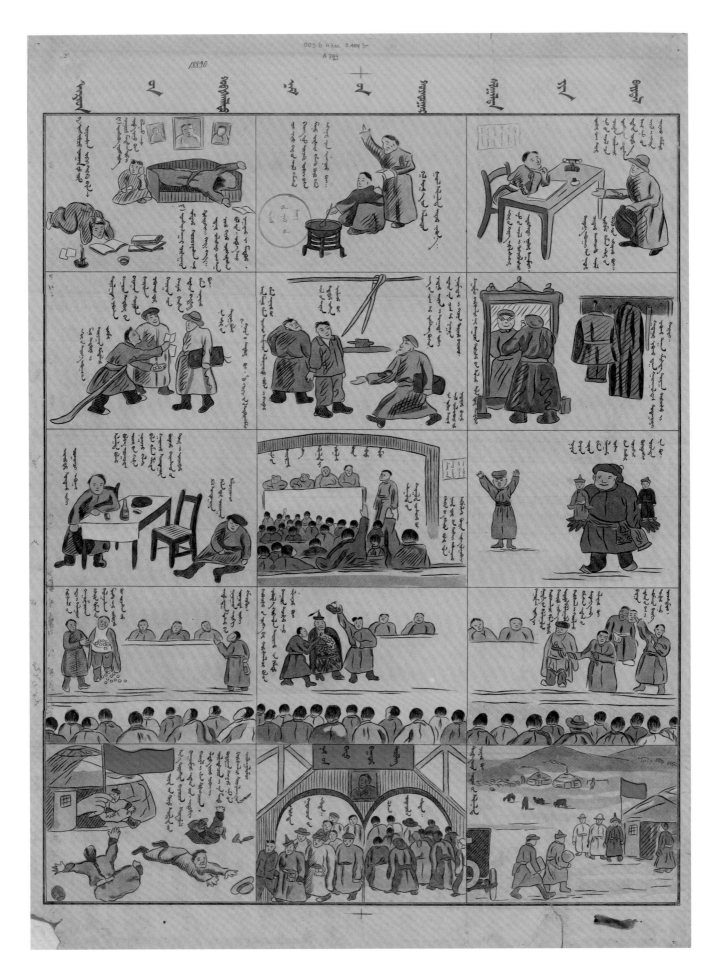

and its attempts to create a New Man with new values. At the same time, more educated herders and workers would more readily profit from printed technical materials relating to their employment, leading to greater output and more efficiency and productivity in the as yet rudimentary industries and in the more traditional and much larger herding sector of the economy. A significant increase in literacy had far-reaching consequences for the transmission of communist morality as well as for economic growth.

It is thus no accident that posters about literacy would be formidable assignments for artists.[55] In the 1930s, the rate of literacy concerned the Mongolian government, but it became a more pressing problem after the Second World War. In the late 1940s, five-year plans would be initiated in which the development of industry would be critical, and such modernization would require a more educated populace. Even after 26 years of communist rule, only 29.6 per cent of the population was literate, although the number of students and schools had increased. Whatever the precise numbers, the MPRP's ambitious plans for economic growth could be thwarted if only just over a quarter of the population had achieved basic literacy. It is important to keep in mind the concept of 'basic literacy' because the 29.6 per cent rate encompassed all who could read a page of simple instructions or text and not necessarily a sophisticated work with an elaborate vocabulary.[56] Advocacy for literacy and education needed to be attractive. Illus. 102 fits in with this requirement by showing a lovely young girl sporting a Young Pioneers red scarf and a red

bow and carrying a school bag, with her school represented in the background.

The inscriptions on the early posters were written in the traditional Uyghur script until the mid-1940s when both that script and the Cyrillic alphabet – which, under pressure from Russia, began to be used for Mongolian – were depicted. By 1945, because even the most literate Mongolians had had only minimal exposure to the Cyrillic alphabet, some of the posters, of necessity, used the traditional script. By the early 1950s, however, nearly all the inscriptions were in Cyrillic, placing Mongolia further into the Soviet cultural orbit. Numerous god-like portraits of Vladimir Lenin (1870–1924) and Stalin, the Soviet heads of state, at the top frames of posters (illus. 103) benevolently looking over a scene of prosperous Mongolia or as exemplars and supporters of the MPRP, reveal the strong links with the USSR. Depictions of Kh. Choibalsan (1895–1952), the Mongolian head of state, in association with Lenin or Stalin or alone, attest to the 'cult of personality' that would be condemned after Stalin's death.

## Support of Government Policies

A series of posters produced in the 1930s resemble ones from the Soviet Union in depictions of villains. Illus. 91 consists of fifteen separate scenes that inveigh against poor attitudes and behaviour. The indolent, as well as women who use housework as an excuse for not reading, are castigated, as are those who fail to participate in Party work or are

91
**Anonymous**
*The Indolent and the Counter-revolutionaries*, mid-1930s

tax evaders. As in the Soviet Union, the Mongolian authorities were concerned about alcoholism and devoted considerable attention to its eradication.[57] Thus they commissioned posters relating alcohol to criminal behaviour. Other villains depicted in illus. 91 are fake revolutionaries, who included unreformed bureaucrats, old feudal nobles and new groups of capitalists. The significant heroic group portrayed in the posters is the Party Disciplinary Inspectors who ferret out these fake revolutionaries. Sketches are colourful and vivid and require little explanation. The viewer can easily identify alcoholics, anti-Party villains, backward thinkers and honest officials.

The MPRP often used visual images to bolster its policies. More revealing is the relatively small number of schools and students founded by the Ministry of Education by the 1930s. Most provinces or *aimags* provided few institutions for students, with the largest number amounting to

124 primary-school students. About one hundred students enlisted in foreign universities, principally in the Soviet Union and in Germany, and nearly all were learning foreign languages or at pedagogical universities learning to teach, along with six who went to art school. Few had as yet enrolled in universities to study in technical fields, such as veterinary medicine, engineering, mathematics or science, which Mongolia would require to foster economic growth. Several decades elapsed before Mongolians travelled abroad, mostly to the Soviet Union and Eastern Europe, to train in specialities that the country needed. Mongolia would not have its own university until 1942.[58]

Posters served to inform the public about government and MPRP policies, one of which was ever-closer connections with the USSR. Japanese expansionism in the 1920s and '30s and the threats it posed to Northeast Asia compelled the Soviet Union and Mongolia to forge formal assertions of

their links. In 1936, the two countries signed a ten-year mutual aid treaty by which an attack on one would be considered an invasion of both, and each would supply the other with weapons and other assistance but would withdraw from the other's territory once the danger had ended. They then signed a Treaty of Friendship. The treaties were copied in illus. 92, which could be readily circulated among the population. Because these posters were dull and could not be read by the large number of illiterates, artists also created more enticing visual images of the bonds between the USSR and Mongolia. They included the typical images of Lenin and Stalin observing the handshake of a Russian and a Mongolian. In illus. 104, representatives of the two peoples with arms around each other hold aloft the Soviet flag, with a red star above a hammer and sickle, and the Mongolian flag, again with a red star above the national symbol, the Soyombo, an indication of the unalterable friendship between the two peoples.

**The Second World War and Patriotic Posters**

The onset of the Second World War provided artists with greater opportunities to create vivid images. In the summer of 1939, Soviet and Mongolian forces defeated an attempted Japanese incursion into Mongolia at the battle of Nomonhan (or Khalkhin Gol).[59] The Japanese made no further efforts to attack eastern Siberia or Mongolia, permitting the USSR to focus its attention, soldiers and weapons on the Nazis' invasion in

the West. Although Mongolia was landlocked and not critically involved in the Second World War, it supported the USSR with meat, horses, shoes and other goods.[60] Its artists joined in the propaganda efforts, portraying, as in illus. 105 and 106, heroes determined to defend the USSR and Mongolia against the Nazis and the Japanese.[61] Beautiful traditional calligraphy, in bright red ink, complemented the dramatic images of determined and patriotic soldiers and women.[62] The posters were generally upbeat and asserted that the combined forces of the USSR, the U.S. and Great Britain would destroy the Nazis: for example, the swords of the three Allies are shown piercing and allegedly severing a Nazi soldier's spine.

Artists portrayed the Japanese as ruthless, wearing belts adorned with swastikas and holding blood-stained bayonets, burning *gers*, killing Mongolians and stealing their animals. Yet the united Soviet and Mongolian forces had decisively defeated the Japanese at Nomonhan, and now they would use their splendid cavalry forces to crush the Japanese and, at the same time, to prevent Mao and the Chinese from occupying the territory of their Inner Mongolian 'brothers'. These inspirational poster tableaux concluded with a remarkable image illustrating a poem by the renowned Mongolian writer and linguist Tsendiin Damdinsüren (1908–1986). Illus. 107 shows the head of a Japanese from which emanate snakes surrounded by the swords of the allies cutting them to pieces. Yet again a swastika adorns the body of the soldier.

Poster artists contributed to the war effort not only by inspiring the population but also by offering

92
**Anonymous**
*Mutual Defence Treaty,*
*USSR and Mongolia,* 1936

advice on weapons of war. They outlined specifics, with carefully drawn images, on the use of hand grenades and bayonets and the optimal methods of destroying tanks (illus. 108). At the same time, they provided instruction on defence in war, including the proper means of digging trenches, the discovery and deactivation of land mines (illus. 93), navigating with maps and compasses, training soldiers to follow commands and the ways medical specialists could treat patients on the battlefield. Precise pictures of rifles and machine guns conveyed additional information to both soldiers and ordinary citizens.

## Post-Second World War Concerns

The most important post-Second World War issue was recognition of Mongolian sovereignty. Neither the Chinese nationalist government of Chiang Kaishek (1887–1975) nor the communist government under Mao Zedong had accepted Mongolia as an independent country. In fact, Mao, in an interview with renowned American journalist Edgar Snow, had said that Mongolia would inevitably return to Chinese jurisdiction after the communist victory in China.[63] He repeated this observation in at least one other interview with a Western reporter.[64] The Soviet Union, the dominant foreign influence in the country, was thus eager for China to relinquish its claims to Mongolia. In February 1945, Stalin, recognizing that the American president Franklin D. Roosevelt (1882–1945) wanted the Soviet Union to declare war on Japan and to dispatch troops for a

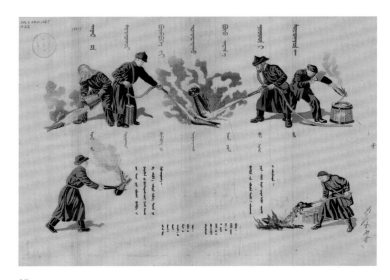

93
**Anonymous**
*Aid on the Battlefield*,
early 1940s

projected and protracted invasion, elicited U.S. support to pressure Chiang Kai-shek to allow self-determination for Mongolia in return for Soviet involvement. Roosevelt and Stalin's insistence compelled Chiang to accept a plebiscite for Mongolia.[65] The Mongolian government scheduled a vote on 20 October 1945 for what was a foregone conclusion – the Mongolian population's approval of independence rather than acquiescence to Chinese rule.

However, the Mongolian government and the MPRP did not want to take chances. They unleashed a major campaign to urge a vote for independence. Seeking to persuade the vast majority of the population, including workers, the elderly and soldiers, to vote, the government helped to issue a barrage of posters. For example, artists showed a happy family in their traditional *deels* in illus. 109, with the Soyombo, a five-pointed red star representing communism, and sheep and camels in the background, encouraging a vote for independence. They relied on nationalism and markers of national identity to promote their efforts to galvanize the population. One theme of this drive was that voting for independence supported the leadership of Sükhbaatar, the founder of the communist state, and Choibalsan, the current head of state. In illus. 110, a heroic-looking figure leads groups in the countryside to vote.

**Drive for Economic Development**

The end of the Second World War resulted in a significant shift from posters emphasizing patriotic themes to those stressing economic recovery and growth. Mongolian herders had supplied numerous animals and animal products to the USSR during its most difficult times in fending off the Nazi invasions.[66] The war had also precluded investment in new industries and the country still depended on a herding economy, with little cultivated agriculture or industry. As early as the 1920s, posters were produced that emphasized industrial expansion (illus. 111), with images of cranes and factories, yet few manufacturing complexes had been built. At the same time, invocations to herders to form collectives, in a campaign that lasted from 1928 to 1932, proved to be abortive. The post-Second World War period ignited a renewed effort to foster rapid industrial growth and to establish herder collectives (or *negdels*), and posters played a role in these vital campaigns.[67]

The development of animal husbandry had to be the first step because it would generate profits and then investment in other sectors of the economy. The government exhorted herders to be more productive in the interests of the entire nation. It pleaded with them to shear sheep and goats carefully to avoid loss of wool and cashmere. Encouragement to the herders was insufficient, as they needed practical advice. To Wang, a colourful figure in the nineteenth century, had written a manual for herders, and J. Sambuu, the Mongolian Ambassador to the USSR during the Second World War and Chair of the Presidium of the Parliament starting in the 1950s, had also written such a guidebook based upon the best practices.[68] Later, in the 1980s, the renowned herder Ts. Namkhainyambuu

would write his own manual.[69] Such comprehensive texts did not receive wide circulation, and would not have been useful for herders, most of whom remained illiterate. Lively and colourful posters could transmit information more effectively. The government thus commissioned artists to provide simple advice for the herders. Protection of the newborns was one of the artists' main themes, and they wrote helpful guides, with images of men and women fixing up pens and barns as living quarters for newborn animals to protect them from the bone-chilling Mongolian cold and wind (illus. 112). Success was characterized by a smiling woman feeding a lamb and by fulfilment of the quotas of newborns mandated by the authorities (illus. 113). Also vital was adequate preparation of hay and fodder in summer and autumn (illus. 114) and proper allocation of these life-saving grasses throughout the winter. The results would include horse carts and trucks transporting abundant piles of hay (as in illus. 94).

Neither the government nor the poster artists ignored agriculture. Herding was central to the economy, but the state authorities had determined that Mongolia should seek to grow its own grains and vegetables in its limited cultivable lands. Eventually, they would organize state farms to foster agriculture, which would be modelled on the 'Virgin Lands' programme initiated by Soviet premier Nikita Khrushchev (1891–1971).[70] Even before the state farms movement, the authorities had encouraged proper mowing, which they claimed had led to a 130 per cent growth in production from 1940 to 1946. The authorities also paid attention to hunting and highlighted progress in fur production, with one poster showing a hunter holding several pelts (illus. 115).

Like the posters they produced on herding, the poster artists offered practical advice on farming. They show techniques of ploughing, with tangible images, and caution farmers not to delay in ploughing in spring. Illus. 116 shows the proper row-planting of cabbage and the need to kill moths, also pictured, which are threats to the plant. The farmer at the top of the poster holds two cabbages that appear larger than he is, a bit of artistic licence. Illus. 117, 118 and 95 depict the proper procedures for growing carrots, turnips and potatoes, including planting, harvesting and the use of animal manure. Small pictures portray the various steps. The artist shows both men and women working in the fields.

Transportation of food from the countryside, including animals and animal products as well as vegetables, is another theme of poster artists, who present images of a variety of animals carrying goods slated for towns and cities. Ox carts and camel carts are portrayed. Artists also depict horse carts and assert that many in so-called feudal times mistreated horses, undermining both transport and communications. They point out that horses were vital to the speedy transmission of messages, with riders using relay stations to obtain fresh horses and thus to move expeditiously. Nonetheless, as the economy developed, trucks would replace animals as conveyors of products.

94
**Anonymous**
*Surplus of Hay*, late 1950s

95
**Anonymous**
*Proper Ways of Farming*,
early 1950s

## Health and Physical Conditioning

In the post-Second World War period, poster artists became concerned not only with the economy but with the good physical condition of individuals.[71] Thus they prescribed the proper ways to sprint and to run long distances, which strengthened muscles and promoted circulation of the blood. They also depicted other athletic endeavours such as the long jump (illus. 96), high jump, discus, shot put and parallel bars. These posters may have originated with the state's desire to train athletes who could compete in Asian and international contests. Success in such competitions permitted the state to promote nationalism and to imply that communism contributed to such victories.[72] Another unusual note is that the athletes portrayed in the posters are exclusively male. Whether other posters showing women taking part in such activities were produced would be worth researching.[73]

Other public health posters in the post-Second World War period proved invaluable.[74] Because infectious and parasitic diseases had taken heavy tolls both in the countryside and in the cities, the government had instituted a campaign about hygiene once the war had ended. As part of the campaign, poster artists drew scenes illustrating ways of preventing typhoid fever, tuberculosis and tapeworm. These very vivid and colourful depictions complemented the visits and work of travelling teams of public health workers. Artists emphasized cleanliness and a healthy living environment. They urged herders and showed them how to dig toilets and to dispose of garbage

96
**Anonymous**
*Physical Activity and Health*,
early 1950s

and the corpses of dead animals away from their *gers*, and warned them to ensure that their children be kept away from swamps and ponds, to avoid washing clothing near wells for drinking water, to wash kitchen utensils and pots and pans with hot water, to air out mattresses and to wipe all furniture, among a plethora of useful advice. Illus. 119 shows young and attractive parents setting a good example by taking baths, brushing their teeth and wearing clean clothes. Still another lovely poster (illus. 120) pictures a healthy young boy and girl having their hair and bedding inspected for lice.

Artists also emphasized the individual's public responsibilities. The highest values were donations of blood to save others and support of the Mongolian Red Cross, which helped everyone in emergencies. Other posters proposed expanding the number of hospitals and an increase in government investment in kindergartens and museums to promote the cultural exposure and health of the 'beloved children'. Such advances in public health and medicine would translate into the creation of a stereotypical family scene (illus. 121), with a beautiful landscape in the background, each member with a joyous appearance, the little girl carrying a doll and the little boy hanging on to his mother.[75]

## Posters, Nationalism and Internationalism

Posters concerning specific government campaigns were also produced. The state supported North Korea during the Korean War of 1950 to 1953 and thus commissioned posters that reflected opposition to U.S. involvement. In illus. 122, a North Korean soldier with an exaggeratedly large rifle is shown crushing a U.S. soldier who seems to be about to use his knife to harm a child. The bottom background depicts buildings destroyed in U.S. bombing. The top background depicts Kim Il Sung (1912–1994), the Korean president, as an inspirational figure. Another foreign relationship in which artists were enlisted was the Sino-Soviet dispute that flared up in the communist world from the late 1950s until the mid-1980s. By the early 1960s, Mongolia had chosen to support the USSR and expelled Chinese workers and rejected Chinese economic assistance. A propaganda war ensued between Mongolia and the USSR on one side and China on the other. Posters played a role in the struggle. A typical one (illus. 98) shows a red flag proclaiming the unity of the socialist countries with a weapon labelled 'the Mao dictatorship' shooting at the flag. Less controversial and less violent was a 1947 poster providing statistics for the production of coal in the Nalaikh coal mine and planning for an increase (illus. 97).

Perhaps the proudest moment in Mongolia was the launching into space in 1981 of a Mongolian cosmonaut, Jügderdemidiin Gürragchaa (b. 1947), in a Soviet spaceship, an event commemorated in numerous colourful and cartoonish posters. For example, illus. 99 lauds the 'Wings of Friendship' between Mongolia and the USSR, and a depiction of a rocket ship dominates the design.[76] Many posters during this time highlighted the flags of both countries, the Soyombo with the red star on top representing Mongolia and the hammer and sickle the USSR. Bright reds, yellows and blues

and a light brown dominated the posters and revealed the 'people's pride' in having a Mongolian on the cutting edge of exploration. Indeed pride recurs as a theme in many of the posters, and it may be appropriate to end by discussing a poster (illus. 80) that proclaims the rise and prosperity of 'our beloved nation, Mongolia' and depicts a Mongolian riding swiftly on horseback, the abiding image of the Mongolian people.

Pride and nationalism aside, the USSR's influence on Mongolian posters cannot be ignored. Soviet posters appeared first, and their techniques and themes affected Mongolian versions. Mongolian artists naturally introduced their own variations and emphasized themes relating to herding and other specific Mongolian practices and traits. Yet many Mongolian artists received their training in the USSR, and some of the early Mongolian posters appear to have been printed in Russia. Like the Soviet introduction of Western-style ballet and opera into Mongolia, Russians contributed significantly to the development of Mongolian poster art.[77]

**Transmission of Posters**

Transmission of these posters with their striking images in a country of such a wide expanse and limited roads, and other impediments to travel, posed significant logistical problems. For much of the twentieth century, few cars ventured into the countryside, and certainly not into the more remote areas. To be sure, distribution and displays of posters in the capital city of Ulaanbaatar and in a few

top:

97

**Anonymous**

*Coal Production Increase*, early 1960s

bottom:

98

**Anonymous**

*Our Soviet Older Brothers and Maoist Excesses*, early 1960s

**Anonymous**
*Mongolian Cosmonaut,*
early 1980s

industrial centres such as Darkhan and Erdenet did not encounter major obstacles. The arrival in 1930 of a more sophisticated German-made offset printing machine from Shanghai also added immeasurably to the quantities of posters that could be produced, presenting greater opportunities for the dissemination of these materials.[78] Posters could be hung in factories, offices and other workplaces, hospitals and classrooms, on the fronts of buildings, on walls and in meeting rooms.[79] Images could be reproduced in newspapers and magazines and on stamps and postcards.[80]

However, the herders dispersed throughout the countryside could not be easily reached. In fact, some communist leaders blamed the failures of the collectivization movement from 1928 to 1932 – which forced its abandonment – on the difficulties of purveying propaganda and 'education', including posters, about the advantages of collectives to the herders. The state did send so-called propaganda brigades to the countryside, and around 1940, one rural informant reveals that they exposed him to his first movie. He writes: 'I was seventeen or eighteen when I saw my first movie . . . The kino was called a shadow film. We thought there were people behind the screen.'[81] Another herder saw his first phonograph in the 1950s.[82] There was some contact between the cities and the countryside, but changes in rural organization in the late 1950s provided greater opportunities to influence the countryside population.

In the mid- to late 1950s, the establishment of state farms for agriculture and of cooperatives (or *negdels*) for herding facilitated efforts to transmit state and communist propaganda. Many of the *negdels*, which had hundreds or thousands of members, built 'cultural palaces' in the central offices for theatrical performances, movies and libraries and, as perhaps the most renowned founder of a *negdel* remarked, 'Whenever possible there was art in the auditorium.'[83] Wall newspapers, which consisted of articles, posters and announcements, were displayed in these same *negdel* headquarters. Horse relays from Ulaanbaatar, as well as from provincial towns, arrived regularly in the *negdels* and brought mail, posters and government propaganda. An American anthropologist who spent considerable time in a *negdel* in the early 1970s wrote:

*The second method of party agitation and propaganda work . . . graphic presentations, is highly characteristic of Mongolian socialist life. In every productive enterprise in Mongolia which I visited, there were extensive displays featuring outstanding workers, highlighting plan targets and their fulfilment . . . Throughout the district, these displays are in the yurts [gers] of the team leaders . . . and at all official meetings and at many celebrations.*[84]

## The Decline of Poster Art

The end of socialism in Mongolia in 1990 had a dramatic impact on posters. In March of that year, the government, under pressure from demonstrations in Ulaanbaatar and the countryside, resigned, and called for the first multi-party elections in Mongolian history. Shortly thereafter, the USSR, which had been Mongolia's most important trading

partner and greatest provider of loans, collapsed, leading the government to adopt a market economy and to engage with the West, as well as with its East Asian neighbours and with Russia.[85] The non-socialist governments elected since 1996 have abandoned the didactic political messages that had been the basis of most poster art. They no longer use posters to convey propaganda or to initiate campaigns about public health, exercise and cleanliness. Moreover, new media, including television and the Internet, have become more pervasive and accessible and have replaced posters. Commercial advertisements have often been substituted for posters in public spaces throughout the country.

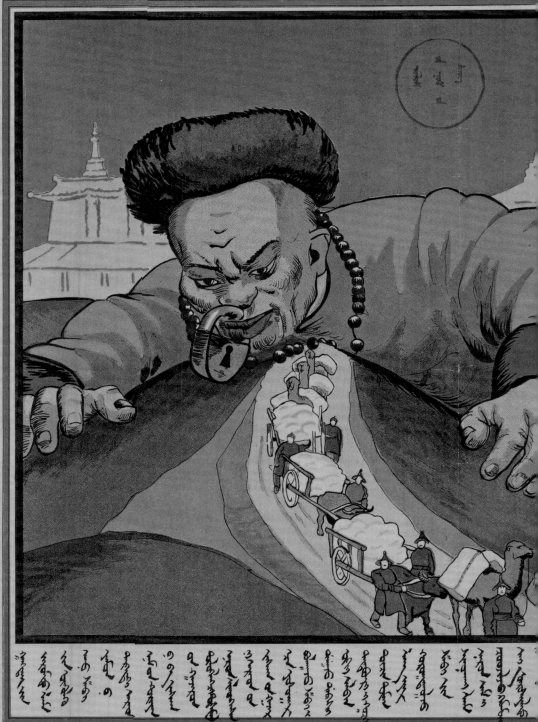

19693

Государственное Издательство · Петроград

Типогра

а Федорова, Звенигородская 11.   Петрооблит 6030.   Тираж 2000.   Гиз. № 6286

100
**Sharav**
*Mongolian People's Party*
*Controls Buddhist Monks*, 1924

101

**Sharav**
*Ungern-Sternberg and Other
Exploiters of Mongolia*, late
1920s

opposite:

102
**Anonymous**
*Growth in Number of Schools*,
late 1940s

# СУРГУУЛЬ БА СУРАГЧДЫН ӨСӨЛТ

... СУРГУУЛИЙН ХҮҮХДЫН СУРГУУЛЬ ХҮМҮҮЖ-
ЛИЙН ЧАНАРЫГ САЙЖРУУЛЖ, МАНАЙ ЭХ ОРНД
ЧИН ҮНЭНЧ БОЛОВСОН. БӨГӨӨД ЭРДЭМТЭЙ
ХҮМҮҮСИЙГ ХҮМҮҮЖҮҮЛЭН ӨГӨГТҮН!

МОНГОЛ АРДЫН ХУВЬСГАЛТ НАМЫН ТӨВ ХОРООНООС, ОКТЯБРИЙН НИЙГЭМ ЖУРАМТ ИХ ХУВЬСГАЛЫН 30 ЖИЛИЙН ОЙД ЗОРИУЛАН ГАРГАСАН УРИАГААС. УЛААН-БАГТОР 1947 ОН ШИРХЭГ 3000

ЛЕНИН-СТА...
НАМЫН УД...
ЖОЛООДЛОГОО...

**Anonymous**
*Mongolia's Elder Brothers Lenin and Stalin*, late 1940s

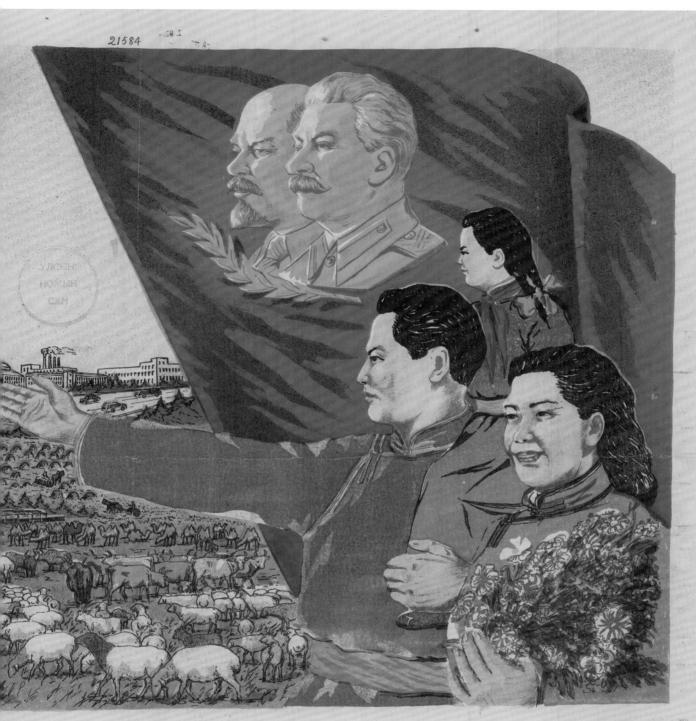

ІНЫ ТУГИЙН ДОР М.А.Х.
ДЛАГА, ЧОЙБАЛСАНГИЙН
ЮЦИАЛИЗМ ӨӨД УРАГШАА!

21612

Зөвлөл, Монголын ард түмний
их нөхөрлөл мандтугай!

105

**Anonymous**

*Patriotic Soldiers Defending
Country*, early 1940s

opposite:

104

**Anonymous**

*Friendship of Russian and
Mongolians*, late 1930s

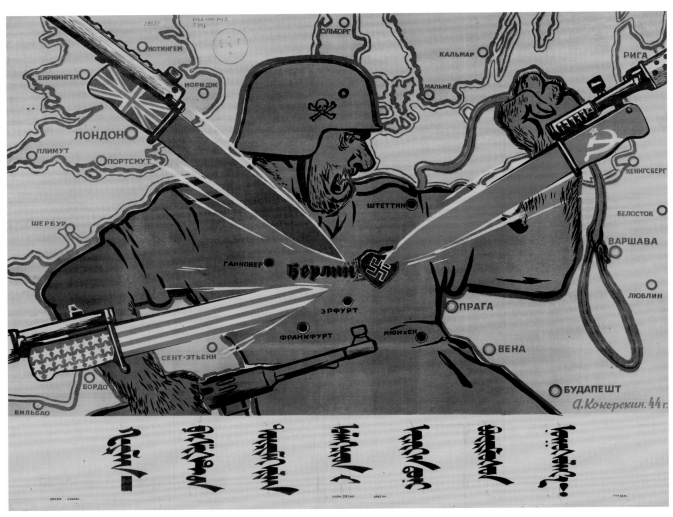

106
**Anonymous**
*Allies Destroying Nazis*, early
1940s

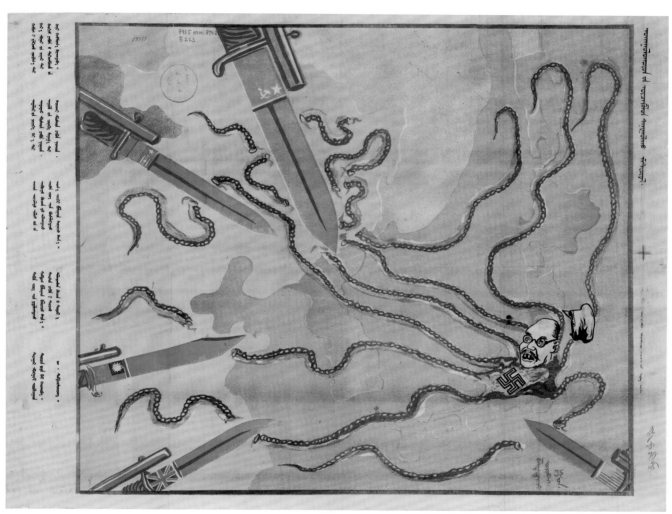

107

**Anonymous**
*Destruction of the Japanese
Snake*, early 1940s

109
**Anonymous**
*Vote for Independence*, 1945

opposite:

108
**Anonymous**
*Early Weapons of War*,
early 1940s

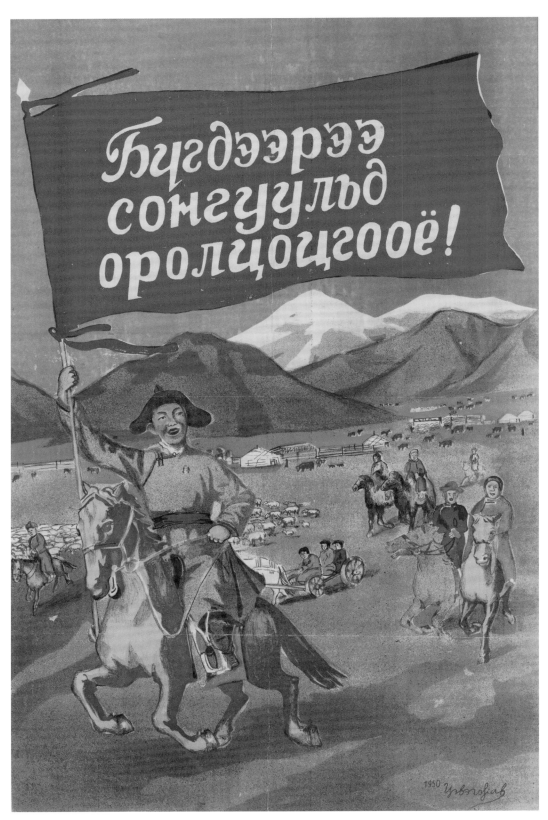

110

**Anonymous**
*Communist Heroes and
Voting*, 1945

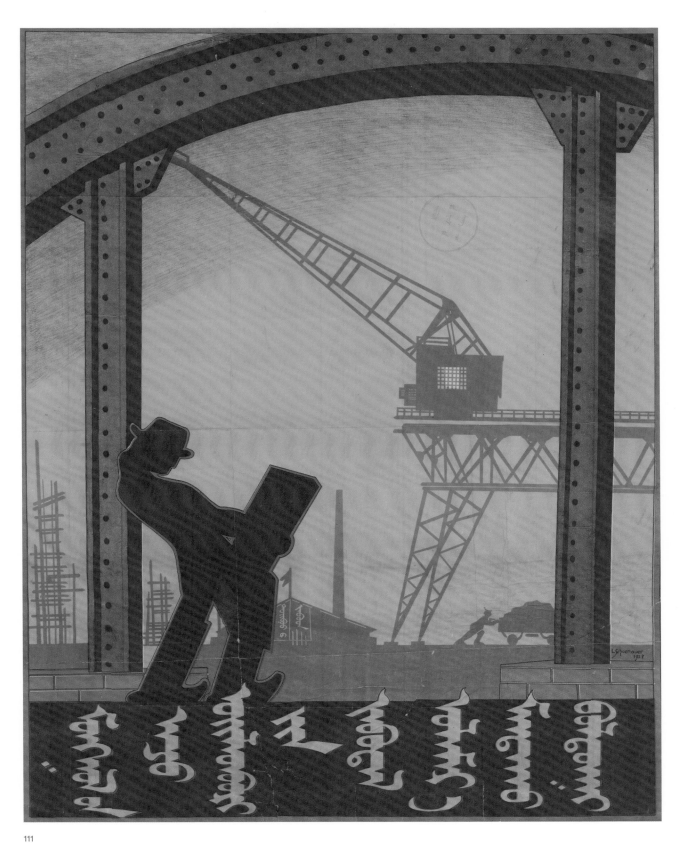

111
**Anonymous**
*Industry Rising*, late 1920s

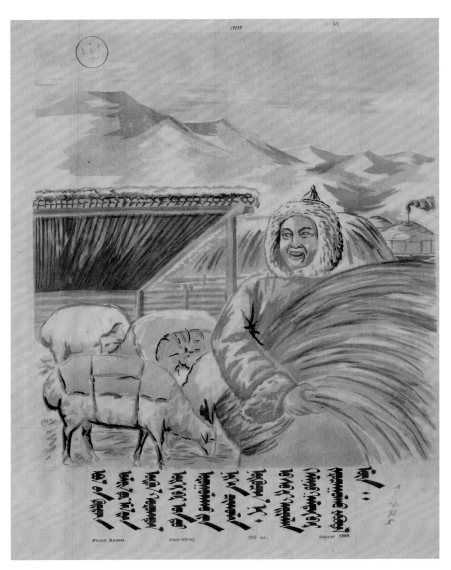

112
**Anonymous**
*Protect Animals*, early 1950s

opposite:

113
**Anonymous**
*Protect Newborn Animals*,
early 1950s

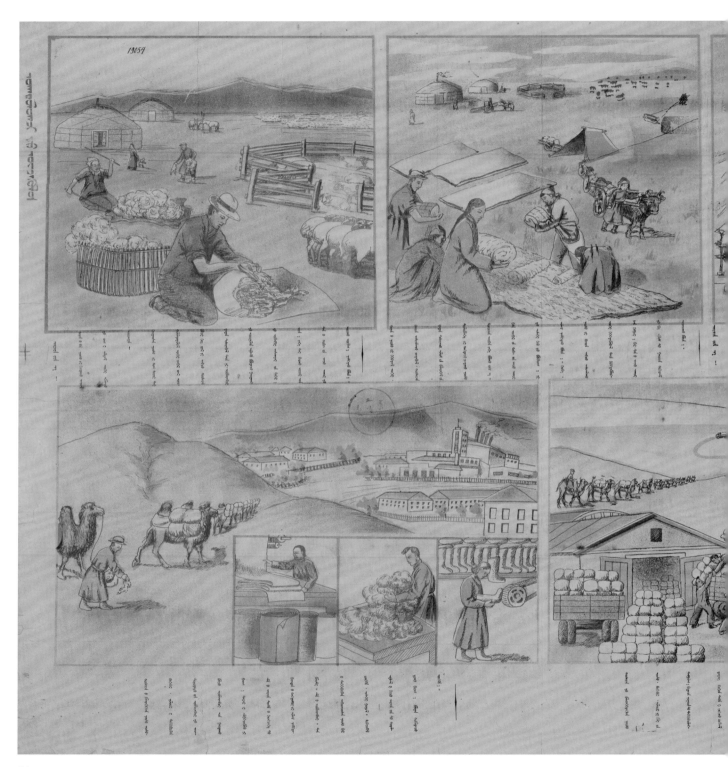

114

**Anonymous**

*Hay as Savior of Animals*, 1950s

115

**Anonymous**

*Heroic Hunters*, early 1950s

116
**Anonymous**
*Good Agriculture*,
early 1950s

117
**Anonymous**
*Proper Ways of Farming*,
early 1950s

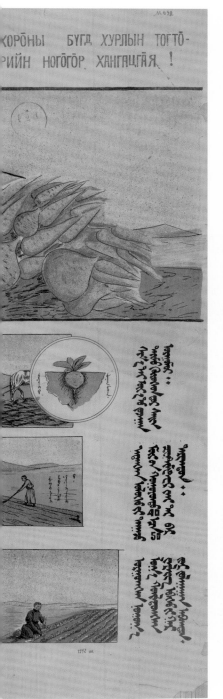

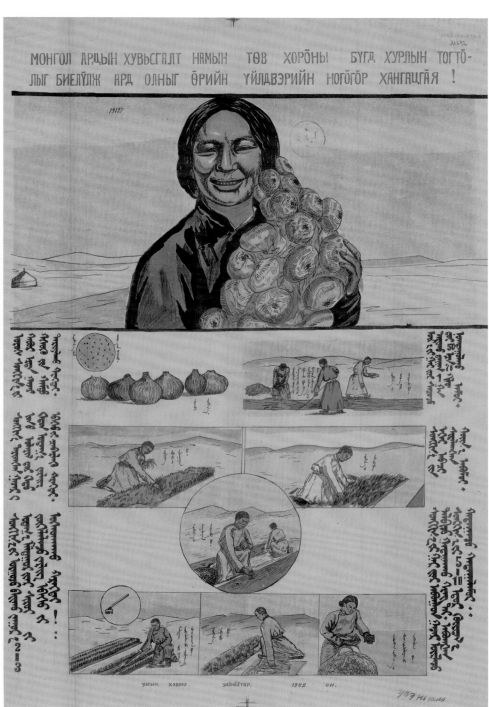

118

**Anonymous**

*Proper Ways of Farming*,

early 1950s

# ХҮҮХДҮҮДЭД БИЕЭ ХЭРХЭН АРИУН ЦЭВЭР АВЧ ЯВАХ ҮЛГЭР ЖИШЭЭГ ҮЗҮҮЛЭГТҮН!

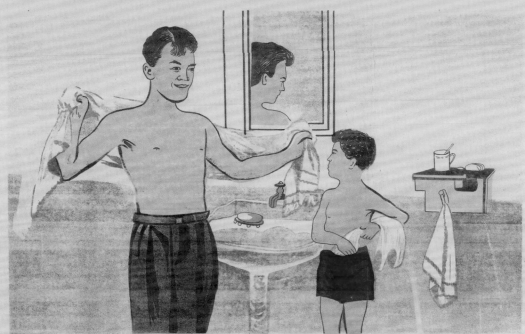

## ХҮҮХДҮҮДИЙГ ХУВИЙН АРИУН ЦЭВРИЙН ШААРДЛАГУУДЫГ ХЭРХЭН ЯАЖ БИЕЛҮҮЛЭХ ЯВДАЛД СУРГА!

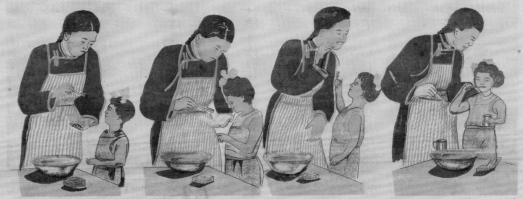

Сайн жишээ ба биеэр үзүүлэн таниулж өх явдал бол хүүхдээс боловсон байдлыг түргэн эзэмших явдалд тусалдаг юм.

119
**Anonymous**
*Good Health for Children*,
early 1950s

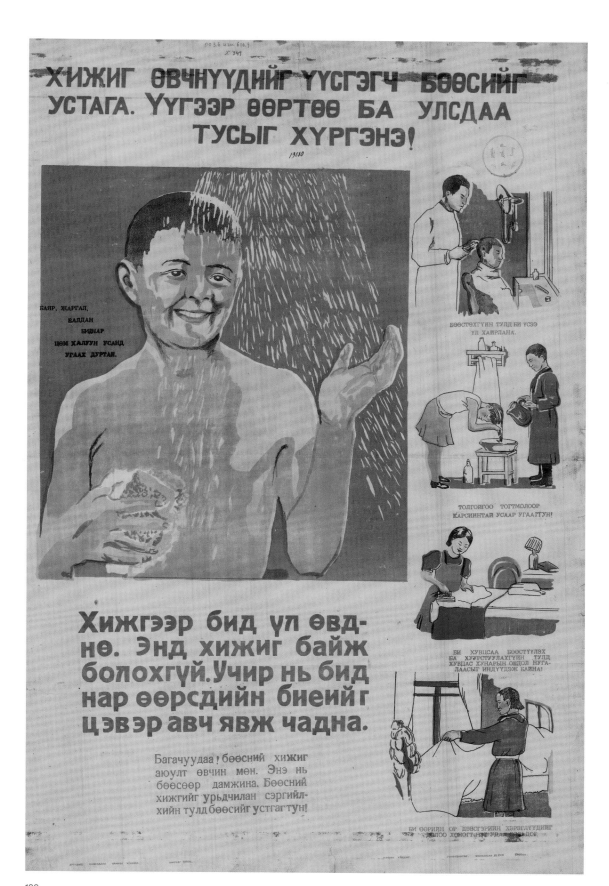

120
**Anonymous**
*Getting Rid of Vermin*,
early 1950s

121

**Anonymous**

*Happy and Healthy Family*,
early 1950s

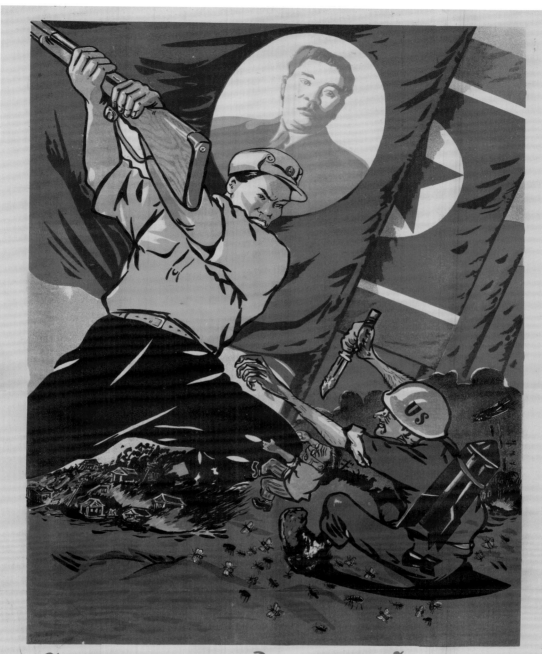

Солонгосын ард түмний тэмцэл
бол эрх чөлөөг хүсэгч улс түм-
ний тэмцэл юм.

122
**Anonymous**
*Support Our North Korean*
*Brothers*, early 1950s

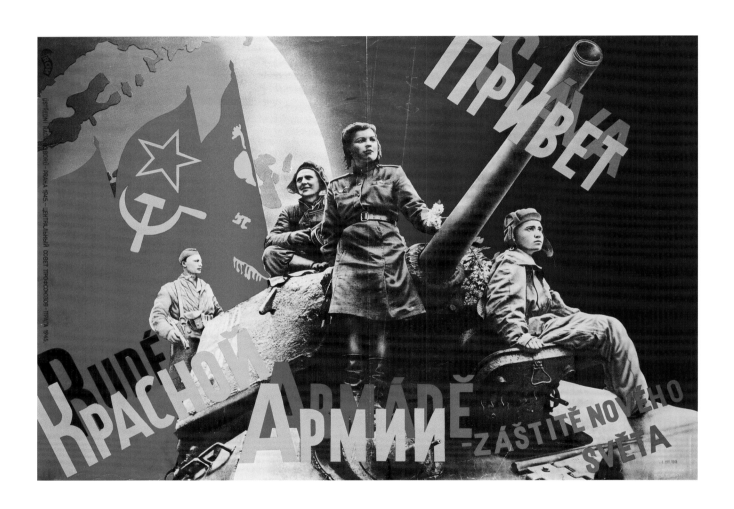

123
**Karel Šourek**
*Welcome to the Red Army –*
*Guarantor of a New World,*
1945

issued by the Central Trade
Union Council.

# 3 Eastern Europe, 1945–91

**David Crowley**

The Sovietization of Eastern Europe in the late 1940s introduced ways of organizing the economy, styles of political organization and roles for culture that were drawn directly from Stalin's Soviet Union. High on the list of Soviet imports was propaganda. The new regimes that took control of Poland, Hungary, Czechoslovakia and the other countries that formed the Eastern Bloc at Moscow's behest in the late 1940s took the political education both of those who flocked to the Communist Party (or its local variants) and of their citizens as primary tasks. School textbooks were written to follow the ideological lines being drawn by the new regimes; factory workers were given shop-floor lectures by Party activists; village halls were furnished with 'red corners' decorated with portraits of Lenin and Stalin framed by red fabric and pendants; the plots of movies bowed under the weight of their didactic messages; newspapers were vehicles for policy announcements; and streets were stripped of commercial ornaments, to be decorated with posters promising a golden future or warning against the dire threat posed by the enemies of the people. At the same time, close control of the media through censorship – as well as the suppression of political opposition – meant that (with the exception of Germany before tight East–West border controls were imposed in 1961) few, if any, contrasting voices

were to be heard. These measures were taken by the one-party state in the expectation of generating unflinching faith in Marxism-Leninism. For Polish diarist Leopold Tyrmand, writing in 1954, this state of affairs meant that ordinary citizens were losing their perspective on reality:

*It is hard to know whether they are aware of the horrific disproportion. Are their brains so muddled by outright lies and subtle shadings, so clogged up with the sludge of things left unsaid that they cannot put one and one together and miss the sum of the parts?*[1]

The poster was given a central role in the formation of these propaganda states. The new regimes that seized power at the end of the 1940s were quick to establish agencies which were charged with the production of posters with political and social messages. The scale of their operations was considerable. In Poland the Wydawnictwo Artystyczno-Graficzne (WAG/State Publisher of Graphic Art), established in 1950, commissioned, printed and distributed more than 4,500 poster designs in its first fifteen years of operation, sometimes in runs of more than 10,000 copies.[2] Even as communist rule started to fail, the poster remained a central – if increasingly anachronistic – tool of state propaganda: many of the political themes that had

been established four decades earlier, such as peace campaigns, opposition to American imperialism and anniversaries of momentous events, remained on the books. A 1983 brochure giving an official briefing on visual propaganda during the period of martial law in Poland – when the state imposed drastic measures on society to check the rise of the Solidarity trade union – could have been published 35 years earlier at the beginning of communist rule:

*An important element in visual propaganda is the unmasking of anti-socialist forces, as well as exposing such practices as intolerance, nationalism, chauvinism, and group and individual egoism, in addition to opposing the manipulation of people and revealing the role of enemy broadcasters and means of sabotage applied in the West to weaken the Polish state.[3]*

East Germany had its own forms of inertia. Unlike in Poland, Socialist Realism was still the official art of the regime there as late as 1988, when the last congress of the Artists' Association of the GDR (VBK/Verband Bildender Künstler der DDR) declared that, henceforth, the term would be replaced by 'Art in Socialism' (*Kunst im Sozialismus*).[4] Socialist Realism had had ideological currency for almost four decades, although what precisely was required of loyal visual artists shifted much over the years. In fact, the posters produced in the states of Eastern Europe under communist rule were often far more varied than the official rhetoric used to describe them. This short essay surveys their diverse and sometimes contradictory faces.[5]

124
**Jan Čumpelík, Jaromír Schoř and Alena Čermáková (aka Kolektiv č.s.č.)**
*The First State-wide Spartakiáda*, 1955

## Poster Engineers

Soviet posters were produced in Central and
Eastern Europe *before* the Soviet-backed authorities
imposed the full propaganda apparatus on their
client states in Eastern Europe. Or, to put this
another way, sympathetic poster designers imag-
ined Soviet power before it took full command. In
the immediate aftermath of war, some designers –
like many intellectuals in Eastern Europe – felt that
the rise of the Nazis in Germany had demonstrated
the weakness of democratic politics and viewed
the Soviet forces in Central and Eastern Europe as
harbingers of much desired social revolution. Karel
Šourek's 1945 poster, *Welcome to the Red Army –
Guarantor of a New World*, greeted the arrival of
Stalin's troops with its ringing slogan printed in
both Czech and Russian (illus. 123). In its dynamic
layout and use of montage, Šourek's design demon-
strates a familiarity with the modernist posters
produced by artists such as Alexander Rodchenko
in Soviet Russia in the 1920s. Before the Second
World War Šourek had been closely associated with
*Žijeme*, a modernist journal designed by Ladislav
Sutnar and published by Družstevní Práce (Coop-
erative Work). His 1945 poster – produced before
the dogma of Socialist Realism was imposed on
Czechoslovak art and literature – represented the
bright hope of the possibility of a revival of avant-
garde design in a new socialist state. Similarly, Filo's
(Ilona Fischer) *Every Hand Should Take Part in the
Rebuilding*, commissioned in 1946 by the Hungarian
Communist Party, was a reanimation of a central
motif in the photomontage posters created by

Gustav Klutsis in the Soviet Union at the time of
the first five-year plan (such as *Let's Fulfil the Plan
of Great Projects*, 1930, see Introduction, illus. 12):
the worker's hand, repeated photomechanically,
signals the combined power of the proletariat as
well as the task of post-war reconstruction (illus.
125).[6] Repetition and the flat planes of Filo's poster
achieved the kind of 'telegraphic' compression and
concentration of meaning that had been claimed
as being the essential character of the modernist
poster in the 1920s.[7]

The designs of Šourek and Filo belong to
the short period of fragile democracy in Eastern
Europe following the conclusion of the Second
World War. The consolidation of communist
authority in 1948 and 1949 was followed soon
after by a set of official diktats about the 'correct'
form and ideological content of culture.[8] Leading
writers, architects and artists were summoned to
national conferences to receive instruction in the
Soviet aesthetic of Socialist Realism, the principles
of which had been formulated at the first Soviet
Writers' Congress in 1934.[9] It hardly needs saying
that, in adapting to the requirements of Socialist
Realism, art in the newly formed Eastern Bloc
was now to be realist. But that did not necessarily
mean verisimilitude or faithfulness to the world
as it was experienced. In Poland in 1950, future
Minister of Culture and Art Włodzimierz Sokorski
explained the technique, employing the twisted
logic of Soviet 'Diamat' (Dialectical Materialism):

*The material power of our (the Party's) idea is its objec-
tive truth. The historical truth of our world determines*

opposite:

125
**Ilona Fischer (Filo)**
*Every Hand Should Take Part in
the Rebuilding*, 1946
commissioned by the Hungarian
Communist Party

the truth of art. *The deeply real truthfulness of our way of living, of our battles and of our victories, requires deeply realistic modes of representation. Truth, as a phenomenon, demands truthful reproduction. Indeed every deformation, whether intended or not, perpetuates an ideological deceit. Therefore art in the Socialist era can only be shaped by the methods of Socialist Realism.*[10]

Realism – for Sokorski (and other cultural commissars in Eastern Europe) – did not mean representation of the actual social and economic conditions of the country after war but understanding of the forces of history. To dwell on the problems and hardships of everyday life during the reconstruction years, for instance, was to show insufficient enthusiasm for the communist future. Socialist Realism was to prefigure the beauty and harmony of the utopia to come. At the same time, abstraction and other modernist 'errors' in visual art were ruled unacceptable because they tested the tastes of the working masses. Moreover, they also suggested individualism, a characteristic of the bourgeois artist. As the philosopher Stefan Morawski recalled, 'One . . . of the characteristic features of that time and trend was the effacement of individuality towards the realisation of a defined iconic and ideological programme.'[11] Visual artists were henceforth to be 'engineers of the human soul', working to state command.

The imposition of Socialist Realism in Eastern Europe closed the gap between the poster and the canvas, which the Soviet avant-garde had opened up in its embrace of montage and photomechanical techniques of image reproduction in the 1920s.

There was relatively little difference between Socialist Realist paintings and posters in subject or form: in fact, art historians have argued that the aesthetic was adopted precisely because of its simple-minded clarity and easy reproducibility.[12] *The First State-wide Spartakiáda*, a 1955 poster by Jan Čumpelík, Jaromír Schoř and Alena Čermáková (also known as Kolektiv č.s.č) is effectively a captioned reproduction of a painting by a cadre of artists who were best known for their monumental canvases (illus. 124).[13] Working as a team for the Military Art Studio (Armádní výtvarné studio), Kolektiv č.s.č.'s design promoted the mass gymnastic displays orchestrated by the authorities in Czechoslovakia. The athletic New Man which it depicts was just one figure in a cast of impossibly perfect stereotypes that included muscular Stakhanovites exhorting increased production, peasant sisters and their proletarian brothers embracing national unity and Polish or Czech workers clasping hands with their Soviet friends. These new heroes of socialism were invariably young, untainted by associations with the past: only the national leaders – each the subject of a personality cult – could display signs of age (illus. 126).

Socialist Realism was a banal and sentimental aesthetic that promised the future harmony of full communism. One zone of exception was formed by the posters representing Moscow's enemies. Here the kinds of visual distortion that could be achieved by photomontage or the grotesque expressivity of caricature were given seemingly free rein. It was as if the 'retrogressive' attitudes and 'reactionary' actions of what the ideologues liked to dub the

126
**István Czeglédi**
*Congress of Young Fighters for Peace and Socialism, June 17–18 1950*, 1950

ELŐRE A BÉKE ÉS A SZOCIALIZMUS
IFJU HARCOSAINAK KONGRESSZUSÁÉRT
1950. JUNIUS 17-18

warmongers of the West during the early years of
the Cold War allowed for the kinds of aesthetic
'distortion' associated with Expressionism and
photomontage. In this way, artists and designers
with long-standing allegiances to communist
politics *and* modernist aesthetics – such as John
Heartfield in East Germany and Bronisław Linke
in Poland – could be commissioned (illus. 127).

### The Polish Poster School

The first posters to break the mould of Socialist
Realism were produced in Poland in the mid-1950s.
Although state-controlled through censorship
offices and professional bodies such as WAG, the
Polish poster escaped the narrow track of Soviet
aesthetics. A number of Polish designers, such
as Wojciech Zamecznik, Henryk Tomaszewski and
Tadeusz Trepkowski (illus. 128), enjoyed interna-
tional renown for the designs they produced from
the early 1950s onwards. They were able to practise
as modernist designers with the patronage of the
state or, at least, indirectly with that of its cultural
agencies. As an example, Tomaszewski's poster
for René Clair's film *La Beauté du diable*, designed
in 1954 (after Stalin's death but before Nikita
Khrushchev's 'Secret Speech' at the Twentieth
Party Congress in Moscow in February 1956) and
commissioned by Centrala Wynajmu Filmów
(CWF), the central body for the distribution of
films in Poland, is strikingly simple (illus. 129).
This design, composed of a briskly drawn figure
reversed in silhouette and a green devil suggested

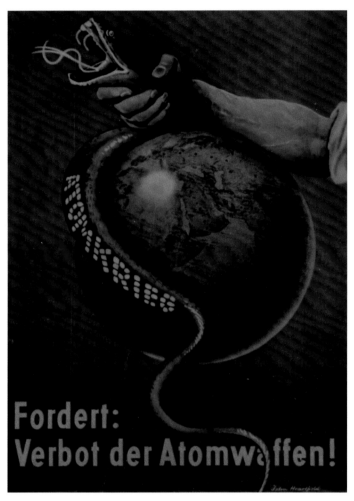

127
**John Heartfield**
*Demand: Ban Atomic
Weapons!*, 1955

issued by Deutschen Friedensrat

opposite:

128
**Tadeusz Trepkowski**
*Be Vigilant Against the Nation's
Enemy*, 1953

T.TREPKOWSKI 53.

Bądź
czujny
WOBEC WROGA NARODU

by loose brushstrokes, paid little heed to aesthetic dogma that called for 'positive types' or imagery that was 'national in form and socialist in content'. By contrast, other poster designers working at the same time bowed to orthodoxy by producing a host of Socialist Realist images.

How can this difference in an age of central command and control be explained? One answer would seem to be found in the relatively decentralized control over the commissioning of posters in Poland. Film Polski, the first national post-war organization responsible for the production and distribution of both Polish and foreign films, was established in 1947. It (and its successor organization, CWF) commissioned up to six hundred film posters a year in print runs of up to 100,000 copies. Despite the scale of its production, it tended to rely on a small roster of designers, including

Tomaszewski.[14] These designers produced many striking designs using techniques employed by the interwar avant-garde, such as photomontage. The consistent modernism of the Polish film poster would seem to suggest an active aesthetic policy on the part of those responsible for employing Tomaszewski. In 1957 Henryk Szemberg, the director of WAG, presented the readers of *Graphis* magazine with his explanation for the modernist character of the Polish film and theatre poster in the Stalinist period: 'This', he wrote, 'was primarily due to the attitude taken by the majority of poster artists who defended unflinchingly their own conception of art. In this they received support from personages in the political and cultural fields, who upheld the principles of creative freedom.'[15] This 'creative freedom' was extended by bureaucratic patrons (such as WAG, Film Polski and CWF) who

130
**Tadeusz Trepkowski**
*No!*, 1955

hand-painted banner based on his
peace poster on Marszałkowska
Street in Warsaw during the
Fifth World Festival of Youth and
Students

opposite:

129
**Henryk Tomaszewski**
*La Beauté du diable (Urok
Szatana)*, 1954

promoting René Clair's film
issued by CWF

offered Tomaszewski and his colleagues greater
liberty than they would have enjoyed designing
political posters, another field of design in the
command of more zealous apparatchiks. Perhaps
paradoxically, even within this zone of relative
freedom, it would seem that designers were their
own aesthetic and political 'police'. Relatively free
of direct censorship, the main poster publisher,
WAG, employed a committee of designers who, in
acts of self-censorship, could disqualify a poster
from production.

The 'Polish Poster School', as it has now become
known, was a professional elite of designers who
had the support of a significant lobby within
state culture. They were a privileged technocracy
who represented Polish design at home and
abroad. During the Fifth World Festival of Youth
and Students (V Światowy Festiwal Młodzieży
i Studentów) organized by the communist youth
organization (Związek Młodzieży Polskiej) in
Warsaw in 1955, for instance, Polish designers
were commissioned to deck out the ruined city
with massive banners that would illustrate the
event's theme, 'For Peace and Friendship – Against
the Aggressive Imperialist Pacts', and to create
temporary music pavilions that would accentuate
the festive atmosphere.[16] With 30,000 young people
from 114 countries gathering in the city, the festival
was recognized by the authorities as an important
opportunity to demonstrate the progressive face of
Polish socialism. The blind ends of broken terraces
were decorated with massive blown-up versions
of already published posters such as Tadeusz Trep-
kowski's *No!* (illus. 130). Picasso's *Guernica* (1937)

was reproduced as a public mural too, a powerful symbol not only against militarism but of the weakening hold of Socialist Realism on art in Poland. In fact, most of the blown-up posters decorating the city that summer owed much to the Spanish artist's lively calligraphic style of drawing, and to Henri Matisse's practice of decoupage.

Feted internationally, idiosyncratic designers like Trepkowski and Tomaszewski became public faces of the People's Republic of Poland. The state organized a number of travelling exhibitions of film and theatre posters from the late 1940s onwards.[17] The soft power politics of the Polish poster was stepped up when, in 1966, the first Warsaw International Poster Biennale was launched and then, two years later, when the Poster Museum was established in the former stables and riding school of a palace in Wilanów on the outskirts of the Polish capital. Architects Jarek Cydzik and Halina Kossuth designed a striking white-walled pavilion with a dramatic projecting roof over its courtyard, an amenable setting for abstract sculptures. Regularly exhibiting the work of artists and designs on both sides of the Cold War divide – not least within the framework of 'peaceful competition' offered by the International Poster Biennale – the museum's curators invariably championed modernist Formalism over Socialist Realism, and benign humanist themes over strident propaganda (whether for political visions or for the corporation). International stars Andy Warhol, Shigeo Fukuda and Armando Testa were given exhibitions in the Poster Museum as laureates of the biennale. Here, it seemed, was proof of the artistic *autonomy*

of the poster in the People's Republic of Poland, as well as evidence of the place of Eastern European designers in the international commonwealth of modern graphic design. However, the museum might well be characterized as a wing of what Hungarian dissident Miklós Haraszti was later to call the 'velvet prison' – the comfortable conditions in which visual artists were given studios, fees and opportunities to exhibit in exchange for compliance.[18] Abstraction – like the Op Art effects employed by Józef Mroszczak in his poster to announce the inaugural exhibition of the Poster Museum in 1968 – was effectively a mute aesthetic, despite the controversy which occasionally attached to it elsewhere in the Bloc.

### The Sleep of Reason

In the late 1950s younger designers associated with the Polish Poster School began to make a feature of out-of-date motifs and incongruous compositions in their designs. Roman Cieślewicz and Jan Lenica regularly incorporated Victorian imagery into their posters announcing theatre performances and film screenings (illus. 131, 147). Evidently indebted to Max Ernst and the Surrealists of the interwar years, their designs often hinted at violence and absurdity: fragmented bodies were collaged together to make ill-formed men and women; monsters were summoned up from frottaged surfaces. This was not just a Polish aesthetic: Czechoslovak designers in the 1960s also explored the shadowy corners of the unconscious. Designers Václav Zeman and

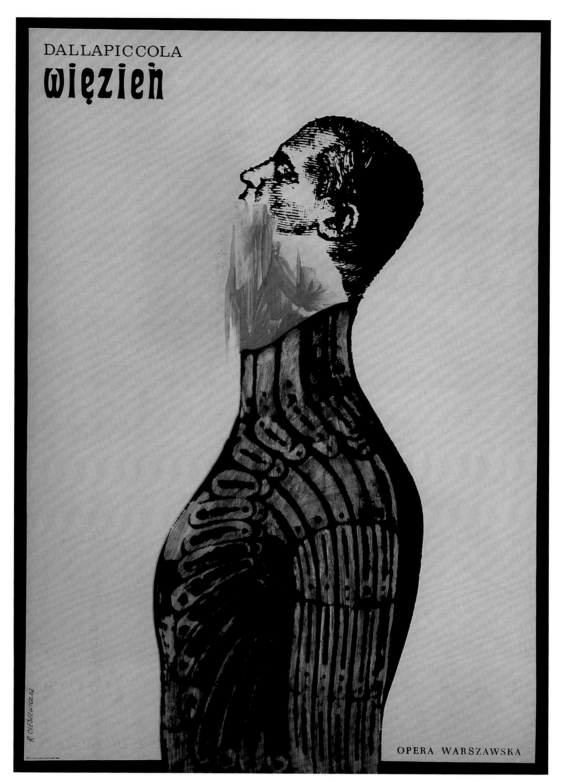

131
**Roman Cieślewicz**
*The Prisoner*, 1962

promoting a Warsaw Opera
performance of Luigi
Dallapiccola's opera *Il prigioniero*

Milan Grygar made a particular feature of the kind of unsettling collage techniques that had been developed by Dada artists during the First World War. Their designs for film and theatre posters were characterized by dizzying contrasts of scale and absurd combinations of images excised from historic and contemporary sources. The effect was often nightmarish, even when the poster was promoting a lightweight comedy or a saccharine romance (illus. 132).

In reanimating scraps of older images, these Czechoslovak and Polish designers seemed to be engaged in a kind of seance, conjuring up outmoded ways of living and being, and perhaps darker associations with death and destruction too. When, for instance, the film *Hiroshima, Mon Amour* (1959) was promoted in Western Europe, cinema publicity tended to emphasize the relationship of the two lovers. The full set of romantic clichés was put in place – smouldering gazes, romantic clinches. In his poster announcing the film in Czech cinemas, Bedřich Dlouhý – better known as an artist associated with the youthful Šmidrové group than as a poster designer – captured something much more menacing (illus. 133).[19] Like Lenica's designs in Poland, Dlouhý's 1963 poster revives the Surrealist technique of frottage. The grainy surface of a piece of knotted wood becomes a strange vertical landscape through Dlouhý's addition of tendrils and organic burrs. Such doodles represent nothing except, perhaps, the unconscious workings of the mind. In this device, Dlouhý captures the melancholic effects of traumatic memory – the theme of Resnais' film.

132
**Václav Zeman**
*Casanova '70*, 1967
poster for Mario Monicelli's film

For many critics in the West in the 1950s, the avant-garde character of Surrealism and its techniques had been fatally undermined by its spectacular qualities. It had given itself over too easily to the spectacle of Hollywood and Madison Avenue and, as a consequence, lost its antagonistic, critical effects. Writing of the fate of modernism after the Second World War, the Marxist philosopher Theodor Adorno claimed that 'after the European catastrophe, the shocks of surrealism have become impotent.'[20] While the aesthetics of these Polish and Czechoslovak posters might be dismissed as being out of date in these terms, it was precisely their anachronistic aesthetic which gave them significance. Self-consciously *démodé* and even nostalgic, they appeared at a time when Eastern European states were broadcasting their hold on modernity. During the so-called Thaw of the mid-1950s, when the communist authorities tried to slough off associations with Stalinism, science and technology were seized as the means by which to revive the communist project. In July 1956 the Kremlin announced its commitment to the Scientific-Technological Revolution, a programme that grew to encompass nuclear science, space exploration, cybernetics and computing. Future-orientated and logical, science could wash away the stains of violence and irrationalism from the recent past. In this setting, the deployment of old-fashioned images of bourgeois life, irrational monsters or broken bodies might – rightly – be understood as perverse.

133
**Bedřich Dlouhý**
*Hiroshima, Mon Amour*, 1963

poster for the Czechoslovak
release of Alain Resnais' film

## Socialist Advertising

Eastern Bloc states promised to overcome injustice by the rational and equal allocation of all the resources of society. The nationalization of industry and central planning of the economy would, according to the booming Party rhetoric of the late 1940s, eradicate venality and overcome poverty. At the same time, capitalism was accused of producing excessive desires and serving the selfish interests of the rich over those of the poor. Accordingly, one ideologue, Ignacy Witz, a painter and critic, writing in *Życie Warszawy* in the early 1950s, announced:

*Capitalist advertising posters do not convince, do not speak, do not teach: they simply scream. Our poster is a professional friend of the masses . . . The difference between posters of capitalist societies and those in progressive countries is like that between a lying, noisy trader and a cultured, whole-hearted advocate of the rights of society.*[21]

Striking a similarly shrill note, Zbigniew Lengren's poster *American Shoe Advertisement* (1952) depicts a barefoot man carrying a sandwich board promoting upmarket footwear (illus. 134). In reality, the reconstruction of production of consumer goods was a low priority in Eastern Europe during the Stalin years: anxious to serve their masters in Moscow, the leaderships in Prague, Warsaw and Budapest set out to boost iron, steel and coal production. The prospect of a third world war that would pitch the Eastern Bloc against the Western states

134
**Zbigniew Lengren**
*American Shoe Advertisement,*
1952

(vilified as the successors of Hitler) meant that national resources were used to build up war chests.

Even when Eastern Bloc states set out to improve the supply of consumer goods in the mid-1950s, considerable effort was put into managing popular expectations and desires. 'Socialist advertising', according to one East German guide,

*truthfully informs consumers about the real benefits of goods and services without the exaggeration typical of capitalist advertising. It does not manipulate consumers by trying to convince them that a given product offers additional benefits, such as an increase in prestige. Customers are given information intended to facilitate a fact-based purchasing decision. They should not allow themselves to get carried away by emotionally driven impulse purchases that they might later regret.*[22]

Rational and honest advertising would overcome the hollow illusions of commodity fetishism by educating consumers about the *correct* attitude toward things.[23] Moreover, as one 1956 Polish handbook for advertisers announced: 'Above all, it has to be made absolutely clear that the goals and the tasks of socialist commercial advertising are completely different to the goals and tasks of capitalist advertising.'[24]

Before the widespread take-up of television, the poster – along with the shop window, magazine advertising and packaging – was a key vehicle for socialist advertising. Its principles were sketched in broad terms in textbooks, journals and speeches delivered at conferences of advertising professionals. The first International Conference of Advertising Workers (Mezinárodní konference reklamních pra-

covníků), held in the International Hotel in Prague in December 1957, laid down three cornerstones of socialist advertising:

*Ideovost (political enlightenment) is the educational role of advertising. Enlightened trade points out useful features and benefits of the goods for sale and, in this way, expresses the socialist state's care for workers and consumers.*

*Pravdivost (truthfulness) of advertising lies in the fact that all information about quality and character, as well as uses, can be demonstrated.*

*Konkrétnost (concreteness) of business advertising means speaking to consumers in clear and persuasive language. In this context, formalism in artistic expression as well as slogans, which undermines the clarity and understandability of advertising is not acceptable.*[25]

How these mainstays translated into design was less than clear. For some commentators, the modernist principles of objectivity, asceticism, clarity and abstraction – associated with the so-called Swiss School of graphic design – provided the means for a new rational advertising.[26] Numerous designers in Poland, Czechoslovakia and Hungary worked in the Swiss manner in the 1960s. In 1967 Hungarian artist and designer Lajos Görög, for instance, was commissioned to promote the TT 695 Minivizor television, a portable set manufactured by the State Television and Radio Factory (Villamossagi Televizio es Radiokeszulekek Gyara) (illus. 135). Görög composed a poster in which the repetition and

opposite:

135
**Lajos Görög**
Advertising poster for the TT 695
Minivizor television, a portable set
manufactured by the State Television
and Radio Factory, 1952

153

136
**György Kemény**
*The Umbrella Dress*, 1969

dynamic scaling of the product's name emphasized its portability – its primary advantage. Eschewing persuasion or exaggeration, Görög's design offered an 'objective' representation of the commodity.

The strongest support for a rational approach to poster advertising tended to characterize it as an experiment in visual communication. For instance, Szymon Bojko, a prominent design critic in Poland and associate of WAG, was a vocal advocate for new research into perception and persuasion: 'We are surrounded by, and under the pressure of mobile and static images,' he wrote in 1965:

*Yet knowledge of the semantics of the image, of its informative structure, is still in a germinal stage, for it is the science of language that has hitherto developed most of all. But now non-verbal systems . . . are also being investigated. It can be expected that semiology will elucidate a great deal concerning the most basic signs of the poster . . . The undertaking of psychological research on the effectiveness of propaganda on the one hand, and the development of theory of visual communication on the other, will create more objective scientific bases for activity in the fields of posters.*[27]

A prominent ideologue as well as a keen champion of modernist design (then engaged in writing a study on the Soviet avant-garde),[28] Bojko offered an image of communication as a smooth transmission of a message to a receptive viewer. This was the Scientific-Technological Revolution expressed in terms of design principles. His vision was as yet unfulfilled, but the work of young modernist designers such as Bronisław Zelek and Leszek

Hołdanowicz was, he claimed, already showing the potential of this order of design science.

Not all poster advertising in the people's republics can be explained in such rational terms. Many film and advertising posters produced in the late 1960s owed much to Pop Art, an aesthetic that conservative Soviet ideologues identified gleefully as a sign of the terminal decadence of the West.[29] Others in Eastern Europe were more admiring. Featuring images of young women and bright, flat colours, György Kemény's designs for fashionable garments in Hungary made a direct appeal to the senses that seemed to bypass the instinct for reason which socialist advertising was supposed to instill (illus. 136). His designs were evidently 'pin-ups' in the Pop manner. Although traces of the permissiveness associated with counter-culture which was emerging in Hungary in the late 1960s can be detected in Kemény's commercial posters, they were by no means unofficial designs: they were commissioned by Magyar Hirdető (Hungarian Advertiser), the central advertising agency responsible for 'internal' communications in the country, which kept a roster of freelance poster designers on its books (illus. 137).[30] A number of designers would be invited to compete for a commission, the winner being selected by a 'jury' of Magyar Hirdető officials and designers. Nevertheless, the winner enjoyed considerable autonomy: Kemény was, for instance, free to select the size of the print (which in the case of his *Új fürdőruhák* design promoting beachwear was double size – two A0 sheets), and officials of the agency would persuade doubtful clients of the merits of Kemény's designs,

137
**Magda Vörösmarty**
*Hungarian Advertiser*, 1965

in one case using illustrations of his work in the Swiss graphic design magazine *Graphis* as evidence of their quality.[31]

Such designs are best understood as symptoms of post-totalitarianism: the Czech dissident and future president Václav Havel described this conflicted condition in succinct terms when, in 1978, he wrote: 'The post-totalitarian system has been built on foundations laid by the historical encounter between dictatorship and the consumer society.'[32] In the course of the 1960s, Eastern Bloc states launched various economic reforms and retailing initiatives in an attempt to satisfy the growing expectations of their citizens. In Hungary, for instance, János Kádár's government introduced the

New Economic Mechanism (Új Gazdasági Mech-anizmus) in 1968: central planning was partially dismantled and state enterprises were encouraged to compete with one another, even setting their own prices for their goods. Two years later Edward Gierek came to power in Poland following rioting over shortages and price hikes, promising to satisfy the pent-up consumer needs of ordinary citizens. Gierek was more than a hard-headed pragmatist: in 1972 he announced the construction of a 'Second Poland' (Druga Polska), a spectacular programme of industrial expansion, grand urban projects and modernization. Poland mortgaged itself to the West in the expectation that it would become an industrial powerhouse selling its products around the world. Society would reap the benefits of this virtuous circle. Like the Hungarians, Poles living in the Second Poland were increasingly addressed as consumers. The communist rhetoric of investment ('work hard today and reap the benefits tomorrow') was exchanged for one of immediate rewards ('con-sume'). Eschewing collectivism and utopianism, such designs set the terms of a new kind of social contract offered by the state to the people.

## The Locomotive of History

Revolution – a fast-turning and irreversible event which brings about the end of an old order and ushers in the new – was a recurrent theme in offi-cial sloganeering and propaganda throughout the history of communist rule in Eastern Europe. In the 1920s, Soviet artists and film-makers developed a rich armoury of symbols and techniques such as montage to represent the historical rupture that had occurred in October 1917. And when the docu-mentary record was lacking, art could compensate: in his film *October* (1927) Sergei Eisenstein provided a set of suitably stirring images for a world-historical event that had, in fact, left few visual traces. Revolution in Eastern Europe in the 1940s had been far less exhilarating: the people's republics had been created by diktat. Grey-suited loyalists had been installed by Moscow to govern societies, large parts of which were resistant to Soviet-style socialism. They achieved power by means of murky machinations against other political parties, rigged elections and show trials. And, of course, Socialist Realism – the official aesthetic of the new order – suggested order, obedience and reconstruction.

Although revolution was a consecrated concept, communist order in Eastern Europe was in fact expressed through returns, reiterations and rituals. Lenin's birthday, May Day, International Women's Day and the anniversary of the October Revolution, as well as the opening of Party con-gresses and international festivals, provided the pretext for numerous poster design competitions and commissions. Eastern European designers attempted to use these commissions to modernize the language of propaganda. In Hungary in 1977, the husband and wife partnership of László Sós and Éva Kemény, known as So-ky, was commissioned to design a poster to commemorate the sixtieth anniversary of the October Revolution. In their design, Lenin's face, as well as a medley of signs including shooting stars and the Spasskaya Tower

138
**So-ky**
**(László Sós and Éva Kemény)**
*Untitled*, 1977

marking the sixtieth anniversary
of the October Revolution

in the Kremlin, emerges from the red surface
(illus. 138). Slogans and promises, enemies and
comrades were no longer needed, nor was evidence
of his actions necessary: Lenin simply *appeared* in
this design, like a miraculous icon in the Russian
Orthodox tradition.[33]

The Tenth World Festival of Youth and
Students (X. Weltfestspiele der Jugend und
Studenten) held in East Berlin in 1973 was seized
on as an opportunity to develop a new image
of state socialism after the renewal of the East
German leadership under Erich Honecker in 1971.
Moreover, it was the first such gathering after
the repression of the Prague Spring by Warsaw
Pact forces in 1968 (see below). As in Warsaw in
1955, the exuberance and diversity of the festival's
participants provided a pretext for a self-conscious
modernization of the publicity and propaganda
(which General Secretary of the Socialist Unity
Party Honecker himself directed, such was the
significance of the event). As the historian Josie
McLellan says, 'East Germany wanted to present
itself as a state which was youthful, dynamic
and international.'[34] For nine days, East German
citizens and guests from 140 countries could freely
mingle, or so it seemed, dancing to rock music in
the streets and singing protest songs (though the
festival was in fact carefully stage-managed, with
the threat of dissent stifled by arrests in the run-up
to the opening events).[35] The festival generated
considerable publicity, much of which was managed
by graphic designer Axel Bertram.[36] To ensure
consistency, Bertram developed a logo for the
event derived from the city's teletower, updated

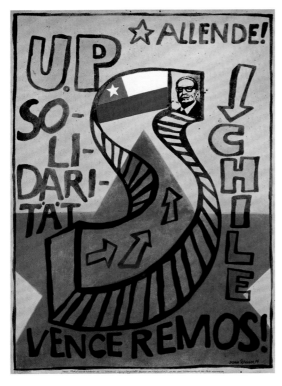

the existing World Festival of Youth emblem and established a set of design principles as well as a rainbow colour palette. Günter Schmitz's design for a poster in Bertram's schema featured a painterly illustration of a young couple raising their arms in celebration, as if the pleasure of being in each other's company in East Berlin was sufficient cause for joy. In an effort to stimulate popular enthusiasm for the festival, East German citizens and institutions were encouraged to design their own souvenirs and publicity too. In Leipzig, for instance, Jutta Damm-Fiedler and Jochen Fiedler were commissioned by the VBK to design *Steps to the Festival in '73*, a lively poster which looked more like publicity for a rock festival than for a communist rally.

The festival was organized to promote the 'anti-imperialist solidarity' of young activists around the world. Socialist internationalism – hollow sloganeering for much of the 1950s – had acquired greater urgency and meaning in the course of the 1960s. Revolutions and liberation movements in Cuba, Latin America, Asia and postcolonial Africa had not only provided dramatic images of history in the making but seemed to live up to the claims that communist politics represented popular will. Moreover, 'American imperialism' – another cliché of Eastern Bloc propaganda since the late 1940s – seemed to have acquired real significance as a consequence of the Vietnam War. In Hungary, a poster-portrait of Hồ Chí Minh, the president of the Democratic Republic of Vietnam, was created independently by György Kemény as an entry in the 1970 Warsaw International Poster Biennale, as a posthumous tribute to a leader who had led

above, top:

139
**Jutta Damm-Fiedler and Jochen Fiedler (Gruppe Plus),**
*Venceremos!*, 1974

above:

140
**Jürgen Haufe,**
*Brother Eichmann*, 1983
poster promoting a performance of Heinar Kipphardt's play at Staatsschauspiel Dresden

stubborn resistance against the U.S.. Kemény's enthusiasm for 'Ho apó' ('Granddad Ho', as he was known in Hungary), was genuine and in marked contrast to popular attitudes to Party leaders in Eastern Europe.[37] Indebted to the dreamy style of psychedelic graphics in the West, Kemény's design perhaps pointed to the confluence of counter-culture imagery and new left politics, at least among youthful radicals in Hungary at the end of the 1960s.[38] Similarly, in East Germany Damm-Fiedler and Fiedler (who were to form the artists' collective Gruppe Plus with Frank Neubauer in 1975) designed a poster to defend President Salvador Allende's Unidad Popular (UP/Popular Unity) coalition government in Chile after it had been deposed in the August 1973 coup d'état (illus. 139). Loose brushstrokes gave the impression of urgency, as if the poster had been handmade on the streets. There is little to distinguish these designs from the taste for 'radical chic' among the young on the other side of the East–West divide.

Another point of correspondence with the counter-culture was found in Jürgen Haufe's 1982 poster for the Dresden State Theatre production of Heinar Kipphardt's play *Bruder Eichmann*, an adaptation of Hannah Arendt's study of Adolf Eichmann's trial in 1961 (illus. 140). Haufe too created an adaptation, this time of a much reproduced poster created by the Art Workers' Coalition in New York in 1970, in which a photo of the bodies of 106 massacred Vietnamese villagers was captioned with the question 'And Babies?' (this was a question asked of the soldier leading the platoon responsible on American television).[39] With traces of the American poster visibly erased in his design, Haufe combined the image of the keyboard of a typewriter with that of the bodies of the dead, a sharp indictment of SS officer Eichmann's claims to have been an ordinary and God-fearing bureaucrat innocently caught up in events. Here was a compelling design which connected the violence of U.S. actions in Vietnam with the Holocaust.

While the form of the Eastern European poster might have been updated in the 1970s, the messages it delivered remained, in large part, relatively unchanged. Vibrant, modernized design or enthusiasm for liberation movements in the so-called Third World did little to stir the political spirits of ordinary citizens. Party slogans and symbols had, according to Havel, become a kind of background noise:

*The manager of a fruit-and-vegetable shop places in his window, among the onions and carrots, the slogan: 'Workers of the world, unite!' Why does he do it? . . . I think it can safely be assumed that the overwhelming majority of shopkeepers never think about the slogans they put in their windows, nor do they use them to express their real opinions . . . He put them all into the window simply because it has been done that way for years, because everyone does it, and because that is the way it has to be. If he were to refuse, there could be trouble . . . the real meaning of the greengrocer's slogan has nothing to do with what the text of the slogan actually says. Even so, this real meaning is quite clear and generally comprehensible because the code is so familiar: the greengrocer declares his loyalty (and he can do no other if his declaration is to be accepted) in the only way the regime is capable of hearing; that is, by accepting the prescribed*

*ritual, by accepting appearances as reality, by accepting the given rules of the game.*[40]

For Havel the unread poster was a symptom of the compromised character of the 'post-totalitarian system', a form of government that 'draws everyone into its sphere of power, not so they may realize themselves as human beings, but so they may surrender their human identity in favor of the identity of the system, that is, so they may become agents of the system's general automatism and servants of its self-determined goals.' What was required, according to Havel, were small but numerous acts of refusal.

**Posters and Dissent**

By employing strict control over access to printing presses and occasional censorship of commissioned designs, the means to produce and distribute posters were in the hands of the state for much of the history of communist rule in Eastern Europe. During moments of crisis and high tension, however, improvised posters were produced by opponents of communist rule, often by appropriating resources controlled by the authorities. Censorship itself was sometimes suspended or relaxed during these moments too, with Party leaders hoping that freedom of expression would allow dissent to be vented harmlessly. When, for instance, Soviet forces occupied Hungary in October 1956 to repress the uprising, Polish designer Franciszek Starowieyski created an image of a weeping dove, which was printed on the presses

of the Warsaw Academy of Fine Arts and pasted up on the walls of the Polish capital (illus. 148).[41] Located on the chief thoroughfare of the Polish capital, the academy was a temporary island of public anti-Soviet sentiment. Appearing at the time when the Polish communist authorities were also struggling to maintain their grip on power, Starowieyski's simple design made a poignant critique of the Soviet Union's claims on peace.

Twelve years later, the occupation of Czechoslovakia by Warsaw Pact forces stimulated a wave of graphic protests by citizens of the country. Some posters and placards were printed in small runs; many more were rendered by hand. In central Prague, the monument to King Wenceslas was plastered with hundreds of handmade posters. Improvised and written in direct response to events as they unfolded during the occupation, these designs had the urgency of the moment. They were often sardonic and humorous, though not necessarily anti-communist. One, for instance, featured a portrait of Lenin in tears above an image of a Soviet tank crushing a banner with the initials of the Czechoslovak Socialist Republic in Cyrillic lettering (ЧССР) (illus. 141). Its intended viewers were the Soviet soldiers, who had been told that they were defending his Czechoslovak comrades from fascist forces in the country. This was an image which accused Moscow of not only abusing the Czechoslovak attempts to reform communist rule (in the name of what the reform leadership under Alexander Dubček called 'socialism with a human face') but betraying Lenin's vision.

One anonymous design made by hand in 1969

141
**Anonymous**
Handmade anti-Soviet poster
from Prague, 1968

Photographer: Josef Koudelka

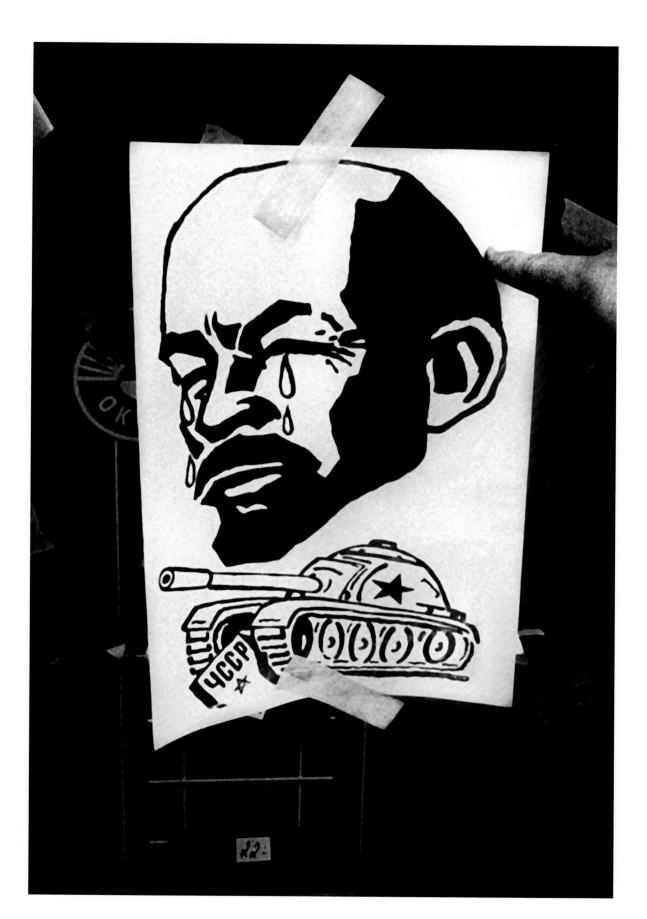

featured a billowing cloud of black smoke and was captioned *1969 1415*. It was fixed to a lamp post close to the place where Jan Palach had committed suicide by self-immolation in a protest against the occupation of the country and, in particular, the repression of free speech. Palach's funeral in January 1969 had been an enormous national protest, with tens of thousands of mourners on the streets. The poster drew a connection between Palach's death and that of Jan Hus, who had been burned at the stake in 1415 for heresy and had long been adopted by the Czechs as a symbol of opposition against oppressive regimes, particularly during the late nineteenth century. Palach had identified strongly with the protestant reformer, signing his last letter 'Your Hus'.[42]

The production of anti-communist posters in large numbers was rare during the turbulent events of 1968. Václav Ševčik's *21. 8. 1968* (1968) is an exception (illus. 142). It too features a weeping eye, rendered as blown-up half-tone dots. The red tear is made into an indictment by the addition of the date, the day on which Warsaw Pact forces invaded the country. Ševčik was, at that time, a member of a young alliance of graphic designers that had formed under the name Plakát (Poster) in 1962 to reform the political poster in Czechoslovakia, seeking to rid it of the unthinking Party-speak and visual clichés of the Stalin years. The group's members argued for a new kind of realism that would match real social experiences: 'It should speak out against human indifference, selfishness and hypocrisy that undermines serious social challenges or, equally, fulfills them ruthlessly,' wrote Zdeněk Chotěnovský

in the catalogue of the group's first exhibition, organized in the Czechoslovak Writers Union gallery in Prague in 1964.[43] Despite their desire to reform socialism, the group enjoyed few commissions and their exhibitions largely featured prototypes and unprinted designs. The group's second exhibition was organized in the headquarters of the Československý spisovatel publishing house in Prague in March 1969 and was entitled the 'Engaged Poster' (Angažovaný Plakát).[44] In the aftermath of the occupation, this hollow cliché of Soviet-style socialism had been given new meaning by the surge of handmade posters which had been pasted on the streets. Ševčik and his colleagues were blacklisted at the exhibition's close.[45]

Of all the states which formed the Eastern Bloc in the 1970s, Poland presented the most favourable conditions for the development of independent and anti-communist posters. The authorities there extended greater freedom to artists, writers and film-makers than any other state (with the exception of non-aligned Yugoslavia). Moreover, the anti-communist opposition was extensive and well organized there. The Drugi Obieg (Second Circulation) of books and journals issued by underground publishers in the mid-1970s meant that Polish samizdat printers – some employing large offset presses – had the means and technical skill to produce posters in large numbers. Books printed in Poland were smuggled into neighbouring countries and dissidents from neighbouring countries went to Poland to learn how to print.[46] But it was the foundation of the Independent and Self-governing Trade Union 'Solidarity' (Niezależny Samorząd

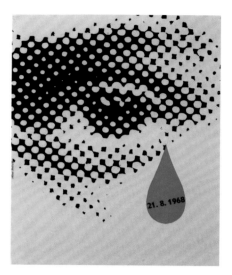

142
**Václav Ševčik**
*21. 8. 1968*, 1968

Związków Zawodowych 'Solidarność') in the summer of 1980 which led to the unexpected revival of the political poster in Eastern Europe. Emerging from strikes in the Gdańsk shipyard to become a mass social movement (with ten million members in 1981), Solidarity negotiated extraordinary concessions from the state, including the right to strike, press freedom and the end of special privileges for the secret police and Party members.[47]

Solidarity's first posters were improvised prints. The graphic designer Jerzy Janiszewski's contribution to the groundswell of opposition was to design a logo for the burgeoning movement in the summer of 1980. He took his design – suggesting the tight-knit bonds and patriotism Solidarity commanded in loose brushstrokes – to the strikers. He recalled:

*Because of the censorship in Poland, it was difficult to print anything. But my friends and I put together a primitive printing machine and started printing the logo, one set at a time. We had difficulty getting paper, but found some through friends. We printed two formats: one small, an A5, and the other larger, A3. The first day we made 50 copies. We had technical problems, the paint dried wrong, things got jammed. The next day, we made 100, then 150. We printed them through the end of the strike. I would take them to the shipyard and give them to the leadership. The very first day they plastered them all over the walls of their conference room.[48]*

Decorating the gates of the shipyard and the headquarters of the strike committee, these small posters formed the backdrop for the historic compromise offered by the Polish state. In this way,

143
**Henryk Tomaszewski**
*History*, 1983

poster for a performance of
Witold Gombrowicz's adaptation
of Oscar Strasnoy's opera at the
Nowy Teatr, Warsaw

the logo was broadcast around the world by the international media.

One of the merits of Janiszewski's design was its easy adaptability. The logo was adopted by chapters of the union for its posters and newsletters as the movement spread with revolutionary speed across the country in 1980 and 1981. The letterforms were put to other uses too. Czesław Bielecki, an architect and anti-communist activist, designed a poster in 1980 in which the pulsing line of a cardio-gram morphs into Janiszewski's logo. Dates – '44, '56, '68, '70, '76, '80 – appear above each peak, references to the flashpoints in the history of Polish opposition to authoritarian rule. This historical consciousness was a striking feature of Polish opposition (and, as we'll see, in the events of 1989, which marked the end of communist rule in Eastern Europe). The writing of history was placed under tremendous pressure during the communist rule in Poland, distorted to suit the ideological interests of the authorities. Insurgents during the Warsaw Uprising in 1944, student protestors in 1968, striking workers in Gdańsk in 1970 and Radom in 1976 were slandered, variously, as fascists, Zionists and hooligans, while state violence against protesters went unreported. Writing in 1988, Adolf Juzwenko noted, somewhat darkly, that to have a career as a historian in the Eastern Bloc was to broker compro-mise, not least with the censor.[49] In the course of the 1970s the anti-communist opposition – across the Bloc – invested tremendous energy in contesting the official record in samizdat publications.[50]

During the euphoric period of 1980–81 when the Solidarity movement tested the limits of communist authority, Polish streets and workplaces were transformed by anti-communist posters and graffiti. Political views and demands that had once been prohibited could now be voiced loudly. Nervous of public opinion, the authorities removed very few of these signs of dissent from the streets. Nevertheless they attempted to stir up popular fears about the threat of Soviet invasion by mod-ifying Solidarity's own publicity. A tidy diagonal stripe with the words 'don't play with fire' was, for instance, pasted over the union's posters.[51]

This period – sometimes dubbed the 'carnival of freedom' – was short-lived. In December 1981 martial law was imposed on the country to extinguish the Solidarity movement and restore communist authority. Strict controls were placed on Polish society, including a curfew, censorship of all telephone calls and letters and the criminalization of independent organizations. Nevertheless, samiz-dat poster production continued underground. At the same time, what Tom Kovacs called the 'spirit of metaphor' allowed anti-communist sentiment to surface publically.[52] When, for instance, Janisze-wski's solidarity logo was banned, Poles invented new symbols that did not draw the rancour of state forces. Ordinary people would wear electronic resistors on their lapels, in the 'national' colours of red and white. Everyone knew what this gesture meant, but for the state and its officers to act against those wearing these tiny pins would have revealed the absurdity of the situation. Such sym-bols and 'Aesopian' parables found their way into posters too. In a design for a production of Witold Gombrowicz's play *Historia* at the Nowy Teatr

in Warsaw in 1983, a few months after the repeal of martial law, Henryk Tomaszewski sketched the image of a foot apparently making the 'V' gesture with its toes, a symbol that Solidarity leaders had adopted during the heady days of its rise (illus. 143). This has been read as an allusion to the irrepressible spirit of the trade union, then under prohibition.[53]

## Endings

In 1988 a wave of strikes broke out in Poland which led, ultimately, to official recognition of the Solidarity trade union again. Martial law had failed to extinguish the movement: it was still a powerful and social force, alongside the Catholic Church. Facing the complete economic collapse of the country, the communist authorities entered into negotiations with the movement's leaders, first in secret and then in public, in what have become known as the Round Table discussions in early 1989. One result of these discussions was the democratic elections that were held in June, the first in the Eastern Bloc for forty years. Events went further and faster in other parts of the region: in Hungary, key events were the reburial of Imre Nagy and the other leaders of the 1956 Revolution in June 1989, and the steady stream of East German citizens across the Austrian–Hungarian border in the summer of the same year. The Czechoslovaks enjoyed a peaceful 'Velvet Revolution' in November, when communist rule imploded in the face of overwhelming popular protest. The same month also saw the breaching of the Berlin Wall. A popular slogan circulated in Eastern Europe at the end of 1989 describing how long it had taken for communism to collapse in Moscow's satellites: 'Poland – Ten years, Hungary – Ten months, GDR – Ten weeks, Czechoslovakia – Ten days.'[54]

Democracy had been a much abused term in communist rhetoric since the late 1940s. Stacked with loyalists, national parliaments had been stage-managed settings where the fiction of debate had been performed. With democratic elections scheduled for the early months of 1990 in most Eastern European states, political parties had to form quickly, developing not only policies and programmes but images and publicity. In the absence of clear visions of the future, one of the most persistent refrains of the period was the idea of 'returning to Europe'. It was often expressed in visual clichés such as bridges and ladders. (It is worth noting that in 1989 'Europe' meant not only democracy and free markets but freedom of speech and the right to travel.) This rhetoric also had the political benefit – to those who deployed it – of casting socialist rule as an Eastern and alien political philosophy. The first election posters feature relatively few portraits of political leaders too. Only Václav Havel, the playwright-president in Czechoslovakia, and Lech Wałęsa, the electrician-turned-president of Poland, stand out. This is perhaps not surprising. Many of the first generation of political leaders after 1989 – like Havel – had been dissidents, ignored by state media and sometimes imprisoned for their activities. Their faces were largely unknown to the public. Accordingly, the techniques of metaphor and allusion that had

been so central to the poster traditions of the region remained current. Produced for the June 1989 elect-ions in Poland, at which Solidarity was able to con-test a limited number of seats, Tomasz Sarnecki's *Solidarity High Noon* poster shows marshal Will Kane – played by a steel-jawed Gary Cooper in the 1952 film – marching out from the movement's logo, a turbulent flag-waving crowd of letters (illus. 149). The gun the Hollywood actor once carried had been replaced by a ballot paper. Evidently, rule by force – the Soviet method – was being exchanged for rule by law and democracy. Sarnecki's design was prescient in various ways: *High Noon* points to the rugged individualism beloved and mythologized in free market capitalism. Ronald Reagan, an actor who also played cowboys, was U.S. President when Sarnecki made his design. Poland in 1989 was about to join a world where politicians and celebrities are easily and sometimes wilfully confused.

The 'return to Europe' was not just a spatial restitution but a temporal one as well. For many commentators, escaping the controlling influence of the Soviet Union meant the possibility of reconnec-tion with the national past. This was evident in the restoration of prohibited symbols, such as the regal crown that had once been placed over the national symbol of the white eagle in interwar Poland, or the Holy Crown of Hungary, a coat of arms which Hungarian illustrator and artist István Orosz depicted emerging from a shattered concrete-grey Soviet emblem (illus. 144). Less a symbol of the monarchy than of independence, this relic testified to continuity (a thousand years of the Hungarian

144
**István Orosz**
*Hungarian Democratic Forum*, 1990

election poster

state). Like many posters produced in 1989 and 1990, Orosz's design for the Magyar Demokrata Fórum (Hungarian Democratic Forum) looked backwards. One of the most widely reproduced images of the period – also by Orosz – depicts the bull-neck of a Red Army soldier captioned with the phrase 'Tovarishchi Adieu!' (Comrades Adieu!). He produced it independently and pasted it up in the streets of Budapest as communist power crumbled. It was then adopted by this nascent political party during the first democratic elections in March 1990 (illus. 145). Articulating a deeply held desire to see the withdrawal of the Red Army from its bases in Central Europe (particularly in Hungary, where the memories of the repression of the Hungarian Uprising in 1956 were still vivid), Orosz's poster was another demand for an end. For others, the events of 1989 were a chance to complete the unfinished revolutions of 1968 or 1956: Ševčik, for instance, revived his 1968 poster with the red tear (see above) by adding a new date, '17 November 1989', a reference to an attack on an officially sanctioned protest in the city in which two students died and many others were beaten by the security forces. 'Before creating new posters,' he recalled, 'I dusted off some of my 1968 "Eye With a Bloody Tear" posters, wrote a new date by hand and took them to where the opposition was being born, to Prague theatres and universities.'[55]

The revolutions and elections of 1989–90 were both the high point and the beginning of the end of the poster in Eastern Europe, at least in the terms in which it had been framed for much of the previous forty years. Museum curators, aware that history was being made, went to the demonstrations and hustings to take posters down from the walls to enrich their collections.[56] Well illustrated books appeared recording these graphic signs of historical change.[57] It was clear to curators and critics that communist rule and the forms of opposition that it engendered had been responsible for the production of often highly original designs. 'Shock therapy' economics, wholesale privatization and the march of global brands, as well as increasingly media-savvy post-communist political parties, had little need for the idiosyncratic symbols and metaphors that had brought garlands to Eastern European poster designers before 1989. Within a few years, the production of cinema publicity – once the testing ground for Czech, Polish and Hungarian talent – became little more than a matter of setting translated text over foreign images supplied by the distributor. Likewise, the political poster became a deracinated shadow of its former self, invariably portraying suited, smiling election candidates crowned with a party logo and an uncontroversial slogan.

It is tragic that the last wave of posters that exploited the characteristics which had sometimes made the Eastern European poster so vital – improvisation and spontaneity, irony and metaphor – was thrown up in the conflict that formed a dreadful aftershock of the collapse of communist rule, the Yugoslav wars of 1991–2001.[58] For much of the previous forty years, the Yugoslav leadership had marked its distinction from the socialist states of the Eastern Bloc (with which it had broken in 1948) by pursuing a relatively open approach to the arts, permitting a degree of experimentation and

opposite:

145

**István Orosz**
*Tovarishchi Adieu*, 1990

issued by Hungarian Democratic Forum

intellectual freedom not found in even the most 'liberal' of Moscow's satellites. Although the federation of six republics that made up the country engaged in the production of propaganda posters, the visual appearance of Yugoslav streets was marked by pluralism rather than by uniformity. Moreover, posters issued by political organizations often adopted the abstract forms of what Yugoslav art historians now call 'socialist modernism' (illus. 146).[59]

Yugoslavia was dismantled by bellicose nationalist politicians whose actions and vicious rhetoric tipped the country into a series of ethnic conflicts in 1991. Turning the mass media into organs of state propaganda, the Serbian leadership spread false or, at the very least, highly exaggerated reports of violence being done to their compatriots living in Bosnia-Herzegovina. Similarly, the Croat leaders created a network of radio stations to do their propaganda work. In this context, the poster was only one instrument of many employed to ferment deep distrust and enmity. Many of the designs that were issued during the outbreak of the Bosnian War (1992–5) and Croatian War (1991–5) had a distinctly emotive character. In an effort to mobilize the population, some designs echoed the techniques of emotional blackmail that were crafted in Europe during the First World War. In one call-up poster for the Hrvatsko Vijeće Obrane (HVO, Croatian Defence Council), for instance, an image of children was accompanied by the question: *Our Father is in the HVO – And Yours?* (illus. 150).

The war in Bosnia – the most multi-ethnic republic in Yugoslavia – was a vicious conflict marked by the four-year siege of Sarajevo and 'ethnic cleansing', the forced removal and murder of the civilian populations to produce ethnically homogenous territories. Posters announced claims on territory in the most literal fashion, often being pasted up and torn down overnight. With ink and paper in short supply and power outages during the siege, screen-printing and other hand processes were revived. Trio, a design studio based in Sarajevo, created a bitterly ironic folio of designs featuring familiar graphic symbols with altered slogans that referred to the siege of their city. The Coca-Cola logo invited the viewer to 'Enjoy Sarajevo'; James Flagg's notorious First World War poster featuring Uncle Sam was re-captioned with the words 'I Want You to Save Sarajevo'; and a portrait of Superman was presented as 'Sarajevo – World's Greatest Adventure Strip Character'. Trio's designs were screen-printed as postcards or in larger formats on unlikely paper stock (including army maps). The postcard-sized posters were posted abroad but they enjoyed their largest audiences as illustrations accompanying articles about the war in the foreign press.[60] Mining the imagery of popular and commercial culture in the West, one interpretation of Trio's designs is that they mirror the way in which the world's media turned the war into a spectacle (at the moment when the efforts of the democratic states of Europe and the United Nations to broker peace were ineffectual).[61] Like Tomasz Sarnecki's *Solidarity High Noon* poster produced for the June 1989 elections in Poland, Trio's designs offered an Eastern European perspective on the West. However, in this case, optimism for the future was replaced by a dark pessimism.

146
**Boris Dogan**
*Youth Votes*, 1958

# OMLADINA

ZA SVOJU VEDRIJU MLADOST I LJEPŠU BUDUĆNOST

ZA PROCVAT SOCIJALISTIČKE JUGOSLAVIJE

# GLASA

147
**Jan Lenica**
*Wizyta Starszej Pani*, 1958

poster for a performance of Swiss
dramatist Friedrich Dürrenmatt's
*Der Besuch der alten Dame* by the
Teatr Dramatyczny in Warsaw

opposite:

148
**Franciszek Starowieyski**
*Untitled*, 1956

print of dove sold on the streets
of Warsaw in 1956 to raise funds
for victims of repression of the
Hungarian Uprising

# W SAMO POŁUDNIE
# 4 CZERWCA 1989

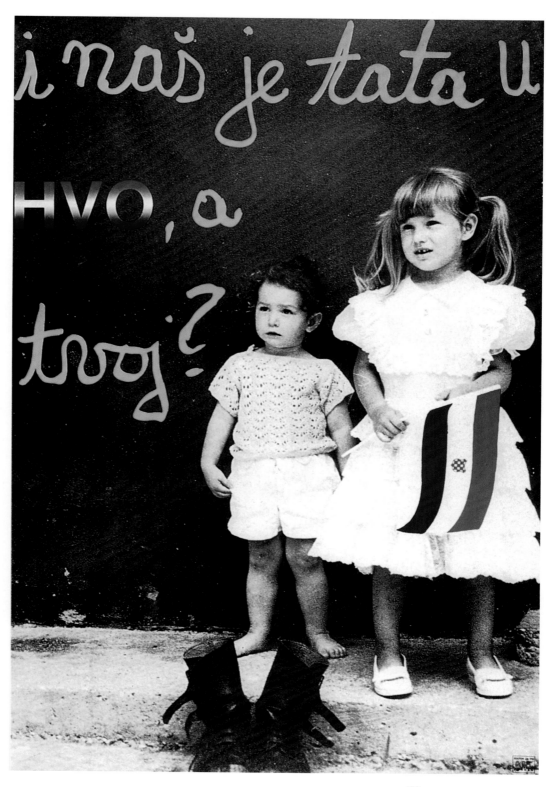

**Tomasz Sarnecki**
*Solidarity High Noon*, 1989

poster for the June elections

150
**Art Forces**
*Our Father Is in the* HVO –
*And Yours?*, 1993

issued by the Croatian Defence
Council

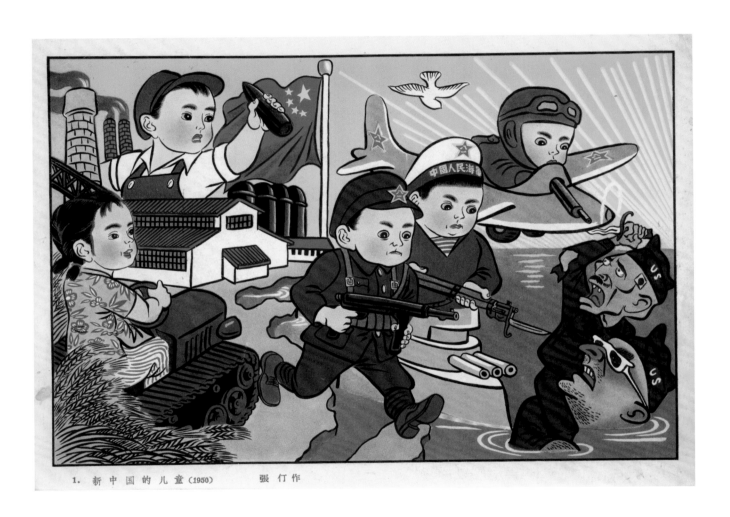

151

**Zhang Ding**

*Children of New China*, 1950

coloured woodblock print

# 4 People's Republic of China, 1949–

**Mary Ginsberg**

Posters tell the story of China's twentieth-century wars, revolution, reconstruction and modernization. They disseminated social policy changes, boosted political campaigns, celebrated heroes and condemned enemies. The principles of communist art were formulated by Mao Zedong and put into practice well before the establishment of the People's Republic. Style and content requirements differed from one propaganda campaign to the next, and posters tell us much about the long path of Chinese communism.

A colourful poster commemorates the 1942 Yan'an Forum on Literature and Art, which formed the basis of Chinese cultural policy until the end of the Great Proletarian Cultural Revolution in 1976 (illus. 181). The purpose of all art and literature was to serve politics, reaching and involving the workers, peasants and soldiers, who constitute the masses. Writers and artists were to learn from the masses and create works showing their daily life. Art had to inspire and enhance the masses' experience: there was no art for art's sake. It was a major change when, after the Cultural Revolution, individual expression was permitted and flourished. Then, in the 1990s, the commercial market became increasingly important, dominating the creative arts in the 2000s.

In October 2014, in a speech surprisingly like Mao Zedong's Yan'an talks, President Xi Jinping addressed a symposium of artists, writers and performers on cultural priorities. He declared that the arts must serve the people and serve socialism, rallying Chinese spirit and strength. Like 'sunshine from blue sky', art should 'inspire minds, warm hearts, cultivate taste and clean up undesirable work styles', telling people in a 'covert but influential way' what is to be praised or denied.[1] Artists must 'form a correct view of art and create more masterpieces . . . Art and culture cannot develop without political guidance.'[2] This essay will show how the message – and the propaganda poster medium – have come full circle, once again integrating ideology and artistic values. Posters present the official view, promoting harmony and progress. Some subjects are invisible. There is no open subversion. Only during the Cultural Revolution was it 'right to rebel' in posters.

The most familiar Chinese posters are from the ten-year Cultural Revolution (1966–76): violent red and black graphics (illus. 187), images from the revolutionary operas (illus. 181) and mass scenes with Chairman Mao high above the crowd (illus. 175). Posters formed an important part of the political and visual culture long before those

years, although relatively few communist examples
are preserved from before 1949. Surviving posters
of the 1930s and '40s generally display messages
from the nationalist (Guomindang, GMD) govern-
ment, both anti-Japanese and anti-communist,
particularly promoting patriotism in wartime.[3]
The communists tapped folk art formats for their
propaganda – papercuts and, especially, popular
prints (*nianhua*) – through the War of Resistance
(1937–45), the Civil War (or War of Liberation,
1945–9) and the first ten years of the People's Re-
public (1949–59). From the Great Leap Forward
(1958–61) and throughout the Cultural Revolu-
tion, posters were by far the most prevalent form
of visual propaganda. During the 1980s, poster
production declined dramatically, and it nearly
disappeared in the 1990s. Under Hu Jintao (2002–
12) and Xi Jinping (2012–), however, posters have
been back on the streets in quantity, promoting
social harmony, public service, civilization,[4] the
Communist Party and the 'China Dream'.

## Political Culture, Old and New

The establishment of the People's Republic of
China (PRC) in 1949 entailed political, economic,
social and cultural transformations. The Chinese
Revolution differed in many respects from the
Bolshevik takeover of 1917 and the circumstances
that prevailed immediately thereafter.

Firstly, members of the Communist Party of
China (CPC) were seen as patriots, the true defend-
ers of the nation against foreign invaders who had

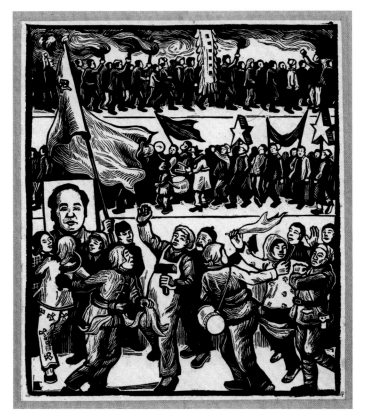

152
**Zhang Yingxue**
*Welcome Liberation*, 1948

woodblock print

wrought such violence, destruction and humiliation. They claimed victory in the War of Resistance against Japan (1937–45). The nationalists and communists had been fighting for control of China since the 1920s, but by 1949, the Civil War had been hard-fought and won, and the communists came to power on a wave of popular support. The Bolsheviks, on the other hand, claimed power by insurrection and then took four years to secure the revolution.

Secondly, the Chinese communists already controlled a large part of the country and had carried out many changes in economic and political life, before officially taking power. Land reform had started as early as 1946 in parts of northern China. By contrast, the Bolsheviks were a small band of urban intellectuals, with internal Party discipline and utopian visions, but no practice in governing, no dedicated propaganda programmes or structures, and a devastated economy.

Mao, like Lenin before him, insisted that cultural revolution was as important as political reorganization and economic modernization. Lenin believed that technological advance and industrialization would pull the people's consciousness towards modernization. Mao believed that the cultural hegemony of the masses was a 'prerequisite for economic modernization'. He consistently emphasized that the important issue was 'the remoulding of the people'.[5]

Unlike Lenin, who depended on an intellectual vanguard to lead the way, Mao put his faith in the 'spontaneous creativity of the masses'. The new Chinese leadership faced great challenges in activating the masses' consciousness. Mao determined to dissolve social structures, most notably the 'corporate' family, which had sustained rural Chinese society for many centuries. He, like Lenin, also struck at old beliefs and practices central to all life-cycle events, condemning them as feudal, superstitious hindrances to progress.

And yet, while ideologically demanding the rejection of tradition, in practice the Soviet and Chinese leaders both acknowledged the 'Necessity of cultural borrowings, of negotiating, consciously or unconsciously, with the former society, with the ancestral cultural customs, with a *habitus* that couldn't be transformed in ten or indeed even twenty years'.[6] Instead of forcing an end to traditional festivals, China's leaders instituted new forms of communal celebration and recreation, and secularization was gradual: 'Religious attitudes and beliefs, unlike the economic and political structure, cannot be forcibly changed in a short time by a revolution' (illus. 155).[7]

For all his rejection of the past, Mao's idea of the malleability of man was not so far from Confucian thought, which had prevailed for two thousand years. This ideal emphasized that people's behaviour would be guided by appropriate models, and internalization of proper thinking would follow from correct actions. Furthermore, it was the obligation of the senior/elder/ruler (in each of the five cardinal relationships) to provide the right model, and for the junior/younger/subject to respond correctly. Arguably, these traditional attitudes to authority made the masses more receptive to the new power structures imposed from above.

177

The post-1949 socialization and propaganda programmes had much to undo besides the old social system and family rituals. From 1931, Japan had occupied Manchuria and from 1937 to 1945 held Beijing, Shanghai, Nanjing, Canton and the eastern coast. Chiang Kai-shek's GMD moved the capital inland to Chongqing and controlled the hinterland. Propaganda campaigns, especially anti-communist ones, had been pervasive in all those areas. Class enemies and wartime collabora-tors had to be turned or eliminated.

The new government had a carefully worked-out programme for propaganda work. This mixed elements of the Soviet model as adapted in Jiangxi in the 1920s and early '30s, and in Yan'an from 1935 throughout the 1940s, and built on imperial and GMD communication practices.[8] In arts policy, they had had several years of practical experience in Yan'an, having followed the principles prescribed by Mao at the 1942 Forum on Literature and Art.[9] Organizational channels included reform of the cultural administration, art education institutions, publications and exhibitions.[10]

**Communist Propaganda Formats and Content**

China's left-wing political art is generally reckoned to have begun with Lu Xun's (1881–1936) Cre-ative Print Movement in the late 1920s and early '30s. Although China had its own tradition with protest woodblock prints, Lu Xun started a new practice inspired by the German Expressionists, such as Käthe Kollwitz (1867–1945) and the Soviet

graphic artists.[11] The new black-and-white prints were made for an urban, relatively sophisticated audience. They raged against corruption, poverty, Japanese incursions and the Nationalist Govern-ment's failure to deal with these ills.

China in the 1930s was an overwhelmingly rural, illiterate society, and the peasants didn't understand or like the prints. As early as 1926, the CPC Central Committee had promoted the use of folk forms to connect with the peasants. However, it was at Yan'an that national forms of literature, visual and performing arts became policy tools of the revolu-tion.[12] In the visual arts, *nianhua* (popular prints),[13] papercuts and *lianhuanhua* (serial cartoon pictures) were the dominant folk art formats employed for propaganda. Where black monochrome prints were made, they were simple and flat, using thick out-lines and little shading, as in Zhang Yingxue's 1948 print, *Welcome Liberation* (illus. 152). In this print, the celebrating peasants carry a portrait poster of Mao Zedong. Portrait posters of Mao, General Zhu De (1886–1976) and Zhou Enlai (1898–1976) were commonly part of rural and urban processions as the communist takeover neared.

Brightly coloured propaganda images were more popular among the peasants, and images were adapted and reproduced from different media; oil painting, for example, was a recent import to China and was used for heroic revolutionary works in the 1940s. Some were reproduced as prints and posters for wide circulation. Mo Pu's (1915–1996) very successful *Settling Accounts* was adapted as a *nianhua* (illus. 153). During the Civil War the communists introduced land reform and redistri-

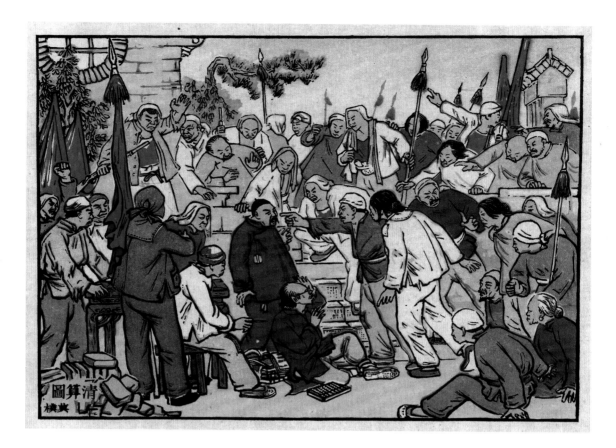

bution policies in the 'liberated areas' under their control. These were very popular measures among the poor, illustrated here as a group of peasants literally tears the landlord's house apart to find his accounts and valuables.

Another multi-format work was Dong Xiwen's (1914–1973) *The Founding of the Nation*, painted in 1953 from photographs of the event in Tiananmen Square on 1 October 1949. Mao especially liked this work, and it was published on the front page of the *People's Daily*.[14] Within a few months, Gao Gang (in spectacles, on Mao's left) had been purged, so the painting was revised before further exhibition. During the Cultural Revolution, Liu Shaoqi was disgraced, so had to be removed. When these 'villains' were rehabilitated, the painting was done again, even after the artist's death. Altogether,

eight versions of the painting were completed across the decades,[15] several of which used to hang near one another in the National Museum of China in Beijing. One might question why an official exhibition would declare the rewriting of history so blatantly. In any event, the painting was reproduced in several versions as a poster for viewing in public places (illus. 154), but also functioned as a decorative print in homes for decades (Introduction, illus. 3).

## Posters of the First Ten Years

The Chinese term *xuanchuanhua* means propaganda pictures, and so is broader than just 'posters'. These images, displayed in offices,

above:

153
**Mo Pu**
*Settling Accounts*, 1949

coloured woodblock print

overleaf:

154
**Dong Xiwen**
*The Founding of the Nation*, 1990

reprinted poster from oil painting

179

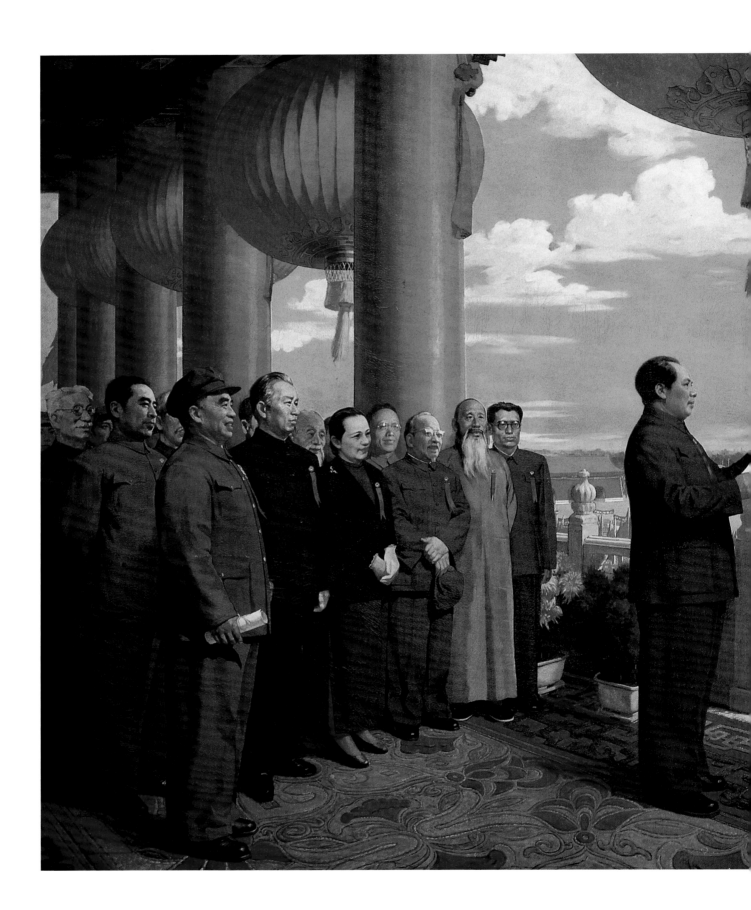

# 新結婚典禮

農曆節氣圖

作者 劉百群（天津美協供稿）

factories, schools and other public places, include cartoons, woodblocks, lithographs and full-colour reproductions of paintings (*huapian*). *Huapian* takes in both Socialist Realist works, generally in oil, and Chinese-style ink and brush paintings (*guohua*). All were important in the propaganda programme of the PRC. Many of the posters were derivative and formulaic, in the Soviet Socialist Realist style. Even so, the graphic output of the 1950s was varied, imaginative, humorous and more interesting than most of what came later.

All artists were employed by the state and were assigned to produce propaganda. Many enthusiastically joined this effort: veteran artists of the War of Resistance, communist partisans in the 'liberated areas' and those who had protested against Chiang Kai-shek's corrupt regime, albeit themselves not communists. This was a time of great optimism and hope for a new society. Artists were assigned to academies, universities or cultural bureaux to fulfil the new propaganda programme and its many campaigns.

One of the first directives of the new Ministry of Culture called for the development and popularization of 'reformed' *nianhua*. These new popular prints were to be 'national in form, socialist in content'. In other words, the old format and colourful style should remain, invigorated with new messages – the great victories of liberation and revolution, economic progress in industry and agriculture, political participation and social reform.[16]

Zhang Ding's (1917–2010) *Children of New China*, made in 1950, contained every possible motif and message for the newly established PRC (illus.

151). Children are shown here representing all spheres of the revolutionary society. A girl drives the tractor, a trope in the art of many communist countries; she is bringing in an abundant harvest. The boy, representing industrial production, brandishes a torpedo made in his modern factory. The armed services are crossing the Taiwan Straits to put an end to a frightened Chiang Kai-shek, who clings to the sinking USA in the form of General Douglas MacArthur. The flag of new China waves above all. The rays of the sun – shining China – and the dove, showing China's wish for peace, complete the iconography in this prizewinning woodblock print.

In new China, children became political actors, and marriage reform broke many traditional family patterns. The 1951 calendar poster in illus. 155 shows the new wedding ceremony in a society where marriage is between labour partners (*laodong banlü*), as written on the banner the bride and groom hold between them. The factory outside is a motif of modernity in this rural setting. The poster, for the years 1952–4, is in the format of an old-style lunar planting calendar. Calendar prints like these usually carried the image of the Stove God, who occupied a watchful place in most homes. Here, Chairman Mao is in the place of honour, overseeing all. This combination of old and new iconography – the familiar everyday and the new heroic – provided an accessible formula for rural propaganda of the 1950s.

Another type of propaganda picture was the *yuefenpai*, or mechanically produced poster, reformed from its 1930s commercial incarnation.

155
**Liu Baixing**
*New Marriage Ceremony*, 1951

coloured lithograph

Produced in Shanghai, these advertising calendar posters had featured glamorous, modern women in the International Style. *Yuefenpai* played no part in the revolution, as more traditional-style *nianhua* had done, and required stylistic and ideological transformation. They were designed with a shaded, brush-rubbing technique called *cabi*, in contrast to the single line and flat colour (*danxian pingtu*) used for *nianhua*.

The family scene in illus. 156 has the right iconography, but possibly the wrong stylistic nuance. The lovely mother is declared by her certificate and medal to be a model producer – one of the revolution's new women. Her tidy daughter wears a Pioneer scarf, the factory in the background hails industrial progress and the ubiquitous dove appears as an ornament. However, few domestic scenes of the early 1950s resembled this well-appointed one. Formerly a commercial artist, Jin Zhaofang (1904–1969) was known for his portrayals of fashionable women engaged in modern pursuits. His new subject-matter is progressive, but bourgeois remnants persist in the style.

Although cultural directives placed emphasis on 'new' *nianhua* and *yuefenpai* prints, larger-format posters were produced for the serial political campaigns of the 1950s. Illus. 157 takes aim at China's foreign enemies. By 1949, the country was exhausted from years of war and disastrous economic conditions. Yet in October 1950, China committed itself to the 'War to Resist U.S. Aggression and Aid Korea'. Estimates vary by source, but over a million Chinese 'volunteers' fought in the Korean War, which went on until 1953. China

suffered a very high casualty rate – several hundred thousand dead and wounded – resulting largely from lack of weaponry and equipment.

*The War Criminals Need Harsher Punishments* was a collaborative effort by some of China's best-known artists. Xu Beihong (1895–1953) was then famous – and admired by Mao – for his monumental allegorical paintings, though he is far better known today for his masterful ink paintings of horses. In the new arts organization of the PRC, Xu was president of the Central Academy of Fine Arts (CAFA) and Chairman of the Artists' Association. The other important name on this poster is Li Hua (1907–1994), among the most gifted and expressive black-and-white woodcut artists, and a professor at CAFA after the revolution.

The poster displays an extraordinary mix of political content. Primarily, it is about the War to Resist America and Aid Korea. This is proclaimed on the banner, followed by 'Guard home, defend the country'. The flag is North Korea's. A belligerent John Foster Dulles (1889–1959) is caricatured with Nazi cufflinks, radio equipment in his hand and a missile in his pocket. (Dulles and Douglas MacArthur (1880–1964) appear in a great many satirical posters and cartoons of the early 1950s. They are both shown with huge, carrot-like hook-noses, and can be difficult to tell apart. If he's wearing a uniform and/or sunglasses, it's MacArthur; if wearing a suit, he's Dulles.) Here, too, are Charles de Gaulle and Clement Attlee, leaders of France and the UK, respectively, in 1951. They stand over the coffins of two colonial casualties, possibly from Algeria and Egypt. A group of angry

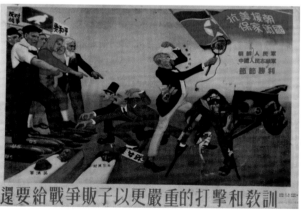

citizens – one of whom looks like Karl Marx – is condemning the war criminals. Their banner stands against war and for peace, and is adorned by the requisite dove.

China's initial participation in the Korean War was at the behest of Joseph Stalin (1878–1953). The Soviets had administered North Korea from the end of the Second World War until the formal separation of the peninsula in 1948 and the establishment of the Democratic People's Republic of Korea (DPRK). Stalin would send no troops to Korea, but he did send money and equipment. Although the cost was very high, Mao proved his willingness to fight the communist cause in Asia.

China desperately needed the economic and technical support provided by the USSR. During the 1950s, about ten thousand Soviet advisers worked in China, and China sent thousands to train in the USSR. Mao and Stalin never had a trustful relationship, but publicly Mao praised the 'Great and splendid socialist state' built by the Communist Party of the Soviet Union (CPSU): 'The CPSU is our best teacher and we must learn from it.'[17] Sino-Soviet relations rose and fell throughout the 1950s, but the final withdrawal of Soviet advisers did not occur until 1960.

Things certainly look rosy in this formulaic poster of Sino-Soviet cooperation (illus. 158). A Soviet expert and his Chinese colleague shake hands over development documents (the first Chinese five-year plan (1953–7) and the Soviet Plan for Developing and Redesigning 141 Factories for China). They are framed by their national flags, while a large factory complex fills the background.

top:

156
**Jin Zhaofang**
*A Glorious Production Model*,
1954

bottom:

157
**Li Hua, Xu Beihong and others**
*The War Criminals Need
Harsher Punishments*, 1951

185

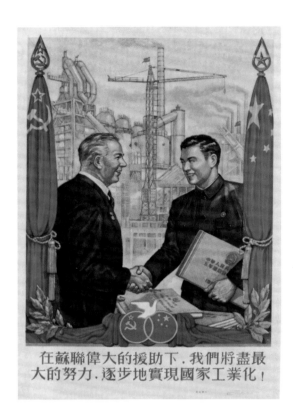

在蘇聯偉大的援助下，我們將盡最
大的努力，逐步地實現國家工業化！

The national logos are joined by the ever-present dove of 1950s Chinese poster design. The title reads: *With the Soviet Union's Great Help, We Will Make Great Efforts to Realize Step by Step the Country's Industrialization!* In addition to scientific, economic and educational advisers, Ministry of Culture personnel and artists came to China. Best known is Konstantin M. Maksimov (1913–1993), who taught Socialist Realist painting in Beijing from 1955 to 1957, but many Chinese poster designers received training from Soviet artists.[18]

The poster in illus. 182 is a fine example of Socialist Realist poster design. These works, often reproduced from oil paintings, were highly coloured and very detailed and generally portrayed heroic figures in spotlight.[19] The young mountaineer exhorts us to *Overcome All Difficulties to Build Socialism*. It was designed by Yu Yunjie (1917–1992), a member of the Maksimov painting class, and Zhao Yannian (1924–2014). Zhao Yannian is universally renowned as a woodblock printmaker. He did serve for a time with Yu Yunjie in a poster design team, but this is a most unusual example of his work.[20] The most interesting thing about this poster, however, is its history as a wedding gift. The bride and groom are named in the inscription, 'From all the comrades in the laboratory [19]56'. While serving as a politically correct gift, it carried an appropriate message for the time. By 1956, the country was finally at peace, the economy had stabilized and people were optimistic about the future.

Society was highly mobilized at all levels, and posters were circulated for every political cause

top:

158

**Anonymous**
*With the Soviet Union's Great Help, We Will Make Great Efforts to Realize Step by Step the Country's Industrialization!*, 1953

bottom:

159
Roadside photo of sparrows and movie poster, 1956

and campaign. Mao was determined to weed out enemies and keep the nation on a revolutionary footing. The first major campaign was against spies and counter-revolutionaries. At the end of 1951, he launched a campaign against corruption, waste and bureaucracy – the 'Three-antis'. This was aimed at officials within and outside the CPC, and old GMD members. Then, in January 1952, he went after the capitalist class, in the Five-Antis campaign: bribery, theft of state property, tax evasion, cheating on government contracts and stealing state economic secrets. Punishment of those found guilty was harsh. The propaganda imagery of this campaign was particularly violent.

The campaign against 'Four Pests' was inaugurated in 1956 and lasted for several years. The four pests were rats, flies, mosquitoes and sparrows. Everyone was mobilized to kill the dirty creatures – especially sparrows, because they ate grain. With children and adults doing their enthusiastic best, millions of sparrows were eliminated. People banged drums to scare them away, aimed slingshots, fell out of trees trying to get them – many actually breeding them, in order to kill more and get the resulting praise and rewards.[21] The poster boy for the campaign appears in an indoor-sized colour image (illus. 183) and a much larger roadside poster (illus. 159), both dated 1956.

Mao's fight against nature did more harm than good. Sparrows may eat some grain, but they usefully kill the insects that can wipe out a harvest. Insect infestations occurred in many provinces.[22] The famine of the Great Leap Forward was definitely made worse by this campaign. When the result could no longer be denied, the fourth targeted pest – sparrows – was changed to bedbugs.

The years 1956–7 saw some respite from the constant demands of political mobilization and censorship. Counter-revolutionaries had been weeded out; the first five-year plan had succeeded, social equalization was progressing under property redistribution and family reform laws, and the potentially hostile intellectual groups – teachers, artists, writers and scientists – were supporting national construction. The CPC leadership thought they could relax a bit, allowing some open expression of opinions. The Hundred Flowers Movement (*Baihua yundong*) was publicly launched in 1956, when Mao proposed a policy to 'Let a hundred flowers bloom, a hundred schools of thought contend' in the arts and sciences. The early response from intellectuals was guarded. In February 1957, Mao published a speech entitled 'On the Correct Handling of Contradictions among the People', wherein he encouraged 'constructive' criticism, open discussion and practical work to settle questions of right and wrong in the arts and sciences. He declared that it is both futile and harmful 'To use crude methods dealing with ideological questions . . . You may ban the expression of wrong ideas, but the ideas will still be there.' Mao seemed confident that 'right' ideas would inevitably win out.

Much of the art produced during this brief period of liberalization was non-political. Artists were encouraged to use various forms and styles, not just Socialist Realism. Traditional ink paintings were exhibited, including landscapes

and bird and flower works. Individual style was fine, as long as the subject was positive. Art from Greece, France, Mexico and Japan appeared in Beijing. Artists were promised better pay and working conditions.[23] The poster in illus. 160 was produced during this happy interval. It celebrates the opening of a new train line to Xiamen. With perspective that calls to mind a Hiroshige print, the main motifs are a banana tree and two large rosettes with ribbons congratulating the railway workers; the actual train hardly features. Such posters were a far cry from the Socialist Realist imagery of much 1950s propaganda. A notable feature of such non-political posters is the varied typography of the slogans. Most posters state their message in standard print characters, but these are artistic and expressive, sometimes reverting to the graphically dynamic and experimental 1930s. Although many posters from that time survive, there seem to be few specifically promoting the Hundred Flowers Movement.

Following Mao's 'Contradictions' speech, a storm of criticism erupted. Students organized protests and hung negative posters; writers and scholars complained about CPC cadres' attitudes and behaviour and questioned the very idea of one-party rule. Mild criticism would be tolerated, but no one had expected this outpouring of condemnation. By May 1957, the criticism was being directed at Mao himself.

That didn't last long. In June, the 'Anti-Rightist' campaign began. Hundreds of thousands of intellectuals and technocrats were criticized, humiliated, stripped of their posts and sent to the countryside

160
**Wang Hui**

*Celebrate the Victorious
Opening of the Yingsha
Railway*, 1957

opposite:

161
**Yang Keyang, Dao Mouji,
Ding Hao, Qian Daxin**

*Smash the Rightists' Furious
Offensive, Defend the Socialist
Construction*, 1957

to be rectified. Some of the most important revo-lutionary artists received this treatment, including Jiang Feng (1910–1982), Yan Han (1916–2011), Mo Pu (illus. 153) and Zhang Ding (illus. 151). All were figures whose loyalty and political commit-ment should never have been questioned. Julia Andrews, who gives a precise, detailed account of the Anti-Rightist Movement, wrote:

*The Anti-Rightist Campaign in the art world arose from a conjunction of political, personal, and artistic factors. To this day, even artists and administrators who participated firsthand are not entirely clear about why it happened and what its ramifications are.*[24]

Some scholars say that the Party was too confident about the progress of socialist construction and was shocked by the torrent of criticism. Others say that Mao allowed the criticism of the Hundred Flowers until it was directed at him, at which point it had to be stopped. Still others say the whole thing was a trap planned by Mao to lure critical artists and intellectuals out of hiding and get them out of the way for good. Perhaps one day we'll know.

For such a far-reaching campaign, there seem to be few surviving graphics. This rare poster from 1957 is in two separate parts (illus. 161): the left side shows, in cartoon style, the 'furious offensive' of the Anti-Rightists. On the right, a worker armed with a book of Marxism-Leninism smashes the villains and upholds the goal of socialist construc-tion. Them and us; villains and heroes – a common device of communist posters. The poster was the collaborative work of four artists, in two parts that do not stitch together. The messages are clear, but the artistic intent is not.

Clearly the revolution had a long way to go. Mao firmly believed that political mobilization was a better route to socialism than technology. He launched the Great Leap Forward in 1958, with the directive to 'Go all out, aim high, achieve greater, faster, better and more economical results to build socialism.'

The poster of white horses soaring above an industrially developed China is a good example of the imaginary type of poster from this period (illus. 163). The horses' ribbons are labelled 'More, faster, better, cheaper', and the front horse breaks right through the frame of the picture. Magical and auspicious motifs – dragons and phoenixes, *ruyi* clouds – abound in propaganda images. Fanciful imagery – children flying on huge ears of corn, a man rowing a pumpkin-boat – evoke papercut fantasies and other folk arts.

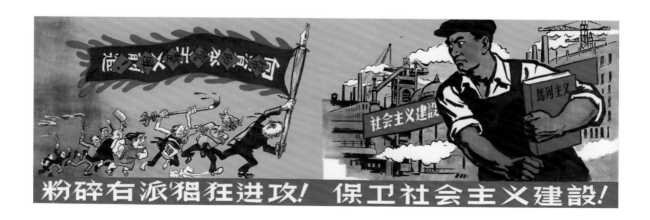

189

The Great Leap Forward was meant to propel China's agricultural and industrial production, known as the policy of 'walking on two legs'. One specific goal was to surpass British steel production within fifteen years. Poster imagery was colourful and celebratory. Two posters, by different artists and issued by unrelated publishing houses, present similar beribboned symbols of soaring grain and steel production (illus. 162, 164). Implied in the first, explicit in the second, the defining form in both these posters is the satellite. The Soviets launched their first satellite in 1957, and China was determined to follow. The term '*fang weixing*' (launch a satellite) was used everywhere to mean 'Go all out'. The slogan on a different edition of illus. 162 uses that dynamic expression, rather than the more prosaic call here to 'bring in a big harvest'.[25]

The Great Leap Forward entailed extraordinary mobilization efforts at every level. An important organizational change was the establishment of communes, consolidating many agricultural cooperatives into huge political and economic entities. Nearly 27,000 had been established by the end of 1958, each consisting of about 5,000 families. Ubiquitous posters promoted them as all-inclusive, efficient, convenient places. *Establishing People's Communes and Speeding Up Socialist Construction* marks where everything is – the communal kitchen, nursery, culture and leisure facilities, equipment repair shop – in a rather sweet, collaborative design led by the former commercial artist Cai Zhenhua (1912–2006) and others (illus. 184). It was possibly

162
**Zhuang Qilai and
Yang Wenxiu**
*In the Agricultural Great
Leap Forward, Everyone
Bring in a Big Harvest*, 1958

opposite:

163
**Central Industrial
Arts Academy**
*Go All Out, Aim Higher and
Gain Greater, Faster, Better
and More Economical Results
in Building Socialism*, 1958

向全国钢铁战士們致敬

为超额完成1070万吨钢而欢呼

made to be displayed in schools. Many posters were reproduced from paintings and many showed commune farmers or industrial workers on a mission, succeeding in all things against enormous odds. Such pictures were in the newly prescribed style known as 'Revolutionary Romanticism'.[26]

All-out deployment in the Great Leap Forward extended, of course, to cultural production. From this time on, posters became the dominant format of propaganda art in China. Although posters had furthered every political movement and campaign since 1949, and the first professional poster team was organized in 1954, it was not until the Great Leap Forward that this format eclipsed the smaller-format popular prints (nianhua).[27] The Tianjin Fine Art Publishing House – one of many production and distribution entities – is a case where comparative statistics are available which clearly indicate the new direction:

|      | Nianhua[28] | Posters[29] |
|------|-------------|-------------|
| 1957 | 4,700,000   | 144,000     |
| 1958 | 8,100,000   | 13,200,000  |

Several things account for the massive increase in poster publishing. Posters could be designed and printed in as little as ten hours, and so reflected new policies immediately, monitored by editors at every step.[30] Nianhua, on the other hand, were produced in great batches, mostly for the New Year festival. In any case, nianhua had not achieved politically correct success. A conference on the problems of nianhua work in 1958 focused on the poor reception

of 'reality' prints – that is, those reflecting the lives of workers, peasants and soldiers. In 1958, 76.4 per cent of the Tianjin production comprised traditional subjects – gods and guardians, calendars and fat babies; only 2.6 per cent were 'reality' nianhua.[31]

A conference on poster production was held in 1959, in coordination with a ten-year poster retrospective. The authoritative catalogue, Ten Years of Propaganda Posters, emphasized the importance of this mass, militant art form in every political movement:

*Propaganda posters, with their simple, lively forms and bright powerful images as well as their high volume printing and circulation throughout the whole nation, publicize the principles and policies of the party and government to the multitude of the masses. This unique form of art, the propaganda poster enables the policies of the party and government to open the door to the hearts of the people and inspire their utmost efforts.[32]*

'Simple, lively and bright' describe popular forms – folk arts – not the imagery of Socialist Realism. The conference called for the incorporation of traditional elements, tacitly acknowledging that, as with nianhua, the contemporary messages were not being accepted in the new style.[33]

During the Great Leap Forward, amateur art was fostered in communes, factories and army units. Amateurs painted murals on internal and external walls, an ideal format, seen from afar and requiring few resources. This was important because by 1959, paper was in very short supply, as was everything else. The amateur artist shown in

164
**Shen Lin and Lu Xingchen**
*Celebrate Surpassing the Steel Production Target of 10,700,000 Tons*, 1958

illus. 165 paints the imaginary. Far simpler artistically, but just as heroic, this climber overcomes obstacles to build socialism, just like the Socialist Realist conqueror in illus. 182. The scene also includes huge fruit and grain among magic clouds. The poster's slogan reads: *We Are Creators of Material Wealth and Also Creators of Human Civilization*.

While participation was required, rather than entirely voluntary, the amateur art campaign proved very effective in some places.[34] Idealism and enthusiasm ran high in agriculture, industry and public works construction, too – in the beginning. The first months of the Great Leap Forward saw extraordinary increases reported in production and public works projects. 'An orgy of inflation' resulted in ever-higher targets, with mismanagement of labour and material inputs in every county.[35] Enormous environmental damage and waste of resources ensued from centralized policies executed in unsuitable local conditions. Catastrophic famine resulted.[36]

By early 1959, it was clear that the Great Leap Forward had failed. Mao Zedong resigned as president, but retained the chairmanship of the Party and continued to exercise power. The worsening starvation was denied, and crop procurements increased everywhere – not just to support urban industrial development, but actually to increase exports.[37] At the end of 1960, measures were finally taken to deal with the famine, and by 1962 conditions had improved.

During the famine years, propaganda denied the ever-growing chasm between slogan and reality. Abundance is everywhere in posters, showing the

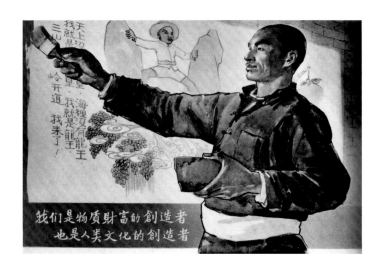

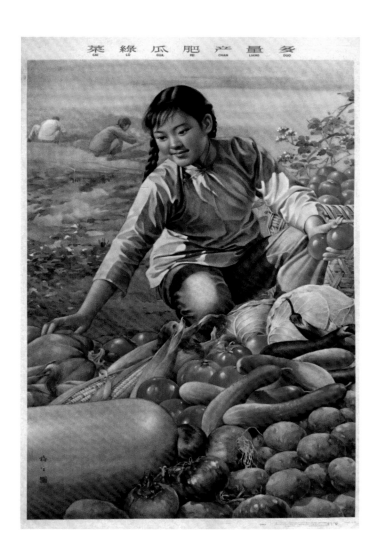

top:

165
**Cao Jianfeng**
*We Are Creators of Material Wealth and Also Creators of Human Civilization*, 1958

bottom:

166
**Jin Meisheng**
*The Vegetables Are Green, the Cucumbers Plump, the Yield is Abundant*, 1959

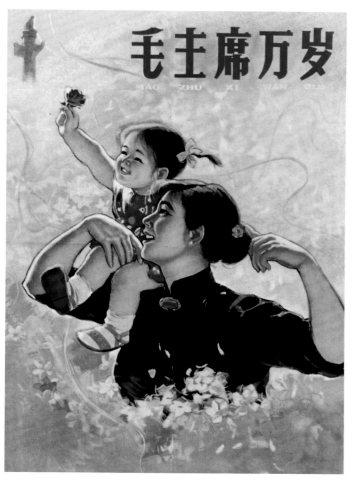

**167**
Ha Qiongwen
*Long Live Chairman Mao*, 1959

168
Reverse of illus. 169

world how it should be – or would be. Well-fed, rosy-cheeked Pioneers cultivate a vegetable garden, in a children's version of Jin Meisheng's more famous work featuring a bucolic beauty (illus. 185, 166).[38] Wu Zhefu's brighter, blue-sky poster is complete with sunflowers, a symbol of loyalty to Chairman Mao, the sun.

The first of October 1959 was the tenth anniversary of the establishment of the PRC and, naturally, many posters commemorated that great event. By this time the glorification of amateur art had waned, and professionals were clearly in charge of the commemorative propaganda. Perhaps the most important anniversary poster, and certainly the most popular, was designed by Ha Qiongwen (1925–2012). Entitled *Long Live Chairman Mao*, the image was approved with no political content, apart from the slogan and a small, pale column signifying Tiananmen (illus. 167). The image shows a very attractive woman and her happy, well-fed daughter, surrounded by a field of pink flowers. The woman is glamorous, wearing a *qipao* and jewellery. The two million available copies sold out quickly.[39]

Many other non-political works were published at this time. The failure of the Great Leap Forward was belied by a host of optimistic images. Artists were encouraged to produce works of varied subject-matter, including landscapes, birds and flowers and still-life. A more liberal atmosphere made room for art to give pleasure and delight. Provided the work did not run counter to the socialist path, many themes and styles were allowed.[40]

This less politically demanding policy lasted until the early 1960s. Posters with family scenes

and secular pursuits were published and were well received. Workers and peasants were shown at leisure, as in a folksy poster from 1963 (illus. 169). The harvest has been good, judging by the pile of pumpkins. The villagers are eating, smoking and chatting, while children play with toys. The electric light and the Thermos show that life is getting more convenient. With politics back in command during the Cultural Revolution, however, the reverse of this poster was used to write a big character poster (*dazibao*), criticizing the famous artist Qi Baishi (1864–1957; illus. 168).

The wind changed again with the launch of the Socialist Education Movement. This was also known as the Four Cleanups Movement, referring to politics, economics, organization and ideology. Mao had been sidelined following the famine resulting from the failed policies of the Great Leap Forward. Under President Liu Shaoqi's direction, education and production had shifted away from 'red' to 'expert', or from revolutionary to pragmatic. It was apparent to Mao, however, that corruption had contaminated the CPC and threatened a return to capitalism. Cadres no longer served the masses, but enriched themselves. To root out bourgeois elements and creeping bureaucratism, intellectuals were once again sent to work alongside the masses, and school timetables were modified to accommodate production schedules.

Liu Shaoqi and other Party leaders did not disagree with the *aims* of the campaign, but with its execution. Mao's strongest support in carrying out his plans was in the People's Liberation Army (PLA), led by Lin Biao (1907–1971). The Army became prominent in all media in the early to mid-1960s. Films, painting exhibitions and posters highlight the role of the PLA: not just as liberators from the Japanese and nationalist oppressors, but as comrades in production and ideological role models.

The favourite PLA hero/model was Lei Feng (1940–1962), who remains a cultural icon in the twenty-first century. Lei Feng was an orphan brought up by the Party. He joined the Army with the fervent goal, he wrote, to be 'the revolutionary screw that never rusts'. He gave his money to the needy, taught children, tended old people and washed his comrades' socks. He died in a freak accident, aged 22, when his best friend backed into an electrical pole that fell on him. The following March, as part of the Socialist Education Movement, Chairman Mao urged all to 'Learn from Lei Feng', symbol of selflessness and voluntarism. Fortunately, it was 'discovered' that Lei Feng had kept a diary of his daily good deeds, which was then published and widely distributed. He has been invoked on numerous occasions since, to inspire people with his revolutionary spirit. *Chairman Mao's Good Soldier – Lei Feng* shows him in 1964, looking rather sweet (illus. 186). He carries the *Collected Works* of the Chairman and a bayonet, so is fully prepared to support the revolution's goals. He also has a ballpoint pen, a mark of material progress.[41] He stands against a background of sunflowers, marking his loyalty to Mao.

The Socialist Education Movement failed in its aims and exacerbated Mao's opposition to President Liu Shaoqi and politburo member Deng Xiaoping (1904–1997). In the summer of 1966,

169
**Chen Guangjian
and Liu Wenxi**
*At the Commune Member's
Home*, 1964

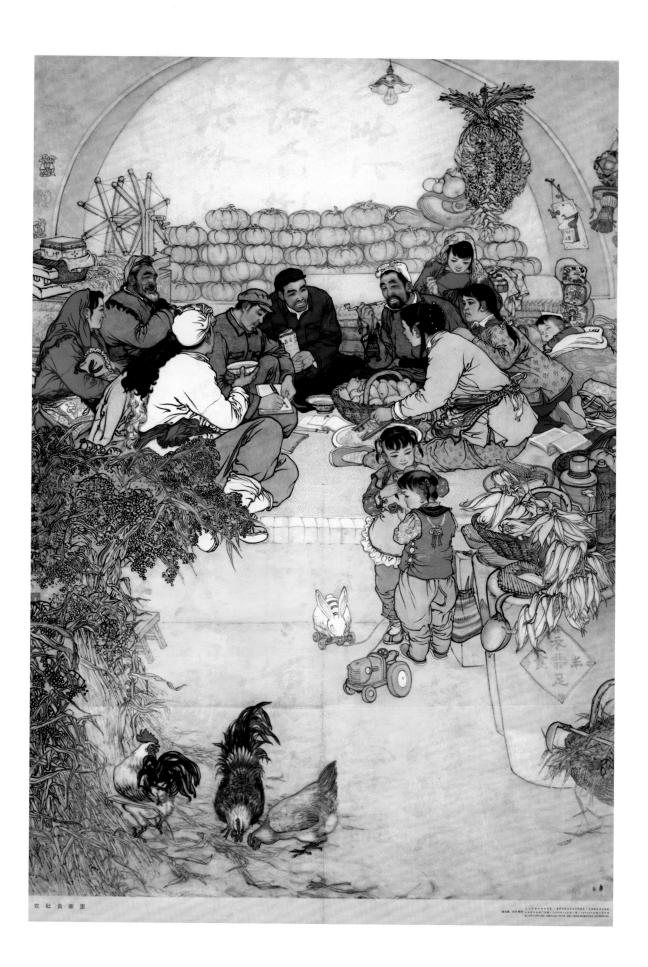

在社员家里

supported by Lin Biao, the PLA and millions of
students, Mao launched the Great Proletarian
Cultural Revolution to reverse bureaucratization,
revive the spirit of revolution and take back power
in the CPC.[42] That is a short, very simplistic expla-
nation for a highly complex, enormously disruptive
decade whose consequences still reverberate.

The Cultural Revolution wrought an explosion
of propaganda, even by the standards of previous
Chinese campaigns. There was some variety in
poster art, though much of it was repetitive in style
and theme, and seems more so today, when viewing
collections focused on those years. All cultural
activity was political, whether ink or oil painting,
graphic, sculpture or performance arts. In terms
of production, the period can be divided into two
phases: Red Guard art, 1966–8, and worker-peasant-
soldier art, from about 1970 to 1976.

The first two years were chaotic, violent and
destructive. Red Guards, and later worker-peasant-
soldier groups, produced thousands of black, white
and red posters, which looked back stylistically
to the revolutionary woodcuts of Yan'an. These may
be the most familiar posters to non-Chinese viewers.
They often carried violent slogans and imagery.
'Smash, destroy, wipe out, sweep away' capitalist
roaders, Liu Shaoqi, reactionaries, the Four Olds
(old ideas, culture, customs and habits) and anyone
or anything else the Red Guards chose to go after.
The Red Guard in illus. 187 is smashing the old
world to establish a new order.

The year 1968 saw student protests, revolution-
ary movements and repression in many countries
(Vietnam, Japan, France, Czechoslovakia, Poland,

top:

170
**Anonymous**
*To the Villages We Go, to the
Borders We Go, to Places in
the Fatherland Where We Are
Most Needed We Go*, 1970

bottom:

171
**Zhao Youcheng
and Men Guang**
*Firmly Support the American
People Who Oppose the
U.S. Imperialist Invasion of
Vietnam*, 1966

Mexico, the USA). Chinese propaganda took an international stance. Posters, many produced for export, supported radical movements and attacked imperialism. The best known of this type oppose the American invasion of Vietnam (illus. 171); others promote the struggle for civil rights. Despite the chaos within, Chinese propaganda projected a leadership image in the developing world, offering an alternative political and economic model.

Things had got so out of control by the summer of 1968 that Mao sent the PLA to restore order. Over the next year, the country came under administration by revolutionary committees.[43] The Red Guards were effectively demobilized, and Mao sent millions of them to the countryside to be 're-educated' by the peasants. This was a life-changing experience for millions of young people – good or bad – as they themselves became workers, peasants and soldiers.[44] *To the Villages We Go, to the Borders We Go, to Places in the Fatherland Where We Are Most Needed We Go* shows a crowd of dedicated young revolutionaries ready to serve wherever the fatherland needs them (illus. 170). While some found this time inspiring and revealing, most were totally unprepared for the years of hardship and drudgery they met. Hundreds of thousands of artists and intellectuals were also 'sent down' to engage in hard labour. Many never recovered.

Work had ceased at most professional art studios at the start of the Cultural Revolution. With professional teams disbanded, an important source of posters was paintings. Posters were reproduced from Socialist Realist/Revolutionary Romantic works, in oils or in Chinese ink and brush. The best known of these is Liu Chunhua's (b. 1944) *Chairman Mao Goes to Anyuan* (illus. 172). Painted in 1967 by a Red Guard art student with others, this became a 'model work' of the Cultural Revolution. It contributed to the increasingly worshipful cult of Mao Zedong, and 900 million copies of this one image were ultimately distributed, as newspaper supplements and then as posters.

The Mao cult was like no mass movement ever before. Mao's image appeared on billions of posters and badges. Everyone carried and chanted the 'Little Red Book' of *Quotations from Chairman Mao Zedong*. Mao was the ubiquitous and omnipotent heroic leader, the great helmsman and the 'reddest red sun in our hearts'. In illus. 175, Mao appears gigantic, high above the masses, with brush in hand. This is Mao as calligrapher-poet and, importantly, as teacher.

Mao's wife, Jiang Qing (1914–1991), took control of culture. She promoted revolutionary operas and ballets almost exclusively as model works, and pictures of the performances were reproduced as posters. Many of the central figures in the poster commemorating the Yan'an Forum (see illus. 181) are heroic characters from the revolutionary operas. Her requisite formula was 'red, bright and shining' (*hong, guang, liang*) and followed the concept of 'the three prominences' (*san tuchu*): give prominence to positive characters; of the positive, stress the heroic ones; and of the heroic characters, give prominence to the central one. The composition should be pyramidal, with the main hero central to the action and supported by the secondary heroic characters. Illus. 170 and 175 satisfied all these requirements.

199

Jiang Qing also approved of and displayed large-scale oil paintings of heroic characters and events, which were then reproduced and circulated as posters. One such work, painted by Shen Jiawei (b. 1948), was altered for exhibition without telling him. *Standing Guard Over Our Great Homeland* depicts three soldiers on the Sino-Soviet border (illus. 188). The changes made the soldiers' faces ruddier, healthier and more heroic. The poster was made from the altered version.[45] Many such works appeared in the early 1970s.

'Amateur' and 'spare-time' art became a political movement in itself, as well as an international phenomenon. Pixian County, Jiangsu, had been the focus of this activity during the Great Leap Forward (see illus. 165), but those groups had mostly disbanded. In the 1970s, Huxian County, Shaanxi, served as the model. Well-received paintings were circulated as posters. The worker-peasant artists painted their world in idealized form – animals, harvests and celebrations – but they had to stick to approved subjects, and many works had explicitly political themes. It was later acknowledged that professional artists were very much involved in this activity.[46] *The Brigade Clinic* (illus. 189) appears to mix professional and amateur work. The foreground, with its perspective and clean design elements, is entirely different from the flat, simple, childlike forms of the rest of the image.

Yet another type of Cultural Revolution poster relied on traditional techniques and formats. Paper-cuts were part of the Yan'an propaganda repertoire, but appeared increasingly as full-size posters from the late 1960s. Sometimes they presented a unified image of a single subject, like the Long March, but often they presented a group of vignettes or portraits.[47]

Harking back to *nianhua*, revolutionary heroes appeared as door gods in 1970s posters. The pair shown here have multiple messages and motifs (illus. 190). Both images celebrate labour productivity, with workers and their modern agricultural equipment, and electricity and factory smoke visible behind the abundant crops. (In fact, production on every economic front had suffered enormously from the disruptions of ceaseless political demands.) The central character in the left panel, armed with a writing brush, is hailed as a pathbreaker in the campaign to criticize Lin Biao and Confucius. His counterpart in the right-hand panel carries a book of articles about that campaign. Lin Biao, head of the PLA, had been Mao's closest deputy and presumed successor in the early years of the Cultural Revolution. He had compiled the *Little Red Book* in 1964 for distribution to all service personnel, and in 1966 it became the icon of revolution for everyone. In 1971, Lin apparently plotted a palace coup, was nearly exposed, and so fled with his family to the Soviet Union; on the way, his plane ran out of fuel over Mongolia and crashed. The facts are still unclear.

In 1973, the 'Criticize Lin, Criticize Confucius' campaign was launched and continued until the end of the Cultural Revolution. Combining those two figures took some pretty complicated manoeuvring with history and ideology (illus. 174). Lin Biao, who had gone after Mao's power, was portrayed as trying to take the throne as emperor.

毛 主 席 去 安 源

一九二一年秋，我们伟大的导师毛主席去安源，亲自点燃了安源的革命烈火。

172

**Liu Chunhua**

*Chairman Mao Goes to Anyuan*, 1968, from a painting of 1967

金猴奋起千钧棒玉宇澄清
万里埃 一九七六年冬赵宏本作

Here he is spinning a web, frantically writing signs and banners, with Confucius by his side. They call for the restoration of capitalism and slavery, and in a quotation from Confucius's *Analects*, for a return to 'the rites'. As with many other fallen heroes, white suddenly became black, and he who had been Mao's chosen was now exposed as having always been evil. Confucius was damned as reactionary, which was in keeping with the original principles of the 1949 revolution. However, this was actually a thinly disguised attack on Zhou Enlai, who died in January 1976. Premier Zhou had been the most effective moderating force against the excesses of the radical Gang of Four.[48]

The Cultural Revolution finally ended when Mao died in September 1976. His successor was Hua Guofeng (1921–2008), who had risen from Party functionary to the politburo. To further his legitimacy, Hua commissioned the well-known painting, which was widely circulated as a poster, showing the meeting where Mao famously (may have) said to Hua, 'With you in charge, my heart is at ease.'[49] Within a month of Mao's death, the Gang of Four were under arrest, eliciting an overwhelming outpouring of joy and relief among the population. A new mass campaign was launched, blaming the Gang for all the horrors of the previous decade. In posters, they were portrayed as Nazis, animals and every manner of villain. *Monkey Thrice Beats the White Bone Demon* (illus. 173) may be an allegory for the fall of Jiang Qing.[50]

Chairman Hua Guofeng did not last very long. He slavishly followed Maoist policies, while other senior Party members wanted to move on – to reform and modernize. Hua tried to remake himself in the image of Mao, as is clear from many posters of 1976–8. In one example, the larger-than-life Chairman Hua stands with raised arm against a sea of red flags, with a 'Learn from Dazhai' sign in the background.[51] It could have been a poster of Mao, simply inserting the image of Hua Guofeng. Many template posters had been produced, changing a slogan here or there, or the image of a central character.

Deng Xiaoping displaced Hua in 1978 and remained China's most powerful leader until his death in 1997, although he never held the title of CPC General Secretary or Premier. Deng avoided the limelight, generally appearing with other

opposite:

173
**Zhao Hongben**
*Monkey Thrice Beats the White Bone Demon*, 1977

174
**Anonymous**
Original artwork for anti-Lin, anti-Kong poster campaign, 1973–4

175
**Anonymous**
*Long Live the Total Victory of
the Great Proletarian Cultural
Revolution*, 1969

leaders, collectively known as the Eight Elders. In 1994, however, a set of posters was produced celebrating *Beloved Comrade Xiaoping*. These are markedly different in style and colour scheme from most propaganda posters. The most interesting among them shows Deng Xiaoping in Paris, where he had worked in the 1920s and been influenced by Marxism-Leninism (illus. 176). The poster, in muted pastel colours, was designed from a photograph of Deng at age sixteen. In later posters and billboards, Deng appears as other paramount leaders did – high above the scene, larger than life, alone and masterful.

**The Four Modernizations**

Deng was the architect of the Four Modernizations – an overarching set of policies that moved China away from the Cultural Revolution and into the future. His reforms were aimed at economic and social development. The programme was pragmatic,

not doctrinaire. Deng enumerated the Four Basic Principles in 1979. These were to uphold the socialist road, the dictatorship of the proletariat, the leadership of the Communist Party and Marxism-Leninism and Mao Zedong Thought.[52] Over the next few years, Mao was reassessed at Party plenums and other forums. The verdict was that Mao had been a great proletarian revolutionary who had made some errors in later years. The cult of Mao was gradually dismantled, along with communes and other leftist elements of the system.

The Four Modernizations were agriculture, industry, national defence and science and technology. These goals were far easier to express visually than the Four Basic Principles. Posters of the Four Modernizations are replete with rockets and spaceships, bullet trains and skyscrapers. This imagery is often combined with national symbols, the message clearly linking patriotism and China's future. Other posters relate the past and the future: a modern *apsaras* and a symbol for atomic power make for a mixed metaphor in illus. 191.[53]

opposite:

176
**Lei Wenbin**
*Beloved Comrade Xiaoping's
Paris Quest*, 1944

敬爱的小平同志——巴黎求索

*Congratulate the Gansu Province Federation of Trade Unions on Its 40th Anniversary* is a comparatively unsophisticated provincial product, but includes many elements of Four Modernizations propaganda. Urban workers, modern structures and a satellite dish signal economic advance. Doves have returned, referencing a wish for peace in the larger world with which China now actively engages.

In the 1980s, spiritual pollution, the evil wind of corruption and bourgeois liberalization were themes in propaganda campaigns. Posters documented these issues, but they were less intense and less effective than in the Mao years. Politically, socially and economically, the state was far less intrusive in people's daily lives. People were apathetic to politics after decades of unrelenting propaganda and required activism. Posters showed non-political aspects of a more comfortable, secular life – enthusiastic customer service, beautiful women, young people on motorcycles or dancing – finally acknowledging people's desire for consumption and fun. Also important were new mass media and sources of information which had never been available. The various agencies of political and creative culture were not all formally coordinated. Films, art exhibitions, commercial advertisements and international news outlets all played their part in changing attitudes and perceptions, in ways unanticipated by the authorities. Some artists were expressing dissent in a limited fashion.[54]

Children remained a primary target for propaganda posters, for several important reasons. Modernizing science and technology required a well-educated population, and a decade had been

177
**Anonymous**
*The Gods of Wealth Enter
the Home from Everywhere.
Wealth, Treasures and Peace
Beckon*, 1933

lost to the Cultural Revolution. Children were encouraged to achieve academic excellence, to link their efforts with national cultural figures such as Lu Xun and Lei Feng (illus. 192). *Study as Hard as Lei Feng* shows a progressive girl with eyes to the future and modern lab equipment, inspired by the model of selfless determination and revolutionary spirit – who almost certainly never studied chemistry.

Other educational posters promoted social norms, including the Primary School Pupils' Behavioural Standard (1987) and the Four Loves (classmates, teachers, the collective and the environment) in 1998.[55] Social propaganda in the 1990s and early 2000s dealt with issues such as health, traffic laws, the environment, providing good customer service and family planning. The one-child policy was adopted in 1979 and was considered vital for economic development. Posters such as *Strive to Fulfil the Ten-year Population Programme and the Eighth Five-year Plan Population Programme* (illus. 193) present the happy family of the future, signified by rockets and skyscrapers. Of course the propaganda child is a girl, since China was still fighting the traditional preference for boys. Those are long-term campaigns, for still-relevant issues. The end of the one-child policy was announced in 2015, but campaigns related to education and environment are ever more prominent.

Traditional iconography reappeared in many propaganda posters of the 1990s and 2000s. Fat babies, fish, peaches, peonies and pots of treasure welcome the new year and promote economic development and prosperity. *The Gods of Wealth*

*Enter the Home from Everywhere* is replete with such symbols, along with a stack of U.S. dollars (illus. 177). No signs here of Marxism-Leninism or Mao Zedong Thought.

It was hard to find political propaganda posters for several years in the late 1990s and early 2000s. The 2008 Beijing Olympics generated a storm of national imagery, much of it for foreign visitors. From about 2010, wall posters used classical language and Confucian references to invoke the 'Chinese spirit' and traditional cultural values. In the Xi Jinping era, the nationalist ideology is articulated in his slogan, 'China Dream', or the 'Chinese Dream':

*The Chinese Dream integrates national and personal aspirations with the twin goals of reclaiming national pride and achieving personal well-being. It requires sustained economic growth, expanded equality and an infusion of cultural values to balance materialism.*[56]

China Dream posters are everywhere: individually or in series, on walls and street hoardings, in stations, airports, schools and offices. Three examples illustrate the range of these ubiquitous graphics. Some use paintings by well-known artists, such as Li Keran (1907–1989) or Feng Zikai (1898–1975) (illus. 178). These promote traditional values. The example shown here is called *Great Virtue China*, with the 'China Dream' slogan below. To the left of the painting are twelve qualities encompassed in the vision. According to some reports, these expressions of virtue are recited every morning in school.[57]

大德中国

中国梦

富强、民主、文明、和谐。
自由、平等、公正、法治。
爱国、敬业、诚信、友善。

西安市文明办 临潼区文明办 秦始皇帝陵博物院 宣

above:

178
**Anonymous**
*Virtuous China, 2015*, 2015

with painting by Feng Zikai.
Xi'an, Shaanxi

没有共产党
就没有新中国

共产党辛劳为民族，共产党他一心救中国，
他指给了人民解放的道路，他领导中国走向光明

西安市文明办 临潼区文明办 秦始皇帝陵博物院

left:

179
**Anonymous**
*Without the Communist Party,
There Would Be No New China*,
2015

Luoyang, Henan

A further type of poster is decorated with papercuts, farmer paintings and folk motifs. Children appear in a great many of these posters, sometimes with a simple 'China Dream' slogan, sometimes with more explicitly political messages. The children in a street poster sing a song known to all and sung for generations: *Without the Communist Party, There Would Be No New China* (illus. 179). There may be no mention of Marx or Lenin in these posters, but loyalty to the Communist Party remains an essential tenet of Chinese political culture and ideology.[58]

As noted at the start of this essay, Xi Jinping has brought back some of the principles and practices of the Mao era. Campaigns have been enacted assailing corruption and promoting discipline. Tighter controls have been imposed in the arts and social media. The final poster shows a return to the language and imagery of the revolution (illus. 180). It features Mao Zedong and his closest comrades at Xibaipo, the military headquarters in the last stages of the War of Liberation (Civil War). The calligraphy is Mao's, with his famous slogan from those years, just as the communists were on the verge of victory: 'We must continue adopting the attitude of being cautious and modest in our endeavours, and we must also continue our style of hardworking and constant struggle to achieve our goal.'[59] Above are the current mantras: 'Chinese spirit', 'Chinese form', 'Chinese culture' and 'Chinese expression'. As China stands on the verge of new victories, it is nationalism – communism, Chinese-style – that frames the political discourse of this generation.

above:

180
**Anonymous**
*We Must Continue Adopting the Attitude of Being Cautious and Modest in Our Endeavours, and We Must Also Continue our Style of Hardworking and Constant Struggle to Our Goal,*
2015

Xi'an, Shaanxi

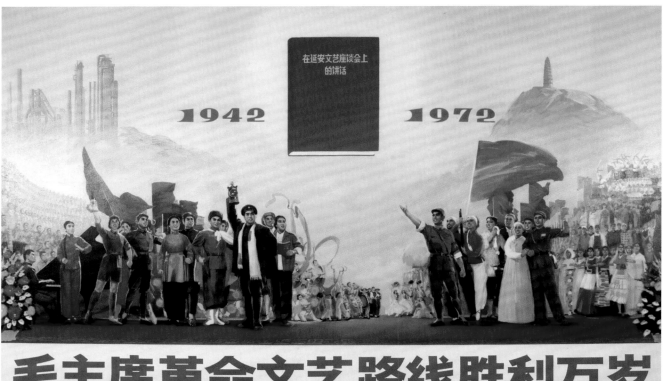

在延安文艺座谈会上的讲话

1942 1972

毛主席革命文艺路线胜利万岁

181
**Anonymous**
*Long Live the Victory of
Chairman Mao's Line on
Revolutionary Literature and
Art*, 1972

opposite:

182
**Yu Yunjie and Zhao Yannian**
*Overcome All Difficulties to
Build Socialism*, 1955

戰勝一切困難
建設社會主義

麻雀多在屋簷、墙窟窿、樹洞里做窝。一只麻雀一年要吃四斤糧食，一对麻雀每年能孵出三、四十只小麻雀，糟蹋的糧食就更多了。为了增產和節約糧食，我們一定要徹底消滅麻雀。

消滅麻雀，可用套夾打、膠粘、籠子扣、竹弓打、網捕，这些都是简單有效的方法。也可以在晚上打着电筒掏雀窝，把大小麻雀和麻雀蛋一起掏出來，然后用碎磚、泥灰堵窝。掏窝时要注意防止發生摔伤和火灾事故。

刘繼卣作 中华人民共和国卫生部宣传局出品

183
**Liu Jiyou**
*Everyone Get to Work
Eliminating Sparrows*, 1956

opposite:

184
**Cai Zhenhua and others**
*Establishing People's
Communes and Speeding Up
Socialist Construction!*, 1958

# 大办人民公社,加速社会主义建设!

185
**Wu Zhefu**
*Schoolchildren Grow a
Vegetable Garden*, 1962

opposite:

186
**Chen Ziyun**
*Chairman Mao's Good
Soldier – Lei Feng*, 1963

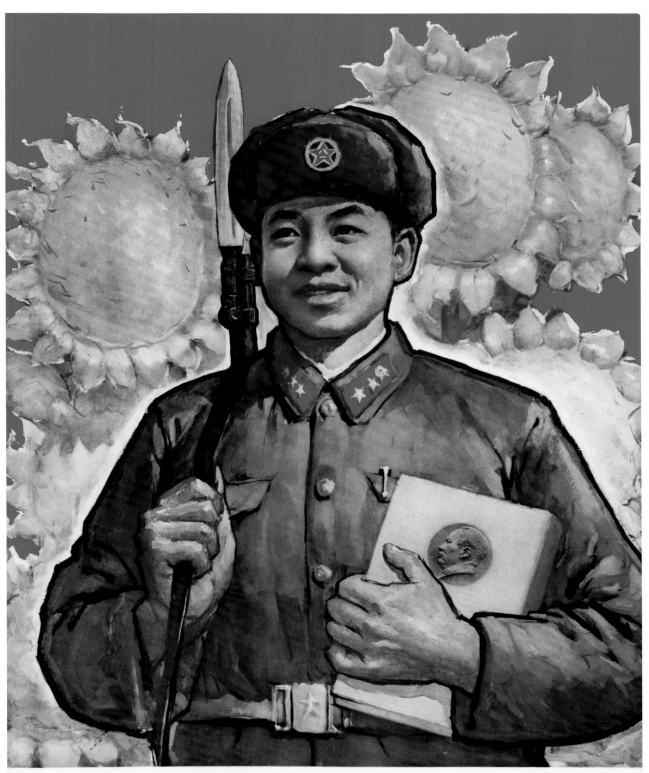

毛主席的好战士——雷锋

187

**Central Academy of
Fine Arts Woodblock Print
Combat Group**
*Smash the Old World. Establish
the New World*, 1967

188
**Shen Jiawei**
*Standing Guard Over Our
Great Homeland*, 1974

190
**Zhao Junjie**
*A Pathbreaker Criticizing*
*Lin and Confucius; Labour*
*Productivity Model*, 1974

opposite:

189
**Li Zhengxuan**
*The Brigade Clinic*, *c.* 1973

191
**Anonymous**
*Congratulate the Gansu
Province Federation of Trade
Unions on Its 40th Anniversary*,
1990

祝贺甘肃省总工会成立四十周年

| | | | | | |
|---|---|---|---|---|---|
| 国营四〇四厂工会 | 兰州电机厂工会 | 甘肃黄羊糖厂工会 | 兰州棉纺织厂工会 | 兰州电力修造厂工会 | 编 者 甘肃省总工会宣教 |
| 西固热电厂工会 | 兰州钢厂工会 | 甘肃酒泉糖厂工会 | 兰州第一毛纺厂工会 | 解放军3512工厂工会 | 设 计 朱志勇 |
| 盐锅峡电厂工会 | 国营长风机器厂工会 | 白龙江林业管理局工会 | 兰州第三毛纺厂工会 | 西北油漆厂工会 | 印 刷 解放军7219工厂 |
| 碧口水电厂工会 | 甘肃长城电器工业公司工会 | 铁道部第一勘测设计院工会 | 兰州生物制品研究所工会 | | 准印证号（90）024号 |

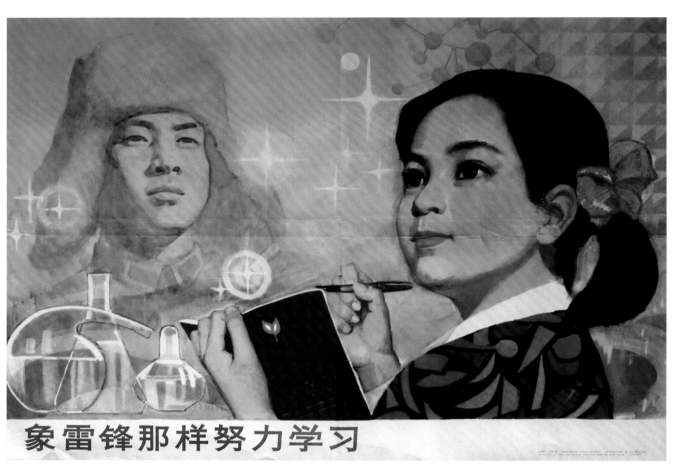

192
**Shi Qiren**
*Study as Hard as Lei Feng*, 1982

为实现十年人口规划和"八五"人口计划而奋斗

　　"八五"期间，要继续严格控制人口增长。主要措施是：坚决稳定和贯彻落实现行计划生育政策，提倡晚婚晚育，少生优生，把工作的重点放在农村。继续加强领导，全面推行计划生育目标管理责任制。要通过加强思想教育，建立社会保障制度，把计划生育变成群众的自觉行动。切实保证计划生育经费的正常需要，继续增加避孕药具的生产和供应。大力研制和推广应用安全长效的新型节育绝育技术和药具。加强计划生育人员的培训，抓好各有关部门对计划生育的协作共管。

摘自《中华人民共和国国民经济和社会发展十年规划和第八个五年计划纲要》

193

**Anonymous**
*Strive to Fulfil the Ten-year
Population Programme and
the Eighth Five-year Plan
Population Programme*, *c.* 1991

# 5 Democratic People's Republic of Korea, 1948–

**Koen De Ceuster**

On 11 February 2015, just a few days short of Kim Jong Il's birthday, the *Rodong Shinmun* (Workers' Newspaper) published a joint declaration of the Central Committee of the Korean Workers' Party (KWP) and the Central Military Committee of the KWP. This declaration contained a list of 310 slogans in anticipation of the seventieth anniversary of the founding of the Democratic People's Republic of Korea (DPRK, 9 September) and the seventieth anniversary of the founding of the KWP (10 October).[1] In international media, this announcement was met with the habitual derision that reduces North Korea to the anecdotal and exotic.[2] For a joint meeting of the Central Committee and the Central Military Committee to sign off on such an apparently mundane subject is, however, a clear indication of the relative importance slogans have in North Korea's political life. Indeed, such slogans are the bedrock of the country's propaganda and agitation apparatus, and as such they are a crucial cog in the machinery that ideologically ties citizens to the Party.

A poster published a decade earlier, on the occasion of the sixtieth anniversary of the founding of the KWP – when a similar set of slogans had been published – visually supports the driving power of slogans in the country's political life (illus. 214). The main figure in this poster is a Party

worker clutching a red folder containing the joint slogans, calling for an all-out effort towards their realization. The Party worker, typically in charge of ideological mobilization at a workplace, towers over a group of male and female workers with their respective props – iconic representations of the various economic sectors addressed in the slogans.[3] Interestingly, this iconic group is shown here as a single-coloured cut-out, explicitly referring to a poster replication. The Party emblem sits as a sun high in the sky, shining its golden light over a utopian North Korean landscape depicted by a combination of an industrial and urban skyline. The overall result is a smooth, evenly coloured poster dominated by the agitational pose of the Party worker.

The political DNA of the DPRK was created in the course of Korea's long twentieth century – a history of confrontation with Western imperialism since the 1860s, fully fledged Japanese colonization from 1910 and post-liberation division since August 1945. In a context of ongoing domestic and international political, economic and social upheaval, the 1917 Russian Revolution inspired Korean activists at home and among émigré communities in Japan, China and the Soviet Union. With Japan's sudden capitulation on 15 August 1945, Korean communists started to make their way home from the USSR

194
**Pak Sang-nak**
*Long Live the 14th Anniversary
of the Founding of the DPRK!*,
1962

225

and from areas under CPC control, or were simply released from prison in Korea.⁴ All came with their own experiences and interpretations of communism. Some had lived under Stalin's wartime mobilization; others had joined Mao Zedong on his Long March and experienced at first hand his revolutionary experiments in Yan'an. Still others were released from Japanese prisons in Korea, victims of colonial repression of their revolutionary social activism. Fuelled by the release of political prisoners and exhilarated by the sudden collapse of Japanese colonial authority, all the pent-up revolutionary fervour burst forth and was channelled by grass-roots people's committees.

Days prior to Japanese surrender, the U.S. had proposed to divide Korea into two military occupation zones to oversee the handover of power. Under this agreement, Soviet troops entered Pyongyang on 24 August 1945 and eventually established a Soviet Civil Administration to coordinate and consolidate the local people's committees. This resulted in the establishment in February 1946 of one centralized North Korean People's Committee – a provisional government under the leadership of Kim Il Sung and the precursor to the formal establishment of the DPRK on 9 September 1948. The intention of the USSR was to establish a client state, its institutions modelled by Soviet Korean advisers after the Soviet Union and its leaders malleable to Soviet interests. Lacking the experience, the expertise or the means of running a country, North Korea's leaders initially looked up to and depended on Soviet advice (see illus. 212). They wholeheartedly accepted Soviet material and

managerial help in establishing and running their revolutionary state, inspired by and modelled after the Soviet Union. However, sensitive to imperialist behaviour, Korea's anti-colonial revolutionaries eventually came to resent Soviet meddling and high-handedness.

This also applies to Kim Il Sung (1912–1994). During the 1930s, Kim Il Sung had made a name for himself as an anti-Japanese partisan in Manchuria, and after 1935 as commander of an all-Korean division of the CPC-organized Northeast Anti-Japanese United Army. In 1941, Kim Il Sung retreated to the USSR, where he was incorporated with the remainder of his partisan unit in the 88th International Brigade of the Red Army. Rather than being mobilized in the liberation of Korea, Kim Il Sung reached Korea a full month after Japan's capitulation, with the Soviet authorities already planning his political future. Rather than the malleable Soviet-trained officer they had in mind, Kim Il Sung proved a shrewd strategist who later skilfully used the Sino-Soviet split to his own advantage. In 1956, Kim Il Sung allied with Mao Zedong in criticizing de-Stalinization in the USSR and domestically sidelined the Soviet Koreans who had tried to unseat him in a Party revolt. Sino-North Korean bonds were sealed by blood mutually shed for each other. Best remembered is the mobilization of Chinese volunteer forces that drove UN troops back to the 38th parallel during the Korean War (1950–53), but the sacrifice made by Koreans fighting with the CPC during the Chinese Civil War was not forgotten either. The last remaining Chinese Volunteers, who provided

형제적 중국인민 지원군과의 전투적 우의와 친선단결을 일층 강화하자!

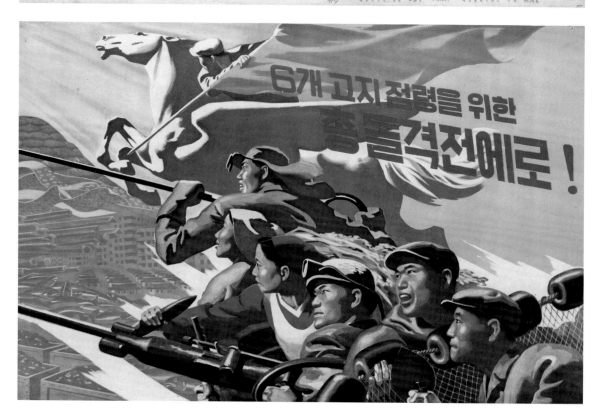

top:

195
**(Pyŏn Wŏl-lyong)**
*Let Us Further Strengthen
Solidarity, Friendship and
Militant Fraternity with the
Brotherly People's Volunteer
Army!*, 1954

bottom:

196
**Yu Hwan-gi**
*Towards a Full-scale Advance
to Achieve the Six Goals!*, 1962

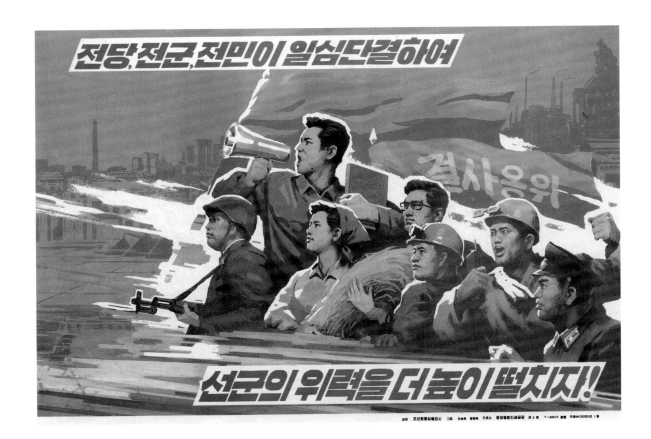

198
**Hwang Myŏng-hyŏk**
*Let Us Become Glorious Victors
in the '100-Day Battle'!*, 2005

above, top:

197
**Ch'ŏn Sŭng-t'aek and Hwang
Myŏng-hyŏk**
*Let Us Exalt the Might of the
Songun Revolution Through
the Single-hearted Unity of the
Entire Party, the Whole Army
and All the People!*, 2005

manpower during the reconstruction of the DPRK
following the devastation of the Korean War, finally
returned home in October 1958 (see illus. 195). By
1960, Kim Il Sung had not only politically wrested
himself free of his foreign sponsors, he had also
gradually eliminated all other historic strands of the
Korean communist movement. In the end, he built
his total hold on power on a small coterie of trusted
former Manchurian partisans.[5]

Although the political genealogy of the North
Korean revolution can be traced back to imperial
Japan, Stalin-era USSR and Mao Zedong's People's
Republic of China (and the Chinese revolution
that led to its establishment), North Korea and its
revolution cannot be reduced to any or all of these
influences. Instead, the North Korean revolution
has to be understood first and foremost as a Korean

revolution, rooted in Korea's own historical experiences. The same is true for DPRK poster culture, where North Korean distinctiveness can neither obscure nor be reduced to obvious Japanese, Chinese and Russian influences.

North Korea's ongoing love affair with posters pre-dates the founding of the country. Although, as so often in North Korean lore, the origins of its poster culture are traced back to the anti-Japanese partisan struggle in Manchuria under the leadership of Kim Il Sung – founder, father and currently eternal president of the DPRK – the story, unsurprisingly, is more complex.[6] That poster culture pre-dates the establishment of the DPRK is uncontested. Just as North Korea itself has a prehistory, neither North Korean art nor poster culture appear out of the blue at the time of the DPRK's founding. North Korean poster culture is the child of many fathers and in that respect reflects the chequered political genealogy of the country. It merits highlighting that imperial Japan (and hence colonial Korea), the Soviet Union and CPC-controlled China – formative cultural influences – had thriving poster cultures. Simply naming these influences, however, is far from determining the nature and extent of their specific contributions to North Korea's unique and enduring poster culture.

The uniqueness of its poster culture is to be found in the stylized depiction of characters in primary colours, along with shrill slogans, often coated in military jargon, dotted with exclamation marks. An early example of this style is to be found in a poster by Yu Hwan-gi from 1962 (illus. 196). The slogan uses a terminology that refers to an all-

out assault on an enemy stronghold. The image shows six figures representing the designated economic sectors mentioned in the slogan, all recognizable by their outfits and the props they brandish, specifically construction, fishing, mining, textiles, agriculture and steel production. This group is inspired by and advances against the backdrop of a winged Chollima (1,000-*li*) horse galloping towards a golden dawn of affluence, a cornucopia of production by the six assigned sectors.[7] Decades later, a design by Hwang Myŏng-hyŏk from 2005 follows the same model (illus. 198). A differently composed group of iconic figures, their props updated, surge in a hundred-day battle towards victory in honour of the sixtieth anniversary of the KWP's founding. The composition (and order) of the line-up is telling. Indicative of the *songun* (Army First) era, a soldier is urging civilians on, a metalworker in the lead, followed by a farmer, scientist, train driver and miner.[8]

Another 2005 poster co-designed by Hwang Myŏng-hyŏk repeats this group line-up, but in a different composition (illus. 197). Here, a soldier leads the pack, but a Party worker, brandishing a megaphone and holding a folder entitled 'Our party's *songun* politics', is spurring the group on. The economic sectors highlighted in this specific poster are agriculture, science, mining, the steel industry and transportation, all represented through the habitual personifications in appropriate attire and holding the right props. Basking in a red glow, the background outlines Pyongyang landmarks such as the Juche Tower, the Victory Arch and the Grand People's Study House (all 1982) against a

229

skyline of high-rises – silent reminders of the feats that have been achieved under Party guidance. In front of this cityscape, a vista of neatly structured rice paddies and ever-growing heaps of coal complement the utopian vision of present and future successes.

The effectiveness of a poster, both visually and politically, depends on its instantaneous accessibility, which feeds on visual recognizability and readability. In the case of North Korean posters, these effects are achieved through visual simplicity and repetitiveness, in both composition and depiction. From the 1950s onwards, one can detect a growing simplification in composition, drawing and colouring, which has become the hallmark of North Korean poster design. More than just a linear evolution towards this highly stylized poster design language, a gradual atrophy in styles is discernible, as posters developed into a unique art form – between graphic design and fine art – and the KWP articulated a specific discourse on poster culture practice. In the early days, graphically sophisticated designs coexisted alongside designs that pasted a slogan onto an oil or ink painting (illus. 199). That a distinct poster identity and style did not appear overnight is illustrated by the fact that Pak Sang-nak produced both elaborate canvases that featured on posters and graphically more intricate designs (see illus. 218) at basically the same time.

Although reports on poster exhibitions in North Korean art yearbooks feature some reproductions, art journals at times discuss specific posters and some designs have acquired the status of iconic images, posters are everyday objects, rather than collectibles, in the DPRK. Because posters are part of propaganda campaigns that relate to immediate conditions and situations, the shelf life of posters is limited. The campaign and its slogans take precedence over the aesthetic design; the message prevails over the package. The unrelenting succession of campaigns makes the turnover of slogans frequent. Consequently, posters are not considered to be particularly valuable artefacts. The famine of the mid-1990s and the unprecedented opening up of the country to a large-scale international aid effort created a growing market for North Korean (poster) art. International interest in North Korean posters has grown to the point that it is time to begin writing a proper art history of North Korean poster culture.

Given the current paucity of available research on North Korean posters, however, this is neither the time nor the place to make that start.[9] One crucial reason for the lack of research has been the absence of a comprehensive and accessible body of North Korean posters.[10] Accustomed as we are to the message that North Korea is reluctant to allow access or to share information, this could be reasoned away as a consequence of the way information is supplied.[11] But also on the demand side, until recently, there has been a remarkable lack of sustained interest. Rare are the collectors who have built up critical knowledge through prolonged intensive contact with local suppliers. Unsurprisingly, with little to work on, research on North Korean (poster) art has not thrived either. Even in South Korea, where a whole legion of scholars study every nook and cranny

199
**Pak Sang-nak**
*Let Us Turn All Our Cities and
Villages Bright with Flowers
and Lushly Green!*, 1960

of North Korean society, posters have been almost totally overlooked.[12]

An additional fundamental reason for the lack of research on North Korean posters is the fact that North Korea has been for too long approached nearly exclusively from an international security angle, with little or no concern beyond regime politics. Given the failure of the often-predicted collapse of the North Korean regime to materialize, a growing body of studies is looking beyond regime dynamics to the workings of North Korean society.[13] It is here that North Korean posters as visual source materials can complement text-based research. Posters, as a graphic art form where text and image converge and mingle, not only illustrate the evolution of the ideology, but document the evolving domestic, political, economic and social agenda. Whereas slogans highlight campaign goals, the imagery seeks to appeal to and involve viewers by talking of an idealized, but recognizable reality. Certainly, studying North Korean posters helps to shed light on what makes the DPRK tick.

The Dutch collector Willem van der Bijl has agreed to make his extensive collection of printed North Korean posters digitally available for research through the Leiden University Library. Through this generous gesture, we can now begin to see the full potential of these posters as research material. With over 1,200 posters covering the period 1952–2011, this collection is unique in both scope and depth. It allows the charting of changes over time in terms of slogans, ideology and/or political agenda, the description of the evolution

in style and design and the tracking of tropes and iconography as they unfold. Through a *longue durée* approach, the detection of changes in ideological terminology, recurrence of slogans, shifts in meaning or returning imagery can be detected. Posters, seen over successive decades, allow us an insight into how North Korean society has changed, informing us on such varied subjects as the social contract, economic development, normative behaviour and gender relations. The release of a full online database in 2017 will make possible the fascinating work of weaving the posters into text-based North Korean history, creating a thick fabric that better reflects the density of North Korea's past. The current contribution will merely scratch the surface by applying a variety of analytical handles to an eclectic selection of posters from this collection, thereby showing the wealth of information hidden in these otherwise ordinary artefacts.

Willem van der Bijl is a stamp dealer based in Utrecht, the Netherlands. Through his frequent and friendly contacts with the (North) Korean Stamp Corporation, he was invited to visit the DPRK in 1998 and set up a business there. Initially, the business, through a branch office, focused on collecting postal documents and North Korean art. Like so many others, he was initially also buying hand-painted posters, until he was shown printed posters and his collector's heart missed a beat.[14] Ever since he started collecting stamps as a little boy, he has had an uncommon love for the printed. Being introduced to North Korean printed posters, he realized he had stumbled onto something unique and went for it with a vengeance. Until his arrest on

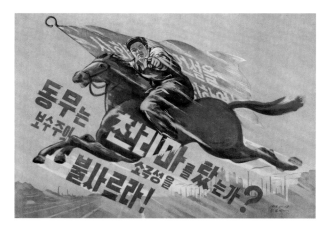

top:

200

**Kwak Hŭng-mo**

*Comrade, Are You Riding the 1,000 li Horse? Burn the Negativity of Conservatism!*, 1958

bottom:

201

**Yu Il-ho**

*Forward in an All-out Charge Towards the Top of a Strong and Powerful Country!*, 2005

charges of anti-state activities in 2011, he travelled a total of 24 times to Pyongyang, buying posters as they were shown to him by his associates.[15] All in all, he purchased more than 1,200 posters along with smaller leaflets and other hard-to-obtain printed materials.

North Korean art is often reduced to 'propaganda art' without much thought being given to what is meant by 'propaganda'.[16] In the case of fine arts, the term is often used broadly to differentiate North Korean art practices from 'Western/free' practices. On closer scrutiny, wielding the propaganda label in such a cavalier way achieves little more than the reification of an absolutely different North Korea versus an equally idealized West through the application of a crude and fundamentally orientalizing distinction. Just as Western art practices are not nearly as pristine as an essentialist interpretation would have it, so too are North Korean art practices more complex and sophisticated than is often taken for granted.[17] This becomes particularly clear when approaching North Korean fine arts alongside North Korean posters. While there cannot be any doubt about the propaganda purposes of many North Korean posters, known initially through the generic loan-word *p'osŭt'ŏ*, posters now go by the more specific Sino-Korean neologism *sŏnjŏnhwa* – propaganda painting – which begs the question of where other art forms feature on the scale of propaganda art.[18] Where does art end and propaganda begin? Or should we rather treat the two – art and propaganda – not as mutually exclusive, but rather as two opposites of a single sliding scale, as North Korean art

theory suggests in its use of the concept of *sasangye-sulsŏng* (ideological and artistic quality)?[19]

One fundamental difference between fine art and poster art is certainly to be found in the immediacy of the poster. Whereas a North Korean painting seeks to appeal through narrative depth that draws the viewer in gradually, a poster communicates its message clearly, directly and unambiguously. This unambiguity relates to the primacy of the slogan. The poster picture visually frames, supports and enhances the slogan. Commissioned as they are in a very specific socio-political context, answering to the very specific political agenda of the Korean Workers' Party, there is an urgency to posters which even politically themed paintings (*chujehwa*) lack. The essential purpose of posters is not only to spread the Party/government's view on politics, society, economy and culture but to affect the thought and behaviour of its viewers. Agitation being an essential part of poster culture in revolutionary societies, propaganda posters in their purest state seek to rouse viewers into action.

No poster illustrates this better than Kwak Hŭng-mo's well-known 1958 Chollima poster (illus. 200). The Chollima Movement coincided with the launch of the first Five-Year Economic Development Plan (1957) and followed on the heels of a worsening of relations with North Korea's main patron, the USSR, following the start of the de-Stalinization process there (illus. 201).[20] Not unlike the Great Leap Forward in China, the Chollima Movement sought to overcome investment and technological bottlenecks by wholesale mobilization of manpower and sheer ideological determination

(illus. 215, 216).[21] Kwak Hŭng-mo's 1958 poster design shows a steelworker speeding along atop this mythical horse holding high the red Chollima campaign flag emblazoned with the slogan 'For the construction of socialism'. The worker stares down at and points his finger towards the viewer with the direct question *Comrade, Are You Riding the 1,000-li Horse?*, as he flies over a landscape of smoking factory chimneys and neatly tended rice paddies. The sense of intimidation evoked by this poster does not stem solely from the (visual) power of the slogan, but also from the perspective of the picture design. This Chollima poster became such an iconic image that it reappeared in many later poster designs (illus. 201, 217). Piercing eyes and pointing fingers have become a recurrent theme in the most forceful posters. A particularly beautiful example is a 1959 poster by Pak Sang-nak related to industrial production efficiency. Appealing to workers to 'work as masters' – masters became a prominent concept in the later development of *Juche* thought – a foreman forcefully smashes poor-quality rejects (illus. 218). Aside from the burning eyes and

forceful hand movement, this poster design is particularly interesting for its imaginative use of lettering, integrating the slogans and words as visual objects in the picture.

Much in the same way as paintings fit the propaganda mould in various ways, North Korean posters speak to viewers in different registers. Aside from unequivocal agitation, posters can be instructive, informative, declarative or exhortative. Fundamentally, all posters ultimately seek to frame and shape political, social and/or personal behaviour and/or thought. Universally, posters are used to warn viewers of looming dangers, whether fire (illus. 219) or approaching trains at level crossings (illus. 202). In North Korea, caution is also called for when it comes to saboteurs, subversives and spies (illus. 203). In such posters, spies are caught red-handed as they snoop around industrial estates at night furtively taking photos and stealing documents (illus. 204). In Kwak Hŭng-mo's 1969 poster, people are instructed not only to be on the alert, but to reflect on their own behaviour. Seven insets bordering the main picture show scenes

202
**Mun Myŏng-ŭn**
*Beware of Trains!*, 1965

203
**An Ch'ang-su**
*Let Us Be Cautious! Let Us Expose and Completely Smash the Activities of Spies, Saboteurs and Subversives!*, undated

204
**Kwak Hŭng-mo**
*Enemies Are Cunning and Sly. Let Us Maintain Ever More Revolutionary Caution!*, 1969

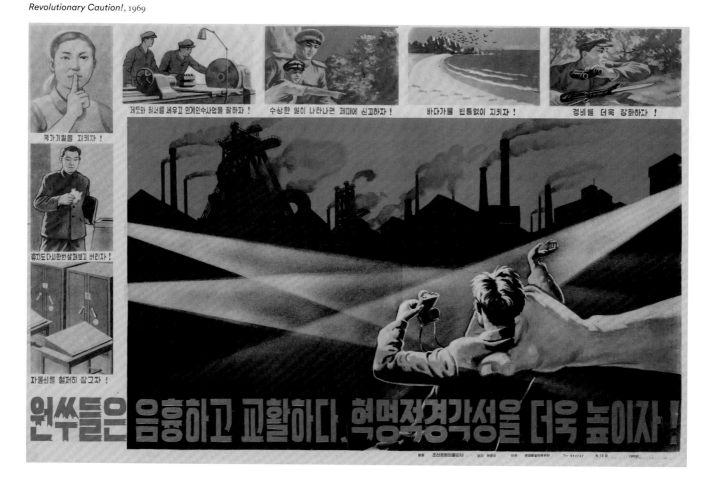

235

where particular attention is required: at work, locking away documents and double-checking papers when throwing them away; and in public places, watching one's words lest one divulge sensitive information, reporting anything out of the ordinary and remaining vigilant at all times. In the sequence of small pictures in this poster, different groups of people are reminded of the contribution they can make to state security. In the same category are posters calling for upholding public etiquette: while boarding public transportation, refraining from smoking or whispering in theatres and respecting public property and cultural relics (illus. 220); abiding by traffic rules in order to prevent mishaps (illus. 221); and being disciplined when travelling (illus. 205).

Less agitational, though no less political, are posters of a declarative or celebratory nature. A nice example is a poster on the occasion of the eleventh anniversary of liberation (here still explicitly identified as a Soviet Army exploit) in 1956 (illus. 222). The slogan frames North Korea's prosperity as built on the success of the Soviet Army. Visually this message is endorsed by the depiction of the Liberation Tower (1947), erected to commemorate the Soviet liberation of the northern half of Korea. The tower overlooks and protects the young North Korean state, represented here by two children bringing a bouquet to the monument in gratitude. A similar protective embrace can be read from the USSR red flag hovering over the DPRK national flag, held high by the marching crowd in the background.

National Day posters are another instance of celebratory posters (illus. 194). Pak Sang-nak's 1962 poster commemorating the fourteenth anniversary of the founding of the DPRK is a very good example of the hope and revolutionary zeal driving the country forward. The poster was inspired by the Chollima statue that had been unveiled just one year before. Seen from its base, the '1,000-*li* horse' soars into a blue sky festooned with balloons and garlands. The Chollima horse/Movement, framed by two red garlands hailing respectively the KWP and Marshal Kim Il Sung, powers economic production in all sectors, from mining and industry to agriculture. Under the garlands, citizens are parading past the Chollima statue, brandishing national flags, Chollima medals pinned to their chests.

Another prevalent tone in posters is exhortation. In the case of Ro Sŭng-hwan's *Let Us Save More!*, the slogan in its simple directness is all this poster needs in terms of exhortation (illus. 223). The image, on the contrary, is softer, showing a radiant woman, Kim Il Sung badge prominently pinned to her chest, coming out of a savings bank expectantly looking into the future. Unsurprisingly, the message of this poster is that saving is not for personal gain, but in order to fuel the national economy, as shown by the mirage of the future depicted in the left-hand half of the picture: a lush landscape of golden rice paddies and smoke-churning chimneys, representative of the country's obsession with heavy industry.

opposite:

206
**Rim Kwang-ju**
*Let Us Make a Breakthrough into the New Century with the Vigour that Made Us Overcome the 'Arduous March'!*, 2001

205
**Hwang Pyŏng-gŭn**
*Let Us Voluntarily Observe Travel Instructions!*, 1989

In other instances, the image reinforces the exhortative tone of the slogan, typically by showing a group of people storming ahead, calling on the viewer to join the advance (illus. 206). Unlike the explicitly agitational posters that show characters facing the individual viewer directly, in the case of exhortations, the movement is rather sideways, with at least one figure looking backwards and shouting encouragement. On the cusp of the twenty-first century, the heyday of *songun* politics, a soldier is leading the charge towards the realization of a breakthrough in turning North Korea into a 'strong and prosperous country'. The slogan is written on the flag held high by a worker riding the Chollima horse in the background, speeding towards the golden dawn of the new century. Figures representing the civilian sectors of the economy – steel, coal, science, agriculture and transportation – are responding to the battle cry.

Another recurrent example of this style is the depiction of a single figure encouraging an imagined group – the viewers – to follow his or her example (illus. 224). A model steelworker (two Chollima medals pinned to his chest) has his fist clenched in determination. His pose full of resolve, he calls out to the viewer to follow him in an unrelenting and brisk seventy-day speed battle, in the spirit of the Chollima Movement. The flag leading from the front mentions the Three Great Revolutions, the campaign that superseded the Chollima campaign in late 1973. Following the steel worker are 'Sea of Blood' and 'Flower Selling Girl' – Red Youth Guard flags, both named after revolutionary operas. Speed is intimated here by the forward thrust of the

slogan, the forward-leaning poise of the steelworker (and the ruffle of his clothes), his outstretched arm pointing towards the same horizon as the speeding slogan and the flagpoles bent in the same forward thrust. The perspective puts the viewer in a subordinate position, intimated by the towering figure of the worker who looks down on him.

Although female protagonists also feature in this type of poster, their pose is much more demure and never as driven or forceful as that of their male counterparts (illus. 225). In this poster from 1994, which supports a government drive to prioritize foreign trade, the relevant slogan runs on a conveyor belt straddling the world, packed with boxes 'made in the DPRK'. The boxes are ostensibly filled with shirts, meticulously packed by a female worker who shows none of the frenzy or heroics of the typical male character, but rather demurely looks at the viewers while getting on with the job. Movement here does not originate with the female worker, who is merely a cog in the export machinery, but is intimated by the steady slog of the conveyor belt.[22]

Text is essential to poster culture. Everything starts with a slogan that is handed down from the Party centre. Individual slogans offer in condensed form the summary of a campaign goal or item on the political agenda.[23] They are painted on banners and held high by parading citizens; they are shouted during mass rallies and repeated in official speeches by public dignitaries; they pop up in news editorials and are studied, discussed and memorized during weekly study sessions. Their repetitiveness and omnipresence in various media, along with the verbal and visual recycling over

the boundaries of distinct media, strengthens and
upholds a hegemony of slogans that affects how
reality is read and experienced (illus. 232, 233).[24]

Grappling with the aftermath of a system-
threatening famine in the mid-1990s, a 'second
grand Chollima advance' was launched in 1998
in an attempt to rekindle revolutionary hope,
ideological motivation and selfless dedication (illus.
228). The (visually) direct historical reference to
the original Chollima Movement not only sought
to rekindle the initial revolutionary zeal of the early
days of the revolution, but speaks to the genera-
tional shift – not just at the top of the leadership,
following the death of Kim Il Sung in 1994, but
taking place in society at large. The campaign's
effectiveness was carried to the next level when six
'heroes of our time' were singled out as forerunners
in this campaign. These six individuals became
household names, partly through a short documen-
tary film made in 1999, but also through a series of
six articles dedicated to one hero each in the KWP
newspaper *Rodong Shinmun*.[25]

All six *Rodong Shinmun* articles featured as
background in a 1999 poster questioning the view-
ers directly whether they too were 'heroes of our
time' (illus. 229). The figure pointing his finger at
the viewer/reader is a miner, referring to the article
on the top of the pile. Unlike the subsequent
article titles, where the name of each 'hero' is read-
able, the figure of the miner here hides the name
of labour hero Kim Yu-bong from view, as if to
highlight the fact that the miner is indeed a generic
figure, not Kim Yu-bong, the subject of the article.
What this intimates is that the viewer should not

respond to the heroics of Kim Yu-bong himself, but
rather follow in the footsteps of the main character
of the poster who was inspired by (studying) the
articles/campaign.

Another poster in the same campaign features
the portraits of these heroes, though here too, the
heroes themselves are not the theme of the poster,
but rather the construction worker is, inspired
by the recognition/medals they received as either
labour or national heroes (illus. 207). This is an
interesting reversal from an earlier poster design
which featured marathon runner Jong Song-ok
(Chŏng Sŏng-ok) as the lead character, shown
here in text and image as a source of inspiration for
North Korean workers (illus. 230). She became
world famous in North Korea following her win in
the women's marathon during the 1999 Athletics
World Championships in Seville. What made
her an invaluable propaganda asset was not only

207
**Pae Sŏk-chun**
*Let Us All Live and Work Like
the Heroes of Our Time!*, 1999

the fact that her international victory symbolically overcame the system-threatening crisis of the mid-1990s, but her declaration at the post-race international press conference that thinking of the Great Leader Kim Jong Il had given her the strength and energy to clinch victory. This poster feeds on and relates to both that statement and the media frenzy that her exploit and pronouncements had created at home. Eventually, her story became absorbed in the second Chollima Movement, as the overall purpose of the campaign was to reignite ideological fervour, total dedication to and inspiration by the leader.

In the above posters the focus shifted from the heroes themselves to their inspirational influence on ordinary workers. In doing so, they speak to and reinforce media campaigns and images, blurring in the process the distinction between the actual event and its media representation. In the case of historical references, a similar development from intimations of actual events to their representations, whether stills from films, photos or other monuments, can be shown. A recurrent background motif in posters are the grand monuments dotting the country, from Pyongyang's Chollima statue, the Juche Tower and the Party Foundation Monument (1995), to monuments at revolutionary sites in the provinces. In 1965, celebrating the twentieth anniversary of the KWP's founding, Pak Sang-nak captured the essence of North Korea's historical narrative of the revolution, born out of the anti-Japanese resistance struggle and the post-liberation construction of a socialist paradise: he simply showcased two monuments, the Pochonbo Battle

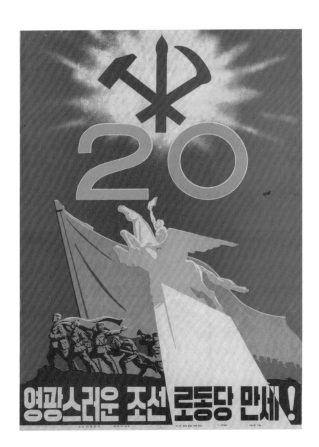

Victory Monument in Hyesan (1967) and the Chollima statue in Pyongyang (illus. 208).

Pyongyang as the ideological heartland of the socialist state is often evoked by a random and therefore fictional clustering of its monumental buildings (illus. 209). Ro Sŭng-hwan's 1989 poster calls for total devotion to the Party and the leader, foregrounding a Party member clutching to his heart a volume of the selected works of Kim Il Sung and Kim Jong Il's treatise 'For the Completion of the Revolutionary *Juche* Cause' (1987). The background is made up of a sun rising through a Party-emblem-embossed golden dawn. One side of the poster background comprises a cluster of heavy industrial facilities, the pride of North Korea's productive activity. Juxtaposed on this industrial landscape are piled iconic Pyongyang buildings,

opposite:

209
**Ro Sŭng-hwan**
*Practise Total Loyalty to the
Party and Filial Devotion to the
Leader!*, 1989

208
**Pak Sang-nak**
*Long Live the Glorious
Korean Workers Party!*, 1965

from the Ch'anggwanwŏn public baths (1980) in the centre, over the ice rink (1982) and the Koryo Hotel (1985) to the Pyongyang Maternity Hospital (1980) and the Grand People's Study House. Towering over this imagined Pyongyang landscape is the Juche Tower, which visually stands in a direct line with Kim Jong Il's treatise. Another visual axis connects the treatise with the Party emblem. At the centre of it all is the beating heart of the Party member, filled with loyalty to the leaders whose *Juche* thought has created the revolution, and to the Party which executed their ideas into the material successes seen in the Pyongyang skyline.

Another major infrastructure project of great national pride was the West Sea Barrage, upheld as a model of self-reliance (*charyŏk kaengsaeng*) and a prolonged speed battle (*soktojŏn*) (illus. 231). This is explicitly stated on the two red flags in Song Shi-yŏp and Ro Sŭng-hwan's 1986 poster, but what is striking here is that the spirit of the speed battle is evoked by reference to a sculpture rather than a depiction of an actual work brigade. In the course of this evolution from reality to representation, posters no longer relate directly to actual events or persons, nor to other posters – as was the case with the replication of Kwak Hŭng-mo's 1958 Chollima poster in a 1999 poster (see illus. 228) – but rather to a self-referential virtual reality consisting of layers of images and slogans.

Posters, banners and monuments dominate and shape the visual landscape. The first are printed and distributed for display on noticeboards in workplaces, schools, hospitals and other public spaces. Posters also appear in store windows or on announcement boards in public places, while some are painted on large billboards, and more recently even reproduced as mosaics. Posters are also reproduced in magazines, reprinted as postcards, or even as postage stamps. Banners line streets, sit on rooftops, span entrances to schools, workplaces and other public facilities and cover the walls of factories and office buildings. They also appear in films, on stage and in paintings, sculptures and poster images. In the last case, the appearance of secondary slogans in the poster image visually anchors, enhances and expands the poster's main slogan. When in 1978 a new seven-year plan was launched, Song Shi-yŏp produced a poster itemizing all the key slogans that framed and drove the plan, in a hierarchy of flags that crowded the image (illus. 232). The general ideological driving force motoring the fulfilment of the economic development plan remained the Three Great Revolutions framework, represented by the largest red flag held up by the Party worker leading the charge towards the realization of the plan. As the successor to the Chollima Movement, the Three Revolutions movement, launched in 1973, identified three areas – ideology, technology and culture – for permanent revolution with the aim of revolutionizing man,

210
**Ryu Hwan-gi and Song Shi-yŏp**
*Forward in a March Towards New Victories under the Leadership of the Party!*, 1979

nature and society, respectively. Under this grand scheme, various subsidiary campaigns developed – in this specific poster, production and saving, and self-reliance. The goals of the seven-year plan are shown in three red flags that tower over a utopian industrial landscape, which appears under a rising radiant '7' and consists of *Juche*-orientation, modernization and scientification.

In the same vein another 1979 poster by Song Shi-yŏp, co-designed with Ryu Hwan-gi, rooted for renewed victories under the leadership of the KWP (illus. 210). Here, a Party worker, clutching two volumes of the selected writings of Kim Il Sung, is encouraging a march of Korean workers. With a KWP flag as backdrop, additional red flags unfurl as workers march by, brandishing banners with slogans. Leading the parade, and towering over the line-up of banners, is a Three Great Revolutions flag. Under the watchful eye of the KWP and spurred on by the genius of Kim Il Sung, the Three Revolutions movement had been unfolding since its launch. Slogans were added as time went by, splashed out here on the banners, from front to back: 'Let us unconditionally uphold

and steadfastly realize party policies and decisions'; 'Production, study, life, all in the mode of the anti-Japanese Guerrilla Army'; 'Ideology, technology, culture, all according to *Juche* demands!'; 'All forward in the speed battle!'

The relentless repetition and recycling of stock phrases, slogans and images from one medium to another not only creates a self-referential virtual reality, but by its physical presence, in return, shapes, frames and structures the public domain, orders the world, gives meaning to life and ultimately informs the actions and thoughts of individual citizens in the DPRK. Exhortational, inspirational and agitational posters are part and parcel of the complex discipline system that shapes North Korean identity, keeps society meek and docile, and controls the thoughts and behaviour of viewers. Seeking to channel emotions, politically motivate and/or rouse viewers into action, posters speak directly to people by making them the main characters.

Posters are visual megaphones, as Ro Sŭng-hwan's 1984 poster on the importance of education amply shows (illus. 211). The poster has a model

211
**Ro Sŭng-hwan**
*Study is the Foremost Duty of a Student!*, 1984

student daydreaming about his future contribution to the scientific and technological development of North Korea. That this is not about gratuitous self-development, but about fulfilling one's duties to the Party, the leader, the revolution and society, is clear from the books behind the boy, their titles clearly readable. The first volumes that come into view on the top shelf are volumes 28 and 29 of the writings of Kim Il Sung. Next is 'On *Juche* Thought' (1982) by Kim Jong Il, followed by the first volume of a biography of Kim Il Sung (*The Embrace of the Sun*, 1981) and the second volume of *The People's Leader* (1983). The next shelf contains science textbooks, from mathematics, physics, chemistry and biology, to books on specific subjects, such as the principle of television. The bottom shelf is reserved for dictionaries and encyclopaedias. As if the tone of the books did not sufficiently highlight the inspiration and guiding light of his daydreams, the badge of the Socialist Working Youth League (1964) on the boy's chest further emphasizes how he is wrapped in the system's embrace. This poster succinctly summarizes the totality of the control system of North Korea, where posters are part of a culture industry that envelops individuals and perfects the socialization process elicited through education, associations and work.

In North Korea, socialization is exacerbated into a national solipsism translated into total dedication to the Party and the leader. A 1992 poster by Song Shi-yŏp and Ro Ŭi-gŏn expresses this well, made on the occasion of the eighth meeting of the Socialist Working Youth League (illus. 233). As so often seen, the Party emblem sits in a golden glow in the sky, overlooking a torchlight parade, forming the slogan 'single-hearted unity', expressing how North Korean society is united as one around the leader. This unity is foregrounded by the tightly marching formation of men and women, soldiers and workers, fists clenched, arms entwined, presenting themselves as a guard detachment (*kŭnwidae*) and death-defying corps (*kyŏlsadae*) – the cardboard letters held high in the parade behind them – ready to give their lives for the protection of the country, the revolution, the Party, but above all, the leader.

North Korea has not always been subject to this kind of national solipsism. In fact, in the early years of the revolution, the Soviet Union was the model society that inspired the next generation of North Korean revolutionaries (illus. 212). Paek Tae-jin's 1955 Liberation Day poster celebrates the event with a call to 'go and study in the USSR!' The primacy of ideology is attested to by the two students holding works by Lenin and Stalin, as they look up at a mirage of Moscow State University. The poster communicates well the conviction that it is the ideological outlook that generates superior revolutionary science and technology, represented here by a line-up of Soviet scientific publications, their titles displayed in Cyrillic.

In the mid-1950s, at a time when Soviet advisers still played a dominant role in various domains of the North Korean state apparatus, including cultural institutions, a poster celebrating Sino-Korean friendship deserves particular attention

212
**Paek Tae-jin**
*Long Live the 10th Anniversary of the Liberation!*, 1955

(illus. 195). Ostensibly commending the war-hardened solidarity between the KPA and the Chinese People's Volunteer Army (CPVA) – which stayed behind in North Korea after the end of the Korean War to help with the reconstruction of the country – this poster, in a subtle way, expresses a particular revolutionary hierarchy. Essentially, the image shows a KPA and CPVA soldier on a break during shooting practice, browsing through the first issue of a new glossy entitled USSR. The cover of the magazine shows the Moscow skyline, featuring in the centre the same Moscow State University building that the students heading for the Soviet Union were dreaming of in illus. 212. The subtlety of the message stems from an inversion of the obvious power triangle with the USSR at the top, as beacon of revolutionary civilization and development for the DPRK and the PRC, two young and inexperienced revolutionary states, eager to learn and emulate the Soviet model. In a strange way, this apparent structural subtlety is simultaneously made quite blunt by pasting the title of the glossy right in the centre of the poster.[26]

Until the end of the 1950s North Korea cheered Soviet technological breakthroughs in the evolving Cold War competition with the U.S. (illus. 247). In 1959, Ch'a Yong-do produced a poster celebrating two major Soviet successes: the launch of the first nuclear-powered icebreaker, *Lenin*, and the launch of the *Luna 2*, the first spacecraft ever to reach the moon. Both events are integrated in a single poster, with the Kremlin as the centre of revolutionary resourcefulness, proving that revolutionary man is destined to control the world and the universe.

From the 1960s, North Korea turned inwards as the position of Kim Il Sung gradually became more and more indisputable. One of the earliest posters in the collection explicitly addressing his sacrosanct supremacy as revolutionary leader and thinker is Pak Sang-nak's *Let Us Arm Ourselves Thoroughly with the Revolutionary Thought of the Great Leader, Comrade Kim Il Sung!* (illus. 235). In the shadow of Korea's holy Paektu Mountain, and under a fluttering KWP Party flag, Korean workers and soldiers vigorously march, holding the Chollima flag high. Three people lead the parade, all holding writings by Kim Il Sung. The central Party worker, two Chollima medals on his chest, holds high a volume of the selected writings of Kim Il Sung. A female farmer confidently faces the future, armed with Kim Il Sung's *Theses on the Socialist Rural Question in Our Country* (1964), while a scientist is inspired by the transcript of a speech by Kim Il Sung on 'the task of scientists and technicians in the execution of a technological revolution' (1963).[27] Gone are the days when revolutionary inspiration sprang from anywhere else but the successive geniuses of Kim Il Sung, Kim Jong Il and, nowadays, Kim Jong Un.

The development of streaming media, from the appearance of the television onwards, has largely undermined the relevance of the poster as a medium for visual communication. Not so in North Korea, where poster production remains a significant niche sector within the culture industry. Posters play an important role in the visual regime of the DPRK. Through their recognizability, posters have secured a place in the propaganda

and agitation machinery as important visual aids that engage, enhance and amplify the slogans that the KWP continues to churn out on a regular basis. Although printed posters are seen to be the work of a handful of dedicated professional artists, students at art schools, members of art circles and schoolchildren do also try their hand at designing posters by participating in yearly local and nation-wide poster drawing campaigns.[28] The fact that individuals actively engage with, regurgitate and visually interpret the slogans in their own poster designs inexorably heightens the controlling and disciplining impact of slogan language. Slogans and posters are versatile tools that make North Korean citizens read reality in a politically correct manner and order their behaviour accordingly.

Since 2012, North Korea has had a young, new leader. Kim Jong Un is touting his youthfulness to force a breakthrough in the cultural domain. His opinion of North Korean cultural production was summed up in just two lines during his 2015 New Year's address, in which he chastised North Korean literature and the arts as 'stagnant' and called for more innovative artwork attuned to the demands of the people.[29] The rejuvenation of North Korean culture is embodied by his flagship project, the all-girl Moranbong Band, whose fresh music, militant lyrics, synchronized dance moves, slick shows and short skirts he holds out as models of innovation (and ideological dedication) to all other spheres of cultural production.[30] Whether this exhortation will also result in innovation and diver-sification in poster art remains to be seen. What is clear, though, is that even under Kim Jong Un's leadership, posters continue to be pictorial anchors in the political landscape of North Korea.

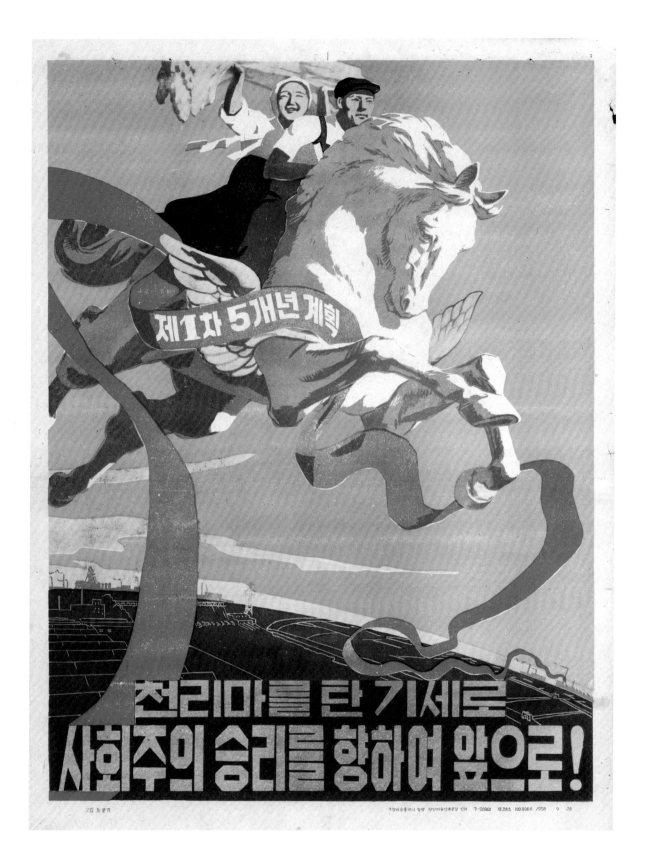

213
**Yu Hwan-gi**
*With the Force of Riding
Chollima, Forward Towards the
Victory of Socialism!*, 1958

214

**Pak Ch'ŏl-hyŏn**
*All for the Realization of the Joint Slogans of
the Central Committee of the Korean Workers
Party and the Central Military Commission of
the Korean Workers Party*, 2005

2.5배이상

1.5배이상

1961 위대한 전망 7개년 계획 1967

opposite:

215
**Rim Su-jim**
*A Great Prospect, the Seven-year Plan, 1961–1967*, 1960

216
**Yu Hwan-gi**
*October 1959: Korean-Chinese Friendship Month. Long Live the Everlasting Friendship and Solidarity between the Korean and Chinese People!*, 1959

217
**Ryu Hwan-gi**
*Let Us Live and Work in the Spirit and with the Vigour of the Period of the Great Post-war Chollima Surge!*, 1990

opposite:

218
**Pak Sang-nak**
*Quality Improvement Through Working as a Master!*, 1959

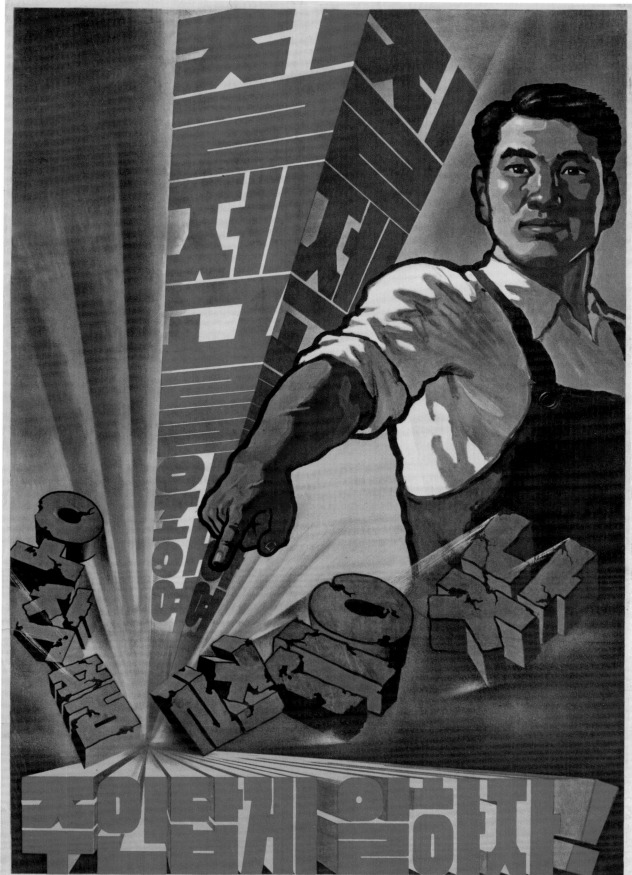

박 상락 그림            군중 문화사 발행   모든 신문 출판 인쇄소  인쇄   ㄱ—27249  100,000부  1959. 4. 5

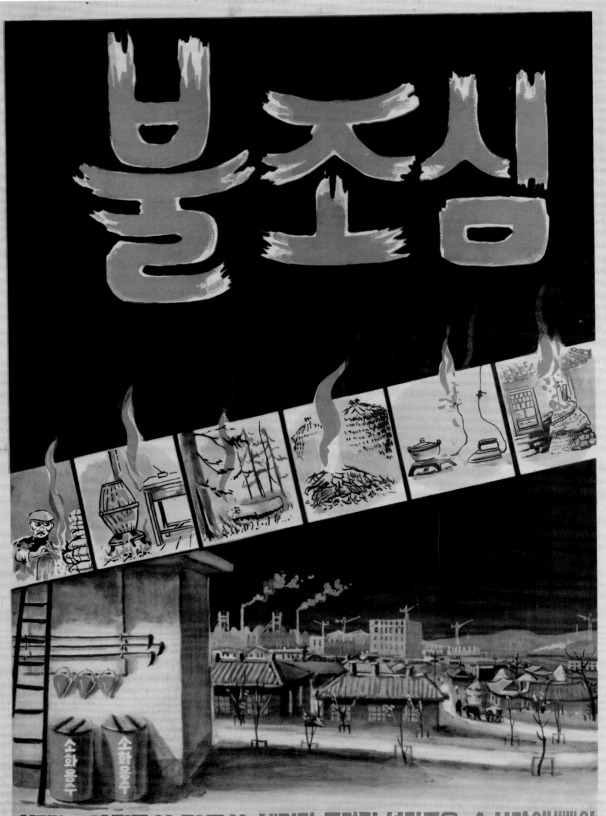

# 불조심

화재는 인민들의 귀중한 생명과 로력적 성과들을 순식간에 빼앗는 무서운 재해이다    항상 불을 조심하자 !

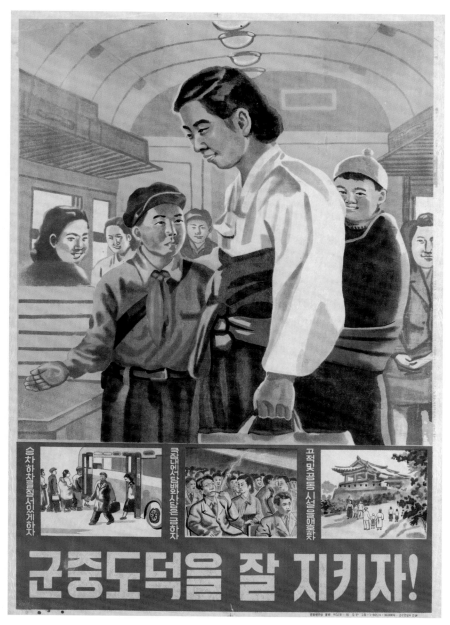

220
**Ŏm To-man**
*Let Us Uphold Public Etiquette!*,
undated

opposite:

219
**Yun Yong-su**
*Beware of Fire! Fire Is a
Frightening Calamity that Takes
Away in an Instant Valuable
Lives and the Results of the
People's Labour!*, 1957

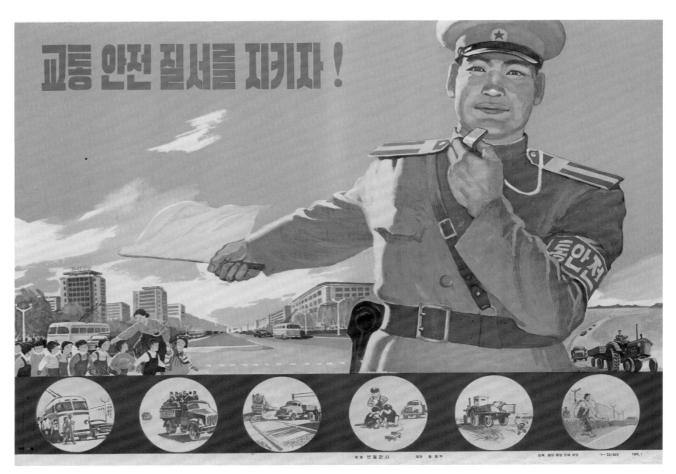

221
**Hong Ch'ŏl-bu**
*Let Us Abide by Traffic
Regulations!*, 1966

opposite:

222
**Paek Tae-jin**
*The Exploits of Our Liberator,
the Soviet Army, Will Forever
Shine Together with the
Prosperity of the Fatherland*,
1956

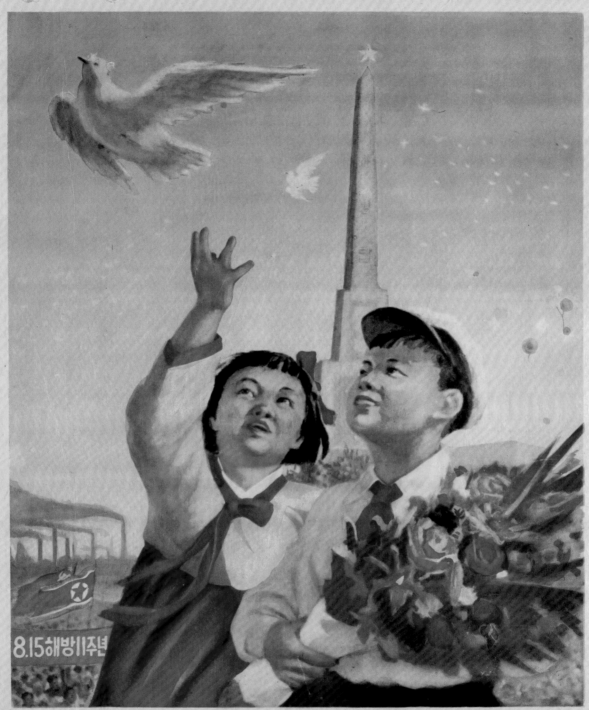

8.15해방11주년

우리의 해방자인 쏘베트 군대의 공훈은
조국의 번영과 함께 영원히 빛나리라!

미술출판사 발행  제7호  7-70463  백대진 그림  미술인쇄용장 인쇄  부수 50,000

저금을
더 많이 합시다 !

223
**Ro Sŭng-hwan**
*Let Us Save More!*, 1979

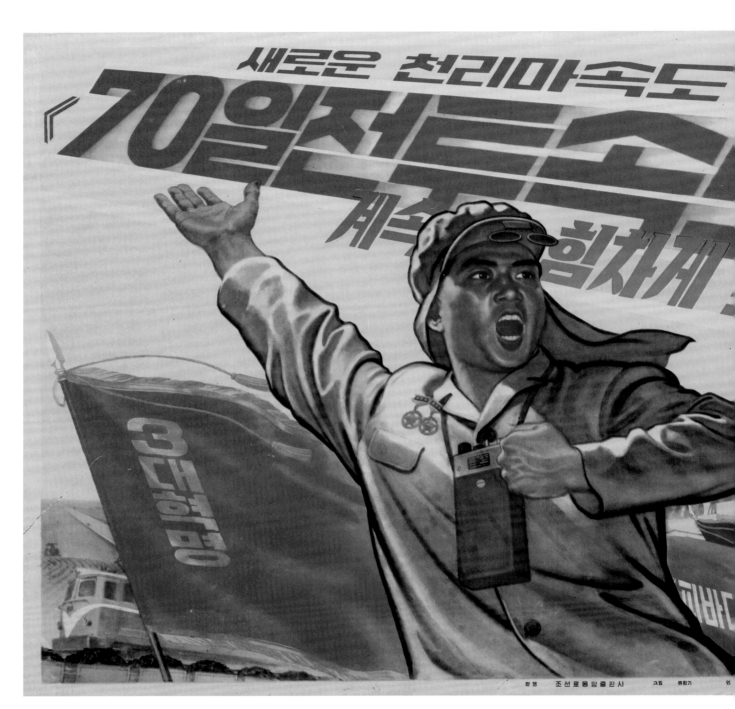

**Ryu Hwan-gi**
*With '70 Day Battle Speed',
the New Chollima Speed,
Continuously and Briskly,
Forward!*, 1975

225
**Ro Ŭi-gŏn**
*Let Us Vigorously Push the
Production of Export Products!*,
1994

opposite:

227
**Ro Ŭi-gŏn**
*Let Us Wholeheartedly Uphold
Party Leadership, Like the Ten
Party Members of Ragwŏn, the
T'aesŏng Grandmother and the
Members of Party Cell Number
Two of the Fifth Office of the
Korean Central News Agency!*,
1990

226
**Ryu Hwan-gi**
*Let Us Thoroughly Carry Out
the Party's 'Foreign Trade First'
Policy!*, 1984

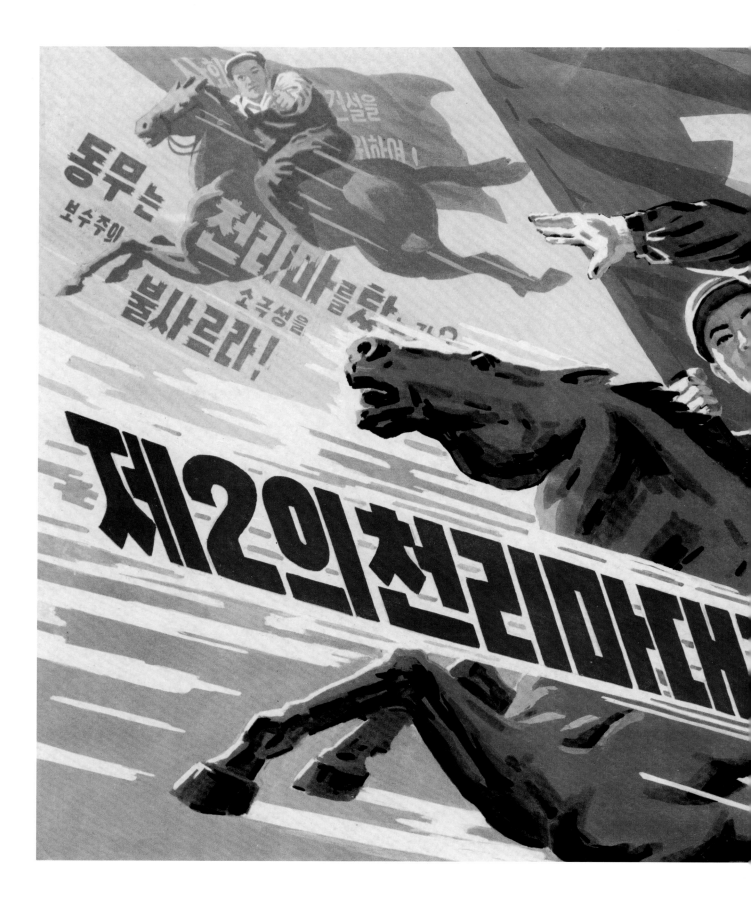

228

**Rim Kwang-ju**
*Forward in the Second Grand
Chollima Advance!*, 1990

229
**Ryu Hwan-gi**
*Comrade, Are You Living and
Working as a Hero of Our
Time?*, 1999

230
**Ri Ch'ŏl-min and
Kim Hang-nim**
*Let Us Become Strong in
Conviction and Thought, Just
Like Athlete Jong Song-ok,
Who Only Thought of the Great
Leader!*, 1999

장군님만을 생각한
정성옥선수처럼

신념의 강자가 되자!

낸곳 조선로동당출판사    그림  리청민 김학림        인쇄소  평양종합인쇄공장    제 10 호   ㄱ— 86340  발행    주체 88(1999) 년 10 월

231
**Song Shi-yŏp
and Ro Sŭng-hwan**
*Let Us Forcefully Press Forward
in the 1980s March in the
Style of the West Sea Barrage
Construction!*, 1986

232

**Song Shi-yŏp**

*All Together in a General
Advance Towards the New
Seven-year Plan!*, 1978

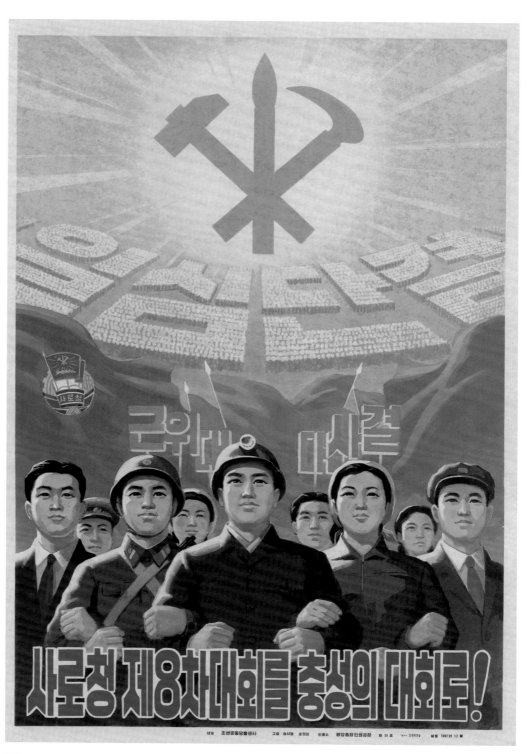

233

**Song Shi-yŏp and Ro Ŭi-gŏn**
*The Eight Saroch'ŏng Meeting
as a Meeting of Loyalty!*, 1992

234
**Ch'a Yong-do**
*Great Victories for*
*Soviet Science!*, 1959

opposite:

235
**Pak Sang-nak**
*Let Us Arm Ourselves Thoroughly*
*with the Revolutionary Thought of*
*the Great Leader, Comrade*
*Kim Il Sung!*, 1970

# 위대한 수령 김일성동지의
# 혁명사상으로 철저히 무장하자!

발행 조선로동당출판사    화가 박살막    인쇄 평양종합인쇄공장    제 9 호    ㄱ－04451    1966년 10 쇄

236

**Pham Thanh Tâm**
*Stay Vigilant [against
American] Bullying*, 1955

# 6 Socialist Republic of Vietnam, 1945–

**Sherry Buchanan**

The Italian contemporary artist Pietro Ruffo was surfing the net for revolutionary posters to inspire his mixed-media artwork *Revolution Globe III* (see illus. 237, 258) when he found one that had all the contemporary graphic appeal he was looking for. It was a 1972 North Vietnamese poster of the 24-year-old Trần Thị Tâm, killed by enemy fire during the Vietnam War or America–Vietnam War (1964–75) (see illus. 260).

Vietnamese revolutionary posters have become popular worldwide for their unique graphics. A stylistic mix differentiates them from hard-core socialist Soviet and Chinese realism. Inspired by French painting styles, folk art, Constructivism, Socialist Realism and even American comic strips, they never cease to surprise and interest. Yet little has been written about their history. Over the last twenty years, I have viewed thousands of propaganda posters in public and private collections inside and outside Vietnam, and have had the opportunity to talk to and spend time with several of the artists who created them. I believe that visual propaganda offers important clues to a nation's psyche and that understanding the 'other's' ideology, beliefs, hopes and fears can help in conflict mitigation and lead to human progress away from war. In contrast to communist posters elsewhere, the fight for independence remained the focal point of Vietnamese propaganda between 1945 and 1979. This heartfelt patriotism against foreign occupation goes a long way in explaining the appeal and poignancy of the war propaganda.

Posters were ideal propaganda tools: cheap to produce, easy to distribute and accessible to an illiterate population. Propaganda permeated art, film, radio, literature, theatre and music. Newly available Vietnamese archives reveal the close links between poster slogans and leaders' addresses, Party directives and revolutionary poems and songs.

## The 1945 Revolution and Independence

*'Vietnam for the Vietnamese.'*
*'Fight against hunger, fight against illiteracy.'*

*The story of Vietnamese propaganda posters started with the 1945 August Revolution that culminated with Hồ Chí Minh's proclamation of Vietnamese independence on 2 September 1945 in Hanoi's Ba Đình Square. The revolution was both nationalist and communist. During the Second World War, Nationalists and Communists joined forces in 1941 in the League for the Independence of Vietnam (or Việt Minh) to fight against Japanese occupation and French colonial rule. But the Việt Minh was under Communist leadership from the start. Hồ Chí*

275

*Minh, the the Việt Minh's leader, had founded the Indochinese Communist Party in 1930 while he was in exile in Hong Kong. As the war against the French escalated, the Communists became the dominant force within the Việt Minh and prioritized propaganda poster art over other art forms.*

Revolutionary art was born in Vietnam at the end of the Second World War, to celebrate Vietnamese independence from French rule. Established artists trained in the French colonial art schools defined the Việt Minh's new revolutionary aesthetics. In their search for a 'national' non-colonial visual language, they abandoned *L'art pour l'art* (art for art's sake) – the French nineteenth-century movement fashionable in Vietnam during the 1930s – to embrace revolutionary subjects that expressed the aspirations of a new nation at a time when Việt Minh propaganda coincided with intellectuals' dreams for a free, more just Vietnam. Artists were graduates of the Gai Dinh Art School, established in Saigon in 1917, and of the École des Beaux Arts d'Indochine (EBAI), which opened in Hanoi in 1925. As admirers of Matisse, Van Gogh or Delacroix, they experimented with Impressionism, Fauvism and Abstract Symbolism. Inspired by Hồ Chí Minh's vision, paradoxically, they kept the visual language of non-revolutionary poetic realism, the dominant style in Vietnamese painting after the introduction of Western art. These early French painting influences distinguish Vietnamese from Soviet, Chinese and other socialist propaganda art.

The three masters of Vietnamese modern art were at the forefront of the revolutionary poster movement: Nam Sơn, the father of Vietnamese Modern Art and co-founder of the EBAI, and EBAI graduates Tô Ngọc Vân and Trần Văn Cẩn, both future directors of the Vietnam College of Fine Arts.[1] Early posters were adapted from drawings and paintings, giving them a vitality that is usually associated with life drawings, not poster art. Early revolutionary themes focused on two major subjects: the first was independence; the second was the fight against the famine that tragically gripped the countryside. Hồ Chí Minh estimated that two million Vietnamese died of starvation, and blamed the catastrophe on the Japanese and the French. In the spring of 1945, Nam Sơn organized Independent Vietnam (Độc Lập), one of the first revolutionary student poster salons, to openly defy Japan's decision to requisition rice from Vietnamese farmers to feed their own troops. (A Japanese coup had temporarily ousted the French. The EBAI closed its doors, and its French director and professors left Vietnam.)

Posters illustrated the Việt Minh's fight against the famine. Nam Sơn, a superb draughtsman versed in Western oil painting and Chinese ink painting, made a small pencil sketch of 'a peasant wearing a conical hat, carrying a book with the Chinese inscription *Heavenly Book*'. One of his students was tasked with adapting the drawing into a large poster (1.2 x 1 m). The former student recalled in a recent interview that 'it took two days of frenzied work, closely following his instructions – from the ochre hues to dotting technique – but his drawing was easy to understand, the image and colours straightforward and the composition

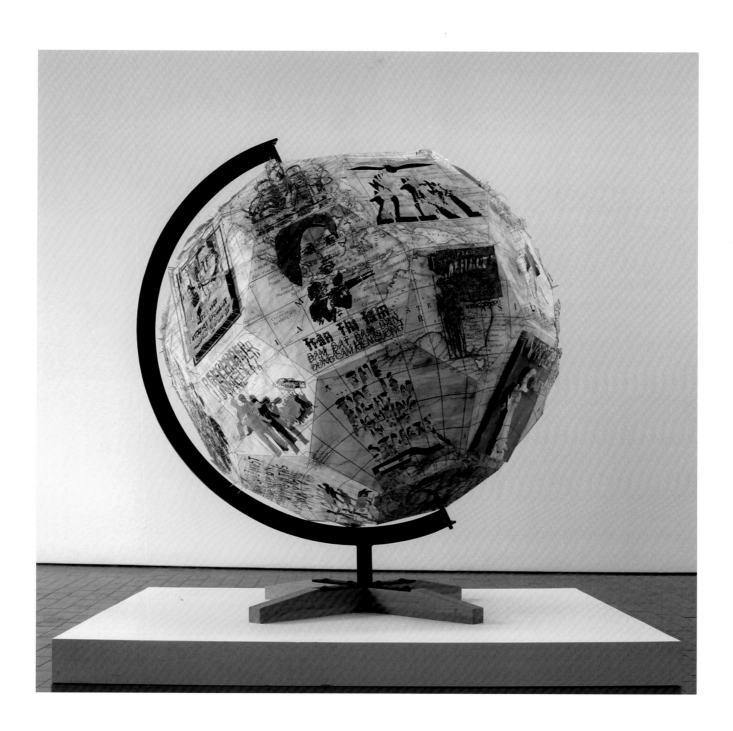

237
**Pietro Ruffo**
*Revolution Globe III*, 2013

watercolours and cut-outs on
paper

sound'.[2] From then on, the technique of adapting posters from the work of established artists became a favoured one in Vietnamese poster design.

The 1945 August Revolution transformed public display and introduced billboard-type propaganda and murals to the urban and rural landscape. Propaganda billboards are still visible today alongside Rolex and Louis Vuitton ads. Posters were a cheap and effective way to communicate the Việt Minh's message to an illiterate population. The Japanese surrender on 8–9 August marked the end of the Second World War, and within weeks, the Việt Minh seized power. Established artists created banners and posters to broadcast the Việt Minh's message. They converted the hall of mirrors in the Hanoi Opera House (modelled after the Palais Garnier opera house in Paris) into a temporary workshop.[3] Trần Văn Cẩn gathered with artist friends at their alma mater to produce *Farmers Rescued, Kill Hunger and Breaking the Chains*.[4] He worked through the night producing a 4 x 6 m long panel, inscribed in Vietnamese and English with the words 'Vietnam for the Vietnamese' to hang on the facade of the Crédit Foncier de l'Indochine, the Hanoi branch of France's national bank on Avenue Garnier, a colonial symbol at the cultural heart of the city.[5] The S-shaped map drawn on the panel symbolized unity and independence. The three figures bearing arms represented the Việt Minh's mobilization of an entire people, men, women and the young (between the ages of seventeen and 24), to defend the country against foreign invaders. Women with guns became a central tenet of Vietnamese revolutionary aesthetics. For the artist Tran Van Can, depicting

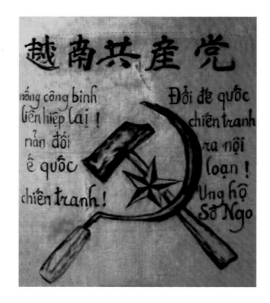

top:

238
**Trần Văn Cẩn**
*Little Thuy*, 1943

oil on canvas

bottom:

239
**Anonymous**
*Farmer Combatants, United Against the Famine. Oppose the Imperialists! Support the Struggle!*, 1930–31

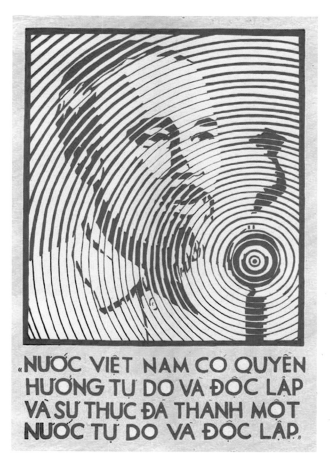

240
**Anonymous**
*All Men Are Created Equal.
They Are Endowed by
Their Creator with Certain
Inalienable Rights; Among
These are Life, Liberty and the
Pursuit of Happiness*, no date

a woman bearing arms was a radical departure from his pre-revolutionary romantic portrayal of women.[6]

This is one of the first representations of women bearing arms. Women combatants are a defining aspect of Vietnamese revolutionary aesthetics and a radical departure from pre-revolutionary romantic portraits. Trần Văn Cẩn's *intimiste* oil painting of his eight-year-old niece, *Little Thuy* (illus. 239), now in the National Fine Arts Museum in Hanoi, won first prize in 1943 at the Foyer de l'art Annamite, as did his woodblock print *Young Woman Shampooing*, the image of a bare-breasted beauty sensuously bending over to wash her magnificent cascading floor-length black hair in a basin.

The 22-year-old Nguyễn Sáng, still a student at the EBAI when the French art school was closed, joined in with *The Whole People Will Struggle for the Independence and Unity of Vietnam*, a poster 10 m high of a wounded soldier-hero on crutches, another theme that became popular during the French and American Wars that followed.[7] The poster was displayed on the Taverne Royale, a well-known French café on Hoan Kiem Lake.[8]

A couple of weeks later, on 2 September 1945, Hồ Chí Minh proclaimed Vietnamese independence in Hanoi's Ba Dinh Square, quoting from the American Declaration of Independence and the French Revolution's Declaration of the Rights of Man. The photographic image of Hồ Chí Minh addressing the crowds through a microphone was used in subsequent poster designs, as were scores of earlier and later photographs of the charismatic leader (illus. 240). Thousands of supporters filled

the square, covered in a sea of Việt Minh red silk
flags adorned with a gold-filled star, a recurring
motif in Vietnamese revolutionary art. The five-
pointed star represents intellectuals, farmers,
workers, traders and soldiers – the five classes
of the new socialist society. The hammer and
sickle, the socialist symbols of the worker-peasant
alliance present on the flag of the Soviet Union, were
reserved for the Indochinese Communist Party,
created in 1930 by Hồ Chí Minh. During the Nghệ-
Tĩnh Revolt, communist-led rural demonstrations
against the French and the mandarin elite, the
socialist symbols were clearly visible on a 1930–31
Party placard with the inscription, 'Oppose the
Imperialists!' (illus. 238). In the early days of
independence, Hồ Chí Minh and the Việt Minh
carefully hid their communist origins, preferring
to emphasize the nationalist component of the rev-
olution. The Communist Party actually dissolved
itself shortly after independence and the socialist
symbols temporarily disappeared from poster art.
The symbols reappeared in February 1951 when
the Communist Party became official once again
and was renamed the Vietnam Workers Party (Báo
Lao Động). (We shall never know if Hồ Chí Minh
would have abandoned his communist roots if he
had got the support he asked for from the United
States.)

Within a few days of independence, on 8 Sep-
tember 1945, Hồ Chí Minh launched the first pro-
paganda campaign of the newly independent state,
to end the famine and bring literacy to the people:
'Fight against hunger, fight against illiteracy.'[9]
Artists embraced the themes at the state-sponsored

241
**Tô Ngọc Vân**
*Uncle Ho Working in the
Bac Bo Palace*, 1946

pencil sketch

First National Fine Arts Exhibition in August 1946.
Art was no longer reserved for the privileged few.
Trần Văn Cẩn won first prize for *Down on the Farm*
or *Descent to the Rice Field*, a silk painting depicting
farmers replanting rice fields after the famine.[10]
Another celebrated painting portrayed schoolgirls
dressed in white *ao dai* collecting money for Golden
Week (Tuần lễ vàng), Hồ Chí Minh's personal
campaign to end the famine. 'For people who are
still suffering extreme poverty, independence and
freedom are of no use,' he said, estimating that
'from January to July this year in the North two mil-
lion people died of starvation. I will practice fasting
once a week,' to encourage food donations.[11] The
award-winning paintings were printed as posters
and widely distributed by the Cultural Association
for National Salvation.

The portrayal of Hồ Chí Minh as a caring
scholar-leader close to his people dates from this
period and stands in marked contrast to the pomp-
ous larger-than-life portrayals of Lenin, Stalin, Mao
and other communist leaders. Tô Ngọc Vân (EBAI
Class II, 1926–31), a draughtsman in the Ingres
tradition, was invited to draw Hồ Chí Minh at the
Presidential Palace. *Uncle Ho Working in the Bac Bo
Palace* depicts Hồ Chí Minh writing at his desk,
pen in hand, in simple surroundings, dressed in
his favorite khaki suit, wearing black cloth sandals.
'His hair is already going grey above his high, large
forehead, and his sparkling eyes are downcast in
concentration,' Quang Phòng, the EBAI graduate
and art critic, who saw the oil painting, wrote
decades later.[12] A pencil sketch of the oil on canvas
survives (illus. 241).

## The Resistance, Folk Art and Woodblock and Lithograph Printing

*'Fight against hunger, fight against illiteracy, fight against foreign invaders.'*

*'Sketches are at the root of creativity'* – Tô Ngọc Vân

*Vietnamese independence was short-lived. War broke out in November 1946 after negotiations failed and the French returned to reclaim their colony. It was the begin-ning of the French War, the Franco-Vietnam War or the First Indochina War (1946–1954) that lasted eight years.*

When French troops reoccupied Hanoi, Hồ Chí
Minh and the Việt Minh's forces left the city for
the Resistance zone (Việt Bắc). Tô Ngọc Vân and
Trần Văn Cẩn, accompanied by their EBAI com-
rades, soon followed. They organized propaganda
teams and set up workshops in the 'liberated'
zones; in the south, artists from the Gia Dinh Art
School joined the Resistance. Posters from this
period are characterized by their small size and
limited colour range. Most were hand-painted or
produced using traditional woodblock printing
methods and manual lithograph presses set up in
the jungles of the Tonkin in the north, and of the
Mekong Delta in the south, where the guerrilla
artists lived with the Việt Minh forces.

Propaganda was key to the Việt Minh's military
strategy against a militarily superior enemy and
was organized by the Cultural Association for
National Salvation, the Việt Minh's cultural arm
created in 1943.[13] The most important campaign of

281

the war was the 1948 Emulate Patriots campaign. 'Fight against hunger, fight against illiteracy, fight against foreign invaders' was the Vietnamese equivalent of the Russian Revolution's 'Peace, bread and land'.[14] The campaign was designed to persuade and encourage all sectors of the population to join forces with the Việt Minh, who with no air power and, until 1949, no heavy artillery, waged a guerrilla war relying on farmers for food, on 'volunteer' labourers to transport rice and other supplies, on youth volunteers (the minimum age was seventeen) to enlist in the People's Army and on women volunteers for combat support missions. Visuals were all-important to persuade an illiterate population to join the revolution. Teams of artists were dispatched to the Việt Minh's administrative and military zones in the north and to the Nam Bo regions in the south, tasked with disseminating Việt Minh propaganda. Artists were responsible for creating, producing and distributing all printed propaganda materials including posters, banners, leaflets and underground newspapers. They trained young Resistance recruits as spies, illustrators, printers and graffiti artists who risked their lives under cover of darkness to paint anti-French slogans on village walls.[15]

In the Resistance zones, Tô Ngọc Vân, Trần Văn Cẩn and their EBAI colleagues innovated in response to the wartime situation. They introduced modernist styles and revolutionary themes to traditional woodblock printing, creating a Woodcut Folk Art movement, a Vietnamese equivalent of the Chinese Modern Woodcut Movement, the political art instigated by the influential Chinese cultural figure Lu Xun in the early 1930s.[16] The EBAI artists may have been aware of the Chinese initiative, but they had their own tradition to draw from right on their doorstep. The Vietnamese woodcut is called Tranh Đông Hồ or Tranh khắc gỗ dân gian or Đông Hồ Tranh làng Hồ – literally folk woodcut painting from Đông Hồ village. Woodblock prints had been part of every aspect of village life since the eleventh century or even earlier. They convey good luck wishes, celebrate festivals and recount folk and popular stories, historical legends and myths. They were also used as social commentaries and political protest against imperial and French rule. Craftsmen regularly updated their designs to suit the period: 'Before World War I, for instance, Đông Hồ villagers produced a set of four prints entitled Văn minh tiến bộ (The Progress of Civilization) in which Westernization . . . was delicately criticized through the satirical portrayal of contemporary Vietnamese people dressing and behaving like French people.'[17]

Đông Hồ village, a centre of traditional woodblock printing in Bắc Ninh province, northeast of Hanoi, was in Area 4 of the Resistance zone. Trần Văn Cẩn, whose woodblock print Young Woman Shampooing won first prize in pre-revolutionary days set up a workshop in the village with EBAI artist Tạ Thúc Bình.[18] Đông Hồ craftsmen were skilled in all the stages of woodblock printing, from carving the woodblocks to producing điệp papers, mixing natural colours and inks, drawing new themes and printing.[19] The workshop printed thousands of small propaganda prints for the Bắc Ninh province's campaign against illiteracy. They were inscribed with the 'Fight against illiteracy' slogan

and were distributed throughout the Resistance zone (illus. 242). Tô Ngọc Vân, who became director of the Vietnam Fine Arts College in 1950, set up a wood engraving and printing workshop in Area 10.[20] Another woodblock printing workshop was set up in Area 12 by the EBAI graduate and artist Hoàng Tích Chù.[21] Posters and newspapers were also printed on lithography presses.[22]

As the war progressed, Party control of the arts increased. Official cultural orthodoxy defined politically correct subjects. In contrast, style and execution were still relatively free and left to the artist's discretion. An important poster that won acclaim at the Second National Fine Arts Exhibition in 1948 is Trần Văn Cẩn's *A Study Session*, a didactic woodblock print advertising the campaign against illiteracy (illus. 243). This signalled Party endorsement of the Woodcut Folk Art Movement and Trần Văn Cẩn's work in particular, as a 'national' art form modernized to transmit political messages.[23] The medium is indigenous – woodblock printing – and the message revolutionary – the campaign against illiteracy, the criteria outlined by Trường Chinh, cultural tsar and General Secretary of the Party.[24] The avant-garde Western style, perhaps surprisingly, did not offend the cultural authorities. Two peasant girls in black trousers and traditional magenta and blue halter-tops or *Yếm* learn the difference between the letters 'i' and 't' against a background of stylized purple flowers. The message is simple and direct: study the Vietnamese alphabet. The choice of dress may have been significant; *Yếm* was worn by women of all classes, from peasants to imperial consorts, unlike most other female garments, which were

above, top:

242
**Propaganda Committee Bắc Ninh 1948–9**
*Year of the Ox (1949) Rivals Learn How to Defeat Illiteracy,* undated

above:

243
**Trần Văn Cẩn**
*Affordable Studies or A Study Session,* 1948

dictated by class. The Việt Minh opted for the easier-to-learn Romanized script over Chinese characters – even though it was a colonial import – to facilitate widespread literacy.

Another important woodblock poster at the Fine Arts Exhibition in 1948 is Tô Ngọc Vân's *Hanoi Standing Up*. The woodblock print was criticized, not for its style but for its subject (illus. 244). The print was inscribed with a lyric from 'Người Hà Nội', the famous revolutionary song about the Hanoi people's defiance against French rule by composer Nguyễn Đình Thi. According to the artist and critic Quang Phòng, writing in 1995, the theme was seen as bourgeois and unrealistic:

*The viewers could not accept the sight of a petty bourgeois woman with her dishevelled hair, wearing a dress, holding a sword in her left hand, flying to the sky reddened by flames. It was considered that the painting was a challenge to science (flying woman) and put in focus a non-representative personage (petty bourgeois woman). Thence a problem arose: should the artists trained under the old regime undergo ideological reform to be able to create in accordance with the line of socialist art?*[25]

The veiled criticism of an artist as admired and established as Tô Ngọc Vân signalled the beginning of the end of the relative artistic freedom of the early years. By 1951, the Third National Fine Arts Exhibition, held shortly after the National Party Congress in Chiêm Hoá in Tuyên Quang province, the Resistance zone northeast of Hanoi, was dominated by poster art.[26] Trường Chinh officially elevated propaganda to art when he wrote in 1948

in *Marxism and Vietnamese Culture*: 'As it attains a certain level, propaganda becomes art which in turn has the unmistakable character of propaganda if it is to some extent realistic. Thus we can say that: Art is only real art if it becomes propaganda.'[27] Hồ Chí Minh, who could not attend, was of a similar mind, and wrote in his letter to the exhibitors: 'I am sorry I am too busy to come and see the exhibition . . . I am sending you some of my comments on art that you can refer to. Culture, literature and art are also a battle front, and you are all fighters on that front' (illus. 245).[28] Significant posters from 1951 are Trần Văn Cẩn's *The Anonymous Combatant* and Tô Ngọc Vân's *The Enemy Kill, Burn and Rape*. Trần Văn Cẩn won second prize for his poster. Tô Ngọc Vân, now director of the Vietnam College of Fine Arts since 1950, was criticized once again. Quang Phòng gives us an insight into the Việt Minh's tightening grip on artistic expression:

*Tô Ngọc Vân even had to abandon his short noon nap to come to the hall of the 1951 National Conference on Culture, Literature and Art where his poster was displayed, to wipe out some figures of Moroccan and Senegalese blacks and replace them by figures of whites: in fact he was criticized for not having aimed at the principal enemy – the French soldier – and for having directed the point of his brush towards the black soldiers. Tô Ngọc Vân had the habit of painting women with their sensual beauty, but it seemed that it was not appropriate for the dramatic situations in which women became the victims, therefore in one of his paintings, the women violated by the French soldiers were old and ugly, but how to present the Frenchman who committed the crime?*

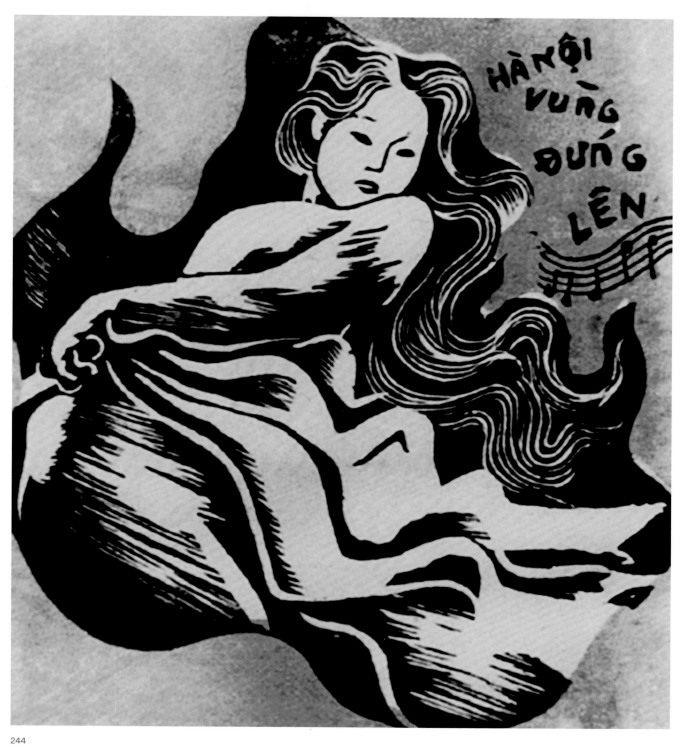

244
**Tô Ngọc Vân**
*Hanoi Standing Up*, undated

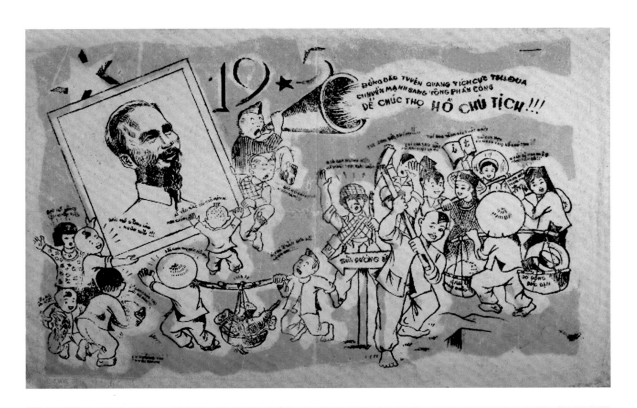

bottom:

246

**Propaganda Committee Bắc Ninh**
*Destroy, Annihilate, Exterminate*
*the Enemy and Develop, Expand*
*Guerrilla Warfare*, undated

top:

245

**Anonymous**
*19 May*, undated

*He asked his colleague to serve as the model. And in his poster, the French was a young robust man whereas he should have been an ogre, savage and brutal.*[29]

As the war intensified, posters depicted violence in a more graphic way with slogans inciting hatred (*căm thù*), such as *Destroy, Annihilate, Exterminate the Enemy* and *Develop, Expand Guerrilla Warfare* and *My Dear Patriots, Fight for the Homeland, Kill the Colonialists* (illus. 246, 247). Leaflets and posters printed in French sought to demoralize the enemy.[30] Their messages varied between expressing compassion for French mothers and wives, to solidarity with enemy fighters separated from their loved ones, to exhortations to defect, to death threats. A series by Lương Xuân Nhị was printed by the *Ligue pour le Rapatriement* (RAPA).[31] RAPA's logo was a flying dove adapted from Picasso's bird of peace. The title *14 juillet 1789, 19 août 1945* (14 July 1789, 19 August 1945) is a direct reference to Hồ Chí Minh's independence speech that drew parallels between the French and Vietnamese revolutions (illus. 267).[32] In the poster, an adaptation of the figure of the bare-breasted Marianne from Eugène Delacroix' *La Liberté guidant le peuple* (actually depicting the 1830 July Revolution to overthrow the Bourbon dynasty), holding the French flag in her right hand and a bayonet in her left hand, is silhouetted against a red map of France. Leading the charge, a Vietnamese woman dressed in the traditional *ao dai* holds the red and gold Việt Minh flag in her left hand and a *pistolet* in her right, silhouetted against the S-shaped map of Vietnam. The female figure holds a gun and replaces the young

top:

247
**Anonymous**
*My Dear Patriots, Fight for the Homeland, Kill the Colonialists*, undated

bottom:

248
**Anonymous**
*Spirit Vietnam-Soviet-China Forever! . . .*, undated

287

boy wielding two *pistolets* in the original painting. The women float on a banderole with the inscription '14 juillet 1789 et 19 août 1945'. The women's *en-avant* stance became a favoured pose in war posters of the 1960s and '70s, with women leading the charge, gun in one hand and flag in the other.

With the official reappearance of the Indochinese Communist Party, renamed the Workers Party in 1951, Việt Minh propaganda shifted from nationalist to socialist themes. *Spirit Vietnam-Soviet-China Forever!. . .* portrays Hồ Chí Minh side by side with the Chinese and Soviet leaders Mao and Stalin (illus. 248). Mao Zedong's communist victory in 1949 and the Sino-Soviet Alliance prompted Hồ Chí Minh to seek new alliances. To boost troop morale, propaganda promoted international socialism and portrayed a cosy alliance between the Soviet Union, the People's Republic of China and Vietnam in their common fight against the imperialists.[33]

In 1953, class struggle, a theme central to communist ideology, came to the fore, as the General Secretary of the Party, Trường Chinh, launched a Land Reform Campaign 'to restore social justice and establish the dictatorship of the proletariat'. EBAI artist (Class XVI 1942–5) Phan Thông, in a series of political drawings, depicts landlords as greedy and violent exploiters of starving farmers and their families (illus. 249).[34] The estimated number of landlords who were executed varies widely between 15,000 and 150,000. By 1956, Hồ Chí Minh had personally acknowledged that there were serious problems with land reform and a subsequent Party announcement ended the campaign.[35]

The war ended in 1954 with the Việt Minh's victory over the French at Điện Biên Phủ. The epic battle lasted over 57 days and nights. Throughout, braving artillery and aerial attacks, artist-soldiers printed propaganda leaflets, posters and newspapers at rear headquarters to boost Việt Minh morale.[36] An iconic red-and-white poster by the artist Nguyễn Bích (an example is in the collection of the National History Museum in Hanoi) celebrates the victory (illus. 250). A People's Army soldier wearing the PLA's quilted jacket uniform and camouflage helmet holds up the Việt Minh flag; the flags of the People's Republic of China and the USSR are represented in the background. A dove, modelled after Picasso's bird of peace, is perched on the soldier's left shoulder. Picasso designed the dove emblem for the Congrès Mondial des Partisans de la Paix in 1949. A lifelong member of the French Communist Party, Picasso publicly opposed the French War in Indochina. Tô Ngọc Vân sent him a moving letter to thank him for his support.[37] The artist Nguyễn Bích, who designed the poster, first

249
**Phan Thông**
*Untitled*, c. 1953–5

watercolour and pen on paper

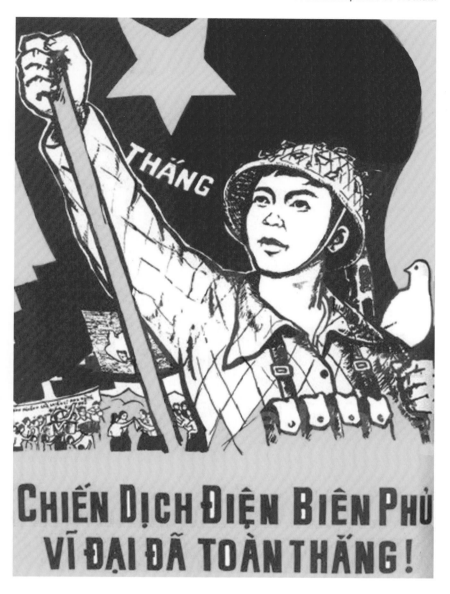

incorporated the peace dove into his design for a
Điện Biên Phủ medal awarded to soldiers during
the campaign. He symbolized a new generation of
self-taught soldier-artists valued as much for their
heroic military careers as for their artistic talent.
He was not a graduate of the EBAI or of the Resis-
tance schools. After the war, he became an
illustrator of popular children's comic books.[38]

Shortly after the victory at Điện Biên Phủ, Tô
Ngọc Vân was killed in an attack by French planes
on 15 June 1954. Artist-inspired revolutionary
aesthetics died with him. After the war, the new
Ministry of Culture created in 1955 was firmly in
control of all propaganda. Speaking to art critic
Quan Phòng decades later, fellow artist Trần Văn
Cẩn recalls the moment when he heard the news of

250
**Nguyễn Bích**
*Campaign Điện Biên Phủ, Great
Complete Victory!*, 1954

leaflet or booklet, inscribed
woodblock print

Tô Ngọc Vân's death, enshrining war sketches in Vietnam's revolutionary aesthetic:

*Upon hearing the sad news, we tried not to believe it was true, hoping he was able to hide somewhere during the bombardment. Not until Nguyễn Đình Thi (the writer and composer) with other combatants came back from the battlefield, bringing his rucksack and his painting folder, did we despair! The folder was carefully wrapped in a piece of raincoat . . . Tô Ngọc Vân was as careful as he had always been. He'd rather get wet than leave his sketches and folder improperly covered . . . among the sketches he made along the way to the battlefield was one with stirring strokes dated 15–6–1954. The sketch depicted our troops marching through Lung Lo pass, the last painting of his life![39]*

## The Democratic Republic of Vietnam and Socialist Realism, 1954–64

*Following the 1954 Geneva Accords, Vietnam was divided into the communist north and the non-communist south. The Democratic Republic of Vietnam (DRV), under Hồ Chí Minh, was backed by the Soviet Union; the Republic of Vietnam, under Ngô Đình Diệm, was backed by the United States. The agreement stipulated that general elections would be held by July 1956 to create a unified Vietnamese state. Given Hồ Chí Minh's popularity, the Allied Powers and U.S.-backed Republic of Vietnam feared a communist victory at the polls. National elections were never held. In Hanoi, hawks led by Lê Duẩn advocated military support for the southern revolution to achieve the reunification that was denied them at the polls. In 1959, the Politburo decided to give military support to the ongoing insurgency against the Diệm regime in the south, as the only way to unify the country.[40] The America–Vietnam War began in 1964.*

The DRV's most urgent task was to rebuild the country, devastated by nine years of war. Propaganda focused on consolidating peace and implementing the 1954 Geneva Accords, restoring and boosting agricultural production and encouraging industrial development.[41] The Ministry of Culture, created in 1955, was in charge of propaganda. In 1957, the Ministry set up its own poster design department and employed artist-soldiers back from the front, hired on the merits of their war record, often with no background in fine arts.[42] This led to a more codified approach to design. Art expressed health and happiness; paintings teemed with optimistic industrial and agricultural scenes, and the depiction of poverty, misery and suffering was banned. Established artists continued to contribute to propaganda campaigns through the annual state-sponsored Fine Arts Exhibitions. Artists were now cadres of the state and operated under conditions of strict censorship. Ideological conformity was enforced by the secret police and through Maoist self- and group-criticism sessions in the workplace. Celebrated Resistance artists were punished during the 1957 Nhân Văn–Giai Phẩm affair for their contributions to *Nhân Văn* (Humanities) and *Giai Phẩm* (Works of Spring), publications that criticized the Party censorship. The journals were closed down. Some contributors were imprisoned; others had their careers ruined. The Vietnam College of Fine Arts

(Trường cao đẳng Mỹ thuật Việt Nam) reopened in Hanoi in 1957 under the control of the Ministry of Culture.[43] EBAI graduate Trần Văn Cẩn, the lyrical French-trained oil painter-turned-revolutionary artist, became its director. His tenure ensured that classical sketching and drawing techniques were taught to a new generation of artists.

Compared to the war years, the printing quality of posters improved dramatically. They were now printed on machine-made paper on industrial presses in Hanoi. Posters were much larger than the woodblock prints of the war years and were printed in three or four colours, which were bolder and more varied than the duotones of the manual printing presses in the jungles of the Việt Bắc.

At the 1955 Party Conference, the Party asserted that the 'U.S. and its minions were supplanting the French in the south' and launched campaigns to 'remain vigilant against U.S. aggression'.[44] At the same time, Socialist Realism, the official art of the Soviet Union since 1934, made its official debut following the DRV's alliance with the Soviet Union: art should be representational, accessible to the people and supportive of the aims of the Party and of the state. Official cultural exchanges with the Soviet Union and Eastern Bloc countries proliferated. Soviet experts were sent to Vietnam to teach oil painting and sculpture at the Vietnam College of Fine Arts. Vietnamese artists studied at Soviet and Eastern Bloc universities. Pham Thanh Tâm's 1955 poster is an early example of Vietnamese Socialist Realism (illus. 251). In a less codified version of its Soviet and Chinese counterparts, Pham Thanh Tâm incorporates American-style comic

strips in his otherwise Socialist Realist poster. The People's Army soldiers warn to *Stay Vigilant [against American] Bullying*, pointing the finger at a long-nosed, angry, green-faced American, a U.S. missile in his back pocket, wearing cowboy boots. The cartoon-like character, brandishing the flame of war, one boot trampling the map of a divided Vietnam with green attack arrows pointing north, orders a cowered Diệm, the South Vietnamese 'puppet' leader, to attack the north. U.S. tanks, the Seventh Fleet and U.S. planes are lined up behind him. Tâm, whose drawings are in the collection of the British Museum, exhibits the classical composition and sketching skills he learned as a teenager from EBAI artist Lương Xuân Nhị in the Resistance art school. His sketches and diary of Điện Biên Phủ are one of the few known contemporaneous diaries of the epic battle, published in English and French in *Drawing Under Fire*.[45]

Restoring agricultural production was another priority for the Party in 1955.[46] The modernist Folk Art Movement, developed in the jungles of the Việt Bắc, with its flat perspective and vivid colours, was ideal for agricultural campaigns, which portrayed happy women field workers wearing the colourful clothes of ethnic minorities in sunlit landscapes. The collection of the Vietnam Women's Museum in Hanoi is representative of the genre, which remained popular well into the 1970s and '80s.[47] Regular campaigns promoted the production of rice, soya beans and cotton and the rearing of poultry and pigs with an emphasis on good husbandry. Typically, posters feature women from the ethnic minorities with idealized features, colourful dress and exotic

headdresses. Animals, crops, fruit and vegetables are used as brightly coloured stylized motifs. The Ministry of Culture's compulsory 'Going Down to the People' campaign exposed artists to the 'real' life of the farmers. Artists on the annual three-month programme lived with the people and farmed the land.[48] Trần Văn Cẩn, the director of the Vietnam Fine Arts College, travelled to the countryside to paint *Irrigation in a Summer Rice Field*, a lacquer painting that he presented at the Seventh National Fine Arts Exhibition in 1957.

Industrial development was seen as crucial to the DRV's new socialist society. In poster art, industrial and technological themes were influenced by Russian Constructivism, a style that became popular with Vietnamese artists studying in Eastern Bloc countries. Following the death of Stalin in 1953, the 'Khrushchev Thaw' led to a modernization of Socialist Realism and a rediscovery of earlier modernist styles. With its angular geometric patterns and red, black, grey and white palette, it was ideally suited to campaigns promoting heavy industry and new technologies. EBAI artist Nguyễn

Đỗ Cung specialized in depicting a new breed of industrial workers in his oil paintings *Mechanical Workers* and *Learning from Each Other*, presented at the 1960 National Fine Arts Exhibition.[49] Later posters by Nguyễn Công Độ, who studied photography and film in East Germany in 1962 and art at the Vietnam College of Fine Arts, exhibit the geometric stylized patterns of Constructivism. In *All for Peace*, orange and black stylized tanks are turned into tractors (illus. 251).[50] Artist Nguyễn Thụ combines agricultural and industrial production goals in his 1960 poster, *The Mountains Belong to You, Child, and Factories Also Belong to You*, portraying an ethnic minority woman holding a child against the background of the Truong Son mountain range and a new factory (illus. 252).

The most historically important posters of the interwar years were created for the reunification campaign. In 1959, the Party took the decision to give military support to the ongoing revolution in the south against the U.S.-backed Diệm government to stop U.S. aggression, which prevented reunification of the country.[51] At the Third National Party

TAT CA VI HOA BINH

251
**Nguyễn Công Độ**
*All for Peace*, 1972

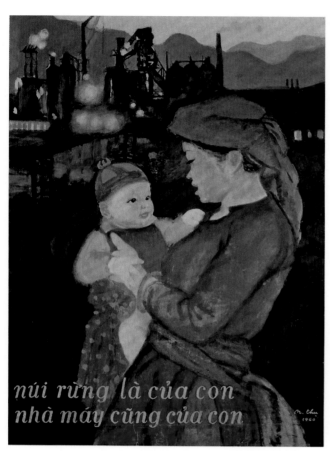

núi rừng là của con
nhà máy cũng của con

252
**Nguyễn Thụ**
*The Mountains Belong to You,*
*Child, and Factories Also*
*Belong to You,* 1960

Congress in 1960, Hồ Chí Minh, in his opening speech, stated that the Party must be 'ready to fight to preserve peace, protect the country and the building of socialism in the North and support the peaceful struggle for national reunification'.[52] In a photograph from 1960, students from the Hanoi College of Fine Arts give the final touches to a giant poster. The poster's slogan echoes Hồ Chí Minh's speech in support of reunification: *South North One House* (illus. 253). North and south, represented by a woman from the north and one from the south holding a white dove, embrace in a show of unity. A year earlier, in 1958, the Party stepped up its anti-American campaign propagating fears of a U.S. nuclear war after the U.S. conducted 35 nuclear tests in the Pacific in a single year. EBAI lacquer artist Nguyễn Đức Nùng did a lacquer work entitled *They Conducted the A-bomb Test Again* or *Imperial America to Test Atomic Bombs* and Nguyễn Đỗ Cung created another poster entitled *Peace Protection against Nuclear War* (1959).[53]

In 1964, Văn Đa, a soldier-artist who graduated from the Vietnam College of Fine Arts in 1963 on the DRV equivalent of the GI Bill, designed a commemorative poster for the tenth anniversary of the Điện Biên Phủ victory. The title of the poster, *Determined to Fight, Determined to Win*, linked Vietnam's independence war against the French with the fight against the Americans and their 'puppets', the South Vietnamese regime. *Determined to Fight, Determined to Win* was the slogan of the 1954 Điện Biên Phủ campaign inscribed on the Việt Minh's red flags.[54] In 1960, *Determined to Fight, Determined to Win* banners were carried by the first Hanoi

delegation sent to support the revolution in the South. In August 1964, the Gulf of Tonkin incident led to U.S. military support for the Republic of Vietnam and to the America–Vietnam War (1964–75) (illus. 254).

## The America–Vietnam War, 1964–75

*'Nothing is more precious than independence and freedom.'*

*The first U.S. Marines landed at Da Nang in March 1965 to support the Republic of Vietnam (South Vietnam) against infiltration by the communist north. The war lasted ten years until 30 April 1975 when the North Vietnamese Army (NVA) entered Saigon. The DRV (North Vietnam), backed by the Soviet Union and the People's Republic of China, fought a conventional war in the north and along the DMZ (Demilitarized Zone) and the Hồ Chí Minh Trail, the military supply route between north and south. The National Liberation Front Army (NLF or Vietcong) fought a guerrilla war in the Republic of Vietnam against South Vietnamese and American troops. According to official Vietnamese sources published in 1995 by Agence France Presse, 1.1 million NVA and NLF combatants died between 1954 and 1975, and another 600,000 were wounded. Civilian deaths between 1954 and 1975 are estimated at two million in the North and two million in the South. A 2008 study published by the* British Medical Journal *estimated a total of 3.8 million casualties between 1955 and 1984. Of the U.S. combatants, 58,193 lost their lives.*[55]

253
**Anonymous**
*South North One House*, 1960

254
**Văn Đa**
*Determined to Win, 10th Anniversary of the Diên Biên Phu Victory*, 1964

Propaganda was central to the DRV's military strategy to mobilize the whole population, including women, against a formidable military and financial superpower. Hanoi portrayed the conflict as an all-out war for national salvation and reunification. Fuelling patriotic fervour against a foreign invader was a powerful motivator. The Republic of Vietnam was presented as a puppet regime – think Vichy during the Second World War – made up of collaborators and traitors. Propaganda campaigns exhorted northerners to save their southern comrades from the murderous excesses of the fascist regimes in the south.

Propaganda was effective because of the state's quasi-total control over society. During the war, the DRV's security apparatus, ultimately responsible for censorship of the arts, was enhanced with the help of the East German Stasi.[56] The depiction of military casualties in art, photography and film was banned. U.S. censorship had banned publication of American dead during the First and Second World Wars, but television, a new technology, changed all that. The Vietnam War was the first U.S. televised war in history. The distressing images of American and South Vietnamese casualties on the American nightly news fuelled anti-war protests, leading the Canadian philosopher Marshall McLuhan to comment in 1975 that 'Television brought the brutality of war into the comfort of the living room. Vietnam was lost in the living rooms of America – not on the battlefields of Vietnam.'[57]

During the August Revolution of 1945, a generation of inspired artists passionate about independence created the first Việt Minh posters.

Twenty years later the DRV's propaganda network employed hundreds of artist-cadres who produced thousands of posters. Artist-cadres included a corps of professional poster designers working for the ministries of Culture and Defence as well as established artists – painters in oil and lacquer and on silk employed by the Vietnam Association of Fine Arts, the Vietnam College of Fine Arts or state-owned illustrated journals and newspapers. Yet far from exhibiting the monolithic style generally associated with socialist censorship and propaganda, poster styles were adapted to maximize their effectiveness on their target audience. Today, the variety in styles contributes to their contemporary appeal, in both concept and design, as in Pietro Ruffo's mixed-media take on *Trần Thị Tâm, Stick to the Land, Stick to the People, She is Valiant and Resilient, 9–1972* (illus. 237, 258).

Vietnamese poetic realism and French-inspired painting styles exhorted women combatants to enlist. Indigenous folk art popular in villages encouraged the rural population to reach production goals to support the war effort. Quốc Thái (b. 1943), a self-taught professional poster designer, is representative of this style. In love with colour since the age of six, Quốc Thái worked as a poster designer in the early 1960s for the regional office of the Ministry of Culture in Kiến An and later for the Police Department designing traffic systems. He graduated from the Vietnam College of Fine Arts in 1982.[58] *Good Production, Good Collection* (1972) features an attractive young woman wearing a fetching green straw hat, a strap under her chin, holding a sheaf of rice against a rice sheaf design

in warm yellow hues. In the background, women comrades aim their guns at the sky (illus. 268). Russian Constructivism and Socialist Realism appealed to the population's patriotism to fight on until victory. American Pop art and Western-style comic-book graphics familiar to the enemy were used in campaigns to demoralize U.S. troops, in the same way that Impressionist-style posters had sought to demoralize French troops during the previous war. Black-and-white woodcut engravings influenced by the Chinese Woodcut Movement of the 1930s became popular, notably with the artists Trần Huy Oánh and Nguyễn Văn Trực, who studied at the Fine Arts College in Shanghai in the early 1960s (illus. 255).

American–Vietnam War posters can be divided into hand-painted posters, woodblock prints and mass-produced printed posters. Posters produced in Hanoi by the ministries exhibit codified designs, are large in size, have bold colours and are usually printed on machine-made paper on conventional presses. Printing was a well-established state industry. In contrast, posters created on the front lines originate from sketches drawn under fire. They are hand-painted, hand-printed from woodblock engravings or produced on manual lithograph presses.

Ten years after the end of the French War, established Hanoi artists and teams of artist-soldiers embedded with the North Vietnamese Army and with the Vietcong guerrillas in the south once again left for the front line. Artists worked from sketches, drawing in the streets of Hanoi or travelling to the front lines of the DMZ and the Hồ Chí Minh Trail to record women manning anti-aircraft artillery, downed U.S. planes, bombed landscapes or bridges being rebuilt. Artist-soldiers produced hand-coloured and woodblock posters on the front line as vivid as their war sketches.[59] Hanoi artists travelled down the Hồ Chí Minh Trail on a perilous journey to set up a clandestine propaganda network. They taught art to guerrilla fighters and held impromptu exhibitions in the jungles of the Mekong Delta. They moved with the soldiers and carried their materials and artworks with them. They stored their drawings in U.S. ammunition boxes, in disused U.S. flares, under termite mounds, in underground kitchens and in rock caves. They collectively created thousands of sketches, watercolours and posters. Posters were hand-drawn in jungle art schools. Kim Liên, one of the few women war artists, was photographed at NLF headquarters near Tây Ninh, hand-painting the image of a woman and child

255
**Nguyễn Văn Trực,**
*Untitled*, undated

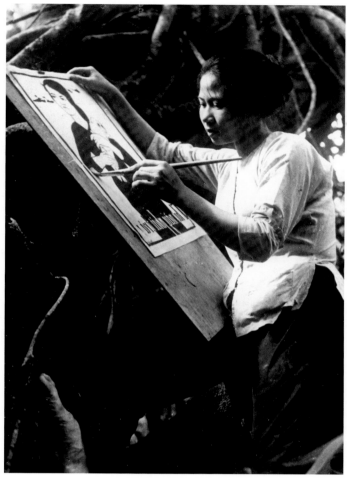

256
Photograph of artist Kim Liên
in the Resistance painting a
woman holding a dead child with
enemy helicopters and battleships
in the background, Viet Cong
Headquarters, Tay Ninh, 1965

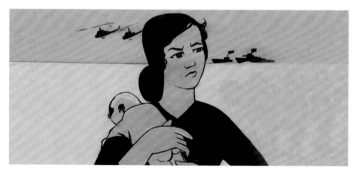

257
Detail of illus. 270

with the inscription *Hatred Must be Avenged!* (illus. 256, 257, 270). Posters were often adapted from sketches drawn under fire and from hundreds of portraits of heroes, heroines and ordinary soldiers. The life drawings and *croquis rapide* so prized by Tô Ngọc Vân lend immediacy and poignancy to the propaganda produced on the front lines, where artist-soldiers lived, fought and died with their fellow combatants.[60]

War propaganda included 'positive' and 'negative' themes. Positive themes depicted heroic combatants and commemorated military victories. 'Emulate Patriots' campaigns encouraged volunteers to enlist in the armed forces and celebrated the sacrifice and bravery of martyred heroes and heroines. 'Sure to Win' campaigns kept up morale in the face of mounting war dead. 'Victory' campaigns were launched at the beginning of offensives to whip up a positive mental state, essential for victory. 'Solidarity' campaigns promoted solidarity between NVA regular troops and NLF guerrilla (Vietcong) fighters in the south and with the ethnic minorities fighting on the DRV side. Allegiance to the leader, the Party and international socialism was popularized by the celebration of communist leaders' birthdays, including Soviet and Chinese leaders, and anniversaries of the Party, the armed forces and the voluntary organizations. In 1970, the artist Trường Sinh, who studied art in East Germany and worked as a poster designer for the Ministry of Culture between 1964 and 1990, created a 320 sq. m poster of Lenin to commemorate the Soviet leader's hundredth birthday, to hang on the opera house in Hanoi.[61] Campaigns were launched

258
Detail of illus. 237

to encourage industrial and agricultural production to support the war effort. Slogans were part of daily life, visible everywhere, on city and village walls, on banners, placards and posters and audible on radio. They were taken verbatim from Hồ Chí Minh's personal letters, speeches and addresses to the nation, from Party directives and from poems and songs written and composed by revolutionary poets, writers and musicians. Slogans went from the mundane, 'Learn BDVH [dentistry] to fight the Americans!', to the didactic, to the optimistic 'Determined to Win', to the cruel or poignant.

Central to the DRV's military strategy were campaigns to 'convince' women and young people to 'volunteer' for combat in the war for national salvation. (Although this is not the subject of this essay, anecdotal evidence suggests that volunteering was as compulsory as the draft.) In 1965, during the first year of the war, the 'Three Ready To' ('Ba sẵn sàng') campaign in the north and 'Year of the Volunteer' ('Năm xung phong') in the south encouraged young men and women to join the Youth Volunteer Corps.[62] The 'Three Responsibilities' campaign ('Ba đảm đang') exhorted women to

volunteer for combat duty.[63] The following year, as U.S. troops reached 400,000 in the south, Hồ Chí Minh launched a personal appeal on national radio to recruit hundreds of thousands of additional volunteers:

*The war may last five years, ten years, twenty years or longer. Hà Nội, Hải Phòng and some cities and factories may be devastated. But the people of Vietnam decided not to fear. Nothing is more precious than independence and freedom.*[64]

A 1967 poster by EBAI artist Phan Thông inscribed with Hồ Chí Minh's popular saying 'Nothing is more precious than independence and freedom' is emblematic of the war's central themes of national salvation and reunification (illus. 259). The poster displays a mix of socialist, Catholic and traditional Vietnamese symbolism. The red and gold socialist palette is softened by touches of cerulean, the traditional Vietnamese colour of optimism. Southern Resistance fighters engage the viewer with a steady gaze. Cupped giant hands hold up a red heart centred with the S-shaped map of a unified Vietnam.

right:

259

**Phan Thông**
*Nothing Is More Precious
than Independence and
Freedom*, 1967

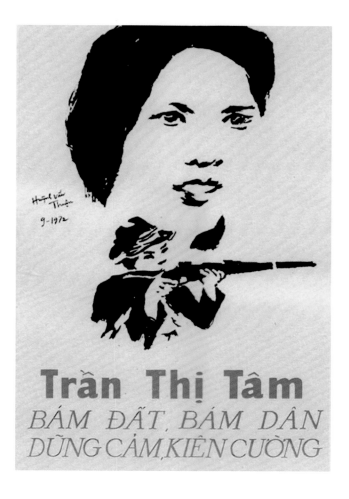

The heart motif is borrowed from the Catholic
imagery of the sacred heart familiar to Vietnamese
Catholics. Contrary to most reports, not all Cath-
olics left the DRV and there were Catholic militias
who fought on the communist side. The S-shaped
map of Vietnam is the one artist Trần Văn Cẩn
drew in 1945 to symbolize national unity. The sheaf
of rice signifies the abundance of the new socialist
society. Most significant is the representation of
the woman combatant, an AK-47 strapped to her
shoulder, clutching a sheaf of rice in her arms.

The representation of women combatants is the
most enduring propaganda image of the American
–Vietnam War. This points to the extraordinary
contribution women made to the war effort. Glo-
rification of women combatants exists throughout
Vietnamese history. The Trưng Sisters were legend-
ary heroines who defeated the occupying Chinese
and ruled for three years from AD 40 to 43. Women
combatants fought in the 1930s communist-led
Nghệ-Tĩnh soviets and during the French War,
when, in the south, they were known as the 'Long-
haired Army'. But this was the first time women
fought in de facto combat roles even though they
were technically recruited for auxiliary services, not
drafted into the Army. An estimated one million
women fought with NLF forces in South Vietnam,
a number that exceeds the estimated 800,000
women in combat and combat support missions
who served in the Soviet Armed Forces during the
Second World War.[65] Women manned anti-aircraft
guns on Hanoi rooftops and decommissioned unex-
ploded bombs along the Hồ Chí Minh Trail. The
Three Responsibilities campaign launched in 1965

above:

260

**Huỳnh Văn Thuận**
*Trần Thị Tâm, Stick to the
Land, Stick to the People, She
is Valiant and Resilient, 9-1972*,
1972

299

compelled women to volunteer for combat. This was translated into poster art, where women are depicted with a rifle, AK-47 or bayonet to signify their new role as defenders of the nation. A flower, a bundle of rice or an infant mark their traditional roles as mothers, custodians of the family and workers responsible for production in wartime. These deceptively poetic images to Western viewers conveyed a loaded message to Vietnamese women. Women's Three Responsibilities to the Party and the nation were clearly defined by the Women's Union:

1. *Women are responsible for production and for the replacement work of their husbands' fighting.*

2. *Women are in charge of the family for husbands, children and brothers enlisted and serving in the Army for a long time.*

3. *Women are responsible for combat service, for joining militias and for military training for combat readiness; to serve the Army, police and militia to fight.*[66]

Women figure prominently in 'Emulate Patriots' campaigns celebrating national heroines killed in combat. EBAI artist Huỳnh Văn Thuận, who designed the DRV's new banknotes in 1953, honours 24-year-old Trần Thị Tâm, killed in combat during the second battle of Quang Tri in his iconic poster *Trần Thị Tâm, Stick to the Land, Stick to the People, She Is Valiant and Resilient, 9–1972* (illus. 260).[67] The close-up of the heroine sketched in thick black lines on a pale background has a Pop art silkscreen-like quality, more American movie poster than Socialist

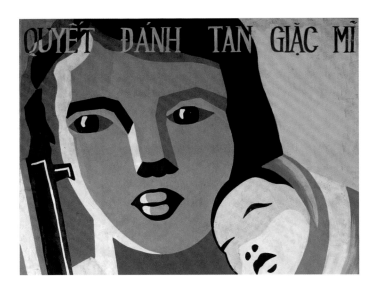

261
Detail of illus. 273

262
**Anonymous**
*Route 9, Khe Sanh, Emulate Frontline Heroes*, undated

Realism. Dương Ánh, a 1958 graduate of the Vietnam College of Fine Arts, celebrates a heroine and martyr fighting with the Vietcong guerrillas in the south in *Lê Thị Hồng Gấm, Determined and Brave [in] Attacking, Steadfastly and Firmly [in] Post Holding* (illus. 271).[68] Lê Thị Hồng Gấm, who joined the Resistance in the south at the age of sixteen, was killed in action at nineteen.[69] She is portrayed as a mature woman aiming an AK-47 at an invisible enemy. Her flowing black hair is worn long, and she is draped in the camouflage poncho liner of a U.S. parachute. Vietcong guerrilla fighters used the nylon liners as raincoats. The poster's composition and red, black and white palette of Constructivism are reminiscent of Soviet posters depicting armed women such as *Women Workers Take Up Your Rifles* (1917), or *Motherland is Calling You. The People of Vietnam Will Surely Win! The American Empire Will Surely Lose!* (signed *hiếu*, 1972) is the portrait of a southern guerrilla fighter in a cool blue palette enhanced by strong black lines and deep shadows, her chequered scarf framing her face (illus. 272). The young mother of *Decided to Beat the American Enemy so My Baby Can Sleep* (illus. 261, 273), a gun by her side to protect her sleeping baby, represented hundreds of thousands of South Vietnamese women in rural South Vietnam, threatened by American aerial bombardments. (The Vietcong did not have any air capability.) Many enlisted with the Vietcong to protect their children and their land. Even though South Vietnam was an American ally, U.S. carpet bombing of rural South Vietnam was unparalleled in its ferocity and scale against an ally's territory. On the ground,

a U.S. 'kill anything that moves' policy threatened civilians in the villages, including women and children, who were suspected of supporting the Vietcong. The poster's slogan targets Americans with no mention of the South Vietnamese government 'puppet' forces, their allies. From observation, Vietcong propaganda to enlist women's support was directed more often at foreign imperialists than at South Vietnamese government forces.

The portrayal of women guerrilla fighters was central to Vietcong propaganda. Posters of female combatants were adapted from war drawings by established Hanoi artists 'embedded' with the NLF.[70] Huỳnh Phương Đông, whose war drawings are part of the collection of the Hồ Chí Minh City Fine Arts Museum, was the first artist and officer to be sent down the Trail in 1963 to set up a propaganda network in the south. *Vent Hatred, Point Your Gun* (illus. 274) was a Women's Union directive encouraging women who lost loved ones to turn hatred into action. A woman guerrilla fighter, her long black hair tied in a ponytail, wears the black pyjama uniform of the Long-haired Army with a stylized American parachute draped over her shoulder. The red and gold background of the DRV flag symbolizes north-south solidarity. Huỳnh Phương Đông graduated from the Gia Dinh Art School in Saigon and was a professor at the Vietnam College of Fine Arts in Hanoi. Under military orders to keep his mission secret, he wrote a farewell poem to his family to say goodbye. He was reunited with his family nine years later, at the end of the war.[71]

Lê Lam was another established Hanoi artist who volunteered to go south. An admirer of

Delacroix and Rubens, Lê Lam graduated from
the Vietnam College of Fine Arts in 1953 and from
the University of Fine Arts in Kiev in 1964. He
travelled down the Trail in 1966, carrying with him
drawing paper, an eraser, a pencil, a knife, a brush
and a watercolour set he had brought back from
Leningrad. His poster *Protect the Nation* depicts in
muted earthen tones an elegant woman guerrilla
fighter wearing the southern uniform, the black
pyjama, Hồ Chí Minh sandals made from rubber
tyres, a chequered scarf and a floppy canvas hat
(illus. 275).[72] The gold-starred, red-and-blue-striped
NLF flag is tied to the blade of her bayonet. The
frayed edges of the Italianate archway are the only
visible traces of war, suggestive of bombings.

Posters by young guerrilla artists trained in the
jungle art schools of the Mekong Delta appealed to
their comrades-in-arms, who identified with their
lifelike portrayals. The poignant *Hold on to Youth*
depicts a southern guerrilla fighter in the black
pyjama uniform, wearing the chequered scarf as a
headdress. She holds a pink lotus blossom (*hoa sen*)
in one hand, and the strap of her gun in the other.
A bamboo forest makes up the background. The
lotus blossom is a Buddhist and popular secular
symbol of beauty, purity and truth, and Hồ Chí
Minh's favourite flower. The poster is inscribed with
a popular 1954 poem written by a girl to her brother,
a soldier at Điện Biên Phủ, and published in the
People's Army front-line newspaper (illus. 276).[73]

Offensives and battles were preceded by propa-
ganda campaigns extolling victory. The 1968 Tết
Offensive (*Tết Mậu Thân*) marked a turning point in
the war. For the first time, the NVA and NFL joined

263
**Trường Sinh**
*3500 USAF, F111A: AC 130,*
*F105, F101, B52*, 1972

264
**Phạm Trí Tuệ**
*Do Your Duty and Vote*,
1976

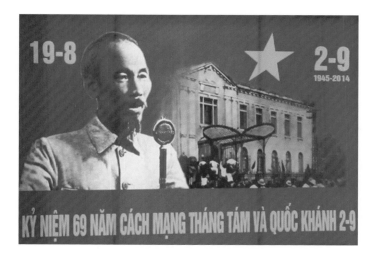

Marine Base at Khe Sanh. Hồ Chí Minh sent a message to the soldiers on the Route 9–Khe Sanh Front proclaiming 'our victory at Khe Sanh' on 13 July 1968. Front-line posters of Route 9 and of the battle of Khe Sanh are relatively rare, as B-52 bombing and artillery shelling was too intense for artists to draw.[75] *Route 9, Khe Sanh, Emulate Frontline Heroes*, by an unknown artist, depicts a soldier ready to launch a bazooka alongside a tunnel digger. NVA engineers dug networks of trenches and tunnels to protect soldiers during the six-month NVA siege of the U.S. Marine base (illus. 262).

Hồ Chí Minh died in Hanoi in 1969 at the age of 79. In death as in life, he remains the most celebrated and depicted leader in Vietnam. In an iconic poster published after his death, Trần Huy Oánh and Nguyễn Thụ portrayed the departed leader of Vietnamese independence still commanding the troops.[76] The inscription comes from a popular NVA marching song, 'You are still marching with us, Uncle Hồ,' by the revolutionary composer Huy Thục.[77] To this day, artist Lê Huy Trấp, a 1964 graduate of the Vietnam Fine Arts College who worked designing theatre sets for the Ministry of Culture, draws posters exclusively of Hồ Chí Minh to express his 'soul and spiritual beauty'.[78] In 1970, a pastel drawing with the inscription 'Nothing is more precious than independence and freedom' was sent for exhibition to Cuba and selected by Fidel Castro to be printed as a poster. Today, more than forty years later, Lê Huy Trấp continues to design award-winning posters of Hồ Chí Minh.

Negative propaganda depicted hatred and called for revenge against U.S. imperialists and the

forces in a general offensive against U.S. and South Vietnamese troops. The Welcome Tết Victory Art Competition was launched within a few days of the beginning of the offensive. The victory poster campaign was timed to have maximum impact on troop morale. The Central Propaganda Committee of the Ministry of Culture and the Vietnam Fine Arts Association received hundreds of images. Nguyễn Tiến Cảnh's painting *Huế Welcomes Victory* was selected for nationwide release as a poster and a stamp. The poster portrays unity in victory: two Vietcong combatants stand in a victorious stance next to the NFL flag planted on the Ngọ Môn Gate or Noon Gate, the main gate to the imperial city. NVA troops and tanks are silhouetted in dark red hues behind them. The battle of Huế lasted until March 1968; it was one of the longest and bloodiest battles of the war, with heavy casualties on both sides. The artist Nguyễn Tiến Cảnh, in a recent interview, recalls painting day and night with artist friends to be ready in time for the competition: 'I was happy and honoured that the painting was chosen to be a poster for wide distribution.'[74] In the biggest battle of the war, compared at the time with Điện Biên Phủ, the NVA laid siege to the U.S.

265
**Anonymous**
*19–8 2–9 1945–2014*
*69th Anniversary of the August*
*Revolution and National Day*, 2014

propaganda poster photographed
on a building in Hanoi

U.S.-backed 'puppet regime' in South Vietnam. *They Shoot Their Guns. We Want Retaliation for the People* is representative of the DRV's anti-American campaigns (illus. 277). It is interesting to note that DRV propaganda differentiated between the American people and the government. It was aimed at the soldiers 'sent to kill us', and the politicians who sent them there, not at the American people, who were not the enemy. Censorship banned the portrayal of fallen Vietnamese soldiers but encouraged the depiction of civilian casualties, victims of enemy bombings or atrocities. Keeping count of the number of U.S. planes shot down was a recurring theme. A poster commemorated the downing of the 3,500th U.S. plane (illus. 263). Anti-campaigns ridiculed enemy leaders, Richard Nixon in particular, and condemned enemy atrocities using both symbolism and graphic violence. Pham Thanh Tâm's symbolic poster-sketch *Hà Nội 18-12-30-12-1972* denounces the Christmas bombings of Hanoi in 1972, a punitive U.S. action that targeted the city's civilian population. The bombing condemned at the time by the U.S. anti-war lobby. Tâm's poster-sketch depicted a U.S. Air Force B-52 plane broken in half by the strength of the people's patriotic spirit, represented by yellow-skinned forearms (illus. 278). During the twelve days of bombing, two hundred B-52s flew more than seven hundred sorties. B-52s, fighters and smaller bombers dropped over twenty thousand tons of bombs. The Hanoi-based artist Trường Sinh, who studied art in East Germany in the 1960s, sketched the destruction in situ. 'I drew the Nixon poster on the night of 26 December 1972, standing on the corner of Kham

Thien Street,' he said in a recent interview. 'I wanted to support the military spirit of the people towards one goal: reunification.'[79] *Nixon Must Pay the Blood Debt* shows Nixon's head in the shape of a B-52 bomb being struck by red lightning bolts and the angry fist of a mother who is holding her dead child (illus. 279, 280). Trường Sinh, who studied art with Trần Văn Cẩn in the Resistance and headed the Youth Volunteer Corps' propaganda team during the Điện Biên Phủ Campaign, created over one thousand posters during a career at the Ministry of Culture between 1964 and 1990.

## After 1975

*The 1973 Paris Peace Accords ended direct U.S. military involvement in Vietnam. In December 1974, joint DRV and NLF (Vietcong) forces launched a full-scale offensive that culminated in the fall, for the South Vietnamese and the Americans, and the liberation, for the North Vietnamese and the Vietcong, of Saigon on 30 April 1975. Nationwide National Assembly elections were held in 1976 and the DRV and the Republic of Vietnam formed the Socialist Republic of Vietnam. Southern 'collaborators' were sent to re-education camps. Thousands, who became known as 'the boat people' in the West, took to the high seas, fleeing persecution or economic hardship. In 1979, a Third Indochina War erupted. China launched an offensive in response to Vietnam's occupation of Cambodia that ended the rule of the Chinese-backed Khmer Rouge and the genocide there. By the mid-1980s, Vietnam's state-run economy was in crisis. In 1986, the government promoted Renovation or Đổi Mới, moving towards an*

266

**Nguyễn Đăng Phú**
*Peace Is Life!*, 1986

*open market economy and a relaxation of censorship of the arts.*

At the end of the war, the newly created Socialist Republic of Vietnam launched a propaganda campaign to mobilize the south to vote in favour of unification (illus. 264). Phạm Trí Tuệ's 1976 Socialist Realist poster *Do Your Duty and Vote* portrays the familiar motifs, with the S-shaped map of Vietnam and the red flag with a gold star representing the unified state of the SRV. Significantly, a single female figure dressed in the black pyjama uniform of the victorious southern revolutionaries (the Vietcong) is portrayed as representative of the whole of the southern electorate. The cheerful young girl, lips and nails painted baby pink, a chequered scarf around her neck, holds a pen in one hand and an electoral ballot paper in the other.

In 1986, economic renovation or *Đổi Mới* was followed by a more relaxed cultural policy that led to innovation in the visual arts, including in poster design. In the mid-1980s, the Vietnam College of Fine Arts introduced graphic design as a course separate from painting and sculpture. Today, old-style propaganda posters are still prominently displayed in town and city centres promoting the political status quo, celebrating Hô Chi Minh and commemorating Party and Army anniversaries (illus. 265).[80] They coexist with new-style state-run environmental, anti-smoking and HIV awareness campaigns. Artist Nguyễn Đăng Phú's *Peace Is Life!*, which won a bronze medal in 1986, is representative of the new wave in design, free of the familiar Socialist Realist motifs of the past (illus. 266).

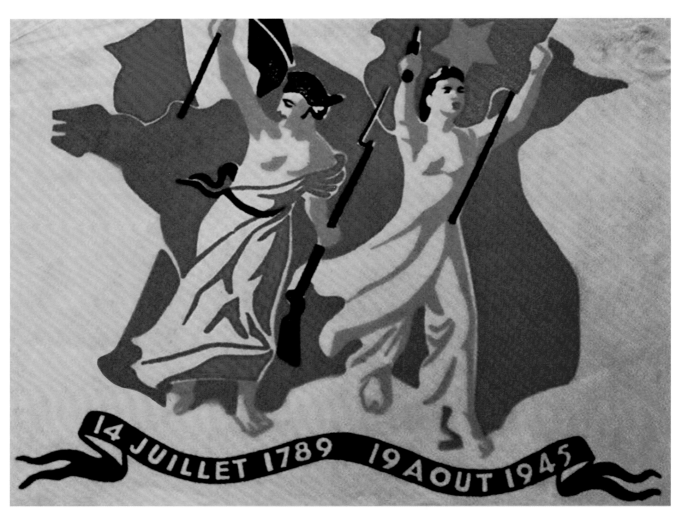

267
**Lương Xuân Nhị**
*14 July 1789, 19 August 1945*,
1945

268
**Quốc Thái**
*Good Production, Good
Collection*, 1972

269

**Thục Phi**
*Succeed in Winter-Spring*
*Crop and Develop Animal*
*Husbandry*, 1972

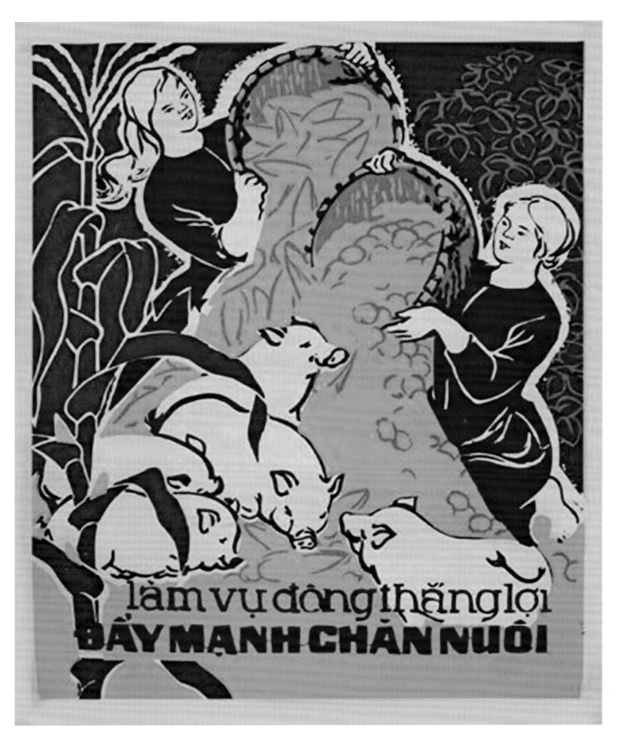

270

**Kim Liên**

*Hatred Must Be Avenged!*, 1965

271
**Dương Ánh, Lê Thị Hồng Gấm**
*Determined and Brave (in)
Attacking/ Steadfastly and
Firmly (in) Post Holding*, 1971

opposite:

272
**hiếu**
*The People of Vietnam Will
Surely Win! The American
Empire Will Surely Lose!*, 1972

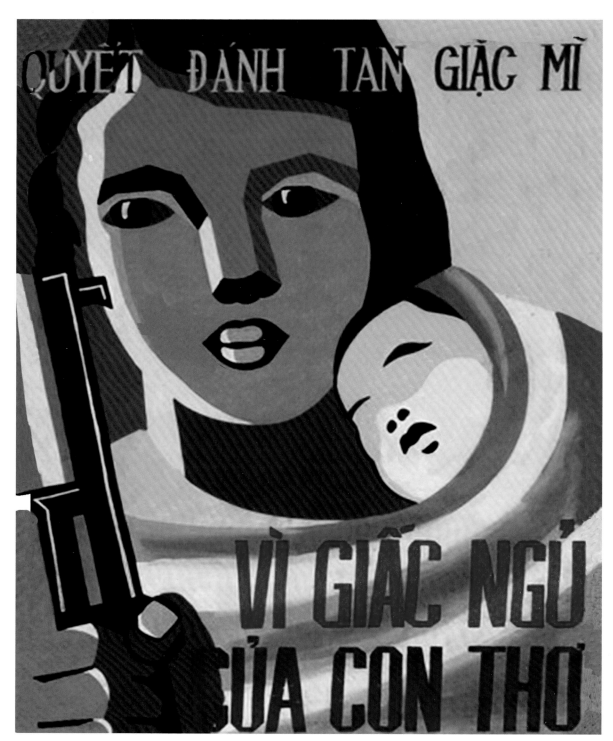

273

**Anonymous**

*Decided to Beat the American
Enemy So My Baby Can Sleep*,
undated

274
**Huỳnh Phương Đông**
*Vent Hatred, Point Your Gun,*
no date

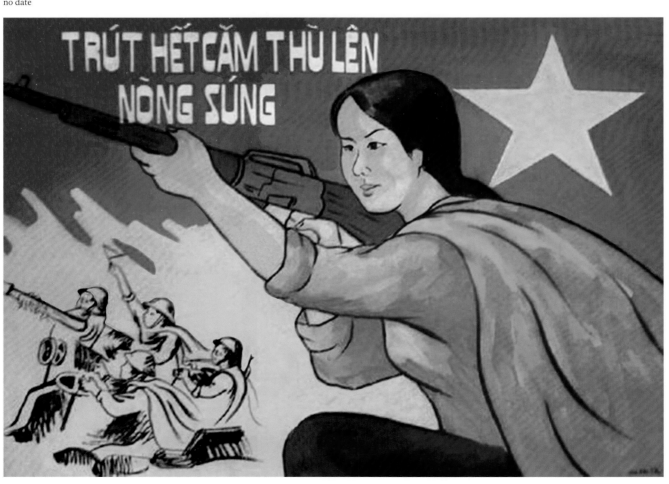

275
**Lê Lam**
*Protect the Nation or Defend the Government*, 1965

276
**Anonymous**
*Hold on to Youth*, no date

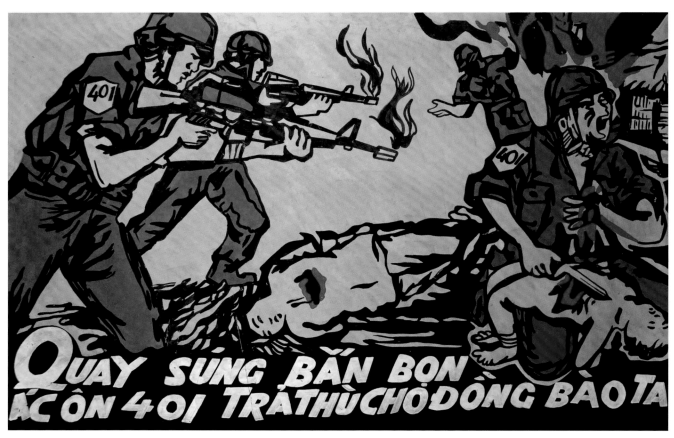

277

**Anonymous**
*They Shoot Their Guns. We
Want Retaliation for the People,*
undated

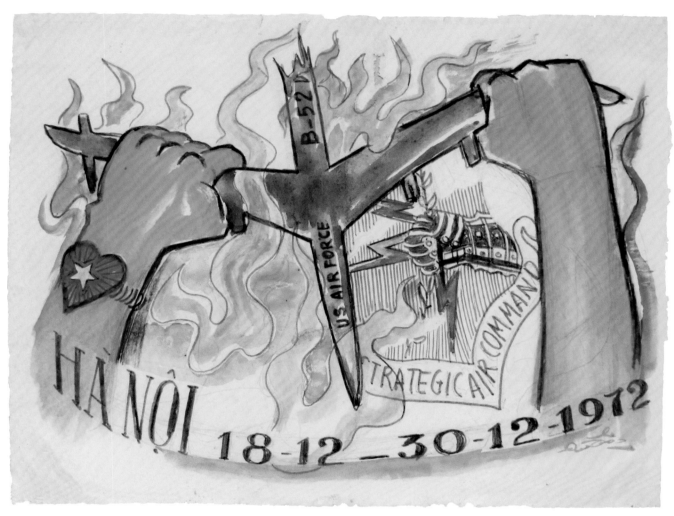

278

**Pham Than Tâm**
*Hà Nội 18-12-30-12-1972; US
air force B-52; Strategic Air
Command*, 1972

watercolour and ink on paper

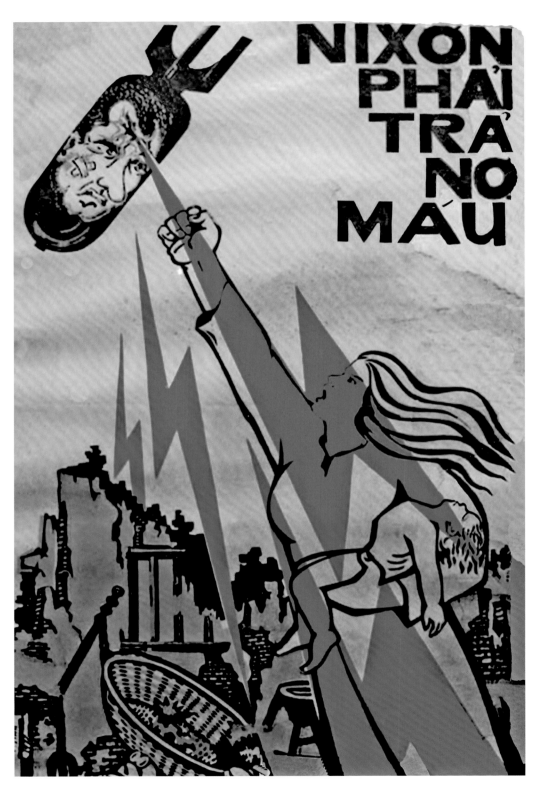

279

**Trường Sinh**

*Nixon Must Pay the Blood Debt,*

1972

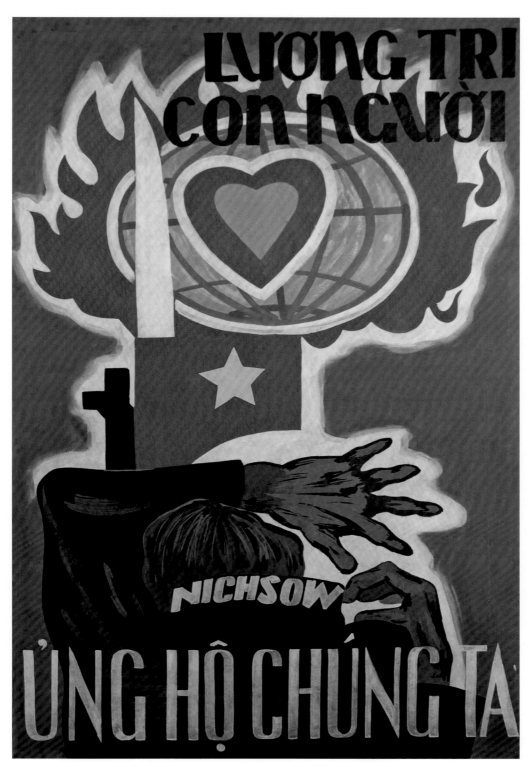

280
**Trường Sinh**
*Conscience. Nixon. Our
Supporters*, 1972

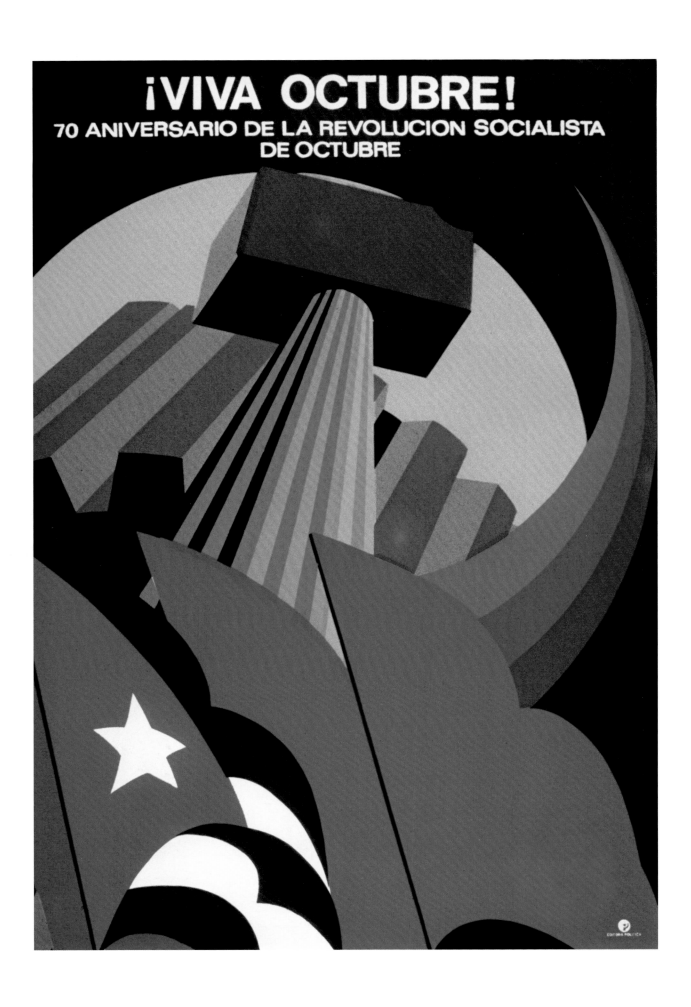

¡VIVA OCTUBRE!
70 ANIVERSARIO DE LA REVOLUCION SOCIALISTA
DE OCTUBRE

# 7 Republic of Cuba, 1959–

**Lincoln Cushing**

Although the conventional notion of communist society is that it is drab and stiff, Cuba's cultural output forces a serious re-evaluation of that view. Cuba's political iconoclasm is mirrored in its poster art.

When Fidel Castro (1926–2016) and the 26th of July Movement forced out the despised dictator Fulgencio Batista (1901–1973) in the early hours of 1959, 'communism' was less of a common motivator for the average Cuban than independence and nationalism. The excesses of colonialism, capitalism and imperialism had been seared into the popular consciousness for several generations, and Castro symbolized an end to all that. Numerous internal and external forces would shape the economic and political forms that followed. But, as a small country with few natural resources, Cuba would always find itself taking a path different from that of any other nation – capitalist *or* socialist.

From the mid-1960s until the early 1980s, Cuban graphic artists produced posters of enormous artistic power and social impact. A unique confluence of conditions aligned to fuel this prolific output – a small and literate nation immersed in the heady rush of building a new society, a dense community of artists willing to explore popular media, a state that actively supported the arts and a highly centralized political apparatus anxious to consolidate power. The energy of a new film industry sparked the process, and by the time the Soviet Union collapsed, Cuba had produced at least 12,000 posters on such wide-ranging subjects as occupational health, the sugar harvest, the war in Vietnam,[1] glass recycling and folk-music festivals. Cuba is small enough for posters to be a viable medium for reaching a wide audience, and mechanisms created for the dissemination of other social goods readily took on the selective scattering of these vocal graphics. Some of the posters (such as those announcing film showings) were limited-edition publicity items, but most were generated in the thousands and freely dispersed like dandelion seeds all over Cuba and the world by travellers and the postal service. Many ended up in union halls, community centres, schools and private residences in Cuba and beyond.

These posters offer a glimpse into Cuban life. Impressive as they are as artistic artefacts, their deeper value lies in their ability to help us understand the Cuba of this period. It was one of those historical moments when human capital was more important than financial capital, when public voluntarism was commonplace and self-sacrifice expected. Social experimentation was the order of the day. Many people's lives were fundamentally transformed, and old political struggles were

281
**Emilio Gómez for**
**Editora Política**
*Long Live October! 70th Anniversary of the Socialist October Revolution*, 1987

resolved as new ones emerged. The overthrow of Batista and the immense national transformation that followed led to a 'golden age' of Cuban posters, roughly encompassing the period from 1966 to 1972.

The non-commercial mass poster was the direct fruit of the revolution, a conscious application of art in the service of social improvement. State resources were allocated as never before to a broad range of cultural and artistic projects, and posters were the right medium at the right time. These posters were steeped in this revolutionary brew, and, like the other posters in this book, they deserve to be understood in their own context.

**The Cuban Poster Tradition**

'Within the revolution, everything; without it, nothing.'[2] Although this much-repeated quotation by Castro would seem to suggest a heavy-handed policy of cultural orthodoxy, the reality of Cuban cultural practice is complex. Cuba is a literate nation of eleven million people; Havana itself is a cosmopolitan capital of one million and has been a cultural nexus between the Old World and the New ever since the 'discovery' of the Americas in 1492. From the beginning, Cuban artists and intellectuals have been active in creating their own national culture. During the intense period before the 1959 revolution, artists of all stylistic persuasions were adding their skills to the overthrow of Batista. My mother, Nancy Cushing, once told me a story from that period while our family lived there that illustrates the sort of engagement that involved

artists of all styles. In 1955 an abstract painting by Luis Martínez Pedro (1910–1989) won top honours at a national art exhibition in Havana. After a wealthy New York collector purchased it, it was reproduced as silkscreen multiples as a fundraiser for Castro's revolutionary forces. Its newly revealed underground title? *Two Rifles*.

Early progressive social movements, including the American and French Revolutions, relied on the power of printed broadsides and posters. Many other distinctive political poster genres had emerged around the world by the time Batista's power was shattered in Cuba. Among them were the prints of José Guadalupe Posada (1851–1913) that energized the Mexican revolution of 1913–15; the Mexican posters generated by the Taller de Gráfica Popular (Popular Arts Workshop), founded in 1937; and the posters produced by the revolutionary governments of the Soviet Union and China that can be seen in this book. In my opinion, what distinguishes Cuban poster art from most (but certainly not all) of these antecedents is their wide range of content, unorthodox use of colour and crisp design style. This is the result of several factors, including a long tradition of international influence in Cuban artwork and a revolutionary government that was relatively open to experimentation and innovation.

As in Europe and the United States, commercial lithographs first appeared in Cuba in the mid-nineteenth century. The emergence of a booming film industry in the 1940s – and the need to publicize those films – led to the first distinctly domestic advertising poster style. In 1943 the

282
**René Mederos Pazos for**
**Editora Política**
*In Honour of October* [the
Bolshevik Revolution of 1917],
*c.* 1989

(12-sheet billboard)

exhibition 'Originales de Tamigraph: Silk Screen Originals', which included 55 works by 27 North American artists, provided a significant impetus for the recognition in Cuba of fine-art screen-printing.[3] During the 1950s, a few artists applied their talents to printmaking, but it remained a lesser cultural form than painting or sculpture until after the revolution. In the years immediately following 1959 there was no particular sign that this art form would blossom. Early public artwork was generally described as unimaginative and hackneyed; in the words of one observer, 'commercial standards of realistic illustration of the Batista era were [simply] given a new political orientation.'[4]

However, artists, critics and other intellectuals began to question this trend, and alternative approaches flowered. On 26 July 1969 the first of many National Poster Shows (Salónes Nacionales de Carteles) was held and the medium itself began to achieve legitimacy.[5] Perhaps more importantly, the Cubans managed to avoid mimicking the Socialist Realism typical of Soviet propaganda and were well on the way to establishing their own unique style. Given that the two countries were in the process of

building deep political and economic ties, this was a highly visible indicator of Cuban independence. In order to understand exactly how the poster art form came to prominence in Cuba we must look at the major contributors to this movement – the publishers and the artists.

### The Publishers

The vast majority of Cuban posters have been produced under the auspices of three agencies: ICAIC (the Cuban Film and Cinematic Industries Institute, more commonly known as the Cuban Film Institute), Editora Política and OSPAAAL (the Organization in Solidarity with the People of Africa, Asia and Latin America). Although each agency developed its own area of specialization, individual artists often created work for all of them.

ICAIC has a silkscreen workshop that is responsible for producing posters for all films made in Cuba, as well as for foreign films shown in Cuba. Its posters have all been of identical size to fit in special kiosks throughout Havana and other cities.

To reach Cuba's large rural population, mobile projection crews also show films in the countryside. Movies have always been enormously popular in Cuba. Before the revolution, film posters, like the films themselves, were usually designed and printed outside the country. The first real breakthrough in establishing a domestic graphic presence occurred in the early 1940s, when the commercial graphic artist Eladio Rivadulla Martínez (1923–2011) and other Cubans began to create silkscreen movie posters specifically for the local market. This trend took a dramatic step forward after the revolution.

ICAIC is generally acknowledged as having been the prime force in the post-revolutionary emergence of a uniquely Cuban style of poster art. Saúl Yelin (1924–2010) was a visionary publicist when ICAIC was created in March 1959, and he was instrumental in turning the fresh, new film institute into a significant international cultural presence.[6] In keeping with the spirit of the times, the contribution of individual artists was seen as less important than the poster's content, and dozens of idealistic and talented artists applied their professional skills to this new enterprise. Given that film showings were already well attended, however, the posters were not as much advertising as an opportunity to present a Cuban slant on the film's subject. ICAIC is the only one of the agencies that actively marketed its posters as a commercial product. It maintained a small retail shop in Havana and sold many posters in the local and international markets.

Editora Política (EP), the official publishing department of the Cuban Communist Party, started out as the Committee of Revolutionary Orientation (COR, 1962–74), then became the Department of Revolutionary Orientation (DOR, 1974–84) and finally settled on Editora Política in 1985. This agency is responsible for a wide range of mostly domestic public-information propaganda in the form of books, brochures, billboards (illus. 282) and posters. Many other government agencies used its resources and distribution powers for their own work, including the Federation of Cuban Women, the National Confederation of Workers and the National Union of Students in Latin America and the Caribbean.

OSPAAAL is officially a non-governmental organization recognized by the United Nations and based in Havana. Its origins were the Tricontinental Conferences organized by OSPAA (Organization for Solidarity for the People of Africa and Asia), first held in Cairo in 1957. It was not until the fourth congress, in Accra in 1965, that OSPAA finally agreed to include Latin America. OSPAAAL's founding conference in Havana in January 1966 involved five hundred delegates from 35 countries representing their national liberation movements and parties.

OSPAAAL became the primary source of solidarity posters produced in Cuba aimed at activists around the world. Between 1966 and 1990 it published *Tricontinental*, a monthly magazine with a circulation that in 1989 peaked at 30,000 copies and reached 87 different countries. *Tricontinental* was produced in four languages (English, Spanish, French and Arabic), and many issues – especially during the early years – included a poster. This simple act, of violating the conventional formal purity of a poster by folding it up for mailing, was

283
**Berta Abelenda for OSPAAAL**
*Day of Solidarity with the Arab Peoples*, 1968

the key to what became the most effective world-wide poster distribution system ever. Some posters were even designed to take advantage of this process, and presented different or modified images as the viewer unfolded them. OSPAAAL produced posters in about 38 different nations and on a wide range of subjects, including the British war against Argentina over the disputed Falkland Islands (the Malvinas), the anniversary of the nuclear bombing of Hiroshima, and nineteen posters on Che Guevara. Although OSPAAAL's publishing activities have been drastically reduced in recent years, it occasionally continues to host international conferences.

**The Artists**

Cuban artists themselves, as individuals and as a group, played a central role in the vibrant cultural explosion of Cuban poster art. Some – such as Eduardo Muñoz Bachs (1937–2001) and René Mederos Pazos (1933–1996) – were staff designers; others contributed as freelancers. Each one brought a particular style that was generally encouraged, rather than subsumed, in the design process. Most had formal training as designers (Félix Beltrán, b. 1938) or painters (Raúl Martínez, 1927–1995). Each left an indelible stylistic mark. Bachs, whose work as a children's book illustrator was influenced by Polish posters, adopted a decidedly whimsical and loose approach. Martínez is generally credited with introducing the 'Pop' style to Cuba. Beltrán's work is characterized by elegant simplicity. Alfrédo Rostgaard (1943–2004) was able to inject the

284
**Alfrédo Rostgaard for**
**OSPAAAL**
[*Many Ches*], 1970

unexpected into images that had been exhausted by previous artists. Mederos was a master at combining painterly flat fields of colour with exquisite line work, and Alberto Blanco explored photomontage in many of his OSPAAAL posters.

Cuban designers were not immune to the tension between artist and client, however, and almost every designer has anecdotes of creative work thwarted by political inappropriateness or bureaucratic thick-headedness. Even the simple issue of artistic recognition was an object of struggle among designers and agencies. Still, many posters were signed or otherwise credited, an uncommon characteristic in state-sponsored socialist art. As art director of OSPAAAL, Rostgaard held the opinion that posters should be signed, 'Because the people want to know.'[7]

## Women Graphic Artists

Despite the efforts of the Cuban revolution to empower women and achieve socialist equality, the work of women artists is very unevenly represented among the thousands of posters produced since 1959. Eight women – Berta Abelenda, Gladys Acosta, Estela Díaz, Daysi García, Clara García, Jane Norling, Asela Pérez and Elena Serrano – designed 22 of OSPAAAL's known output of approximately 326 distinct titles (less than 7 per cent). Although Serrano and Pérez each created only one image for this agency, their posters were among the more memorable – the famous *Day of the Heroic Guerrilla, October 8* (commonly known

as 'Continental Che') and *International Week of Solidarity with Latin America* respectively. Norling, a muralist and graphic artist from the San Francisco Bay area, designed one while she was working there in 1973. Every single one of Abelenda's posters included some form of weapon, ranging from spears to bazookas, always treated in a witty and unexpected manner, as in *Day of Solidarity with the Arab Peoples* (illus. 283). Interestingly, although ICAIC was responsible for a prolific output, it appears that only a handful of its posters – as few as four – may have been designed by women. Many of the women who designed posters for OSPAAAL also did so for EP, including Acosta, Díaz, Clara García, Daysi García and Pérez. Other designers included Eufemia Alvarez, Isabel Carrillo, Cecilia Guerra and Vivian Lechuga. Of the 218 EP posters I have catalogued, 35 (15 per cent) were designed by women.

## Style

The posters in this essay were selected out of thousands to reveal certain consistent characteristics of Cuban design. Although a tremendous range of styles is evident among them, certain patterns emerge that help to describe this body of work. Perhaps the most surprising is the low quotient of Socialist Realism – the relative absence of the heroic, amped-up super-workers and production equipment so prevalent in the revolutionary artwork of the Soviet Union, China and other communist countries, as displayed elsewhere in

327

this book. Rather, Cuban artists used alternative and creative approaches to graphic representation, producing a distinctive and rich poster genre.

There are a number of identifiable stylistic features displayed by these posters. The first is their use of illustration and graphics: very few of these posters use photographs as source elements or rely on full-colour reproduction of original art; almost all are based on what is known as 'flat colour' in the graphic arts. This stylistic convention comes partly from the technical limitations of hand-cut silkscreen stencils, but a more complete explanation would have to include a fondness for this particular graphic treatment on the part of the designers, since many posters were reproduced in offset. Another identifiable feature is their use of humour and visual wit. Overt satire and subtle wit of imagery, like Che Guevara's repeated faces in Rostgaard's *Many Ches* (illus. 284), represent an accepted design approach. This also includes the convention of fusing disparate images, such as the two-way radio, grenades, cartridges and bazooka neatly drawn into a classic Egyptian style in *Day in Solidarity with the Arab People* (illus. 283) or the hand grenade knight's torso in *Chess Tournament – Military Garrison of Havana* (illus. 297).

Many Cuban poster artists use the imagery of weapons, from spears to AK-47s, to symbolize the ultimate extension of political power. After experiencing a major revolution less than two generations ago, Cuba has had to continue to defend itself against armed attacks from the United States government and militant members of the Cuban exile community. In addition, for many

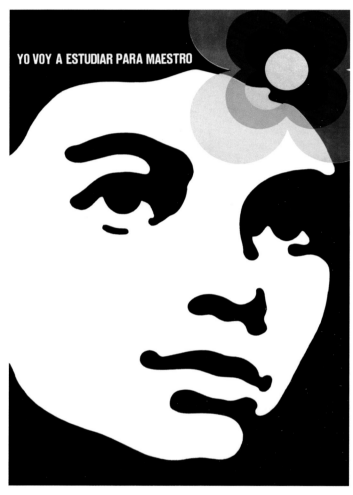

285
**René Mederos Pazos for Editora Política**
*I Am Going to Study to Be a Teacher*, 1971

years Cuban foreign policy actively supported revolutionary movements around the world, and Cuba sent regular army troops, clandestine forces and arms to many countries. Weapons can show up in obvious settings, such as posters expressing solidarity with nations in struggle, as well as in less obvious situations, such as *First UNEAC [Cuban National Union of Writers and Artists] Graphic Design Conference* (illus. 298), or the poster for the tenth anniversary of ICAIC (illus. 299). In some cases, the use of indigenous images is fused with modern weaponry, as in posters on Guatemala or the Arab people. The type of weapon also has a political dimension; sophisticated hardware, such as missiles and fighter jets, is always associated with the forces of oppression and imperialism. AK-47s and shoulder-fired rockets are weapons of resistance.

Another significant feature of these posters is their treatment of conceptual abstraction. Cuban art was not wedded to strict realism; Castro famously proclaimed in 1977: 'our enemy is imperialism, not abstract art.' Many of these posters elegantly demonstrate the designer's ability to reduce abstract concepts to simple images, as evidenced in the representation of anti-capitalism or anti-colonialism (illus. 300). They also use techniques of appropriation; in several examples, well-known or popular artwork is radically transformed, for example Leonardo da Vinci's classic Vitruvian Man in *Capitalism: Denial of Human Rights* (illus. 301), or the traditional religious painting genre of Christ nailed to an International Monetary Fund cross in *Cristo Guerrillero*. The use of iconography is also prominent, and many posters use commonly understood visual shorthand to express their subject. Icons include Uncle Sam, the imperial eagle, the dollar sign, continental shapes, stylized flags and machetes.

## Content

Although the separate 'fine art' and 'commercial art' worlds continue to exist in Cuba, significant amounts of resources and talent have been funnelled into challenging that dichotomy. From the late 1960s until the late 1990s, public agency support for artists and designers made it possible for them to make a living producing public service materials. The lack of a mercantile infrastructure made it difficult for individual artists to sell their work, although that has changed considerably in recent years. Posters have publicized motorcycle-based health brigades, exhorted citizens to join the sugar harvest, advocated efficient work in the sugar mills and encouraged the planting of healthy fruit and vegetables on available land. Some crops, such as tobacco, require a challenging balance of public policy approaches; one poster pleads for *Your Youthful Hand* in helping the harvest, but another warns, *Tobacco Burns Health*. Sports, education and culture all play significant roles. One poster proudly proclaims, *I Am Going to Study to Be a Teacher* (illus. 285).

International solidarity is an important part of the national culture, especially because Cuba has had its own long fight against U.S. domination. This deep connection to other underdeveloped countries

286
**René Mederos Pazos for
80th Anniversary of the
Birth of Hồ Chí Minh**, 1970

Cuban postage stamp

struggling for self-determination resulted in many works succinctly and elegantly showing resistance against colonialism and u.s. imperialism. In 1969, and again in 1971, EP sent the artist René Mederos Pazos to Vietnam, where he spent several months experiencing the American war on the ground. He created two stunning series of paintings, many of which were turned into silkscreen prints and offset posters. The Cuban government also issued seven as postage stamps based on these posters (illus. 286).

The persistent theme of 'as in Viet Nam' underscores a deep national determination to be as self-reliant, brave and resourceful as the people of Vietnam, equating domestic food and industrial production with the urgency of armed struggle. This theme, of a nation surviving under siege, largely reflects the economic and political reality of u.s.–Cuban relations and has artistic precedents in posters produced in the United States during the Second World War.

Many posters include visual references to Africa and to the struggle against slavery and racism. Cuba is an extraordinarily racially integrated country, a feature that can be traced to wars of independence in which trust and respect between Spanish-origin *criollos* and Afro-Cuban leaders and troops were essential to victory against the Spanish. A poster from 1986 commemorating the centennial of the abolition of slavery is titled *Rebel Slaves – Precursors of Our Social Revolutions* (illus. 302), articulating a theme repeated in many Cuban posters. Africa is a popular subject of films, as are slave revolts and solidarity with forces fighting the slave trade and colonial legacy in Africa and the Americas (illus.

287
**Emilio Gómez for
Editora Política**
*Granma: Tiller Held Firmly,
Bow Towards the Future: 30th
Anniversary of the Landing*,
1986

**288**
**René Mederos Pazos for**
**Editora Política (DOR)**
*Exhibition* (collage of historical
figures, left to right: Máximo
Gomez, Eduardo Agramonte,
Quintín Bandera, Che Guevara,
Camilo Cienfuegos, José Martí),
1971

303). (Note the artistic device employed here that, in storyboard fashion, first shows the Africans in a chain gang, then in the process of being freed, and finally armed for self-defence.) Historical events from Cuba's own revolution are also regularly portrayed, including the 1953 attack on the Moncada Barracks (illus. 304), the 1955 voyage of Fidel's forces from Mexico to Cuba aboard the *Granma* (illus. 287) and the 1961 repulsion of the U.S.-backed invasion at the Bay of Pigs (Playa Girón).

There are few examples of 'leader worship', a conventional critique of communist propaganda as evidenced by the prolific portraiture of Chairman Mao in Chinese posters. Only a handful of posters show Fidel Castro, and even those are not expected to follow an aesthetic orthodoxy (illus. 305). By far the two most prominently featured individuals are José Martí (1853–1995, illus. 288) and Ernesto 'Che' Guevara. There are posters of well-known revolutionary heroes and martyrs, including Chile's Salvador Allende, Congo's Patrice Lumumba, South Africa's Nelson Mandela, Nicaragua's Augusto César Sandino (illus. 306) and Vietnam's Hồ Chí Minh (illus. 307). Also represented are lesser-known Cuban revolutionary martyrs such as Frank País (1934–1957, illus. 308).[8] Figures from other countries honoured in print include Vladimir Lenin (illus. 289), the Black Panthers' George Jackson (illus. 309) and Angela Davis (illus. 310), Yasser Arafat and even Sweden's Olof Palme. Villains also get their share, with Nixon (illus. 311), Hitler (illus. 312) and Chile's Augusto Pinochet among them.

## Form

Although most of the posters are produced in offset format, many of them (including all the older ICAIC posters) were printed as silkscreens in somewhat limited numbers.[9] Many of the more popular ICAIC posters have been reissued, often many times, to meet the demand for sales. Although the silkscreen print shop for ICAIC did not have the capacity to produce photographic stencils (all the posters, including those with a 'halftone dot' appearance, were painstakingly cut by hand), the Editora Política offset shop certainly could – and did – produce full-colour separations. EP's state sponsorship meant that it controlled the most modern production facilities, including a silkscreen press capable of printing twelve-sheet billboards, and a large sheet-fed offset plant.[10] Billboards in Cuba have a special impact since commercial advertising, which clots most public space in capitalist countries, is absent.

It is also interesting to note that almost all Cuban posters are orientated in a vertical format. All the ICAIC posters needed to be that way to fit into existing street kiosks, but the vertical uniformity of the others – only five of the OSPAAAL posters are orientated horizontally – appears simply to be a matter of convention.

## Cuban Artistic Interrelationships Abroad

Despite the fervent wish on the part of the United States government to isolate the 'rogue state' of Cuba from the world community, Cuban artists routinely engage in exhibitions and work abroad. Europe, Canada and Latin America all regularly include Cuban visual artists, musicians and film-makers in festivals, symposia and shows. Until recently, the United States embargo has served as an ominous, though penetrable, barrier to artistic exchanges between U.S. and Cuban nationals. Visas for visiting artists and scholars were often denied at the last minute by the U.S. State Department. Some institutions, such as New York's Center for Cuban Studies, persisted in bringing Cuban artists to the United States in the spirit of cultural exchange.

Likewise, there is no doubt that the efflorescence of graphic artwork flowing from Cuba influenced and stimulated the work of poster artists in the United States. Any political poster-maker with a pulse had at least a passing familiarity with some of the OSPAAAL posters. Many of the images were formally or informally copied into domestic posters. Some were reproduced for the Vietnam solidarity movement, such as René Mederos Pazos's stunning graphic of Hô Chí Minh (illus. 313), reprinted in 1971 by Glad Day Press in Ithaca, New York, to raise money for Medical Aid to Indochina. The United States solidarity organization Venceremos Brigade has reissued many images for years as part of its campaign to end the Cuban embargo. Others were appropriated for concerns such as Puerto Rican independence and the struggle against apartheid in South Africa. Several U.S. print shops donated use of their facilities to print posters for Cuba – one of the OSPAAAL reprints proudly bears the union label of Berkeley's (California)

Inkworks Press, printed in a joint publishing project with Fireworks Graphics Collective.

But, more importantly, collaborative projects emerged when U.S. artists went to Cuba to teach and learn, and their Cuban counterparts were brought to the United States to share their experiences. Several progressive cultural institutions, such as the Center for Cuban Studies in New York and Mission Gráfica in San Francisco, sponsored shows and tours. The first California exhibition of Cuban posters was held in San Francisco's Palace of the Legion of Honor in 1975.[11] Two years later one of the organizers of that show, Juan Fuentes, visited Cuba to co-curate an exhibit by Bay Area Latino artists. Many U.S. artists acknowledge a deep debt to the creative spirit and political savvy that the Cuban poster movement engendered.

## Poster Themes

*National Pride*

*'Neither nations nor men respect those that don't respect them.' – José Martí*

Cuba has a complex colonial history, deeply affected by the slave trade and by the foreign powers that have interfered in its quest for self-determination – Spain, England, the U.S. and the Soviet Union. This history strongly defines the national character and is essential to understanding Cuba's dogged efforts to be treated as an equal on the world stage.

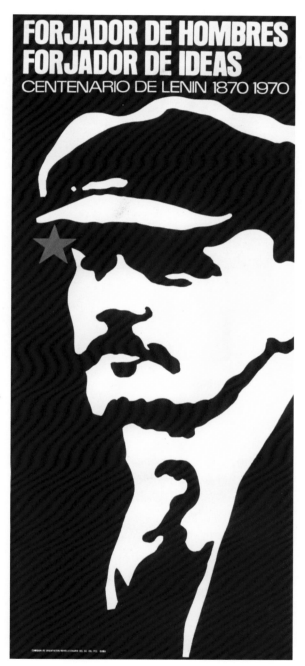

289
**Antonio Pérez González (Ñiko or Ñico) for Editora Política**
*Builder of Men, Builder of Ideas: Lenin Centennial, 1870–1970,*
1970

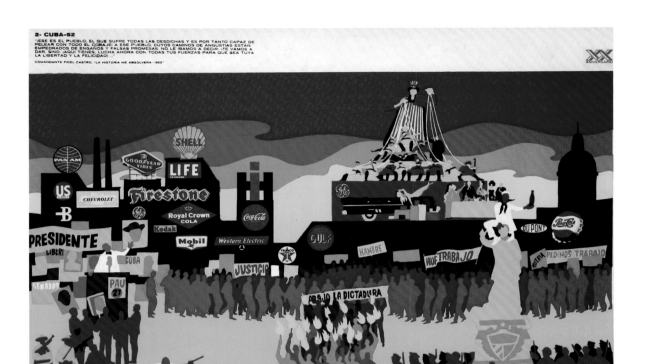

By the time Pope Alexander VI (1492–1503) granted Cuba formal self-control in 1493, it was the unequalled hub of the Spanish Empire in the Americas. Indigenous people were forced into serfdom, inspiring the first revolt in the New World under Taíno chief Hatuey (who was burned at the stake in 1512). The Taínos perished from overwork and disease, and were replaced by African slaves as early as 1513. Spain levied heavy taxes and forced unfair trade agreements on Cuba, and the first in a long series of citizen rebellions against the Spanish Crown broke out in 1740. England occupied Cuba in 1762 but traded it back for Florida the following

year. As in other colonial countries, the local population – Cuban-born *criollos* – developed an interest in self-determination and was inspired by the success of the American Revolution. From the earliest days of the republic, however, the United States government and business leaders seemed more interested in owning Cuba than in seeing it free.

Cuba's First War of Independence (1868–78) was led by General Máximo Gómez (1836–1905), a white *criollo*, and the *mulatto* Antonio Macéo (1845–1896), and resulted in 250,000 Cuban and 80,000 Spanish casualties. The revolt failed, however, and left the island's economy in shambles. The poet

290
**René Mederos Pazos for**
**Editora Política**
*Cuba 52 [1952]*, #2 in Moncada
series, 1973

and author José Martí, imprisoned and deported during that war, used his stay in New York to found the Cuban Revolutionary Party on the mutual principles of nationalism and social justice. In 1895 he joined up with fellow exiles Gómez and Macéo for another revolution. Although Martí was killed almost immediately, and Macéo the following year, the Second War of Independence (1895–8) continued to wrack the country until the fateful evening of 15 February 1898, when the battleship USS *Maine* exploded in Havana harbour, killing 260 men. Although a board of American naval officers determined that a submarine mine caused the ship's forward magazine to explode, no specific persons or parties were implicated.

A variety of political and economic forces had put the United States on a collision course with Spain over Cuba and its only other remaining colony in the Americas, Puerto Rico. Trade between Cuba and the United States had grown steadily since the American colonial period, and American citizens eventually came to own millions of dollars' worth of Cuban property, primarily in the sugar, tobacco and iron industries, all of which were imperilled by the fighting. These conditions – economic self-interest, coupled with expansionist interests in the hemisphere and public outrage over accounts of Spanish military brutality against the Cubans and the U.S. citizens – created a powder keg, and the USS *Maine* was the fuse. On 19 April 1898 the United States Congress passed a joint resolution proclaiming Cuba 'free and independent', and when signed by President McKinley the next day, it served as a declaration of war.

The war was immensely popular in the United States and was over in less than a year. In the end, the U.S. goals were overwhelmingly achieved, but at the expense of Cuban aspirations. The Cuban war for independence had been hijacked to become 'the Spanish–American War (1898)'. Cuban forces were not allowed to attend the surrender ceremonies, nor were Cuban representatives invited to the signing of the peace treaty in Paris. The U.S. army of occupation demobilized the Cuban army and appointed Spanish officers to security positions. In 1902 the Cubans accepted the Platt Amendment, which gave the United States the unconditional right to intervene in Cuba's internal affairs and perpetual rights to the coaling station at Guantánamo Bay as the only alternative to direct U.S. military rule. Cuba had essentially become a corporate-dominated colony of the United States (illus. 290). A cycle of dependence on U.S. approval had begun, only to be broken with the success of the revolution against the corrupt and hated Batista government in 1959.

It was against this backdrop that the new revolutionary government struggled to establish itself. Like Martí before him, Fidel Castro was a nationalist and an anti-imperialist, and the United States government grew increasingly uncomfortable as a series of popular measures – starting with the Agrarian Reform Law during Castro's first year in power – made it clear that he had no wish to follow the U.S. policy. Relations between the two countries continued to unravel. When Soviet crude oil arrived in Havana, American-owned refineries refused to process it, and they were nationalized. When the

United States refused to buy Cuban sugar (and the Soviet Union did not), American-owned sugar mills were nationalized. Eventually this downward spiral led to an effort by exiled nationals to retake the country in the failed Bay of Pigs invasion in 1961. This escalation of hostilities led to the Cuban Missile Crisis the next year. Although formal invasion efforts ceased, covert operations against Castro and the Cuban economy continued for many years. The u.s. government has also pursued an official economic blockade of the island that has significantly hurt Cuba's effort to become self-sufficient. Aid from, and trade with, other countries has to a large extent mitigated the impact of the u.s. embargo, but it has unquestionably reinforced the United States government's appearance to the Cuban people (and much of the rest of the world) as a bully.[12] This, in turn, has fuelled Cuban nationalism, and the cycle showed no sign of ending until a bilateral thawing of relations was announced at the end of 2014 under the u.s. president Barack Obama. At the time of writing the normalization of u.s.–Cuban relations is continuing at a steady pace. At the time of writing, progress towards normalization of u.s.–Cuban relations under President Trump seems unlikely.

*Production and Resources*

For many years approximately a quarter of the Cuban workforce was employed in agriculture, a quarter in industry and the remaining half in the services sector.[13] However, since the mid-1990s agriculture has declined and the hotel and hospitality industries have expanded. Exports went principally to Russia and the Netherlands, followed by Canada and other countries. Imports have come from Spain, Venezuela and Canada.[14]

Ever since its founding, Cuba's entire economy has relied on the cultivation and export of just two crops: sugar and tobacco. This is owing to the influence and needs of foreign interests, and the resulting distortion of an export monoculture has driven Cuba's economy for hundreds of years. Promoting agriculture remains a major emphasis of domestic poster campaigns, many of them equating the struggle for economic self-sufficiency with the military sacrifice of the revolution as exemplified by the poster *To Camaguey: With the Faith and Valour of the Moncada Combatants* (illus. 315). Similarly, the phrase 'as in Viet Nam' is used as an exhortation to emulate the tenacity, organization and discipline of the Vietnamese people (illus. 316).

Cuba's soil chemistry and climate are perfect for the cultivation of cane sugar, and about 75 per cent of the agricultural export income is drawn from this single crop. A national volunteer campaign to realize a ten-million-ton sugar harvest by 1970 fell short of its goal, but the *zafra* – the sugar harvest – and the ancillary activities of operating and maintaining the mills remain significant. Posters promote the *Sugar Harvest 1985 – At Full Capacity* and encourage workers to *Pull Together with Efficiency and Quality* and to *Cut Until the Last [Sugar] Cane – Whether It Rains a Lot or a Little* (illus. 314). When it is all over, we are told, the *Cane Cutting Quota Is Completed* (illus. 317).

291
**Heriberto Trujillo
for Editora Política**
*Only That Which Is Necessary
[Electricity Conservation]*, 1981

The growing and processing of tobacco are also an essential part of the culture – posters (not illustrated here) announce that *The Tobacco Harvest Awaits Your Youthful Hand* and rejoice in *Happiness in the Tobacco Fields*. Other crops are encouraged as well: *The Land is Fertile – Work for the Whole Population [to] Plant Every Field*. As an island nation, Cuba is particularly dependent on imported goods. Because of the blockade and a shortage of natural resources, many public campaigns have been advanced on such issues as reducing electrical consumption (illus. 291), saving fresh water (illus. 292) and recycling glass.

*Sports and Health*

*'I would rather play for 10,000,000 people than 10,000,000 dollars.' – Cuban baseball pitcher Omar Linares, answering reporters' questions about why he didn't wish to defect to the United States at the 1996 Olympics in Atlanta, Georgia*

Cuba has produced many great athletes and teams. Its boxers have earned 23 Olympic gold medals (Teófilo Stevenson alone took three heavyweight gold medals), 87 senior and junior world titles and 25 world cups. Cuba has excelled in other Olympic sports as well, including swimming, judo, fencing, volleyball and track (Alberto Juantorena won gold medals in the 400-m and 800-m runs at the xxi Olympiad in Montreal, Canada, in 1976). Sports, as part of physical culture in general, are considered to be an integral component of

left:

292
**Faustino Pérez for Editora
Política (Poder Popular)**
*Save It [Water]*, 1983

293
**Daysi García for
Editora Política**
*Working for the 10 Million in
Good Health [Rural Motorbike
Health Brigades]*, 1970

a well-rounded and healthy populace. In many Western countries massive private advertising budgets are spent encouraging people to buy a particular athletic shoe or paying for naming rights to sports facilities. Teams and players are bought and sold as commodities. The commercialization of physical activity is so pervasive that it is taken for granted. Yet in Cuba, posters advertise sporting events, rather than individual teams, and encourage whole communities to participate in sports for the simple reason that it is good for them. This public campaign is captured in the sweet, simple message, 'To practise sports is to grow healthy.'

A commitment to public well-being is also at the heart of healthcare policy in Cuba. As one would expect of a state agency responsible for educating the citizenry about issues of public health, EP's posters cover a wide range of topics, including encouraging people to plant fruit and vegetables, to work carefully when trimming meats and to quit smoking. Other posters publicize important public services such as the motorized health brigades that serve the rural population (illus. 293).

## Solidarity and Revolution

*'Solidarity is not charity, but mutual aid in pursuit of shared objectives.' – Samora Machel, FRELIMO (Frente de Libertação de Moçambique) revolutionary hero and first president of Mozambique*

Ever since Fidel Castro's troops defeated the Batista regime in 1959, Cuba has actively supported movements for fundamental political change all over the world. This includes support of struggles for national liberation – the process that many countries endured to emerge from colonial control during the 1960s and '70s – and of revolutionary organizations within certain countries that have resorted to armed struggle to overthrow unpopular regimes. Most of these countries constitute what is known as the 'third world'. They have suffered underdevelopment as a consequence of modern colonial status or have experienced dramatic social inequality as a result of corrupt foreign-supported governments, and they are generally in the continents of Africa, Asia and South America.

Solidarity is a political term that can mean many things. It can range from formal support, with military troops and materiel (such as Cuba sent to aid guerrillas in the Congo), to more benign activities such as sending food or skilled personnel to other countries. It also means public support of these countries and their subjects, with United Nations speeches and posters distributed worldwide. Some of these posters take on abstract political issues, such as foreign debt, liberation theology, armed struggle, the influence of the International Monetary Fund and even capitalism itself. However, most solidarity posters focus on specific countries, events and problems.

The primary enemy of subjects in colonial countries was usually the military and police forces of the occupying Europeans. However, national liberation struggles also served as a theatre for the grander geopolitical battle being waged between the United States and its archenemies, the Soviet

Union and China. Thus, by engaging in support for the oppositional forces, Cuba became a significant participant in the larger struggle between capitalism and socialism. In many cases, public u.s. foreign policy only hinted at the actual role the u.s. played in supporting the colonial powers, and the implementation of more clandestine foreign policy goals fell to the Central Intelligence Agency (CIA), special operations units of the armed forces and surrogate mercenaries. Many of the affected countries are ones that most Americans are only vaguely aware of – the Congo, Zimbabwe, Guinea-Bissau – but others, such as Vietnam and South Africa, are better known. Cuba deeply identified with Vietnam, a small, poor country attempting to overthrow a series of corrupt leaders serving the interests of a chain of foreign masters (illus. 318). Cuba was one of the earliest and most persistent supporters of Nelson Mandela and the African National Congress at the same time that the United States government avoided taking a stand. In some cases, Cuban solidarity has extended to geopolitical entities that were not even countries: Puerto Rico, a 'commonwealth' of the United States, is represented as a colonial vestige of more than a hundred years of u.s. occupation, and Palestine is respected as a nation without recognized statehood. North Korea, a nation with which Cuba had very little active engagement, was nonetheless supported because of its affiliation with the socialist bloc (illus. 319).

Because the Soviet Union was the mainstay of Cuban political and economic support for many years, it is not surprising to see posters in the Soviet style and supporting broad themes of the Russian Revolution (illus. 281, 294, 320). Cuban solidarity posters have honoured martyrs (Sandino in Nicaragua, illus. 306), criticized u.s. intervention (in the Dominican Republic), endorsed domestic opposition within the United States (as carried out by the Black Panther Party), or simply noted the struggle of whole countries (Guatemala, illus. 321), populations (the Arab people, illus. 283) and generic exploited classes (peasants in Peru). Many posters have supported the struggle of Cuban allies that u.s. foreign policy has simply labelled unacceptable. The democratically elected governments of these countries were seen as a threat to u.s. business and political interests, and overt military invasions (Grenada) or covert CIA actions (Chile) resulted in their replacement by more acceptable leadership.

Finally, there is the theme of Che and the exporting of revolution. Ernesto 'Che' Guevara was an asthmatic Argentinian doctor who met Fidel Castro in 1954, participated in the Cuban revolution, served as head of various government agencies and never gave up his dream of world revolution. He participated in clandestine guerrilla activities in the Congo and in Bolivia, where he was finally caught and executed in 1967. He has attained mythic status for some as a hero of the oppressed, is criticized by others for adventurism and vanguardism, and is demonized by yet others as a murderous Marxist-Leninist. His image is by far the best-known symbol of revolution in the world. Public and private display of his portrait in Cuba is ubiquitous.

*Education and Culture*

*'In the morning, the pen – but in the afternoon, the plough.'* – José Martí

The post-revolutionary Cuban government has established a strong record on education. Although literacy statistics from the time Batista fled the island in 1959 range from 43 per cent to 80 per cent, there is little dispute over the data on Cuba's status at present. In 2001, a task force assessing a 1998 UNESCO (United Nations Educational, Scientific and Cultural Organization) region-wide test of primary-school pupils concluded: 'In test scores, completion rates, and literacy levels, Cuban primary students are at or near the top of a list of peers from across Latin America.'[15] The report went on to note: 'Cuba far and away led the region in third- and

fourth-grade mathematics and language achievement . . . Even the lowest fourth of Cuban students performed above the regional average.' UNESCO ranks Cuba's basic literacy rate at just over 96 per cent. This is remarkable given that current per-student funding is less than a thousand dollars a year. Part of the reason for such high rates can be traced back to 1961, when the new revolutionary government launched a massive literacy campaign in which all schools were closed for eight months and 120,000 volunteers worked to raise the reading level of almost a million people. Another factor may be the large number of educated professionals who, because of the slow economy, have had difficulty finding work in their field and have ended up in teaching positions.

Cuban public policy has always included a commitment to supporting universal public education, compulsory through to the ninth grade (age fifteen

294

**Eduardo Marin Potrillé for Editora Política**
*The Optimistic Tragedy by Vsievolod Vishnievsky; Saluting the First Congress of the Cuban Communist Party, Cuban-Soviet Coproduction of the Brecht Political Theatre,* 1975

or sixteen). Education is seen as essential to building the New Socialist Man and Woman. The role of an intelligent populace, articulate in the relative merits of socialism over capitalism, is promoted as a defence against corrupt foreign influences in martial terms: *Education: A Weapon Against the Enemy* (illus. 295), proclaims one poster. Promotion of an educated population went beyond simple literacy – it also included creative problem-solving and critical thinking (illus. 296, 322).

It is also significant that, given Cuba's mostly rural population, it has risen to the dual challenge of educating agricultural workers and breaking down social divisions between city and countryside. In 1971 Cuba established the 'Secondary Schools in the Countryside' campaign, in which students spent summers on farms and on orchards, dividing their time between their studies and bringing in the harvest. This approach is captured in a poster (not shown), *Alongside the Workers Harvesting Wealth*, with interwoven images of tobacco leaves, books and sugar cane.

Like education, Cuban cultural development since the revolution has been shaped by the influence of state support. Posters proclaim a multitude of public events, including music festivals, art exhibitions and graphic arts conferences. Cuban music – everything from traditional folk music, to Afro-Cuban drumming, to jazz and rock – is a popular form of expression that pulsates from clubs and concert halls. Art exhibitions both large and small are often promoted with powerful graphic art. But the cultural activity most frequently expressed through the poster art form has been cinema. What

top:

295

**Arturo Alfonso Palomino for Editora Política (MININT)**
*Education: A Weapon Against the Enemy*, 1972

bottom:

296

**Asela Pérez for Editora Política**
*Against Bureaucracy: Improved Technical Preparation*, 1977

has been exceptional is that not only does the 'advertising' division of ICAIC produce posters for Cuban films, it does so for *all* films shown in Cuba. Approximately one-third of the films promoted are Cuban; the rest come from all over the world. It is fascinating to see the range of countries, directors and topics that appear in ICAIC's posters. Films by Kurosawa, Hitchcock and Buñuel are all repackaged through Cuban eyes, often by artists interpreting the movie's theme rather than promoting a particular actor or director. Compare this approach to the conventional Hollywood-style advertisement featuring close-ups of box-office stars, and you begin to see the radical departure these posters represent. Conversely, because these are limited-edition silkscreen prints, the ICAIC posters also represent the form of the Cuban poster that most closely mimics the fine art collectible and commercial prints sold in galleries around the world.

## The Road Ahead

Beginning in the late 1980s, when the collapse of the Soviet Union left Cuba on its own, Cuba entered what it called the 'Special Period'. The country went into a tailspin, losing favourable trade agreements, oil and sugar subsidies, and technical assistance almost overnight. Ever since, it has followed a path of rebuilding its economy through international tourism. Massive joint-venture projects with Spain, Canada, Brazil, Mexico and other nations have focused almost entirely on the hotel and ancillary service industries. During the 2000s the strong

relationship between Cuba and Venezuela's Hugo Chávez (1954–2013) offered a supporting role, but the Bolivarian Revolution has waned, and at the time of writing Cuba is deeply involved in negotiating new diplomatic and economic relations with the United States. This process, though justifiable given Cuba's limited economic options, has resulted in considerable distortion of the cultural fabric.

All the poster-producing agencies have had to shift themselves from being supported by the state to relying on fee-for-service work. Although an organization such as ICAIC may have a chance at pulling this off, agencies with an explicit political message, such as EP or OSPAAAL, are withering on the vine. This belt-tightening has affected Cuban art production in every way. What's more, because many supplies such as ink are in short supply, even aesthetic options are affected. One example is billboard design, which during the early 1990s encouraged the use of white space to save ink.

All this has had a direct impact on production of the sort of posters described in this chapter, and it's unclear what role the publishing department of the Cuban Communist Party will play in the future. However, Cuba has a talented and vibrant art community, and what may well emerge is a shift away from state-sponsored channels to more independent ones such as community-based organizations, student groups and independent workshops. This will unquestionably result in a different range of subjects and styles from that produced in Cuba's 'Golden Era', but if Cuban history is anything to go by, the new graphic art will continue to be powerful, opinionated and unexpected.

297
**Israel Fundora for
Editora Política**
*Chess Tournament – Military
Garrison of Havana*, 1973

298
**Francisco Masvidal for
Editora Política (UNEAC)**
*First UNEAC [Cuban National
Union of Writers and Artists]
Graphic Design Conference*,
1979

opposite:

299
**Alfrédo Rostgaard for ICAIC**
*ICAIC 10th Anniversary*, 1969

rostgaard/69

icaic décimo aniversario

JORNADA DE SOLIDARIDAD CON ZIMBABWE (17 de marzo)
DAY OF SOLIDARITY WITH ZIMBABWE (March 17)
JOURNEE DE SOLIDARITE AVEC LE ZIMBABWE (17 mars)
أسبوع التضامن الدولي مع ثياتنام منذ ١٢ الغاية ١٩ مارس

OSPAAAL

FAUSTO 70

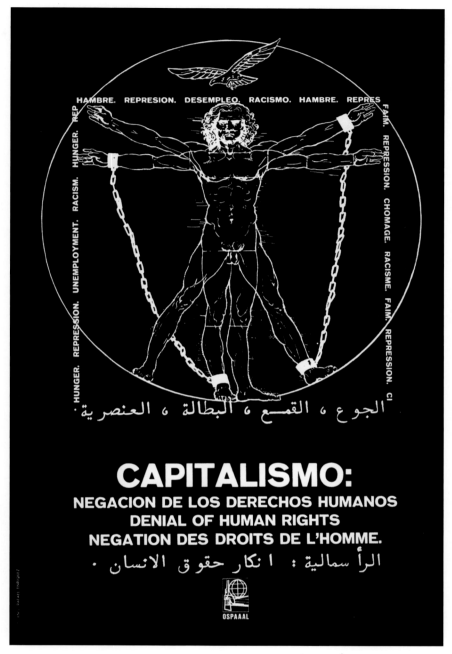

301
**Rafael Enríquez for OSPAAAL**
*Capitalism: Denial of Human Rights*, 1977

opposite:

300
**Faustino Pérez for OSPAAAL**
*Day of Solidarity with Zimbabwe*, 1970

302
**Anonymous for**
**Editora Política**
*Rebel Slaves – Precursors of*
*Our Social Revolutions*, 1986

opposite:

303
**Antonio Pérez González**
**(Ñiko or Ñico) for ICAIC**
*Maputo, the Ninth Meridian*
(Cuban film), 1977

26 DE JULIO

XXX ANIVERSARIO DEL MONCADA

1983 AÑO DEL XXX ANIVERSARIO DEL MONCADA
DEPARTAMENTO DE ORIENTACION REVOLUCIONARIA CC-PCC

opposite:

304
**Faustino Pérez for
Editora Política**
*26th July*, 1983

305
**Raúl Martínez for ICAIC**
*Fidel*, 1968

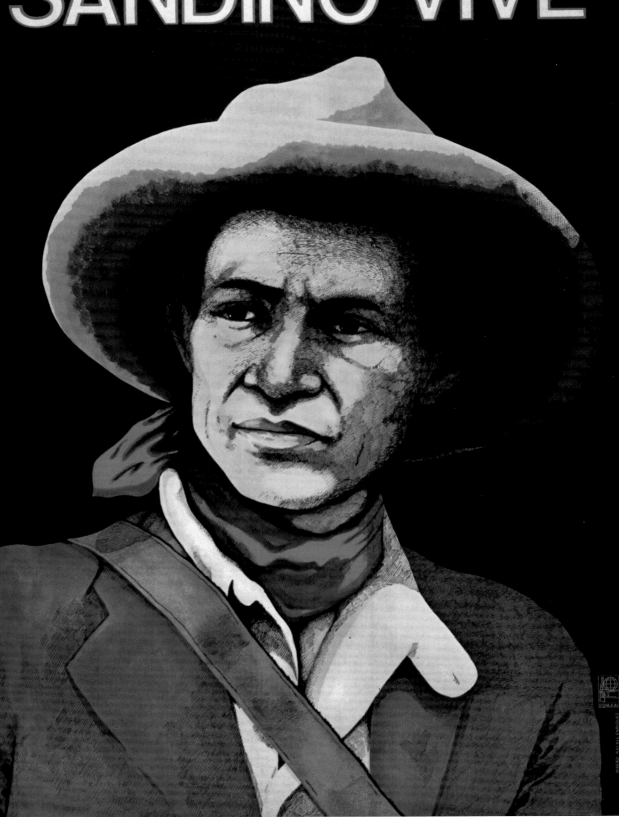

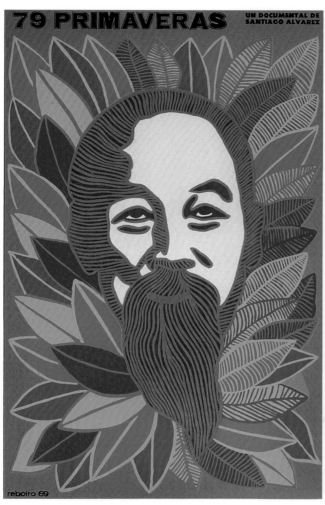

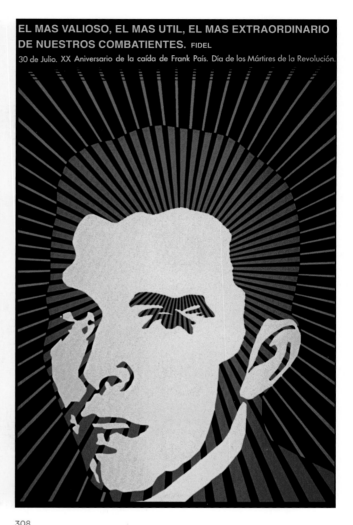

307
**Antonio Reboiro, ICAIC**
*'79 Springs: A Documentary
by Santiago Alvarez*
[Vietnam, Ho Chi Minh], 1969

308
**Roberto Figueredo for
Editora Política (DOR)**
*The Bravest, the Most
Helpful, the Most
Extraordinary of our
Comrades* (Fidel Castro
quotation, image of Frank
País), 1977

opposite:

306
**Rafael Enríquez for OSPAAAL**
*Sandino Lives*, 1984

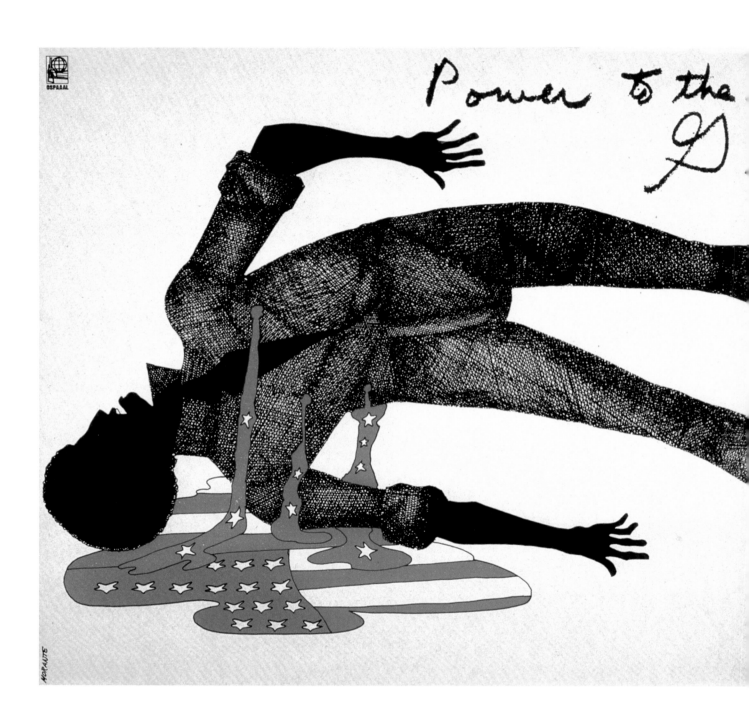

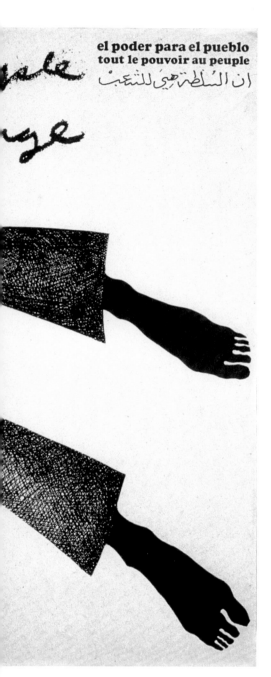

el poder para el pueblo
tout le pouvoir au peuple
إن السلطة هي للشعب

309

**Rafael Morante for OSPAAAL**
*Power to the People: George
[Jackson]*, 1971

LIBERTAD PARA ANGELA DAVIS

COMITE POR LA LIBERTAD DE ANGELA DAVIS, CUBA

310
**Félix Beltrán for
Editora Política**
*Freedom for Angela Davis,* 1971

JORNADA CONTINENTAL DE APOYO A VIET NAM, CAMBODIA Y LAOS 15 AL 21 DE OCTUBRE **oclæ**

# VIET NAM

NHẤT ĐỊNH THẮNG 승리할것이다 趙南 必胜! جويتنام سوف VENKOS ITAFHINDA WIRD SIEGEN
VENCERA 승리할것이다 SHALL WIN ПОБЕДИТ VAINCRA 必勝 VINCERA

MEDEROS-CUBA/71

opposite:

312
**Antonio Pérez González
(Ñiko or Ñico) for ICAIC**
*30th Anniversary of the
Downfall of the Nazi-Fascist
Axis. The Future Entirely
Belongs to Socialism*, 1975

313
**René Mederos Pazos
for Editora Política**
*Viet Nam Shall Win*, 1971

CORTAR HASTA LA ULTIMA CAÑA
LLUEVA MUCHO O LLUEVA POCO

COMISION DE ORIENTACION REVOLUCIONARIA DEL C.C.P.C.C.

314
**Gladys Acosta for
Editora Política**
*Cut Until the Last [Sugar]
Cane – Whether It Rains a
Lot or a Little*, 1971

315
**René Mederos Pazos,**
**Editora Política**
*To Camagüey: With the Faith*
*and Valour of the Moncada*
*Combatants,* c. 1971

316
**René Mederos Pazos**
**for Editora Política**
*As in Vietnam*, 1970

opposite:

317
**Heriberto Echeverria**
**for Editora Política**
*Cane Cutting Quota Is*
*Completed: A New Standard*
*for the Sugar Mill*, 1972

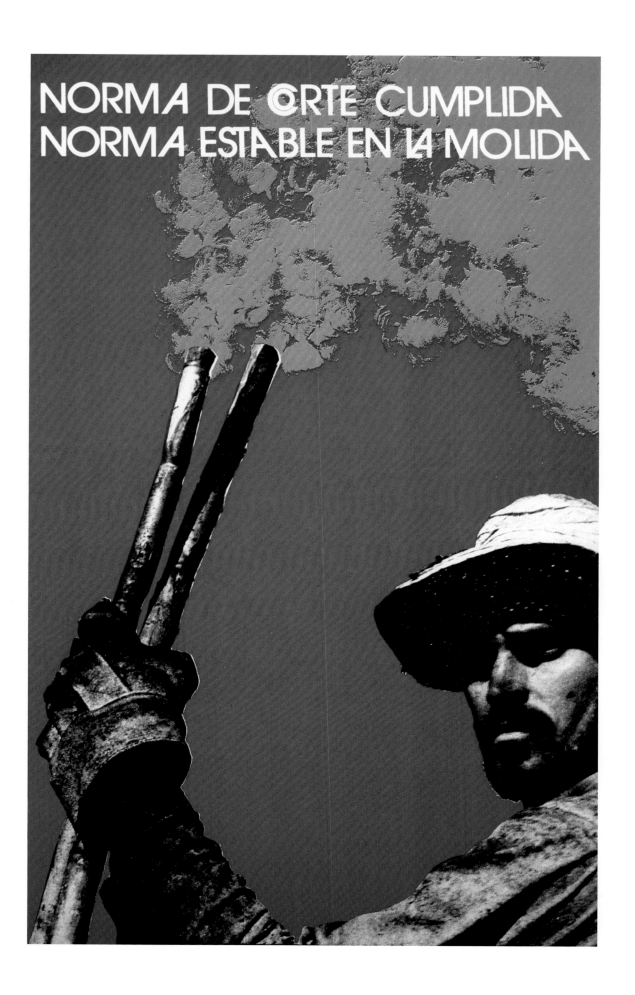

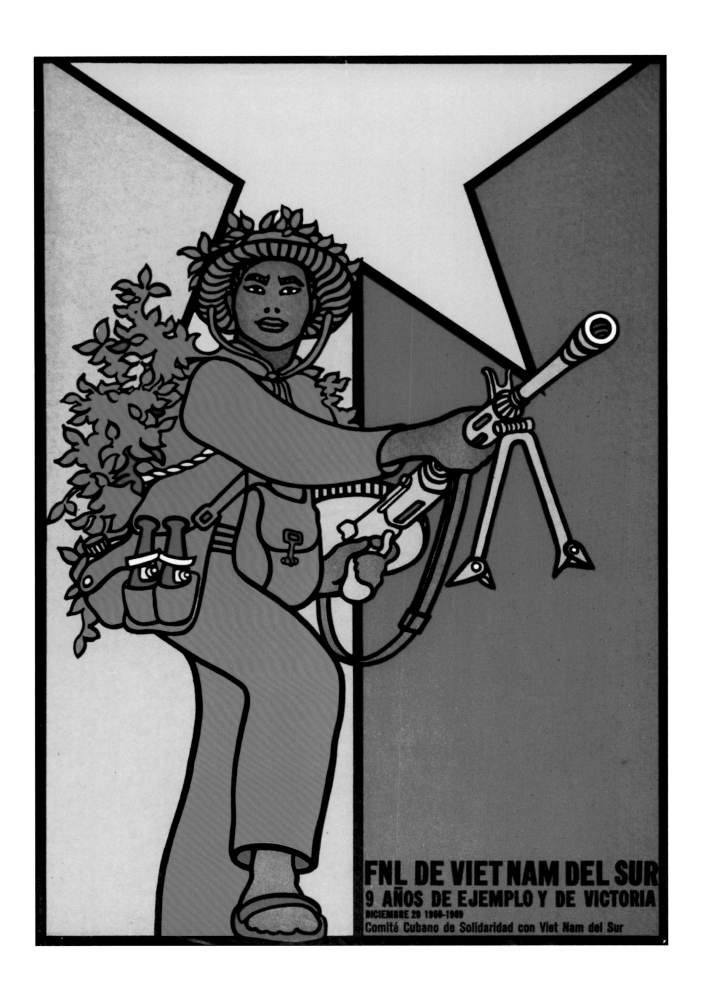

FNL DE VIET NAM DEL SUR
9 AÑOS DE EJEMPLO Y DE VICTORIA
DICIEMBRE 20 1960-1969
Comité Cubano de Solidaridad con Viet Nam del Sur

318
**René Mederos Pazos**
**for Editora Política**
*National Liberation Front
of South Vietnam*, 1969

319
**Olivio Martínez for OSPAAAL**
*International Campaign of
Solidarity with the People of
Korea*, 1973

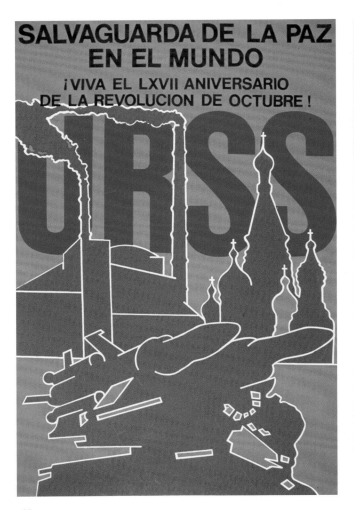

320
**Dagoberto Marcelo for
Editora Política (DOR)**
*Defender of the World: Long
Live the 67th Anniversary of the
USSR October Revolution!*, 1984

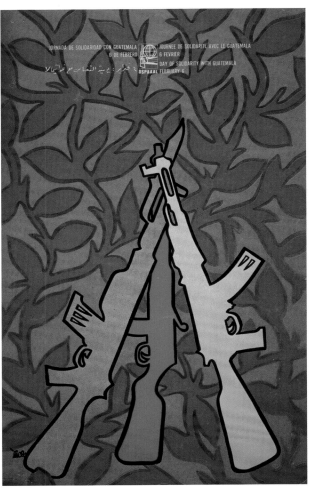

321
**Antonio Pérez González
(Ñiko or Ñico) for OSPAAAL**
*Day of Solidarity with
Guatemala*, 1970

opposite:

322
**Félix Beltrán for Editora
Política (MININT)**
*With Preparation, There Is No
Need for Improvisation*, 1973

CON PREPARACION, NO HAY IMPROVISACION

COMISION DE PROPAGANDA Y CULTURA DIRECCION POLITICA MININT

# References

## Introduction

1  Both Mao and Stalin insisted that, 'There is no such thing as art for art's sake.' In Vietnam, Trường Chinh declared, 'Art is only real art if it becomes propaganda.' Kim Jong Il said that art 'cannot be disconnected from social life'. Communist art theory and practice were rooted in these principles.

2  Quoted in Stephen White, *The Bolshevik Poster* (New Haven, CT, and London, 1988), p. 111.

3  Picasso was a committed member of the French Communist Party.

4  These contrasting messages appear, too, in actual military displays. In October 2015 China held a grand military procession to celebrate the seventieth anniversary of the victory against Japan – during which 70,000 doves were released into the sky. *Time* (21 September 2015), p. 24.

5  This wasn't even a real poster, never mind a reproduction. The style is typical of the Cultural Revolution, but the subject is 'Communes are good' and it is dated 1958. Such imagery did not appear during the Great Leap Forward (see chap. 4, illus. 162–5).

6  Maurice Rickards, *Posters of Protest and Revolution* (New York, 1970), p. 13.

7  The terms are often used interchangeably. Ruling communist parties often refer to their societies as 'socialist'. The goal of communism as prescribed by Marx seems to have been abandoned.

8  The People's Republic of China, Republic of Cuba, Lao People's Democratic Republic and Socialist Republic of Vietnam. The Democratic People's Republic of Korea calls itself a 'socialist' state, but has dropped the terms 'Marxism-Leninism' and 'communism'. Its official ideology is *Juche*, generally translated as 'self-reliance', and is strongly nationalistic. Its economy is mostly state-controlled, though some private production and markets are developing. Chalmers Johnson, 'Comparing Communist Nations', in *Change in Communist Systems*, ed. Chalmers Johnson (Stanford, CA, 1970), pp. 1–32.

9  The expression 'revolution of underdevelopment' is used by Robert C. Tucker in *The Marxian Revolutionary Idea* (Princeton, NJ, 1969), pp. 134–8.

10  Walter Laqueur, *The Dream that Failed: Reflections on the Soviet Union* (Oxford and New York, 1994), pp. 77–95. 'Mobilization' regimes is perhaps more useful than 'totalitarian' – now a compromised term. See the Introduction in Michael Geyer and Sheila Fitzpatrick, eds, *Beyond Totalitarianism: Stalinism and Nazism Compared* (New York, 2008).

11  Werner Haftmann, quoted in Igor Golomstock, *Totalitarian Art* (London, 1990), p. ix.

12  Steven Heller argues that while the four 'shared a taste for monumentalism and heroic realism, what they didn't have in common was modernism'. Steven Heller, *Iron Fists: Branding the 20th-century Totalitarian State* (London and New York, 2008), p. 10.

13  Richard Lowenthal, 'Development vs. Utopia in Communist Policy', in *Change in Communist Systems*, ed. Johnson, pp. 33–116.

14  See, for example, Jonathan Unger, ed., *Using the Past to Serve the Present: Historiography and Politics in Contemporary China* (Armonk, NY, 1993).

15  See Eric Hobsbawm, 'Introduction: Inventing Traditions', in *The Invention of Tradition*, ed. Eric Hobsbawm and Terence Ranger (Cambridge, 1983), pp. 1–14.

16  James Aulich and Marta Sylvestrová, *Political Posters in Central and Eastern Europe, 1945–95* (Manchester and New York, 1999), p. 4.

17  Most socialist/communist countries, and some non-socialist ones, adopted national emblems with similar imagery: hammer and sickle or other national symbol within a wreath of grain, with a five-pointed star at the top.

18  A full-colour Chinese version of this montage-poster commemorated the seventieth anniversary of the Communist Party's founding. See www.flickr.com/

photos/chinesepostersnet/16101166311, accessed 28 July 2015.

19  This is not to say that women were not also shown as industrial workers, train drivers and pilots. They were depicted as economic equals in most communist countries. Gender issues are discussed in each chapter.

20  B. R. Myers, *The Cleanest Race: How North Koreans See Themselves – and Why It Matters* (Brooklyn, NY, 2010), pp. 96–7.

21  Carrie Warra, 'The Bare Truth: Nudes, Sex, and the Modernization Project in Shanghai', in *Visual Culture in Shanghai: 1850s–1930s*, ed. Jason C. Kuo (Washington, DC, 2007), pp. 178–9 and fig. 4.

22  See David Crowley's essay, p. 144. The hand and clenched fist have been important signs in the propaganda art of communist, capitalist, fascist, Islamist, post-colonial and other political movements. See, for example, Jeffrey T. Schnapp, *Revolutionary Tides: The Art of the Political Poster, 1914–1989* (Milan, 2005), pp. 47–65.

23  The image appears on posters, postage stamps and the huge mosaic on the wall of the Sinchon Museum of American War Atrocities. Koen De Ceuster notes that the official narrative of the Sinchon Massacre has been reduced to that one image (private correspondence, 2015).

24  The post-revolution change from the Julian to the Gregorian calendar brought the 25 October events to 7 November. Reference is invariably to the October Revolution.

25  The United Nations declared Universal Children's Day to be 20 November, but communist countries (and former ones) still follow 1 June.

26  Jessica Harrison-Hall, Sherry Buchanan and Thu Stern, eds, *Vietnam Behind the Lines: Images from the War, 1965–1975* (London, 2002), p. 67.

27  The obvious message of this Great Leap Forward poster is agricultural plenty. Millions were starving at the time. The sunflowers are a sign of loyalty to Chairman Mao. The poster is entitled *Zhuge Comes Out of the Thatched Cottage*, referring to a heroic character in the famous novel *Romance of the Three Kingdoms* (*Sanguo Yanyi*).

28  See Chapter Two, p. 99–101 (Posters and Education).

29  Mt Paektu (or Baekdu) is the legendary birthplace of the Korean nation, but also the (spurious) birthplace of Kim Jong Il (1941–2011).

30  Socialist realism has been wittily defined as 'girl meets tractor'.

31  The slogan was first used by Louis Blanc in the 1850s, but popularized in Karl Marx's *Critique of the Gotha Programme* (1875).

32  Trotsky's more politically demanding dictum was: 'In a country where the sole employer is the State, opposition means death by slow starvation. The old principle: who does not work shall not eat, has been replaced by a new one: who does not obey shall not eat.'

33  See Chapter Seven, p. 337.

34  See, for example, Yunxiang Yan, *Private Life Under Socialism: Love, Intimacy and Family Change in a Chinese Village, 1949–1999* (Stanford, CA, 2003).

35  See Chapter One, p. 47.

36  Richard Stites, *Revolutionary Dreams: Utopian Vision and Experimental Life in the Russian Revolution* (Oxford and New York, 1989), pp. 200–204.

37  Victoria F. Bonnell, *Iconography of Power: Soviet Political Posters Under Lenin and Stalin* (Berkeley and Los Angeles, CA, 1997), pp. 118–20.

38  Stefan Landsberger, www.chineseposters.net, accessed 28 July 2015.

39  David Heather and Koen De Ceuster, *North Korean Posters: The David Heather Collection* (Munich, 2008), p. 79.

40  Spartakiads were also held in Czechoslovakia and Albania. Russia hosted the Summer Olympics in 1980; Beijing in 2008.

41  Beibei, Jingjing, Huanhuan, Yingying, Nini. Combining them gave '*Beijing huanying ni*' (Beijing welcomes you).

42  Quoted in David Heather and Sherry Buchanan, *Vietnam Posters: The David Heather Collection* (Munich, 2009), p. 242.

43  'Remarks at the Spring Festival', 13 February 1964, quoted at www.marxists.org, accessed 2 September 2015.

44  Poster can be viewed at www.chineseposters.net/posters/e-15-278.php, accessed 2 September 2015.

45  Tina Mai Chen, 'Propagating the Propaganda Film: The Meaning of Film in CCP Writings, 1949–1965', *Modern Chinese Literature and Culture*, XV/2 (Fall 2003), pp. 154–93 (p. 154).

46  For international release, the film was entitled *The Beginning of the Great Revival*.

47  The Communist International, also known as the Third International, was an association of the world's communist parties, established in 1919 and dissolved in 1943. The Warsaw Pact, founded in 1955, was the defence pact between the USSR and the satellite states of Eastern and Central Europe.

48  In the mid-1920s the Comintern supported Chiang Kai-shek's Guomindang against the Communist Party.

49  OSPAAAL, the Organization in Solidarity with the People of Asia, Africa and Latin America, was founded in 1966, when the original solidarity organization OSPAA added Latin America to its concerns. As its goals and activities were internationalist, poster slogans were generally written in Spanish, French, English and Arabic; Editora Política is the publishing arm of the Cuban Communist Party.

## 1 Russia/Union of Soviet Socialist Republics, 1917–91

1  Stephen White, *The Bolshevik Poster* (New Haven, CT, and London, 1998), p. 1.

2  Yuri Ovsyannikov, *The Lubok: 17th–18th Century Russian Broadsides* (Moscow, 1968), pp. 5–33.

3  Andrew M. Nedd, 'Segodniashnii Lubok: Art, War and National Identity', in *Picture This: World War I Posters and Visual Culture*, ed. Pearl James (Lincoln, NE, 2007), p. 241.

4  Stephen M. Norris, *A War of Images: Russian Popular Prints, Wartime Culture, and National Identity, 1812–1945* (DeKalb, IL, 2006), p. 1.

5  Hubertus F. Jahn, *Patriotic Culture in Russia During World War I* (Ithaca, NY, 1995), pp. 17–18.

6  Tatyana Vilinbakhova, 'Red in Old Russian Art', in *Red in Russian Art*, exh. cat., The State Russian Museum, St Petersburg (1997), p. 9.

7  White, *The Bolshevik Poster*, p. 6.

8  ROSTA was the Russian Telegraph Agency. See the section on ROSTA windows below.

9  See, for example, Leah Dickerman, ed., *Building the Collective: Soviet Graphic Design, 1917–1937: Selections from the Merrill C. Berman Collection* (New York, 1996); see Victoria F. Bonnell, *Iconography of Power: Soviet Political Posters Under Lenin and Stalin* (Berkeley and Los Angeles, CA, 1997); David King, *Red Star Over Russia: A Visual History of the Soviet Union from 1917 to the Death of Stalin* (London, 2009).

10  7 November in the Gregorian calendar adopted in 1918.

11  Sheila Fitzpatrick, *The Russian Revolution, 1917–1932* (Oxford, 1982), pp. 70–76.

12  Julian Chang, 'The Mechanics of State Propaganda: The People's Republic of China and the Soviet Union in the 1950s', in *New Perspectives on State Socialism in China*, ed. Timothy Cheek and Tony Saich (Armonk, NY, 1997), p. 76.

13  Peter Kenez, *The Birth of the Propaganda State: Soviet Methods of Mass Mobilization, 1917–1929* (Cambridge, 1985), p. ix.

14  By 1920, some 44.1 per cent of the overall population of the RSFSR was claimed to be literate, but this was heavily skewed to the urban areas. Non-Russian territories (the Caucasus, Central Asia) suffered higher rates of illiteracy. See White, *The Bolshevik Poster*, pp. 18–19.

15  Agitprop, from the Russian *agitatsaya propaganda* (agitation propaganda) refers to promotion of

Communist propaganda. The term itself was first used in the 1930s.

16 White, *The Bolshevik Poster*, p. 91.

17 Ibid., p. 110.

18 Camilla Gray, *The Russian Experiment in Art, 1863–1922*, revd edn (London, 1986), pp. 219–20.

19 White, *The Bolshevik Poster*, p. 15.

20 Yakov Lurye, Mercer and Middlesex Auctions, online catalogue, February 2015, lot 1.

21 Yakov Lurye, Mercer and Middlesex Auctions, online catalogue, June 2014, lot 10.

22 White, *The Bolshevik Poster*, p. 23.

23 Bonnell, *Iconography of Power*, p. 142.

24 Ilya Repin (1844–1936) was Russia's most renowned nineteenth-century painter. His *Barge Haulers on the Volga* was invoked in Soviet propaganda imagery for decades. See illus. 75.

25 Bonnell, *Iconography of Power*, p. 72.

26 Alex Ward, ed., *Power to the People: Early Soviet Propaganda Posters from the Israel Museum, Jerusalem* (Jerusalem, 2007), p. 20.

27 Bonnell, *Iconography of Power*, pp. 26–7.

28 The Caucasian and Central Asian republics did not join the USSR willingly. The resistance struggles were downplayed in Soviet history, but continued through the 1920s and even into the early 1930s.

29 Neil MacGregor, *A History of the World in 100 Objects* (London, 2010), pp. 628–33, plate 96.

30 Ward, *Power to the People*, p. 20.

31 ROSTA (*Rossiiskoye telegrafnoye agentstvo*) was established in 1918, combining the old telegraph agency with the newly created press bureau, under the Council of People's Commissars.

32 Ward, *Power to the People*, pp. 21, 25. The authors provide a comprehensive lexicon, pp. 27–31.

33 White, *The Bolshevik Poster*, p. 84.

34 Ward, *Power to the People*, p. 20.

35 White, *The Bolshevik Poster*, p. 88.

36 For the origins and development of Suprematism, see Gray, *The Russian Experiment*, pp. 158–67.

37 King, *Red Star Over Russia*, p. 61.

38 Ward, *Power to the People*, p. 19.

39 Quoted in White, *The Bolshevik Poster*, p. 76.

40 Dickerman, *Building the Collective*, p. 16.

41 Kenez, *The Birth of the Propaganda State*, p. 96.

42 White, *The Bolshevik Poster*, p. 91.

43 Fitzpatrick, *The Russian Revolution*, p. 85.

44 Randi Cox, '"NEP Without Nepmen!" Soviet Advertising and the Transition to Socialism', in *Everyday Life in Soviet Russia: Taking the Revolution Inside*, ed. Christina Kaier and Eric Naiman (Bloomington, IN, 2006), pp. 119–52.

45 Ibid., p. 120.

46 Ibid., p. 127.

47 *Mosselprom* was the Moscow Association of Enterprises Processing Agro-Industrial Products.

48 Quoted in Victor Margolin, *The Struggle for Utopia: Rodchenko, Lissitzky, Moholy-Nagy, 1917–1946* (Chicago, IL, 1997), p. 113.

49 Robert C. Williams, *Russia Imagined: Art, Culture, and National Identity, 1840–1995* (New York, 1999), p. 247.

50 Richard Stites, 'Iconoclastic Currents in the Russian Revolution,' in *Bolshevik Culture: Experiment and Order in the Russian Revolution*, ed. Abbot Gleason, Peter Kenez and Richard Stites (Bloomington and Indianapolis, IN, 1985), pp. 1–24.

51 Anne Odom and Wendy R. Salmond, eds, *Treasures into Tractors: The Selling of Russia's Cultural Heritage, 1918–1938* (Seattle, WA, and Washington, DC, 2009), especially pp. 14–26.

52 Mikhail Anikst, ed., *Soviet Commercial Design of the Twenties* (New York, 1987), p. 66.

53 Orlando Figes, *Revolutionary Russia, 1891–1991* (London, 2004), pp. 193–4.

54 On the changing representation of working and peasant women in posters, see Bonnell, *Iconography of Power*, chaps 2 and 3.

55 Walter Benjamin, 'The Political Groupings of Russian Writers', in *Walter Benjamin: Selected Writings, Vol. 2: Part 1, 1927–1930*, ed. Michael W. Jennings, Howard

Eiland and Gary Smith (Cambridge, MA, 2005), pp. 6–11 (p. 7).

56 Catriona Kelly, *Children's World: Growing Up in Russia, 1890–1991* (New Haven, CT, and London, 2007), pp. 71–2.

57 Ibid., p. 547.

58 Leah Dickerman, 'Lenin in the Age of Mechanical Reproduction', in *Disturbing Remains: Memory, History and Crisis in the Twentieth Century*, ed. Michael S. Roth and Charles G. Salas (Los Angeles, CA, 2001), pp. 77–110.

59 Bonnell, *Iconography of Power*, p. 147.

60 Quoted in Fitzpatrick, *Revolutionary Russia*, p. 118.

61 Collective farms and state farms.

62 Fitzpatrick, *Revolutionary Russia*, p. 127.

63 LEF was the journal of the Left Front of the Arts in the 1920s.

64 Sheila Fitzpatrick, *Everyday Stalinism: Ordinary Life in Extraordinary Times: Soviet Russia in the 1930s* (Oxford, 1999), p. 40.

65 Figes, *Revolutionary Russia*, p. 249.

66 The classic account, originally published in 1968, is Robert Conquest, *The Great Terror: A Re-assessment*, revd edn (London, 2008).

67 Alexander Nevsky (1221–1263), Alexander Suvorov (1730–1800) and Vasily Chapaev (1887–1919) were among Russia's greatest military heroes.

68 'Kukryniksy' took a syllable from each artist's name: Mikhail Vasil'evich Kupriyanov (1903–1991), Porfirii Nikitich Krylov (1902–1990) and Nikolai Aleksandrovich Sokolov (1903–2000). They worked collaboratively from 1924.

69 Norris, *War of Images*, pp. 179–83.

70 ROSTA was renamed TASS (Telegraph Agency of the Soviet Union) in 1925. For a full account of the wartime TASS posters, see Peter Kort Zegers and Douglas W. Druick, eds, *Windows on the War: Soviet TASS Posters at Home and Abroad, 1941–1945* (Chicago, IL, New Haven, CT, and London, 2011).

71 Ibid., p. 13.

72 Bonnell, *Iconography of Power*, p. 243.

73 Graeme Gill, *Symbols and Legitimacy in Soviet Politics* (Cambridge, 2011), p. 164.

74 Constantin Boym, *New Russian Design* (New York, 1992), p. 176, Chapter Three, pp. 144–8).

75 Alexander Yegorov and Victor Litvinov, *The Posters of Glasnost and Perestroika*, trans. John Crowfoot (London, 1989), no. 16.

76 Ibid., no. 10.

77 Walter Laqueur, *The Dream that Failed: Reflections on the Soviet Union* (Oxford, 1994), pp. 150–53.

## 2 Mongolian People's Republic, 1924–92

I Maekawa, a Lecturer at the Kyoto University of Foreign Studies and a PhD candidate at the National Museum of Ethnology (Minpaku), classified and categorized the posters and Khorloo Batpurev and Baasanjar Byambar translated the inscriptions.

I have had the honour of collaborating with Dr Yuki Konagaya, Curator at the National Museum of Ethnology in Osaka and currently Executive Director of the National Institutes for the Humanities in Tokyo, for many years. She is one of the most well-informed specialists on modern Mongolia, and her various projects, including extensive interviews with Mongolians of a variety of occupations and her studies of the Mongolian environment, have added profoundly to knowledge of socialist and post-socialist Mongolia. A major analysis of the social, cultural and environmental status of Mongolia, Korea, Japan, Russia and China's Northeast, her latest collaborative project, will contribute immeasurably to an understanding of Northeast Asia. She has proved to be an invaluable guide for this essay, providing the images of the posters and translations of the inscriptions found on them. Her perceptions about the posters have influenced my thinking, and I am extremely grateful for her insights.

1 A brief book about the Mongolian Empire for the general reader is Morris Rossabi, *The Mongols: A Very Short Introduction* (New York, 2012).

2 A convenient introduction to Mongolian history and society is William Fitzhugh, Morris Rossabi and William Honeychurch, eds, *Genghis Khan and the Mongol Empire* (Seattle, WA, 2009).

3 I am grateful to Professor Daniel Waugh for a careful reading of this essay and for his excellent suggestions.

4 John Barnicoat, *A Concise History of Posters, 1870–1970* (London, 1972), p. 7.

5 Victoria F. Bonnell, *Iconography of Power: Soviet Political Posters Under Lenin and Stalin* (Berkeley and Los Angeles, CA, 1997), p. 5.

6 Graeme Gill, *Symbols and Legitimacy in Soviet Politics* (Cambridge, 2011), p. 11; for similar advantages in China, see Harriet Evans and Stephanie Donald, eds, *Picturing Power in the People's Republic of China: Posters of the Cultural Revolution* (Lanham, MD, 1999), pp. 10–18.

7 See Stephen White, *The Bolshevik Poster* (New Haven, CT, and London, 1998), for the various influences on the posters. On the *lubok*, see Yuri Ovsyannikov, *The Lubok: 17th–18th Century Broadsides* (Moscow, 1968); *Loubok: Russian Popular Prints from the Late 18th–Early 20th Centuries from the Collection of the State Historical Museum, Moscow* (Moscow, 1992); Alla Sytova, *The Lubok: Russian Folk Pictures, 17th to 19th Century* (Leningrad, 1984), and the beautiful book by E. Ivanov, *Russkii narodnii lubok* (Moscow, 1937). Also see Mary Jane Rossabi, 'Peasants, Peddlers, and Popular Prints in Nineteenth-century Russia', *New York Public Library Bulletin of Research in the Humanities*, LXXXVII/4 (1987), pp. 418–30.

8 Ts. Erdenetsog and J. Saruulbuyantsog, *Mongoliin zuragt khuudas* (Ulaanbaatar, 2011), p. 6, lists him and other artists as intermediaries.

9 The official name of the National Museum is the Ts. S. Sampilov Buryat Republic Art Museum in Ulan-Ude. For some of his works, see I. I. Soktoeva et al., *Ts. Sampilov: etnograficheskie zarisovki* (Novosibirsk, n.d.).

10 See D. Maidar, *Grafika Mongolii* (Moscow, 1988), p. 11.

11 Robert Kenneth Doebler, 'Cities, Population Redistribution, and Urbanization in Mongolia', PhD diss., Indiana University, 1994, p. 64.

12 For specific references concerning the significance of the postal relay system, see Morris Rossabi, ed., *Herdsman to Statesman: The Autobiography of Jamsrangiin Sambuu of Mongolia*, trans. Mary Rossabi (Lanham, MD, 2010), pp. 3–4, 30–34.

13 David Heather and Sherry Buchanan, *Vietnam Posters: The David Heather Collection* (Munich, 2009), pp. 6–10; Gill, *Symbols and Legitimacy*, p. 10; Stefan Landsberger, *Chinese Propaganda Posters* (Amsterdam, 1995), pp. 22–8.

14 Charles Bawden, *The Modern History of Mongolia* (New York, 1968), pp. 246–8.

15 Rossabi, *Herdsman to Statesman*, pp. 31–2.

16 Gita Steiner-Khamsi and Ines Stolpe, *Educational Import: Local Encounters and Global Forces in Mongolia* (New York, 2006), pp. 36–8.

17 Bawden, *The Modern History of Mongolia*, p. 249.

18 Mary Rossabi, trans., *Three Buddhists in Modern Mongolia* (Osaka, 2013), pp. 275–6; Ts. Namkhainyambuu, *Bounty from the Sheep: Autobiography of a Herdsman*, trans. Mary Rossabi, intro. Morris Rossabi (Cambridge, 2000), notes that his district school went through to the seventh grade in the late 1950s, but he left after the fourth grade, apparently a typical pattern. Herder children either dropped out or were pulled out by their parents because they were needed to tend the animals. See the account of Badamkhand in Rossabi, *Three Buddhists*.

19 Julia Andrews and Kuiyi Shen, *The Art of Modern China* (Berkeley, CA, 2012), p. 152; for a useful work on Chinese posters, see Min Anchee, *Chinese Propaganda Posters* (Cologne, 2003).

20 Heather and Buchanan, *Vietnam Posters*, pp. 7–10; Gill, *Symbols and Legitimacy*, pp. 9–10; for example, the images of Uncle Sam and the U.S. dollar sign were

often used and were easily recognizable. See Lincoln
Cushing, *Revolución: Cuban Poster Art* (San Francisco,
CA, 2003), pp. 15–16.

21  Erdenetsog and Saruulbuyantsog, *Mongoliin zuragt
khuudas*, pp. 7–8.

22  Bonnell, *Iconography of Power*, p. 2; see also Morris
Rossabi, 'A New Mongolia in a New World', in
*Mongolian Political and Economic Development During the
Past Ten Years and Future Prospects* (Taipei, 2000), p. 45.

23  Ellen Johnston Laing, *The Winking Owl: Art in the
People's Republic of China* (Berkeley, CA, 1988), pp. 2–3.

24  For his speeches, see Bonnie McDougall, *Mao Zedong's
'Talks at the Yan'an Forum on Literature and Art'* (Ann
Arbor, MI, 1980).

25  The North Korean Communist leadership expressed
the same view. See David Heather and Koen De
Ceuster, *North Korean Posters: The David Heather
Collection* (Munich, 2008), p. 11.

26  Laing, *The Winking Owl*, pp. 2–3.

27  Michael Sullivan, *Art and Artists of Twentieth-century
China* (Berkeley, CA, 1996), p. 139.

28  For example, *Peasant Paintings from Huhsien County*
(Peking, 1974), p. 1, asserts that 'The works of these
peasant painters are militant and have broad mass
appeal.' Sullivan, *Art and Artists of Twentieth-century
China*, p. 148, and Laing, *The Winking Owl*, p. 83, concur
that the peasants received professional assistance.

29  David King, *Russian Revolutionary Posters* (London,
2011), p. 7; Alex Ward, ed., *Power to the People: Early
Soviet Propaganda Posters in The Israel Museum, Jerusalem*
(Jerusalem, 2007), pp. 18–19.

30  New Economic Policy, a period from 1921 to 1928
during which the Soviet Union pursued relatively
moderate policies instead of immediate and rapid
introduction of communism; Elena Barkhatova, *Soviet
Constructivist Posters* (Moscow, 2005), p. 11.

31  I. I. Lomakina, *Marzan Sharav* (Moscow, 1974), pp.
17, 30. Lomakina's book proved to be invaluable for
this essay, but it devotes only one chapter to Sharav's
involvement with posters.

32  For colour depictions of these portraits, see *Mongol:
orchin ueiin durslekh urlagiin tuukh (1911–2011)*
[Mongolian Modern Art History (1911–2011)]
(Ulaanbaatar, 2012), p. 31; Maidar, *Grafika Mongolii*,
pp. 8–10.

33  See Stephen Beyer, *The Cult of Tārā: Magic and Ritual
in Tibet* (Berkeley, CA, 1978), for additional information
about Tara.

34  A colour depiction is in *Mongol: orchin ueiin durslekh
urlagiin tuukh*, p. 32. Lomakina, *Marzan Sharav*, pp.
59–62, provides a fine description of the painting.

35  N. Tsultem, *Development of the Mongolian National
Style Painting 'Mongol Zurag' in Brief* (Ulaanbaatar,
1986), offers a useful description of the painting and of
Sharav's career.

36  Lomakina, *Marzan Sharav*, pp. 143–50.

37  *Tales of an Old Lama*, trans. Charles Bawden (Tring,
1997), p. 15.

38  The Lenin portrait is found in *Mongol: orchin ueiin
durslekh urlagiin tuukh*, p. 34, and the illustrations for
*Robinson Crusoe* may be found in Maidar, *Grafika
Mongolii*, nos 80–83. The book must have been one of
the most popular during the communist era. A herder
in Zavkhan *aimag* mentions it as one of the books he
read and to which he had access; see Namkhainyambuu,
*Bounty from the Sheep*, p. 49.

39  Gill, *Symbols and Legitimacy*, p. 20.

40  Each communist country had its own enemies.
Heather and Buchanan, in *Vietnam Posters*, find that the
North Vietnamese had a plethora of enemies, starting
with the French imperialists and continuing with the
rich landowners, the South Vietnamese government
and the United States. Lincoln Cushing and Ann
Tompkins, in *Chinese Posters from the Great Proletarian
Cultural Revolution* (San Francisco, CA, 2007), note
the state's attacks on 'capitalist roaders' as well as
the United States. Ironically, in the late 1980s, artists
from the Eastern and Central European countries that
were breaking away from communism imitated the
communists and employed posters to criticize Soviet

rule, Joseph Stalin and the Romanian head of state Nicolae Ceaușescu, among other features of their governments. See *Art as Activist: Revolutionary Posters from Central and Eastern Europe*, Smithsonian Institution Traveling Exhibition Service (New York, 1992).

41 Joseph Fletcher, 'The Heyday of the Ch'ing Order in Mongolia, Sinkiang and Tibet', in *The Cambridge History of China: Volume 10: Late Ch'ing, 1800–1911, Part 1*, ed. John K. Fairbank (Cambridge, 1978), p. 353.

42 Larry W. Moses, *The Political Role of Mongol Buddhism* (Bloomington, IN, 1977), pp. 6–7; Rossabi, *Herdsman to Statesman*, p. 64, also offers a negative appraisal.

43 Numbers in bold are the numbers of the posters in this book.

44 'Khuvsgal khigeed uls tör', *Toim*, 48 (2012), p. 19. The Soviets produced similarly anti-clerical posters: *The Priests Help Capital and Hinder the Workers* is a typical critique of the Orthodox Church, as is *The Spider and the Flies*, with the spider-like and ugly Orthodox priest taking advantage of the 'flies' or 'people'. See White, *Bolshevik Posters*, p. 51.

45 Lomakina, *Marzan Sharav*, p. 177.

46 Ibid., p. 161.

47 The Soviets celebrated this victory with a poster titled *At the Grave of the Counter-revolution*. See White, *Bolshevik Posters*, pp. 57–8. The Mongolians had similar posters, including *Words and Deeds of Counter-revolutionaries*. See Maidar, *Grafika Mongolii*, no. 30. The Chinese, too, had a version entitled 'Destroy the Old World, Establish the New World.' See Andrews and Shen, *The Art of Modern China*, p. 196.

48 Erdenetsog and Saruulbuyantsog, *Mongoliin zuragt khuudas*, pp. 13–14.

49 For a popular account of Baron Ungern-Sternberg, see James Palmer, *The Bloody White Baron* (New York, 2009).

50 Sechin Jagchid and Paul Hyer, *Mongolia's Culture and Society* (Boulder, CO, 1979), p. 26.

51 For the accusations made against them, see *History of the Mongolian People's Republic*, trans. William Brown and Urgunge Onon (Cambridge, MA, 1976), pp. 191–3, and for an unbiased version of events, see Bawden, *The Modern History of Mongolia*, pp. 276–82. Robert Rupen, in *How Mongolia Is Really Ruled: A Political History of the Mongolian People's Republic, 1900–1978* (Stanford, CA, 1979), p. 134, lists the early revolutionaries who were executed within a few years of the communists taking power. His book is a useful and brief handbook of developments in Mongolia through much of the twentieth century. His massive *Mongols of the Twentieth Century* (Bloomington, IN, 1964), is obviously more comprehensive.

52 Erdenetsog and Saruulbuyantsog, *Mongoliin zuragt khuudas*, p. 13.

53 A *deel* was a long robe, made of sheepskin, with a sash.

54 Erdenetsog and Saruulbuyantsog, *Mongoliin zuragt khuudas*, pp. 13–14.

55 A typical poster would be L. Namsrai's *Are You Teaching Grammar on the Tenth Anniversary of the Revolution?*; see Maidar, *Grafika Mongolii*, no. 31.

56 On the concept of literacy, see Jeffrey Brooks, *When Russia Learned to Read: Literacy and Popular Literature, 1861–1917* (Princeton, NJ, 1985), and Evelyn Sakakida Rawski, *Education and Popular Literacy in Ch'ing China* (Ann Arbor, MI, 1979).

57 See *Soviet Anti-alcohol Posters from the Sergo Grigorian Collection* (Moscow, 2011).

58 Rupen, *How Mongolia Is Really Ruled*, p. 68. The most prominent early rector of the university would eventually write about its founding and early years. See *Through the Ocean Waves: The Autobiography of Bazaryn Shirendev*, trans. Temujin Onon (Bellingham, WA, 1997), pp. 123–7.

59 On the importance of this battle, see the monumental work by Alvin Coox, *Nomonhan: Japan Against Russia, 1939* (Stanford, CA, 1985), 2 vols, and the more recent work of Stuart Goldman, *Nomonhan, 1939: The Red Army's Victory that Shaped World War II* (Annapolis, MD, 2012).

60 Rossabi, *Herdsman to Statesman*, p. 115.

61 Artists from the Soviet Union produced their own anti-Nazi posters. See Peter Kort Zegers and Douglas W. Druick, eds, *Windows on the War: Soviet TASS Posters at Home and Abroad, 1941–1945* (New Haven, CT, 2011). They continued in this vein after the war. See *We Demand Peace!: Soviet Posters of the Cold War* (Moscow, 2007).

62 One of the anti-Nazi depictions shows Hitler eating flesh. See Erdenetsog and Saruulbuyantsog, *Mongoliin zuragt khuudas*, p. 15. Ürjingiin Yadamsüren (1905–1987), who produced this poster, was one of the founders of the new traditional style of *zurag*. On Yadamsüren, see Christopher Atwood, *Encyclopedia of Mongolia and the Mongol Empire* (New York, 2004), p. 598.

63 Edgar Snow, *Red Star Over China* (New York, 1938), pp. 88–9, n. 1.

64 Gunther Stein, *The Challenge of Red China* (New York, 1945), pp. 442–3.

65 On this plebiscite, see Bruce Elleman, 'The Final Consolidation of the U.S.S.R.'s Sphere of Interest in Outer Mongolia', in *Mongolia in the 20th Century: Landlocked Cosmopolitan*, ed. Bruce Elleman and Stephen Kotkin (Armonk, NY, 1999), p. 131, and George G. S. Murphy, *Soviet Mongolia: A Study of the Oldest Political Satellite* (Berkeley, CA, 1966), p. 205. For a first-hand account, see *Through the Ocean Waves*, pp. 115–18.

66 Rossabi, *Herdsman to Statesman*, pp. 16, 115–24.

67 For the reminiscences of Paavangiin Damdin, one of the leaders of the industrialization movement, see Yuki Konagaya and I. Lkhagvasuren, *Socialist Devotees and Dissenters: Three Twentieth-century Mongolian Leaders*, ed. Morris Rossabi, trans. Mary Rossabi (Osaka, 2011), pp. 235–85.

68 On To Wang's work, see Sh. Natsagdorj, *To Wang ba tüünii surgaal* (Ulaanbaatar, 1968). Sambuu's text is entitled *Malchidatgl Okh Zovlogoo* (Ulaanbaatar, 1956 reprint).

69 An English translation of that work may be found in Naimkhainyambuu, *Bounty from the Sheep*, pp. 103–50.

70 For a brief description of this programme, see William Taubman, *Khrushchev: The Man and His Era* (New York, 2003), pp. 260–62. On a leader of this state farm movement, see Konagaya and Lkhagvasuren, *Socialist Devotees and Dissenters*, pp. 84–97.

71 Other communist states also emphasized healthcare and athletics in their posters. See Heather and Buchanan, *Vietnam Posters*, p. 245, and Cushing, *Revolución*, pp. 45–59.

72 On the Olympics posters, see Erdenetsog and Saruulbuyantsog, *Mongoliin zuragt khuudas*, p. 18.

73 Depictions of women differ in different cultures. Cuban posters apparently depicted few women (Cushing, *Revolución*, p. 12), while Chinese posters emphasized that women could readily perform work commonly associated with men (Landsberger, *Chinese Propaganda Posters*, pp. 38–40). North Korean posters link women to bumper harvests, joy and peace (Heather and De Ceuster, *North Korean Posters*, pp. 14–15). On North Korean posters, see also Jane Portal, *Art Under Control in North Korea* (London, 2005), especially pp. 75, 78, 160–62.

74 As early as the 1930s, the renowned poet and playwright Dashdorjiin Natsagdorj (1906–1937) had written plays promoting the use of Western medicine, proper sanitation and good health. See Erdenetsog and Saruulbuyantsog, *Mongoliin zuragt khuudas*, p. 12. See Atwood on Natsagdorj, *Encyclopedia of Mongolia and the Mongol Empire*, p. 400.

75 Even earlier, a poster artist conveyed the message that the 'Teaching of Science and Technology Leads to a New Life'; Maidar, *Grafika Mongolii*, no. 32.

76 On ventures into space, see Erdenetsog and Saruulbayantsog, *Mongoliin zuragt khuudas*, p. 19.

77 On ballet, see Morris Rossabi, 'Ulaanbaatar Ballet', *Ballet Review* (Spring 2010), pp. 41–3, and on opera, see Morris Rossabi, 'Baritone in the Mongolian Steppes', *Cerise Press*, V/13 (Summer 2013), n.p.

78 Lomakina, *Marzan Sharav*, p. 154.

79 Evans and Donald, *Picturing Power*, pp. 1–3, cites similar places in China in which posters were hung.

80 North Korea also made use of such other media.

See Heather and De Ceuster, *North Korean Posters*, pp. 12–14.

81 Konagaya and Lkhagvasuren, *Socialist Devotees and Dissenters*, p. 51.

82 Naimkhainyambuu, *Bounty from the Sheep*, p. 44.

83 Yuki Konagaya and I. Lkhagvasuren, *A Herder, a Trader, and a Lawyer: Three Twentieth-century Mongolian Leaders*, ed. Morris Rossabi, trans. Mary Rossabi (Osaka, 2012), p. 71.

84 Daniel Rosenberg, 'Political Leadership in a Mongolian Nomadic Pastoralist Collective', PhD diss., University of Minnesota, 1977, p. 274. Some of the posters appear to have been rolled or unrolled depending on the need to show them or to preserve them. A few appear to have been attached to items in the *gers* and displayed in that way. Rosenberg also describes the cultural palace (p. 98) and the postal system (p. 183).

85 For an account of the changes from 1990 to 2004, see Morris Rossabi, *Modern Mongolia: From Khans to Commissars to Capitalists* (Berkeley and Los Angeles, CA, 2005).

## 3 Eastern Europe, 1945–91

1 Leopold Tyrmand, *Dziennik 1954* (London, 1983), p. 361.

2 Tadeusz Galiński, 'Dorobek WAG-u', *Projekt* (May–June 1965), p. 3.

3 *Propaganda wizualna: treści, formy, propozycje* (Warsaw, 1983).

4 See Ulrike Goeschen, 'From Socialist Realism to Art in Socialism: The Reception of Modernism as an Instigating Force in the Development of Art in the GDR', *Third Text*, XXIII/1 (January 2009), p. 47.

5 For a detailed account and analysis of the political poster in Eastern Europe under communist rule, see James Aulich and Marta Sylvestrová, *Political Posters in Central and Eastern Europe*, 1945–95 (Manchester, 2000).

6 On this theme, see Katalin Bakos, 'The Years of "The Turn": Continuity and Rupture in Hungarian Posters Between 1945–1949', in *Znamení Doby: Mezinárodní Sympozium Kultura, politika a společnost ve Střední a Východní Evropě 1945–2000* (Manchester/Brno, 2003).

7 Lajos Kassák, 'A plakát és az új festészet', *MA*, I/1 (November 1916).

8 Here a distinction should be drawn between Yugoslavia and the rest of socialist Eastern Europe after the Tito–Stalin split in 1948. For histories of the Yugoslav poster, see Želimir Koščević, 'The Poster in Yugoslavia', *Journal of Decorative and Propaganda Arts*, x (Autumn 1988), pp. 54–61; Jasna Galjer, *100 plakata MSU* (Zagreb, 2012).

9 See Régine Robin, *Socialist Realism: An Impossible Aesthetic* (Redwood City, CA, 1992).

10 Włodzimierz Sokorski, 'Kryteria realizmu socjalistycznego', *Przegląd Artystyczny*, nos 1–2 (1950), p. 6.

11 Stefan Morawski, 'Utopie i realia', *Sztuka*, III/7 (1980), pp. 16–21.

12 See Maryla Sitkowska, 'The Posterlike Art of Socialist Realism', *Polish Art Studies*, 11 (1990), pp. 313–18.

13 Václav Šmidrkal, 'Dlátem a štětcem. Proměny Armádního výtvarného studia v letech 1953–1995', *Dějiny a současnost*, 2 (2008), pp. 21–2.

14 Henryk Szemberg, 'Polish Posters 1957', *Graphis*, 13 (1957), pp. 398–9.

15 Ibid., p. 399.

16 Andrzej Krzywicki, *Poststalinowski karnawał radości. V Światowy Festiwal Młodzieży i Studentów o Pokój i Przyjaźń, Warszawa 1955 rok* (Warsaw, 2009).

17 As the Cold War grew frostier, London-based Charles Rosner, writing about Polish posters in *Art and Industry*, wondered why 'few political posters have come our way'. Charles Rosner, 'Posters for Art Exhibitions and Films', *Art and Industry*, 47 (1948), p. 50.

18 Miklós Haraszti, *The Velvet Prison: Artists Under State Socialism* (Harmondsworth, 1989).

19 See Bedřich Dlouhý and Jan Koblasa, *Šmidrové – Jednou Šmidrou, Šmidrou navěky* (Olomouc, 2005).

20 Theodor Adorno, 'Looking Back on Surrealism', in *Notes to Literature*, vol. 1, trans. Shierry Weber Nicholsen (New York, 1991), pp. 87–8.

21 Ignacy Witz, 'Nasz Plakat' (originally published in *Życie Warszawy*, 1953), in *Przechadzki po warszawskich wystawach 1945–1968* (Warsaw, 1972), p. 53.

22 Cited by Anne Kaminsky in '"True Advertising Means Promoting a Good Thing Through a Good Form": Advertising in the German Democratic Republic', in *Selling Modernity: Advertising in Twentieth-century Germany*, ed. Pamela E. Swett, S. Jonathan Wiesen and Jonathan R. Zatlin (Durham, NC, 2007), pp. 264–5.

23 Karl Marx's writing on the fetishistic relations characteristic of commodities under capitalism was invoked by Hungarian critics of 'Goulash Socialism'; see G. Gömöri, '"Consumerism" in Hungary', *Problems in Communism*, XII/1 (1963), p. 64.

24 Wacław Jastrzębowski, Józef Jaworski and Jerzy Wesołowski, *Reklama handlowa – poradnik* (Warsaw, 1956), cited by Tomasz Lachowski in *Permanentny remanent. Polska grafika reklamowa w czasach prl-u* (Warsaw, 2006), p. 5.

25 The proceedings of the conference were published in *Reklama* (1958), cited by Daniela Nebeská in 'Hospodářské Reformy N. S. Chruščova', PhD thesis, Vysoká škola ekonomická v Praze, 2012, pp. 71–2.

26 See Richard Hollis, *Swiss Graphic Design: The Origins and Growth of an International Style, 1920–1965* (New Haven, CT, 2006).

27 Szymon Bojko, 'Grafika WAG-u i zagadnienia komunikacji wizualnej', *Projekt*, 5–6 (May–June 1965), pp. 13–14.

28 This appeared in English as *New Graphic Design in Revolutionary Russia* (London, 1972).

29 See, for instance, Mikhail Alexandrovich Lifshits and Lidija Jakovlevna Rejngardt, *Krizis bezobrazija. Ot kubizma k pop-art* (Moscow, 1968); Viktor Sibirjakov, *Pop-art i paradoksy modernizma* (Moscow, 1969).

30 A second agency, Hungexpo, was responsible for the promotion of Hungary's exports.

31 Katalin Bakos, *10x10 év az utcán – A magyar plakátművészet története* (Budapest, 2007), pp. 144–5.

32 Václav Havel, 'The Power of the Powerless' [1978], in *The Power of the Powerless: Citizens Against the State in Central-Eastern Europe*, ed. John Keane, trans. Paul Wilson (London, 2009), p. 20.

33 Elena Boeck, 'Strength in Numbers or Unity in Diversity? Compilations of Miracle-working Virgin Icons', in *Alter Icons: The Russian Icon and Modernity*, ed. Jefferson J. A. Gatrall and Douglas Greenfield (University Park, PA, 2010), pp. 27–49; Anthony Spira, *The Avant-garde Icon: Russian Avant-garde Art and the Icon Painting Tradition* (London, 2008).

34 Jessie McLellan, *Love in the Time of Communism: Intimacy and Sexuality in the GDR* (Cambridge, 2011), p. 28.

35 Ibid.

36 See Jessica Jenkins, 'Visual Arts in the Urban Environment in the German Democratic Republic: Formal, Theoretical and Functional Change, 1949–1980', PhD Thesis, Royal College of Art, London, 2014, p. 517.

37 Kemény's views relayed by Katalin Bakos in an email communication with the author (25 February 2015).

38 On this theme, see James Mark, Nigel Townson and Polymeris Voglis, 'Inspirations', in *Europe's 1968: Voices of Revolt*, ed. Robert Gildea, James Mark and Anette Warring (Oxford, 2013), p. 99.

39 See Vicki Goldberg, *The Power of Photography* (New York, 1993), pp. 234–6.

40 Havel, 'The Power of the Powerless', p. 15.

41 György Sümegi, *1956 plakátjai (1956–2006)* (Budapest, 2015), pp. 75–7.

42 See Robert B. Pynsent, *Questions of Identity: Czech and Slovak Ideas of Nationality and Personality* (Budapest, 1994), p. 209.

43 Cited in the text panels of 'Skupina Plakát 1962–1969', an exhibition curated by Marta Sylvestrová at the Moravian Gallery, Brno, 2009.

44 *Angažovaný plakát*, exh. cat., Galerie Československý Spisovatel (Prague, 1969).

45 Active in dissident Charter 77 circles, Ševčik opened his home for theatre and musical evenings in the 1970s and '80s and was also involved in the production of samizdat publications. He was arrested by the security forces in March 1985. They confiscated seventeen posters.

46 Padraic Kenney, 'Opposition Networks and Transnational Diffusion', in *Transnational Moments of Change: Europe 1945, 1968, 1989*, ed. Gerd-Rainer Horn and Padraic Kenney (Lanham, MD, 2004), pp. 214–16.

47 See Roman Laba, *The Roots of Solidarity: A Political Sociology of Poland's Working-class Democratization* [1981] (Princeton, NJ, 2014).

48 'A Conversation with the Artist of the Solidarity Logo: Jerzy Janiszewski', http://washington.mfa.gov.pl, 7 December 2011.

49 Adolf Juzwenko, 'The Right to Historical Truth', *Index on Censorship* (October 1988), p. 11.

50 See Ivo Bock et al., *Samizdat: Alternative Kultur in Zentral- und Osteuropa, die 6oer bis 8oer Jahre* (Bremen, 2000).

51 Michael Yardley, *Poland: A Tragedy* (Sherborne, 1982), p. 83.

52 Tom Kovacs, 'The Spirit of Metaphor: An Alternate Visual Language', *Il Mobilia*, 322 (1984), pp. 17–20.

53 See Hugues Boekraad's introduction in *Henryk Tomaszewski: Affiches tekeningen*, exh. cat., Stedelijk Museum (Amsterdam, 1991), p. 24.

54 British writer and academic Timothy Garton Ash recalled using this phrase in a conversation with Havel on 23 November 1989 in Prague. See his 'The Revolution of the Magic Lantern', *New York Review of Books* (18 January 1990), p. 42.

55 Václav Ševčik, 'Is There a Future for the Czech Political Poster?', in Marta Sylvestrová and Dana Bartelt, *Art as Activist: Revolutionary Posters from Central and Eastern Europe* (London, 1992), p. 46.

56 See Margaret Timmers, 'Posters of Freedom', *Eye*, 1/1 (1990), pp. 32–9.

57 See James Aulich and Tim Wilcox, eds, *Europe Without Walls: Art, Posters and Revolution, 1989–1993* (Manchester, 1993); Dana Bartelt, *Art as Activist; A változás jelei Plakátok 1988–1990*, exh. cat., Magyar Nemzeti Galéria (Budapest, 1990).

58 For a survey of these posters, see Daoud Sarhandi and Alina Boboc, *Evil Doesn't Live Here: Posters of the Bosnian War* (New York, 2001).

59 Ješa Denegri, 'Inside or Outside "Socialist Modernism"? Radical Views of the Yugoslav Art Scene', in *Impossible Histories: Historical Avant-gardes, Neo-avant-gardes, and Post-avant-gardes in Yugoslavia, 1918–1991*, ed. Dubravka Djurić and Miško Šuvaković (Cambridge, MA, 2003), pp. 170–209.

60 See Nermina Zildžo, 'Burying the Past and Exhuming Mass Graves', in *East Art Map: Contemporary Art and Eastern Europe*, ed. IRWIN (London, 2006), pp. 141–52.

61 Aulich and Sylvestrová, *Political Posters*, p. 81.

## 4 People's Republic of China, 1949–

1 See www.news.xinhuanet.com/english, 15 October 2014.

2 'China Sends Artists to the Countryside in Mao-style Cultural Campaign', www.theguardian.com, 2 December 2014.

3 Hoover Institution Political Posters Database. See www.hoohila.stanford.edu, accessed 15 January 2015.

4 Hu Jintao was General Secretary of the Communist Party, President of the People's Republic and Chairman of the Central Military Commission. Xi Jinping holds the same titles; 'civilization' is a translation of the term '*Wenming*': for an explanation of this term's political usage, see Thomas Boutonnet, 'From Local Control to Globalised Citizenship: The Civilising Concept of *Wenming* in Official Chinese Rhetoric', 2011, www.academia.edu.

5 Maurice Meisner, 'Iconoclasm and Cultural Revolution in China and Russia', in *Bolshevik Culture: Experiment and Order in the Russian Revolution*, ed. A. Gleason, P. Kenez and R. Stites (Bloomington, IN, and Indianapolis, IA,

1985), pp. 279–83. Meisner argues that their different conceptions of this term greatly influenced the course of their revolutionary development. And by the time the PRC was established, Stalin's version of 'cultural revolution' – and *kulturnost* – had changed the USSR to a conservative, conformist society.

6　Régine Robin, 'Stalinism and Popular Culture', in *The Culture of the Stalin Period*, ed. Hans Gunther (Basingstoke, 1990), pp. 15–40 (p. 22).

7　C. K. Yang, *Chinese Communist Society: The Family and the Village* (Cambridge, MA, and London, 1959), pp. 189–90.

8　David Holm, *Art and Ideology in Revolutionary China* (Oxford, 1991), pp. 23–30; Julian Chang, 'The Mechanics of State Propaganda: The People's Republic of China and the Soviet Union in the 1950s', in *New Perspectives on State Socialism in China*, ed. Timothy Cheek and Tony Saich (Armonk, NY, and London, 1997), pp. 76–124 (p. 76).

9　The standard account of this definitive event is Bonnie S. McDougall, *Mao Zedong's 'Talks at the Y an'an Conference on Literature and Art': A Translation of the 1943 Text with Commentary* (Ann Arbor, MI, 1980).

10　Julia F. Andrews, *Painters and Politics in the People's Republic of China, 1949–1979* (Berkeley, CA, 1994), especially chap. 2; Maria Galikowski, 'Introduction', in *Art and Politics in China, 1949–1984* (Hong Kong, 1998) pp. 16–21.

11　Ellen Johnston Laing, *The Winking Owl: Art in the People's Republic of China* (Berkeley, CA, 1998), fig. 4, *The Peasants are Starving*.

12　Holm, *Art and Ideology*, especially pp. 53–66.

13　Literally 'New Year prints', *nianhua* are single-sheet popular prints for the home. These appeared as early as the Han dynasty (206 BC–AD 221), with images of protective gods. *Nianhua* were replaced at the New Year festival, with specified imagery for gates, walls and other parts of the home. From the Ming dynasty (1368–1644), plays and stories were illustrated, and by the late nineteenth century, urban scenes, new inventions and current events were subjects for *nianhua*.

14　Andrews, *Painters and Politics*, p. 80.

15　See Stefan Landsberger, www.chineseposters.net; accessed 15 March 2015.

16　Chang-tai Hung, 'Repainting China: New Year Prints (*nianhua*) and Peasant Resistance in the Early Years of the People's Republic', *Comparative Studies in Society and History*, XLII/4 (October 2000), pp. 770–810 (p. 770).

17　Quoted in Thomas P. Bernstein, 'Introduction', in *China Learns from the Soviet Union, 1949–Present*, ed. Thomas P. Bernstein and Hua-Yu Li (Plymouth, 2010), pp. 1–23 (p. 1).

18　Stefan R. Landsberger and Marien van der Heijden, *Chinese Posters: The IISH-Landsberger Collection* (Munich, 2009), p. 55.

19　Laing, *The Winking Owl*, pp. 20–23.

20　Kuiyi Shen, 'Publishing Posters before the Cultural Revolution', *Modern Chinese Literature and Culture*, XII/2 (Fall 2000), pp. 177–201 (p. 188).

21　Frank Dikötter, *Mao's Great Famine: The History of China's Most Devastating Catastrophe, 1958–62* (London, 2010), pp. 186–7.

22　Ibid., p. 188.

23　Laing, *The Winking Owl*, p. 26.

24　Andrews, *Painters and Politics*, p. 196.

25　Thanks to Wenyuan Xin for this piece of history.

26　Galikowski, *Art and Politics in China*, pp. 100–104.

27　Julia F. Andrews and Kuiyi Shen, *The Art of Modern China* (Berkeley, CA, 2012), p. 152.

28　'Nianhua gongzuozhong cunzai de zhuyao wenti' ('Important problems in *nianhua* work'), *Meishu* (April 1958), pp. 6–7. These numbers are rounded, because the totals given don't add up to 100%.

29　Galikowski, *Art and Politics in China*, p. 98.

30　Ibid., p. 98.

31　*Meishu* (April 1958), pp. 6–7. Chang-tai Hung called the failure of the *nianhua* campaign, 'an ideological battle between communist visions and China's native folk tradition'. Hung, 'Repainting China', p. 773.

32  *Ten Years of Propaganda Posters* (Shanghai, 1960s), editor's introduction, trans. in Shen, 'Publishing Posters', p. 177.

33  Galikowski, *Art and Politics in China*, p. 98.

34  Sulamith Heins Potter and Jack M. Potter, *China's Peasants: The Anthropology of a Revolution* (Cambridge, 1990), p. 71.

35  Dikötter, *Mao's Great Famine*, p. 36.

36  Estimates vary greatly about the number of premature deaths that resulted during the 1958–62 famine. Dikötter's account concludes that 32.5 million is a conservative baseline. He also cites Chen Yizi's study stating that 45 million people died prematurely. Ibid., pp. 324–34.

37  Ibid., p. 114.

38  Jin Meisheng's luscious vision of rural plenty was reprinted several times, with total production running to a million copies; see Landsberger, www.chineseposters.net.

39  Shen, 'Publishing Posters', p. 192.

40  Laing, *The Winking Owl*, pp. 34–5.

41  The pen remained a political symbol of modernity. In 1980, Luo Zhongli was awarded a national painting prize for his hyper-realist *Father*, after he agreed to paint in a pen behind the peasant's ear, indicating his progressiveness; see Andrews, *Painters and Politics*, p. 396.

42  Roderick MacFarquhar and Michael Schoenhals, *Mao's Last Revolution* (Cambridge, MA, 2006), pp. 7–13.

43  In late 1968 and early 1969, every province established a revolutionary committee, comprising members of the PLA, the CPC and Red Guards; nearly all were dominated by the PLA.

44  See, for example, Li Zhensheng, *Red-color News Soldier: A Chinese Photographer's Odyssey Through the Cultural Revolution*, ed. Robert Pledge (New York, 2003).

45  See Nicole Winfield, www.therecord.com, 11 April 2015. In 2014 Shen Jiawei painted the official portrait of Pope Francis.

46  Cao Zhengfeng, 'Chinese Huxian Farmer Paintings' [1997], www.artelino.com, 2014, accessed 15 March 2015.

47  Steven Heller, *Iron Fists: Branding the 20th-century Totalitarian State* (London, 2008), p. 187, fig. 386.

48  The Gang of Four was a political faction which exerted control in the later stages of the Cultural Revolution. The leading figure was Jiang Qing, Mao Zedong's last wife. The other three were Wang Hongwen, Yao Wenyuan and Zhang Qunqiao.

49  Associated Press, *China: From the Long March to Tiananmen Square* (London, 1990), p. 146.

50  Landsberger, www.chineseposters.net. The image illustrates a scene from the Ming-dynasty novel about the Buddhist pilgrim Xuanzang, *Xi You Ji* (*Journey to the West*, better known in English as *Monkey*). In this interpretation, Landsberger sees Monkey as the personification of the Chinese people. Known and loved by all Chinese, the character of Monkey was interpreted or appropriated for many purposes during the twentieth century. The communist version highlighted the fact that the novel, while Buddhist, also criticized the old society, and that Monkey was a rebel.

51  Dazhai was a 'model' agricultural commune in the 1960s and throughout the Cultural Revolution. Its methods were followed by communes everywhere in China without regard to local conditions, and with terrible results. It became clear in the 1970s that the facts and figures of Dazhai's success had been highly inflated.

52  Deng Xiaoping, 'Uphold the Four Basic Principles', 30 March 1979, trans. in *Sources of Chinese Tradition: From 1600 Through the Twentieth Century*, vol. II (Introduction to Asian Civilizations), ed. William Theodore de Bary and Richard Lufrano (New York, 2000), pp. 492–3.

53  An *apsaras* is a female Buddhist deity. The Buddhist Dunhuang caves are in Gansu province, so the *apsaras* would be a locally recognized motif.

54  Lü Peng, *A History of Art in 20th-century China* (New York, 2010), chaps 17–18.

55  Landsberger, www.chineseposters.net, accessed 15 March 2015.

56  'Potential of the Chinese Dream', www.usa.chinadaily.com.cn, 26 March 2014.

57 The twelve qualities, from left to right, are: patriotism, independence, prosperity and strength, dedication to one's work, equality, democracy, sincerity, justice, civilization, friendliness, rule by law and harmony.

58 President Xi Jinping is promoting Marxism among intellectuals in China, supporting publications and other projects by universities. Didi Kirste Tatlow, 'China Seeks to Promote the "Right" Western Philosophy: Marxism', http://sinosphere.blogs.nytimes.com/2015/09/23, accessed 11 December 2015.

59 Thanks to Mexin Wang for this and other translations.

## 5 Democratic People's Republic of Korea, 1948–

1 'Chosŏn rodongdang chungang wiwŏnhoe, Chosŏn rodongdang chungang kunsa wiwŏnhoe kongdong kuho – Choguk haebang irhŭn tok-kwa Chosŏn rodongdang ch'anggŏn irhŭn tos-e chŭŭmhayŏ', *Rodong Shinmun*, www.rodong.rep.kp, 12 February 2015.

2 See 'Grow Vegetables Extensively! North Korea Unveils 310 New Slogans', *The Guardian* (12 February 2015), and Alison Gee, 'Decoding North Korea's Fish and Mushroom Slogans', www.bbc.com, 13 February 2015.

3 Each economic sector is represented by an individual man or woman dressed in a typical set of work clothes and armed with a recurring set of props that makes them instantly recognizable. In this case, the front row consists of a steelworker (hard hat and goggles), a soldier (helmet), a farmer (female, head scarf, rice bushel), a scientist (male, glasses, white coat, carrying a blueprint) and a miner (hard hat with headlamp, rock drill over his shoulder).

4 The CPC is the Communist Party of China.

5 Useful surveys of the intertwined history of Kim Il Sung and the DPRK are Adrian Buzo, *The Guerilla Dynasty: Politics and Leadership in North Korea* (Boulder, CO, 1999), and Bradley K. Martin, *Under the Loving Care of the Fatherly Leader: North Korea and the Kim Dynasty* (New York, 2004). For more detailed historical analyses of the political roots of the DPRK, see Charles Armstrong, *The North Korean Revolution, 1945–1950* (Ithaca, NY, 2003); Andrei Lankov, *From Stalin to Kim Il Sung: The Formation of North Korea, 1945–1960* (New Brunswick, NJ, 2002); Bruce Cumings, *Korea's Place in the Sun: A Modern History* (New York, 1997).

6 Kim Il Sung's position as the eternal president of the DPRK was designated and enshrined in the revised 1998 Constitution.

7 The Chollima horse is a mythical animal that covers great distances in a short period of time. In North Korea, this '1,000-li horse' became the symbol of a large-scale mobilization movement in the late 1950s.

8 *Songun* – Army First – politics are synonymous with the reign of Kim Jong Il. Following the systemic meltdown in the mid-1990s, *songun* became an ideological shield that was draped over Kim Il Sung's revolutionary *Juche* legacy. *Songun* highlighted the primacy of the army both as protector of the DPRK and the *Juche* revolution, and as an inspirational model of total dedication to the leader for the people.

9 Not only posters suffer from a lack of scholarly interest; there is equally a dearth of research into the fine arts of North Korea. Aside from Jane Portal's *Art under Control in North Korea* (London, 2005), a diverse collection of papers was published under the title *Exploring North Korean Arts*, ed. Rüdiger Frank (Nuremberg, 2011), in the wake of the 'Blumen für Kim Il Sung' exhibition in the Viennese Museum für Angewante Kunst in the summer of 2010. Small wonder that Igor Golomstock in his expanded *Totalitarian Art: In the Soviet Union, the Third Reich, Fascist Italy and the People's Republic of China* (New York and London, 2011) pays due attention to China (and even dedicates a postscript on Iraq), but remains silent on North Korea. One unspoken reason for overlooking North Korea may be found in the conviction that the DPRK represents no more than a replica of either the USSR or the PRC.

10   In 2008 I collaborated on the publication of the
     Prestel volume *North Korean Posters: The David
     Heather Collection*, ed. David Heather and Koen De
     Ceuster (Munich, 2008). A coffee-table book rather
     than an academic publication, it is rich in images, but
     analytically thin. The bias for anti-American posters
     makes this book hardly representative of the scope of
     North Korean poster production. Furthermore, since
     the David Heather collection consists mainly of hand-
     painted copies of North Korean posters, determining
     production dates and authorship proved difficult, if not
     impossible, further undermining the research value of
     this collection.

11   The generalization that information is hard to come
     by in North Korea stems partly from the fact that very
     often a specific kind of information, related to the
     inner workings of state power, is meant. Used as we
     are to political debates taking place under the glare
     of news media, North Korea is inevitably opaque and
     unreadable. Conditions for doing fieldwork in North
     Korea are also very constrained and site-specific, but
     this does not mean that fieldwork is impossible, nor
     that nothing credible can be said about North Korea.
     What it does mean is that one should always be wary
     of the fine print: the applied methodology and the
     acknowledgement of its limitations (surprisingly absent
     in many popular publications on North Korea that
     claim to give us the full story).

12   In that respect, it is notable that the Seoul Museum of
     Art was the first South Korean public museum to exhibit
     a closely vetted selection of North Korean posters from
     the Willem van der Bijl collection in its 'NK Project'
     exhibition (Seoul, SeMA, 21 July – 29 September 2015).
     Incidentally, prior to the opening of that exhibition, the
     private Modern Design Museum showed a selection of
     143 donated North Korean posters from the collection
     of Sungkyunkwan University Emeritus Professor
     of graphic design Paek Kŭm-nam. (Taehanmin'guk,
     Pukhan p'osŭt'ŏ rŭl p'umda [ROK embraces North
     Korean Posters], Seoul, 22 June – 21 July 2015.) North

     Korean posters are a dangerous item to possess in
     South Korea, since the National Security Law makes
     possession of seditious materials a criminal offence.

13   A random selection of recent published works in English
     that seek to offer a more informed understanding
     of North Korea are: Suk-Young Kim, *Illusive Utopia:
     Theater, Film and Everyday Performance in North Korea*
     (Ann Arbor, MI, 2010); Sonia Ryang, *Reading North
     Korea: An Ethnological Enquiry* (Cambridge, MA, and
     London, 2012); Heonik Kwon and Byung-Ho Chung,
     *North Korea: Beyond Charismatic Politics* (Lanham, MD,
     2012); Suzy Kim, *Everyday Life in the North Korean
     Revolution, 1945–1950* (Ithaca, NY, 2013).

14   More than the hand-painted copies readily available
     at Pyongyang tourist outlets, printed posters are
     particularly valuable research material because their
     imprint (on the bottom of the poster) gives us a lot of
     meta-information. The imprint usually includes the
     name of the publisher, the artist and the printing
     house, but also the print run, a serial number, an
     internal catalogue number and the publication date.

15   After ten days of solitary confinement and constant
     interrogation, he was forced to sign a confession and
     found guilty as charged, whereupon he was asked to
     leave the country. Contrary to what has been circulated
     in some media (see Maeve Shearlaw, 'The North
     Korean Posters that Got Me Arrested for Espionage',
     www.theguardian.com, 20 July 2015), his business
     venture was not the reason for his arrest (though he
     was queried about his weird interest in North Korean
     art and poster culture).

16   One of the more recent examples of this must be Tobias
     Müller, 'Propaganda-Kunst? Im Paradies des Bösen',
     *Luxx* (30 July 2015). Not only is the claim that all
     North Korean art is mere propaganda rarely based
     on any real knowledge, the label 'propaganda' is also
     always used in the context of what 'the other' does,
     not unlike the way 'ideology' is often presented as
     something unbecoming that only political opponents
     engage in.

17 See Koen De Ceuster, 'To Be an Artist in North Korea: Talent and Then Some More', in Rüdiger Frank, *Exploring North Korean Arts*, pp. 51–71 (pp. 69–71).

18 It is unclear when the name change occurred. In the 1972 *Literature and Arts Dictionary* (*Munhak yesul sajŏn*, comp. Sahoe kwahagwŏn munhak yŏn'guso, Pyongyang, 1972, p. 882), *p'osŭt'ŏ* is still used. By the time of Kim Jong Il's *Fine Arts Treatise* (1992), *sŏnjŏnhwa* is exclusively used.

19 Koen De Ceuster, 'On Misconceptions of North Korean Art and Why It Matters', in *The 70th Anniversary of Liberation Day NK Project*, ed. Seoul Museum of Art (Seoul, 2015), pp. 138–42.

20 Yu Hwan-gi's poster (illus. 208) shows the Chollima horse as the mythical winged white stallion, the way it also appears in the Chollima statue (1961) in central Pyongyang. Unlike what we see in Kwak Hŭng-mo's design, the horse here is mounted by an industrial worker and a peasant woman, and draped with a red garland emblazoned with the text 'First Five-Year Plan'. In Yu's design, the worker is holding a book close to his chest. In its most iconic form, defined by the Chollima statue, the worker is riding the winged horse with his arm outstretched, his hand holding high a treatise of Kim Il Sung. This is exactly how the Chollima horse appears atop a huge red '7' in a poster design by Rim Su-jim in 1960, announcing the launch of the Seven-Year Economic Development Plan (1961–7) (illus. 215).

21 To celebrate the Korean-Chinese Friendship Month in 1959, Yu Hwan-gi produced a poster (illus. 216) depicting the solidarity between a Chinese and a Korean worker, reinforced by the image of two smoke-billowing chimneys emblazoned with the characters for 'Great Leap Forward' and 'Chollima', affirming mutual ideological inspiration and solidarity (both deviating from the Soviet revolutionary model).

22 One of the many misconceptions about North Korea is the suggestion that it is bent on economic autarky. This misrepresentation stems from a narrow understanding of the meaning of *Juche*, which is all too often translated as self-reliance. *Juche* is a much broader, fundamentally anti-colonial concept that seeks to establish Korean autonomy and agency in politics, economy and national defence. Contrary to popular wisdom, North Korea has always had a foreign trade policy, as attested to by the number of posters dedicated to the subject in the Willem van der Bijl collection. Another beautifully designed example of such a foreign trade promotion poster is Ryu Hwan-gi's *Let Us Thoroughly Carry Out the Party's 'Foreign Trade First' Policy!* (1984), which clearly shows where North Korean domestic endowment and production are deficient (alloy elements, palm oil, agrochemicals, raw and processed rubber, cokes and crude oil), which it seeks to offset by selling its industrial products, ceramics, iron and steel products, cement, machinery, zinc and magnesia clinker (illus. 232).

23 Slogans are so crucial, if not essential, to North Korea's political language that even Kim Jong Un elaborated his ideas in his 2016 New Year's address coated in the explicit mention of a number of slogans.

24 A self-referential circularity of slogans and images blurs the boundaries of time and space, of the actual and the virtual, and makes North Korea into an innate total work of art (*Gesamtkunstwerk*). See Boris Groys, *Gesamtkunstwerk Stalin: Die Gespaltene Kultur in der Sowjetunion* (Munich and Vienna, 1988/1996).

25 The six 'heroes of our time' were farmer Pak Ok-hŭi, collier Kim Yu-bong, electrician Ŏ Yŏng-gu, forester Ri Ŭng-ch'an, scientist Hyŏn Yŏng-na and marathon runner Chŏng Sŏng-ok. Except for Chŏng Sŏng-ok, they all worked in target sectors of the economy. Marathoner Chŏng stands out for internationally defending the DPRK's honour.

26 Given the explicit vaunting of the Soviet Union as a guiding model for the young PRC and DPRK in this poster (illus. 246), the pencilled addition of a date –

1954 – and the name of the Soviet Russian painter Pyŏn Wŏl-lyong (Pen Varlen in Russian, 1916–1990) gains in credibility. Until his return to Moscow in August 1954, Pyŏn Wŏl-lyong spent nearly fourteen months in the DPRK as part of a cultural exchange programme between the Soviet Union and North Korea, where he worked as an adviser for the Pyongyang College of Fine Arts, both teaching and developing the new curriculum. On Pyŏn Wŏl-lyong, see Mun Yŏng-dae, *Uri-ga irhŏbŏrin ch'ŏnjae hwaga Pyŏn Wŏl-lyong* (The Forgotten Painting Genius Pyŏn Wŏl-lyong) (Seoul, 2012).

27 The date on the imprint of this poster has been altered to March 1960. The book covers it shows all refer to events/books/speeches after that date. In the entry on Pak Sang-nak in a biographical dictionary of Korean artists, 1970 is given as the publication date for this poster. Ri Chae-hyŏn, ed., *Chŏson ryŏktae misulga p'yŏllam* (Guidebook to Successive Korean Artists) (Pyongyang, 1999), p. 454.

28 Whereas professional artists are affiliated with art studios (*misul ch'angjaksa*) dotted across the country, amateur artists congregate in art circles at their place of work. Aside from printed posters, painted posters are produced on a more grass-roots level. Work units often have their own artists who constantly produce artwork, painted posters among them, as part of the daily routine of propaganda work. Turnover is swift here, with posters painted sometimes weekly, translating national campaigns into site-specific images.

29 Kim Jong Un, 'New Year Address', *Rodong Shinmun* (2 January 2015), www.rodong.rep.kp/en.

30 The most comprehensive research on the Moranbong Band to date is Ch'ŏn Hyŏn-shik, 'Moranbong aktan-ŭi ŭmak chŏngch'i' (The Music Politics of the Moranbong Band), research commissioned by the Ministry of Unification (South Korea) and published in December 2015 on the ROK government's policy research management system (PRISM), www.prism.go.kr.

## 6 Socialist Republic of Vietnam, 1945–

1 'Painter Nam Sơn (*hoa sĩ*) (1890–1973)', www.vietnamfineart.com.vn, accessed 27 October 2014; 'Painter Tô Ngọc Vân (*hoa sĩ*) (1906–1954)', www.vietnamfineart.com.vn, accessed 27 October 2014; 'The Artist Trần Văn Cẩn (*Dan hoạ*)', www.vietnamfineart.com.vn and www.witnesscollection.com, accessed 27 October 2014.

2 Vietnam News Agency, www.vietnamplus.vn, accessed 27 October 2014.

3 Quang Phòng, '1945–1954: Painters Volunteer to Fight for National Salvation', in *Vietnamese Painting from 1925 Up to Now* (Hanoi, 1995), p. 249. Quang Phòng (1924–2013) was an artist and arts editor contemporaneous to the events he describes. A student at the École des Beaux Arts d'Indochine between 1942 and 1945, he joined the Resistance and attended art school in Area 4, where Trần Văn Cẩn set up a woodblock printing workshop.

4 'Trần Văn Cẩn (1910–1994)', http://haiphong.gov.vn, 17 October 2012.

5 Avenue Garnier is Đinh Tiên Hòang Street today.

6 'Trần Văn Cẩn (1910–1994)', http://haiphong.gov.vn, 17 October 2012. This is a description of the poster: 'Trần Văn Cẩn painted a large format poster, four by six meters, with three characters: old, young and women handle primitive weapons, standing on the S-shaped strip of land with the words . . . *Vietnam to the Vietnamese*.'

7 Nguyễn Sáng (1923–1988), www.wikipedia.org, accessed 30 October 2014.

8 Nguyễn Thu Thủy, 'August Revolution Led the Way for Vietnamese Painting (*Cách mạng tháng Tám dẫn đường cho hội họa Việt Nam*)', www.designs.vn, 20 January 2012, and Quang Phòng, '1945–1954: Painters Volunteer to Fight for National Salvation', p. 249.

9 Hồ Chí Minh, 'Lesson 24: The Fight to Protect and Build Democratic Government (*Bai 24 tinh binh VN*) (1945–1946)', text.123doc.vn/document, accessed 27 October 2014. Lesson 24 includes the slogan: 'Fight

against hunger, Fight against illiteracy' ('*Diệt giặc đói, diệt giặc dốt*'), 8 September 1945.

10  Quang Phòng, '1945–1954: Painters Volunteer to Fight for National Salvation', p. 249.

11  'President Hồ Chí Minh's Anti-hunger and Anti-illiteracy Movements in the Early Years after the 1945 August Revolution', tcvg.hochiminhcity.gov.vn, 24 November 2013.

12  Quang Phòng, '1945–1954: Painters Volunteer to Fight for National Salvation', p. 250.

13  The Cultural Association for National Salvation was replaced by the Vietnamese Union for Art and Literature (*Hội văn nghệ Việt Nam*) in 1948.

14  Hồ Chí Minh, '11-06-1948: Uncle Ho's Call for Patriotic Emulation' includes the slogan: 'Fight against Hunger, Fight against Illiteracy, Fight against Foreign Invaders ('Diệt giặc đói, diệt giặc dốt, diệt giặc ngoại xâm'), 24 June 1948, www.lichsuvietnam.vn, accessed 27 October 2014.

15  Sherry Buchanan, 'The Artist Under Fire', in Pham Thanh Tâm, *Drawing Under Fire: War Diary of a Young Vietnamese Artist* (London, 2005), pp. 19–25.

16  Mary Ginsberg, *The Art of Influence: Asian Propaganda* (London, 2013), p. 25.

17  Kathryn Robson and Jennifer Yee, eds, *France and Indochina: Cultural Representations* (New York, 2005), p. 69.

18  'Tạ Thúc Bình, Realistic Painter (1919–1998),' www.vietnamfineart.com.vn, accessed 28 October 2014.

19  *Điệp* paper is obtained in almost the same way as *dó* paper. The bark of the *dó* tree, which normally is grown in Tuyên Quang Province, is soaked in water for months, then mixed with powders of seashells (*sò điệp*), which is the origin of the paper's name, and glutinous rice to make sheets of paper.

20  Quang Phòng, '1945–1954: Painters Volunteer to Fight for National Salvation', p. 250.

21  'Hoàng Tích Chù, Painter (1912–2003)', www.vietnamfineart.com.vn, accessed 28 October 2014.

During Golden Week in 1945, he painted the oil on canvas *Night Flowers*.

22  David Heather and Sherry Buchanan, *Vietnam Posters: The David Heather Collection* (Munich, 2009), p. 9. Author's interview with the artist Nguyễn Thụ: 'In 1951, I was an illustrator for the newspaper of a People's Army division. We were constantly on the move evading the enemy. We used lithography to print the newspaper. We carried the stone and the paper with us. The stone weighed ten kilos. I was lucky, I didn't have to carry the stone because I was too small, only my rice belt. I learnt to draw on the stone and to write the words in reverse. We had to do it very fast. We spread a sugary liquid onto the stone so the ink would be absorbed more quickly. We made the ink ourselves mixing half honeycomb and half soap in a can. We heated it up until it melted and added soot from our kerosene lamps. We stirred the mixture. Once it had cooled and was hard again, we transported the ink, like an ink cake. When we needed ink, we cut a piece from the ink cake, added water to it and melted it again.'

23  Quang Phòng, '1945–1954: Painters Volunteer to Fight for National Salvation', p. 250.

24  'Trường Chinh 1907–1988', www.wikipedia.org, accessed 3 November 2014.

25  Quang Phòng, '1945–1954: Painters Volunteer to Fight for National Salvation', p. 250.

26  Ibid., p. 251.

27  Trường Chinh, *Selected Writings* (Hanoi, 1977), p. 283, and Trường Chinh, *Chủ nghĩa Mác và vấn đề văn hóa Việt Nam* (Marxism and Vietnamese Culture), (Hanoi, 1948), p. 113. Cited in Kim N. B. Ninh, *A World Transformed: The Politics of Culture in Revolutionary Vietnam, 1945–1965* (Ann Arbor, MI, 2005), p. 43.

28  'Sixty years ago Hồ Chí Minh sent a letter to artists with an important message on art, 1951–2011', www.vietnamfineart.com.vn, November 2011. The letter includes the quotation: 'Culture, literature and art are also a battle front, and you are all fighters on that front.'

29  Quang Phòng, '1945–1954: Painters Volunteer to Fight for National Salvation', p. 251.

30  'Painter Lương Xuân Nhị, 1914–2006, (EBAI, Class VIII, 1932–1937)', www.vietnamfineart.com.vn, accessed 28 October 2014.

31  'Impressionist-style posters and pamphlets against the French (*Chiêm ngưỡng những bức "truyền đơn bằng tranh" thờ chống Pháp*)', www.baomoi.com, 11 April 2014; *Ligue pour le Rapatriement* (RAPA), Section d'Hanoi, Imp. non a la guerre.

32  Hồ Chí Minh, 'Proclamation of Independence Speech (*Tuyên ngôn độc lập Việt Nam Dân chủ Cộng hòa*), 2 September 1945', www.lichsuvietnam.vn, accessed 27 October 2014. In the speech, Hồ Chí Minh quotes Article 2 of the 1791 French Revolution's *Déclaration des droits de l'homme et du citoyen*: 'All men are born and remain free and equal in rights.'

33  Telegram, Mao Zedong and Zhou Enlai to Liu Shaoqi, 1 February 1950, Wilson Center, http://digitalarchive. wilsoncenter.org/document/111266.

34  Phan Cẩm Thượng and Nguyen Anh Tuan, *Phan Thông's Important Works of Modern Art in Vietnam: The Collection of Mr. Tira Vanichtheeranont* (Hanoi, 2010).

35  Ninh, *A World Transformed*, p. 121.

36  Conversation of the author with Pham Thanh Tâm, Hồ Chí Minh City, 2006.

37  Phan Cẩm Thượng, *Tô Ngọc Vân – Tấm gương phản chiếu xã hội Việt Nam 1906–1954* (Hanoi, 2013); Quang Phòng, '1945–1954: Painters Volunteer to Fight for National Salvation', p. 251, and Phạm Mỹ, *Công bố bức thư của Tô Ngọc Vân gửi Picasso, Matisse*, www. thethaovanhoa.vn, 6 December 2013.

38  Giáng Ngọc, 'Nguyễn Bích (1925–2011): The Artist and Illustrator of Children's Books', www.qdnd.vn, 3 August 2011.

39  Quang Phòng, '1945–1954: Painters Volunteer to Fight for National Salvation', p. 251.

40  Resolution at the Fifteenth Plenum of the Party Central Committee, May 1959.

41  'A Politburo resolution in early September 1954 called for a shift from war to peace, from the struggle for reunification to building a new society. The resolution called for attempts in the South . . . to consolidate peace and implement the Geneva Accords.' Fredrik Logevall, *The Origins of the Vietnam War* (London, 2014), p. 35.

42  'In 1957, the Ministry of Culture and Information established a body of specialized designers to create posters to support the Government of the Democratic Republic of Vietnam and the important messages of the state to the population. This decision of the Ministry of Culture and Information resulted in the development of a contingent of specialized poster designers.' Quynh Trang, 'The Struggle for Independence Through Poster Art', www.lecourrier.vnagency.com.vn, 9 May 2005.

43  'A Government Decree No. 379 – TTg established the Vietnam Fine Arts College on 20 August 1957 under the Ministry of Culture (*Trường trực thuộc Bộ Văn*).' Vietnam University of Fine Arts, www. mythuatvietnam.edu.vn, 12 August 2011.

44  Doãng Hưng, 'Building Socialism in the North, 1954–1975', *The Communist Party of Vietnam* (National Institute of Politics, Hanoi, 2010), http://dangcongsan. vn/tu-lieu-van-kien/tu-lieu-ve-dang/sach-chinh-tri/ books-310520153565356/index-41052015348385651.html, Vietnamese Communist Party website, accessed 9 October 2016.

45  Pham Thanh Tâm, *Drawing under Fire*.

46  Doãng Hưng, 'Building Socialism in the North, 1954–1975'.

47  Bảo tàng phụ nữ Việt Nam (Vietnam Women's Museum), www.baotangphunu.org.vn, accessed 28 October 2014.

48  Conversations by the author with Hanoi artists, and Kim N. B. Ninh, *A World Transformed*, pp. 188–99.

49  'The Khrushchev Thaw led to a modernization of Socialist Realism and to the search for a contemporary art style that included rediscovering and revalidating early modernist Russian and Western art.' Susan Emily Reid and Polly Jones, eds, *The Dilemmas of*

*De-Stalinization: Negotiating Social and Political Change in the Khrushchev Era* (London, 2009), p. 211.

50 Nguyễn Đỗ Cung (1912–1977), www.wikipedia. org, accessed 28 October 2014; see also Thu Stern and Sherry Buchanan, 'Biographies of the Artists', in *Vietnam Behind the Lines: Images from the War, 1965–1975*, ed. Jessica Harrison-Hall, Sherry Buchanan and Thu Stern (London, 2002), p. 87.

51 Resolution at the Fifteenth Plenum of the Party Central Committee, May 1959.

52 Hồ Chí Minh, 'Speech to the Third National Party Congress, 10. 9. 1960' ('Đại hội lần này là Đại hội xây dựng chủ nghĩa xã hội ở miền Bắc và đấu tranh hòa bình thống nhất nước nhà, 10. 9. 1960').

53 Artist Nguyễn Đức Nùng (1914–1983)', www. vietnamfineart.com.vn, accessed 29 October 2014.

54 'Artist Văn Đa (1928–2008)', www.vietnamfineart.com. vn, accessed 29 October 2014, and Stern and Buchanan, 'Biographies of the Artists', p. 90.

55 'Five Million Dead: 20 Years after the end of the Vietnam War', press release from Vietnam's Ministry of Labour, War Invalids and Social Affairs, *Agence France Presse* (4 April 1995); Ziad Obermeyer, Christopher J. L. Murray and Emmanuela A. Gakidou, 'Fifty years of Violent War Deaths from Vietnam to Bosnia: Analysis of Data from the World Health Survey Programme', *British Medical Journal*, 336/1482, 28 June 2008.

56 Martin Grossheim, 'Stasi Aid and the Modernization of the Vietnamese Secret Police', Cold War International History Project, Wilson Center, www.wilsoncenter.org/ publication, accessed 1 April 2015.

57 Marshall McLuhan, *Montreal Gazette* (16 May 1975).

58 Bùi Ngọc Tấn, 'Artist Quốc Thái (1943–)', http:// mythuathaiphong.blogspot.co.uk, accessed 28 October 2014.

59 Guerrilla artists' drawings and stories are recorded in Sherry Buchanan, *Mekong Diaries: Viet Cong Drawings and Stories, 1964–1975* (London, 2008).

60 Conversations by the author with artists Huỳnh Phương Đông, Lê Lam, Nguyễn Thụ, Van Da and Thai Ha, 2002, 2006 and 2014; www.dogmacollection. com. In addition to the major public collections of museums in Vietnam, important private collections of Vietnamese propaganda posters include the David Heather Collection, the Dogma Collection and the Collection of Ambassador Dato' N. Parameswaran who, fascinated by the Vietnamese perspective of the war, started collecting wartime propaganda posters from artists when he was Malaysian High Commissioner in Hanoi in the 1990s.

61 Thiên Lam, 'Looking Back at a Time of Fire', *Báo Dân Trí*, 27 December 2012, accessed 9 October 2016, http://dantri.com.vn/van-hoa/nhin-lai-mot-thoi-mau-lua-1356996993.htm.

62 'A ceremony was held at Hanoi's Mai Dịch Cemetery, the burial ground for government leaders and revolutionary heroes, to the National Communist Youth Union Academy in Hanoi on 30 April 1964 to launch *The Three Ready To* Campaign: "Ready to fight, Ready to join the armed forces, Ready to go anywhere, do anything that the Nation needs." The *Emulate Patriots* Campaign originated during the French War.' Lê Khiêm, '21 June 1965: Youth Volunteer Campaign (*Năm xung phong*)', www.baotanglichsu.vn, 19 June 2014.

63 Brigadier Lê Mã Lê Ương, 'Marking the History of the Three Ready Movement (*Dấu ấn lịch sử của phong trào: Ba sẵn sang*)', www.qdnd.vn, 1 August 2009.

64 'Johnson and his clique must understand that even if they send 500,000, one million or even more troops in order to step up their war of aggression in South Vietnam, or even if they use thousands of airplanes and intensify their attacks against the North, they cannot weaken the heroic Vietnamese people's iron will and determination to oppose the United States for national salvation. The war may last five years, ten years, twenty years or longer. Hà Nội, Hải Phòng and some cities, factories may be devastated. But the people of Vietnam decided not to fear. *Nothing is more precious than independence and freedom.*' Hồ Chí Minh, 'Address to the

Nation', broadcast on Radio Voice of Vietnam, 17 July 1966, http://tennguoidepnhat.net, accessed 30 October 2014. An estimated 200,000 people joined the Youth Volunteer Corps within a month of the broadcast.

65 Karen Gottschang Turner and Phan Thanh Hao, *Even the Women Must Fight: Memories of War from North Vietnam* (Hoboken, NJ, 1998), p. 33.

66 'From being slaves, women had to make the revolution . . . In March 1965 (on the occasion of the fifteenth anniversary of the National Day against the Americans: 3/1950–3/1965) the Women's Union called for inculcating women to hate American imperialism, to turn hate into determination to defeat the U.S. imperialist aggression, the Central Council has launched the movement *Three Responsibilities*'. Nguyễn Thị Nhi, 'Uncle Hồ and the Women's *Three Responsibilities* Movement', www.hoilhpn.org.vn, 27 January 2010.

67 'Trần Thị Tâm was born in 1948 in Quang Tri province, she joined the revolution at the age of seventeen, was arrested twice and brutally tortured. She participated in many combat actions, her team killed 180 enemy soldiers, she personally killed thirty enemy soldiers and destroyed two armored vehicle cars. She shot down enemy aircraft flying low over the sand dunes, dropping mines. She looked after one hundred wounded. She was killed during the Second Battle of Quảng Trị.' 'Trần Thị Tâm, Hero and Martyr', in 'Heroes of the People's Army in the War against America', www.vnmilitaryhistory.net, accessed 29 October 2014; 'Huỳnh Văn Thuận (1921–)', www.witnesscollection.com, accessed 29 October 2014.

68 Minh Hặt, 'Artist Dương Ánh (*Họa sĩ Dương Ánh và những người đẹp không có tuổi*)', www.baomoi.com, 19 October 2009.

69 Lê Thị Hồng Gấm, Vietnamese Language Wikipedia, https://vi.wikipedia.org, accessed 9 October 2016.

70 Buchanan, *Mekong Diaries*, pp. 12–34.

71 Ibid., pp. 176–95.

72 Ibid., pp. 96–111.

73 Hồ Quang, *Hold onto Youth* (Giữ lấy tuổi tre), www.qdnd.vn, 3 May 2014; poem written by a young woman to her brother fighting at DBP, *People's Army Newspaper*, Điện Biên Phủ, 10 March 1954.

74 Trần Lê, 'Painter Nguyễn Tiến Cảnh, Designer of the Stamp "Huế Liberation"', www.nhandan.com.vn, 24 December 2007.

75 Conversation of the author with artist-soldier Pham Thanh Tâm who was 'embedded' with the NVA during the battle of Khe Sanh.

76 Conversation of the author with artist Trần Huy Oánh, Hanoi, 6 December 2014; 'Nguyễn Thụ (1930–)', www.vietnamfineart.com.vn and vi.wikipedia.org, accessed 3 November 2014; Stern and Buchanan, 'Biographies of the Artists', p. 88.

77 'Huy Thục (1935–)', vi.wikipedia.org, accessed 3 November 2014.

78 Thùy Vinh, 'Artist Lê Huy Trắp: "I will continue to draw the Uncle."', www.baonghean.vn, 19 May 2014.

79 'Trường Sinh', www.bqllang.gov.vn, 23 January 2013.

80 Observation by the author, who travelled by road from Hanoi to Hồ Chí Minh City between 8 December 2014 and 3 January 2015.

## 7 Republic of Cuba, 1959–

1 'Viet Nam' is the spelling used by the Vietnamese (their language is monosyllabic), which is the form used by the Cubans. The single word version is a legacy of the French colonialists, and is the preferred U.S. spelling.

2 Fidel Castro, 'Palabras a los intelectuales', speech delivered during a series of talks at the José Martí National Library, 16, 23 and 30 June 1961. The quotation continues: 'Against the Revolution, nothing, because the Revolution also has its rights, and the first right of the Revolution is the right to exist, and no one may stand before this right of the Revolution to be and to exist. As long as the Revolution understands the interests of the people, as long as the Revolution

means the interests of the whole nation, no one may reasonably allege a right against it.' Quoted in Jorge R. Bermúdez, *La Imagen Constante: El Cartel Cubano del Siglo XX* (Havana, 2000), p. 82.

3   Eladio Rivadulla Pérez, *La Serigrafía Artistica en Cuba* (Havana, 1996), p. 42.

4   David Kunzle, 'Public Graphics in Cuba', *Latin American Perspectives*, issue 7, II/4 (1975), supplement, p. 90.

5   Adelaida de Juan, 'Three Essays on Design', *Design Issues*, XVI/2 (Summer 2000), pp. 45–8.

6   Yelin's contribution was commemorated in a 1979 exhibition at the National Museum, '1000 Carteles Cubanos de Cine' (1000 Cuban Film Posters in 1979).

7   Anecdote provided by Jane Norling.

8   País was the head of the underground urban revolutionary movement, and his death in 1957 prompted mass demonstrations.

9   I was told by the production manager at the ICAIC silkscreen facility that typical runs were between 200 and 1,500.

10  Printed 95 x 152 cm sheets were assembled in twelve-segment billboards called *vallas*.

11  The show was organized by Juan Fuentes and Susan Adelman, and went on to San Jose, California, and Albuquerque, New Mexico.

12  Estimated direct costs of the embargo include higher freight charges, a higher cost of imports, lower export revenues and poor currency exchange values, which total as much as $800 million a year, or 20 per cent of Cuba's current import bill. See Pedro Monreal, 'Sea Changes: The New Cuban Economy', *North American Congress on Latin America (NACLA) Report on the Americas* (March/April 1999), p. 27.

13  U.S. Central Intelligence Agency, *The World Factbook – Cuba*, www.cia.gov, accessed 2002.

14  Ibid.

15  Christopher Marquis, 'Cuba's Schools Shine Despite Few Resources', *San Francisco Chronicle* (20 December 2001).

# Bibliography

## Introduction

Aulich, James, *War Posters: Weapons of Mass Communication* (London, 2001)

Clark, Toby, *Art and Propaganda in the Twentieth Century: The Political Image in the Age of Mass Culture* (London, 1997)

Dörling, Jürgen, *Power to the Imagination: Artists, Posters and Politics* (Munich, 2011)

Elliott, David, et al., *Art and Power: Europe Under the Dictators, 1930–45*; exh. cat., Hayward Gallery (London, 1995)

Ginsberg, Mary, *The Art of Influence: Asian Propaganda* (London, 2013)

Glaser, Milton, and Mirko Ilić, *The Design of Dissent: Socially and Politically Driven Graphics* (Gloucester, MA, 2006)

Guffey, Elizabeth, *Posters: A Global History* (London, 2015)

Heller, Steven, *Iron Fists: Branding the 20th-Century Totalitarian State* (London, 2008)

James, Daniel, and Ruth Thomson, *Posters and Propaganda in Wartime: Weapons of Mass Persuasion* (London, 2007)

MacPhee, Josh, *Celebrate People's History: The Poster Book of Resistance and Revolution* (New York, 2010)

Portal, Jane, *Art Under Control in North Korea* (London, 2005)

Schnapp, Jeffrey T., *Revolutionary Tides: The Art of the Political Poster, 1914–1989* (Stanford, CA, 2005)

Taylor, Philip M., *Munitions of the Mind* (Wellingborough, 1990)

Timmers, Margaret, ed., *The Power of the Poster* (London, 1998)

Welch, David, *Propaganda: Power and Persuasion* (London, 2013)

## Russia/Soviet Union

Anikst, Mikhail, *Soviet Commercial Design of the Twenties* (New York, 1987)

Bonnell, Victoria E., *Iconography of Power: Soviet Political Posters Under Lenin and Stalin* (Berkeley and Los Angeles, CA, 1997)

Crowley, David, *Posters of the Cold War* (London, 2008)

Dickerman, Leah, ed., *Building the Collective: Soviet Graphic Design, 1917–1937: Selections from the Merrill C. Berman Collection* (New York, 1996)

Gill, Graeme, *Symbols and Legitimacy in Soviet Politics* (Cambridge, 2011)

Kenez, Peter, *The Birth of the Propaganda State: Soviet Methods of Mass Mobilization, 1917–1929* (Cambridge, New York and Melbourne, 1985)

King, David, *Red Star Over Russia: A Visual History of the Soviet Union from 1917 to the Death of Stalin* (London, 2008)

Lafont, Maria, *Soviet Posters: The Sergo Grigorian Collection* (Munich, Berlin, London and New York, 2007)

Norris, Stephen M., *A War of Images: Russian Popular Prints, Wartime Culture, and National Identity, 1812–1945* (DeKalb, IL, 2006)

Ward, Alex, ed., *Power to the People: Early Soviet Propaganda Posters from the Israel Museum, Jerusalem* (Jerusalem, 2007)

White, Stephen, *The Bolshevik Poster* (New Haven, CT, and London, 1998)

Yegorov, Alexander, *The Posters of Glasnost and Perestroika* (Moscow, 1989)

## Mongolia

Berger, Patricia, and Terese Bartholomew, eds, *Mongolia: The Legacy of Chinggis Khan* (London, 1995)

Bruun, Ole, *Precious Steppe: Mongolian Nomadic Pastoralists in Pursuit of the Market* (Lanham, MD, 2008)

Fitzhugh, William, Morris Rossabi and William Honeychurch, eds, *Genghis Khan and the Mongol Empire* (Media, PA, Washington, DC, and Seattle, WA, 2009)

Jagchid, Sechin, and Paul Hyer, *Mongolia's Culture and Society* (Boulder, CO, 1979)

Lattimore, Owen, *Nomads and Commissars: Mongolia Revisited* (Oxford, 1962)

Maidar, D., *Grafika Mongolii* (Moscow, 1988)

Murphy, George G. S., *Soviet Mongolia: A Study of the Oldest Political Satellite* (Berkeley, CA, Los Angeles, CA, and London, 1966)

Pedersen, Morten, *Not Quite Shamans: Spirit Worlds and Political Lives in Northern Mongolia* (Ithaca, NY, 2011)

Rossabi, Morris, *Modern Mongolia: From Khans to Commissars to Capitalists* (Berkeley and Los Angeles, CA, 2005)

Tsultem, N., *Development of the Mongolian National Style Painting 'Mongol Zurag' in Brief* (Ulaanbaatar, 1986)

## Eastern Europe

*A változás jelei Plakátok 1988–1990*, exh. cat., Magyar Nemzeti Galéria, Budapest (Budapest, 1990)

Aulich, James, and Marta Sylvestrová, *Political Posters in Central and Eastern Europe, 1945–95* (Manchester, 2000)

__ , and Tim Wilcox, eds, *Europe without Walls: Art, Posters and Revolution, 1989–1993* (Manchester, 1993)

Bakos, Katalin, *10x10 év az utcán – A magyar plakátművészet története* (Budapest, 2007)

Bartelt, Dana, and Marta Sylvestrová, *Art as Activist: Revolutionary Posters from Central and Eastern Europe* (London, 1992)

Bock, Ivo, et al., eds, *Samizdat: Alternative Kultur in Zentral- und Osteuropa, die 6oer bis 8oer Jahre*, exh. cat., Akademie der Künste, Berlin (Bremen, 2000)

Djurić, Dubravka, and Miško Šuvaković, eds, *Impossible Histories: Historical Avant-gardes, Neo-avant-gardes, and Post-avant-gardes in Yugoslavia, 1918–1991* (Cambridge, MA, 2003)

*Henryk Tomaszewski: Affiches tekeningen*, exh. cat., Stedelijk Museum, Amsterdam (Amsterdam, 1991)

Irwin, ed., *East Art Map: Contemporary Art and Eastern Europe* (London, 2006)

Jenkins, Jessica, 'Visual Arts in the Urban Environment in the German Democratic Republic: Formal, Theoretical and

Functional Change, 1949–1980', PhD thesis, Royal College of Art, London, 2014

Koščević, Želimir, 'The Poster in Yugoslavia', *Journal of Decorative and Propaganda Arts*, x (Autumn 1988), pp. 54–61

Lachowski, Tomasz, *Permanentny remanent: Polska grafika reklamowa w czasach PRL-u* (Warsaw, 2006)

Sarhandi, Daoud, and Alina Bobic, *Evil Doesn't Live Here: Posters of the Bosnian War* (New York, 2001)

Swett, Pamela E., S. Jonathan Wiesen and Jonathan R. Zatlin, eds, *Selling Modernity: Advertising in Twentieth-century Germany* (Durham, NC, 2007)

## China

Andrews, Julia F., *Painters and Politics in the People's Republic of China, 1949–1979* (Berkeley, CA, 1994)

__ , and Shen Kuiyi, *The Art of Modern China* (Berkeley, CA, 2012)

Cushing, Lincoln, and Ann Tompkins, *Chinese Revolutionary Posters of the Great Proletarian Cultural Revolution* (San Francisco, CA, 2007)

Evans, Harriet, and Stephanie Donald, eds, *Picturing Power in the People's Republic of China: Posters of the Cultural Revolution* (Lanham, MD, 1999)

Galikowski, Maria, *Art and Politics in China, 1949–1984* (Hong Kong, 1998)

King, Richard, ed., *Art in Turmoil: The Chinese Cultural Revolution, 1966–76* (Vancouver and Toronto, 2010)

Laing, Ellen Johnston, *The Winking Owl: Art in the People's Republic of China* (Berkeley, CA, 1988)

Landsberger, Stefan, *Chinese Propaganda Posters: From Revolution to Modernization* (Armonk, NY, 1995)

__ , and Marien van der Heijden, *Chinese Posters: The IISH-Landsberger Collection* (Munich, 2009)

Peng, Lü, *A History of Art in 20th Century China* (Peking, 2009)

## North Korea

Frank, Rüdiger, ed., *Exploring North Korean Arts* (Nuremberg, 2011)

Kim, Suk-Young, *Illusive Utopia: Theater, Film, and Everyday Performance in North Korea* (Ann Arbor, MI, 2010)

Kim, Suzy, *Everyday Life in the North Korean Revolution, 1945–1950* (Ithaca, NY, 2013)

Kwon, Heonik, and Byung-Ho Chung, *North Korea: Beyond Charismatic Politics* (Lanham, MD, 2012)

Noever, Peter, ed., *Blumen für Kim Il Sung: Kunst und Architektur aus der Demokratischen Volksrepublik Korea/Flowers for Kim Il Sung: Art and Architecture from the Democratic People's Republic of Korea* (bilingual German/English) (Nuremberg, 2010)

Portal, Jane, *Art under Control in North Korea* (London, 2005)

Ryang, Sonia, *Reading North Korea: An Ethnological Enquiry* (Cambridge, MA, and London, 2012)

Seoul Museum of Art, ed., *The 70th Anniversary of Liberation Day: NK Project* (Seoul, 2015)

## Vietnam

Buchanan, Sherry, 'Artists and the Role of Propaganda', in *Vietnam Behind the Lines: Images from the War, 1965–1975* (London, 2002)

__, *Mekong Diaries: Viet Cong Drawings & Stories, 1964–1975* (London, 2008)

__, and David Heather, *Vietnam Posters: The David Heather Collection* (London, 2009)

Christie, Clive J., *Ideology and Revolution in Southeast Asia, 1900–75* (Surrey, 2001)

Ginsberg, Mary, *The Art of Influence: Asian Propaganda* (London, 2013)

Gunn, Geoffrey C., *Rice Wars in Colonial Vietnam: The Great Famine and the Viet Minh Road to Power* (Lanham, MD, and Plymouth, 2014)

Harrison-Hall, Jessica, Sherry Buchanan and Thu Stern, eds, *Vietnam Behind the Lines: Images from the War, 1965–1975* (London, 2002)

Jamieson, Neil, *Understanding Vietnam* (Berkeley, CA, 1993)

Ninh, Kim N. B., *A World Transformed: The Politics of Culture in Revolutionary Vietnam, 1945–1965* (Ann Arbor, MI, 2005)

Pham Thanh Tâm, *Drawing Under Fire: War Diary of a Young Vietnamese Artist* (London, 2005)

Quang Phòng, *Vietnamese Painting from 1925 Up to Now* (Hanoi, 1995)

Turner, Karen Gottschang, with Phan Thanh Hao, *Even the Women Must Fight: Memories of War from North Vietnam* (New York, 1998)

## Cuba

Bermúdez, Jorge R., *La Imagen Constante: El Cartel Cubano del Siglo XX* (Havana, 2000)

Cushing, Lincoln, *Revolución!: Cuban Poster Art* (San Francisco, CA, 2003)

Davidson, Russ, and David Craven, *Latin American Posters: Public Aesthetics and Mass Politics* (Santa Fe, CA, 2006)

Frick, Richard, and Ulises Estrada, *Das Trikontinentale Solidaritätsplakat* (Bern, 2003)

García-Rayo, Antonio, Montserrat Villa and José Carlos Peña, *El Cartel de Cine Cubano* (Madrid, 2004)

Martin, Susan, *Decade of Protest: Political Posters from the United States, Viet Nam, Cuba, 1965–1975* (Santa Monica, CA, 1996)

Pez Ferro, Ramon et al., *OSPAAAL's Poster: Art of Solidarity* (Varese, 1997)

Stermer, Dugald, and Susan Sontag, *The Art of Revolution: Ninety Six Posters from Cuba* (New York, 1970)

## Notes on Contributors

### Sherry Buchanan

Sherry Buchanan is an author, editor, publisher and independent curator. Educated in Switzerland and the United States, she served as an editor and columnist with the *Wall Street Journal* and the *International Herald Tribune* in New York, Brussels, Paris, London and Hong Kong. She created Asia Ink in 2002 to publish a visual record of the Vietnam wars from the Vietnamese perspective, offering an alternative historical view to the thousands of publications from the French and American side (www.asiainkbooks.com). Buchanan is a trustee of the John Younger Trust and is active in a number of charities, whose work includes funding de-mining projects in Vietnam and Laos. She is the author of *The Ho Chi Minh Trail: A Journey* (2016), *A History of Vietnamese Posters* (2015), *Vietnam Posters: The David Heather Collection* (2009), *Mekong Diaries: Viet Cong Drawings and Stories, 1964–1975* (2008), *Vietnam Zippos: American Soldiers' Engravings and Stories (1964–1973)* (2007) and *Tran Trung Tin: Paintings and Poems from Vietnam* (2002), and co-author of *Vietnam Behind the Lines: Images from the War, 1965–1975* (2002). She has edited and translated numerous publications and guest curated exhibitions in London and Vietnam.

### David Crowley

David Crowley is professor of Critical Writing in Art and Design at the Royal College of Art in London. His interests lie in the history of art and design in Eastern Europe in the nineteenth and twentieth centuries. He has written a number of books on this theme, including *Warsaw* (2003) and *Pleasures in Socialism: Leisure and Luxury in the Eastern Bloc* (with Susan Reid, 2010). Crowley has also curated a number of exhibitions, including 'Cold War Modern: Design 1945–1970' at the Victoria and Albert Museum, London, in 2009 and 'Sounding the Body Electric: Experiments in Art and Music in Eastern Europe, 1957–1984' at Muzeum Sztuki, Łódź, in 2012 and Calvert 22, London, in 2013. He curated 'The Poster Remediated', the Warsaw International Poster Biennale exhibition in 2016.

### Lincoln Cushing

Lincoln Cushing, born in Havana, Cuba, has at various times been a printer, artist, librarian, archivist and author. He is involved in numerous efforts to document, catalogue and disseminate oppositional political culture of the late twentieth century. He began compiling the first catalogue raisonné of OSPAAAL posters in 1994 and completed it in 2000 with the assistance of Michael Rossman. Also, as co-director of the Cuba Poster Project, he scanned slides and photographed posters loaned by other Cuban poster agencies, the results of which have provided the foundation for research and scholarship such as this essay. His first book was *Revolucion! Cuban Poster Art* (2003). Subsequent books include *Visions of Peace & Justice: Over 30 Years of Political Posters from the Archives*

*of Inkworks Press* (2007), *Chinese Posters: Art from the Great Proletarian Cultural Revolution* (2007), *Agitate! Educate! Organize! – American Labor Posters* (2009) and an illustrated essay in *Ten Years That Shook The City: San Francisco 1968–78* (2011). He was guest curator of the exhibition 'All of Us or None: Poster Art of the San Francisco Bay Area' at the Oakland Museum of California, and author of a catalogue by the same title (2012). In 2015 he contributed to the exhibition and catalogue on OSPAAAL, Armed by Design/El Diseño a las Armas, at the Interference Archive in Brooklyn, New York. His research and publishing projects can be seen at www. docspopuli.org.

## Koen De Ceuster

Koen De Ceuster has lectured in modern Korean history at Leiden University, the Netherlands, since 1995. His research deals with the intellectual and socio-cultural history of modern Korea, the historiography and politics of memory in contemporary Korea, and North Korea's politics of culture. An internationally recognized authority on North Korean art theory and practice, he has (co-)curated North Korean art exhibitions in Rotterdam (2004), Honolulu (2011) and Assen, the Netherlands (2015). He co-authored (with David Heather) *North Korean Posters: The David Heather Collection* (2008), and co-edited (with Harry Tupan) the exhibition catalogue *De Kim Utopie: Schilderijen uit Noord-Korea*, Drents Museum, Assen (2015). Other publications include 'To Be an Artist in North Korea: Talent

and Then Some More', in *Exploring North Korean Arts*, ed. Rüdiger Frank (2011); 'South Korea's Encounter with North Korean Art: Between Barbershop Paintings and True Art', in *De-bordering Korea: Tangible and Intangible Legacies of the Sunshine Policy*, ed. V. Gelézeau, K. De Ceuster and A. Delissen (2013), and 'Bildende Kunst und Kulturpolitik in Nordkorea', in *Länderbericht Korea*, ed. Lee Eun-Jeung and Hannes Mosler (2015).

## Mary Ginsberg

Mary Ginsberg is an international banker-turned-art historian. She writes and lectures on propaganda art, comparative communism and museum curation practice. She guest-curated and wrote the exhibition catalogue for 'The Art of Influence: Asian Propaganda' at the British Museum, London (2013). She is a former curator of the Chinese collections at the British Museum and has contributed to exhibitions and catalogues on painting, calligraphy and prints.

## Morris Rossabi

Morris Rossabi, born in Alexandria, Egypt, teaches Chinese and Mongol History at the City University of New York and Columbia University. He is the author and editor of scores of books, chapters and articles, including the award-winning *Khubilai Khan: His Life and Times* (1988). Other important works include *Modern Mongolia: From Khans to Commissars to Capitalists* (2005), *The Mongols: A Very*

*Short Introduction* (2012), *A History of China* (2014) and three chapters for the authoritative *Cambridge History of China* (1994, 1998). He has contributed to exhibitions and catalogues at the Metropolitan Museum of Art, the Cleveland Museum of Art and the Los Angeles County Museum of Art. He has given lectures at universities, institutes and museums around the world, and was the recipient of an Honorary Doctorate from the National University of Mongolia.

# Acknowledgements

Firstly, of course, my gratitude to our collaborators in this project – some of whom I'd worked with before; others, new acquaintances. Sherry Buchanan, David Crowley, Lincoln Cushing, Koen De Ceuster and Morris Rossabi spiritedly share their expertise here across art, history and politics. It has been an illuminating pleasure. On behalf of us all, I thank Michael Leaman, Martha Jay and Becca Wright at Reaktion for patiently shepherding this enterprise.

It's a pleasure to acknowledge the collectors who offered their posters, knowledge and passion for the subject: John Constable, Paul Crook, David Heather, Peggy Grieve, Sergo Grigorian, Stefan Landsberger, Yakov Lurye and Yang Peiming. I went running for help many times, and always got an answer.

My colleagues at the British Museum supported this project in ways both practical and intangible. I'm indebted to Jessica Harrison-Hall and Jane Portal for always easing the way; to Kevin Lovelock and John Williams for their photographic flair; to Eleanor Hyun, Wenyuan Xin and Meixin Wang for frequent translation and research help, not to mention ever-gentle corrections; and especially to Sophie Sorrondegui, for truly endless help with photography and organization.

Thanks to my favourite critics, for their knowledge, encouragement and frank opinions – Paul Bevan, Graham Hettlinger, William Knowles, Helen Wang and Frances Wood. And finally, a long-overdue note of gratitude to Professor Tom Bernstein, who decades ago set me on the road to comparative communism.

# Photo Acknowledgements

The Authors and Publishers wish to express their thanks to the following sources for illustrative material and/or permission to reproduce it. Some locations of works are given below rather than in the captions for brevity.

## Introduction
© DACS 2017: 12; courtesy of David Heather, from Vietnam Posters: The David Heather Collection (Prestel, 2009): 21, 29, 30; courtesy of IISH/ Landsberger Collection, Amsterdam: 26; courtesy of the Paul Crook Collection, London: 4; © Rodchenko & Stepanova Archive, DACS, RAO 2017: 31; courtesy of the Trustees of the British Museum, London: 9, 22, 24.

## 1 Russia/Union of Soviet Socialist Republics, 1917–91
© DACS 2017: 48, 66, 68, 70; courtesy of the Grieve Collection, Naples, Florida: 37; © Rodchenko & Stepanova Archive, DACS, RAO 2017: 44; courtesy of The Sergo Grigorian Collection, London: 47, 65, 67, 71.

## 2 Mongolian People's Republic, 1924–92
All images courtesy of the Museum of the Mongolian People's Party and Yuki Konagaya. The Author and Publishers are grateful to the Museum of the Mongolian People's Party for granting copyright permission to reproduce these Mongolian posters for academic purposes in this book.

## 3 Eastern Europe, 1945–91
© ADAGP, Paris and DACS, London 2017: 131, 147; © DACS 2017: 137, 144, 145; © Jutta Damm-Fiedler / Jochen Fiedler: 139 (photo Stiftung Plakat OST); © Jürgen Haufe: 140 (photo Stiftung Plakat OST); © The Heartfield Community of Heirs / VG Bild-Kunst, Bonn and DACS, London 2017: 127; © Josef Koudelka / Magnum Photos: 141.

## 4 People's Republic of China, 1949–
Courtesy of IISH / Landsberger Collection, Amsterdam: 156, 158, 166, 170, 173, 177; courtesy of the Trustees of the British Museum, London: 168, 169, 174, 181, 182, 183, 185, 186; courtesy of Yang Pei Ming / the Shanghai Propaganda Poster Art Center, China: 161.

## 5 Democratic People's Republic of Korea, 1948–
All images from the collection of Willem van der Bijl, Utrecht, courtesy of Willem van der Bijl.

## 6 Socialist Republic of Vietnam, 1945–
Photo © Asia Ink: 265; Buchanan-Spurgin Collection, London © Asia Ink and Sherry Buchanan: 236, 255, 278; artwork provided courtesy of the Dogma Collection, Ho Chi Minh City: 274; courtesy of David Heather, from Vietnam Posters: The David Heather Collection (Prestel, 2009): 259, 261, 262, 263, 271, 272, 273, 276, 277, 280; collection of the Museum of the Revolution, Hanoi: 242, 247; collection of the National Gallery Singapore, image courtesy of National Heritage Board: 249; collection of Ambassador Dato' N. Pamasweran, reproduced by permission of the Ambassador, image © the Ambassador: 257, 270, 275; © Pietro Ruffo, courtesy Lorcan O'Neill Gallery, Rome, Italy: 237, 258; collection of the Southern Women's Museum, Ho Chi Minh City, image © Asia Ink: 256; courtesy of the Trustees of the British Museum, London: 251, 252; courtesy of Tira Vanichtheeranont, private collection: 241; collection of the Vietnam National Museum of History, Hanoi: 245, 246, 248, 250; Vietnam College of Fine Arts, Hanoi: 253; collection of the Vietnam Fine Arts Museum, Hanoi: 239 (photo Sherry Buchanan), 243, 244; © Vietnamese Women's Museum, Hanoi: 260, 268, 269, 279.

## 7 Republic of Cuba, 1959–
All images courtesy of Lincoln Cushing / Docs Populi. Correos de Cuba: 286; Editora Política: 281, 282 (photo René Mederos), 285, 287, 288, 289, 290, 291, 292, 293, 294, 295, 296, 297, 302, 304, 308, 310, 313, 314, 315, 316, 317, 318, 320; ICAIC: 299, 303, 305, 307, 312; MININT: 322; OCLAE: 311; OSPAAAL: 283, 284, 300, 301, 306, 309, 319, 321; UNEAC: 298.

# Index